# ART HEALS

# ART HEALS

*How Creativity Cures the Soul*

**SHAUN MCNIFF**

SHAMBHALA

*Boston & London.*

2004

Shambhala Publications, Inc.
Horticultural Hall
300 Massachusetts Avenue
Boston, Massachusetts 02115
www.shambhala.com

9 8 7 6 5 4 3

Printed in the United States of America

♾ This edition is printed on acid-free paper that meets the
American National Standards Institute z39.48 Standard.
Distributed in the United States by Random House, Inc.,
and in Canada by Random House of Canada Ltd

Library of Congress Cataloging-in-Publication Data
McNiff, Shaun.
Art heals: how creativity cures the soul / Shaun McNiff.
p.   cm.
Includes bibliographical references and index.
ISBN 978-1-59030-166-1 (alk. paper)
1. Art therapy.   2. Creative ability.   3. Healing.   I. Title.
RC489.A7M3563   2004
615.8'5156—dc22
2004006996

*Art heals by accepting the pain*

*and doing something with it.*

# CONTENTS

*Preface*    ix
*Acknowledgments*    xv

*Part One*    **INTRODUCTION**    1
   **1**    Liberating Creativity    3

*Part Two*    **ART IS SOUL'S MEDICINE**    9
   **2**    The Creative Space    15
   **3**    Letting Go in a Safe Place    28
   **4**    Embracing Upheaval    31
   **5**    The Early Work, 1970–1974: Anthony, Bernice, and Christopher    34
   **6**    The Art Therapist as Artist    52
   **7**    Aesthetic Meditation    55

*Part Three*    **OPENING TO IMAGES AND MEDIA**    69
   **8**    The Interpretation of Imagery    75
   **9**    Treating Images as Persons and Dialoguing with Them    82
   **10**    The Challenge of Disturbing Images    96
   **11**    Images as Angels    100

**12** Angels of the Wound   112

**13** Artistic Auras and Their Medicines   121

**14** The Effects of Different Kinds
of Art Experiences   137

*Part Four*   **TOTAL EXPRESSION**   147

**15** Pandora's Gifts: Using All of the Arts in Healing   151

**16** A Pantheon of Creative Arts Therapies   163

**17** Working with Everything We Have   168

**18** A Review of *Jung on Active
Imagination* by Joan Chodorow   171

*Part Five*   **CONNECTIONS TO SHAMANISM**   181

**19** From Shamanism to Art Therapy   183

**20** The Shaman as Archetypal Figure   194

**21** The Shaman Within   200

*Part Six*   **REFLECTIONS ON THE SOURCE**   209

**22** The Basis of Energy   211

**23** The Healing Powers of Imagination   221

**24** Surrender to the Rhythm   230

*Part Seven*   **USING NEW MEDIA TO EXPAND**

**CREATIVE EXPRESSION**   239

**25** Video Enactment in the Expressive Therapies   243

**26** A Virtual Studio   255

*Part Eight*   **ART HEALING IS FOR EVERYONE**   263

**27** Art Therapy Is a Big Idea   267

**28** An Inclusive Vision of Art Therapy: A Spectrum
of Partnerships   271

**29** The Way of Empathy: The Practice of Creativity
in the Workplace   283

**30** The Test of Time   290

*Sources and Credits*   295
*Selected Publications by Shaun McNiff*   299
*Index*   307

## PREFACE

I did not set out with a plan to spend my life furthering the work of art and healing. My start was serendipitous, as I described in *Art as Medicine* (1992). Let me repeat some of my story here and add some further details to set the context for this book.

I graduated from Fordham College in 1968 with a liberal arts degree and a commitment to art and social change. I made large minimalist paintings the following summer while working as a welfare social worker in Brooklyn. When the paintings became increasingly minimal, exploring different ways of placing a single line or band of color on differently sized canvases of cadmium yellow and white, it seemed that the most artistically faithful thing I could do was to stop painting altogether.

I attended law school in Boston but left in the middle of my second year to return to art and took a job in an iron works so I could learn how to weld and make steel sculpture. After two months I decided that I had to do something more professional. On the basis of my New York summer experience and rumors that one could get hired without an MSW, I went in late February to the local state hospital in Danvers, Massachusetts, looking for a social work job. I met with the hospital personnel director who told me that the rumors were not true, but he looked at my résumé and said that the art therapist had just left for Honolulu. It turns

out that he was director of volunteers when my grandmother, Margaret Tyndall, came to the hospital every Thursday to sew and create with the hospital patients. I left the hospital that morning in the beginning of 1970 as an "art therapist," never having heard the term before. Art therapy "happened to me." Like most of the important ideas and insights of my life, it arrived outside the frames of my plans and intentions. If there was anything important that I did, it was to respond to the invitation.

I was given the opportunity to set up an art studio for the patients and immediately immersed myself in supervision and training. The hospital had a psychiatric residency program in affiliation with the Massachusetts General Hospital and I had access to wonderful supervisors. Within a few months I was giving regular talks to groups of nursing and pastoral counseling students who visited the art studio and who were always eager to see the patients' art and hear about what we were doing. Through these studio talks I realized that people were keenly interested in art therapy. Shortly afterward, Rudolf Arnheim at Harvard agreed to supervise me in a masters program offered by Goddard College, and he sent me a student intern from the Harvard Divinity School and another from Radcliffe. Receiving the support of Arnheim, the preeminent authority on the psychology of art, gave me the confidence to start publishing my ideas and to become more of a public advocate for art and healing.

Students came from other colleges and universities to do internships in the studio. Christopher Cook, the director of the Addison Gallery of American Art at Phillips Academy in Andover, made a commitment to the program and started to work with me together with his wife, Julie, and students they brought from Andover. A major exhibition of the patients' art that we organized at the museum received rave reviews from the Boston art critics and a grant from the state arts council to have the show travel to museums and universities throughout the northeast. I started teaching courses at Lesley University (then Lesley College), and the demand resulted in my starting a graduate program in March of 1974 after just turning twenty-seven. Simultaneously we ran an art therapy program in the Addison Gallery for patients from the state hospital and other adult and children's mental health centers in the community as an ongoing installation/art event right in the museum, with one of the large galleries set aside as a permanent space for the work. The Lesley program grew dramatically, and students came from around the world. Ever since, I have been at the work of art and healing in various settings,

thanking God, my grandmother, and the hospital personnel director for giving me the chance to make these contributions.

I tell this story to emphasize how each of us can use the ordinary circumstances of our lives to spread the work of art and healing. Once one gets started with this process, others will come to assist. I have found that this work has a deep appeal to people everywhere. At every turn of my career with art and healing—starting in the mental health field and spreading through the Addison Gallery connections to the world of art, and then to higher education, public schools, community development, health care, and various other venues with mainstream communities—people have been there to work with me, to offer support, and ultimately to take the process further through their own activities. This open-ended multiplication of the process has been my continuous goal.

Art therapy work within the mental health field has started a process that is good for everyone. Art heals all of us—not just the mentally ill. After ten years of immersion with the Danvers patients and others, I left full-time clinical work to bring this experience of healing through art to a wider range of people. Since the early 1980s, I have offered studio retreats for the general public. Participants have included people from every sector of society, including therapists and healers in need of their own creative renewal. The essays assembled in this book give a sense of the different threads of practice that grew from these unplanned beginnings. I have tried to select materials for a broad audience, and most of the previously published essays have been revised to fit within the overall scheme of the book and in some cases to present an idea or segment from a larger essay.

I have approached the process of choosing materials from my life work like a gathering of seeds. Consequently the range of topics is wide contrasted with my other books, which generally focus on a particular theme. New essays have also been written with the goal of giving a complete overview of how art heals. I have included a number of my more theoretical or scholarly essays, in which I try to articulate the dynamics of healing through art and how the process connects to other forces and ideas about human experience. I have also provided references to the sources that have informed my thinking and the positions I take.

The collection is a concentrated presentation of the key ideas that I keep returning to over and over again throughout my career, discussed for the first time in one text. I hope that this gathering of thoughts will

be experienced like a spontaneous cottage garden or as a musical ensemble in which all of the components manifest themselves simultaneously rather than according to a calculated progression. Different ideas and ways of working move into the foreground and recede to give the stage to others, all the while sustaining their particular contributions to the whole and appearing again to take the lead at later points. This is the way the process has occurred and developed over the years, with the primary principles acting more like sustained visions and rhythms than strategic plans. There is a repetition of key ideas throughout the book and I hope the reader experiences this process as presenting creative variations on the themes that mean the most to me.

The chapters are arranged thematically rather than chronologically, although the thematic placements are flexible since ideas in each essay cross over to all parts of the book. I have often described my work as "antidevelopmental" in that everything was present at the start; as Jung suggested, there is no linear evolution, only a "circumambulation" of experience. I cannot say that anything I am doing today is better or more enlightened than the things I did in March 1970 when I first met with people in the art studio at Danvers State Hospital or anything that young art therapy students do when they first work with people. I believe strongly that the powers of art and healing are ready to be activated in all of us at any time.

The basis of my understanding of how art heals has always been personal experience with artistic expression from childhood to the present. My colleague at Lesley University, counseling psychologist Eleanor Roffman, once observed that students usually enter the field of expressive arts therapy because of a personal experience they have had with the healing powers of art, in contrast to "talk" therapists, whose careers are often inspired by their personal experiences as clients in therapy. My years of working with thousands of people in the arts and therapy field affirm Eleanor's observation. All visions of art and healing emanate from our experience with the creative process.

In shamanic cultures the initiate goes on a vision quest in search of a healing revelation that guides future practice. In our era these archetypal processes are apt to happen outside the scope of a conscious search because we have lost contact with many of the universal rites of human experience. But I have learned that the primary and eternal process of art and healing goes on in spite our inattentiveness to its cultivation. Art and

creativity are the soul's medicines—what the soul uses to minister to itself, cure its maladies, and restore its vitality.

This book suggests an ongoing method of looking and re-looking at how art heals from ever-expanding perspectives. The selection of essays attempts to extract the essence of my experience and the gathering process leads to letting the seeds go, tossing them to the wind, so that they can grow anew among my readers.

**SHAUN MCNIFF**
*Cambridge, Massachusetts*

## ACKNOWLEDGMENTS

In creating this collection of essays from over thirty years of writing, I am indebted to many mentors, beginning with Rudolf Arnheim, who first encouraged me to write essays as a way of researching, refining, and testing ideas before presenting them in books. I am also grateful to the various journals, editors, and readers who support what I write. My longest editorial relationship was with Sylvia Halpern, who was the managing editor of *The Arts in Psychotherapy* from its inception to her retirement. A stickler for precision with a formidable intellect and a person known for her one-minute phone calls, Sylvia rarely altered my essays or made a negative comment, and I actually felt that she may have liked them; this gave me the confidence to keep writing.

The number of essays that I have written, and perhaps their relevance, have been significantly enhanced by my close relationships with three editors: Robert Landy, former editor in chief of *The Arts in Psychotherapy*; Cathy Malchiodi, former editor of *Art Therapy: The Journal of the American Art Therapy Association*; and Steve Levine, editor of *Poiesis: A Journal of the Arts and Communication*, and its predecessor, *C.R.E.A.T.E.* Their requests for articles generated many of the essays included in this book. Gilda Grossman, former associate editor of *The Canadian Art*

*Therapy Association Journal,* also requested essays and helped make writing a consistent and satisfying part of my life.

Thanks to Amber Frid-Jimenez for her cover design, and to Bob Evans, Mark Kuhn, and Peter Hart for mentoring me in computer technology and helping me to initiate the virtual studio, and to all the people who have read and responded to manuscripts before publication—especially Paolo Knill, who read everything I wrote over a twenty-year period at Lesley University, with remarkably sustained enthusiasm, intelligence, and creative insight.

My greatest thanks and credit for the creation of this book go to Kendra Crossen Burroughs of Shambhala Publications, who has been my editor and writing mentor, critic, and supporter for the past fifteen years and the person most responsible for bringing my work to a larger audience through trade book publications. Kendra has also connected me to Jacob Morris, who has edited my last two books. Jacob has been a teacher during the process of editing *Art Heals.* His keen sense of prose style and his physical science expertise have been of great use to me. He and Kendra have been a tag team in generating probing queries and suggestions that have given this senior professor one of the most challenging intellectual exercises of his career. If this book is able to meet "the test of time" and reach the next generation of people committed to art and healing, much of the credit goes to Kendra and Jacob.

And finally, thanks to Dave O'Neal, managing editor of Shambhala Publications; Liz Shaw, assistant managing editor; and all of the staff of this enlightened company who have honored me and my work by publishing my books.

# PART ONE

*Introduction*

# 1

## *Liberating Creativity*

There was a time not long ago when the mention of the word *healing* evoked suspicion within the art therapy community. To associate our profession with the realm of healers was considered threatening because it suggested that art therapy was something other than a scientifically valid method of treatment. Similar reactions were aroused by the use of the word *soul* in connection with the therapeutic process, as I have experienced firsthand. Following a university lecture that I gave in the 1980s, a psychiatrist friend told me, only half-jokingly: "Shaun, you're not a therapist. You're a priest."

Healing belonged to the "soft" realm of spirituality, whereas clinical treatment aspired to a more technical and controlled realm of expertise. Our culture had lost the ancient insight of Socrates, who chided Charmides for trying to heal the body without first engaging the soul. "Curing the soul," he said, "is the first and essential thing."

We've come a long way in a short time. Whereas art therapy was initially used almost exclusively with psychologically handicapped people, it has now expanded to every sector of society. In its very first sentence, the present mission statement of the American Art Therapy Association declares that the making of art is "healing and life enhancing." A similar embrace of the healing process has taken place within the medical

community, largely as a result of needs expressed by patients and their families.

People today who suffer from illnesses want to be involved in their recovery, to contribute to the healing process, not just passively receive treatments administered by others. When psychologically sound people experience life crises and medical traumas, they understand that recovery will be enhanced by their active and creative involvement. One outstanding such person was a colleague of mine, Mary Louise O'Connor, who pioneered the use of the creative arts in cooperation with her own medical treatments and those of other patients at the prestigious Dana-Farber Cancer Institute. At her memorial service, the CEO of the institute described how O'Connor taught doctors that there is a difference between curing and healing, that there can be healing when curing is impossible, and that art heals.

The revolution that is quietly taking place in the application of the creative process to healing results largely from people beset by medical and life crises that provoke major changes in how they view themselves and their places in the world. The threats stimulate a new creative response. Nietzsche wrote in *The Birth of Tragedy* that when we are faced with the most dreadful circumstances, "art approaches as a saving sorceress, expert at healing. She alone knows how to turn these nauseous thoughts about the horror or absurdity of existence into notions with which one can live."

After the tragedy of September 11, 2001, the world media spotlighted the way the arts were used by ordinary people to respond to this great crisis. When words could not begin to express the feelings of both children and adults, artworks were made spontaneously across the country as a way of dealing with grief, fear, trauma, and the larger complex of emotions provoked by the devastating events. For example, the drawings and writings and cards created by schoolchildren brought solace to New York City firefighters and other public safety workers for weeks and months after the tragedy. Artistic expression has a unique and timeless ability to touch every person in times of personal crisis and collective distress.

Since healing through art is one of the oldest cultural practices in every region of the world, it is curious that some people dismiss contemporary efforts to revive this tradition as a "New Age" practice. I express solidarity with the many innovative people whose work is negatively labeled in this way because they are thinking differently about the ways

things operate in our world and how they might be improved. It seems that those who cannot identify with creative and divergent ways of approaching situations use the term *New Age* to lump together whatever does not fit into their worldview. Rather than run from the concept, I want to embrace it and the many people who have contributed to this community of creative ideas and practices.

The way in which art heals within daily life is not far removed from the therapeutic transformations of creativity that we first explored with chronically ill people in the back wards of psychiatric hospitals. We are discovering that the medicines of art will flow through every life situation but that the conditions of healing and treatment vary according to environments and the requirements of the people involved. Art adapts to every conceivable problem and lends its transformative, insightful, and experience-heightening powers to people in need. Many of us explore the healing power of art on our own, while others do it with the guidance and in the safety of therapeutic relationships. The medicines of art are not confined within fixed borders. Wherever the soul is in need, art presents itself as a resourceful healer.

I have consistently discovered that the core process of healing through art involves the cultivation and release of the creative spirit. If we can liberate the creative process in our lives, it will always find the way to whatever needs attention and transformation. The challenge, then, is first to free our creativity and then to sustain it as a disciplined practice.

My career has continuously taken me back and forth between the studio and the workplace; in the latter, people are increasingly aware of the need for creativity in community life. I believe the creative imagination is an intelligence that gathers and integrates varied resources, and it manifests itself most completely in our experiences with others. Community, at local and global levels, contributes both the tensions and gifts that fuel the process of creative transformation and healing. If I had to identify one fundamental or defining element that informs every aspect of my work, I would probably point to the activation and circulation of creative energy in groups and communities. My first graduate thesis was concerned with making art in groups, and in my practical work I have never veered away from this focus. As I emphasize in my book *Creating with Others*, the "slipstream" of group participation takes individuals to places where they cannot go alone. Groups of people can generate, reinforce, and revive creative energy and imagination.

Experiences with groups of people from throughout the world have shown me that there is a universal force of art and healing that can help everyone who has access to it. The group, from the first enactments of shamans to contemporary therapy groups, is a crucial factor in either restricting or liberating the creative energies of healing.

Art is ultimately a way of looking at life that involves everything we do. In addition to my use of painting, I have explored ways of integrating all of the arts in my work. This inclusion of different media reflects a desire to embrace all of life in art's healing process. Although my primary personal medium is painting, my work involves all of the fine arts. Thus, when I use the word *art,* I am addressing every form of expression and creative perception.

The making of a painting, a dance, or a poem is a microcosm of the larger movements of creative energy in nature that we bring to bear on the totality of our experience in the world. Different forms of expression feed off one another and generate an ecological dynamic through which the forces of healing and transformation in nature merge with those of the individual. Through the discipline of creative expression we foster healing within ourselves while also giving back to nature in a spirit of reciprocation.

This larger cultivation of creativity requires an appreciation for the contributions made by every person who makes art. For more than three decades I have urged my art therapy colleagues to reach out to artists. There is no need for conflicts between healing art and art therapy. The latter is part of the former, and the differences are clear. Art can heal wherever it is practiced, whereas art therapy is a more circumscribed experience that takes place within the context of a therapeutic relationship between qualified therapists and clients and with resources that do not exist when a person creates alone.

While maintaining a close involvement with the art therapy profession through every phase of my career, I have focused on the study of the universal healing qualities of art as experienced by people inside and outside therapy. I have gratefully received strong support for this work from readers within the art therapy community, while always reaching out to enlarge the circle of people committed to art and healing. Even angry and revolutionary artists who view themselves as operating far from the process of healing and art therapy may be more closely allied than they realize. As with disturbing dreams, artistic expressions that aggressively

provoke audiences and decry the conditions of the world can embody important aspects of the healing process where the identification and destruction of harmful patterns is necessary.

Art's healing is more than art therapy alone. Art therapy therefore needs to re-vision itself as a leader in cultivating, understanding, and caring for the phenomenon of art and healing, just as the medical field can do more to support holistic wellness. Art therapy benefits by opening itself to this larger process and creative "energy" of healing. The experiences of people everywhere and throughout world history affirm that art heals.

# Art Is Soul's Medicine

The studio, with its artmaking energies, is central to the practice of art and healing. This first part gathers together writings that address the primary process of art and healing as practiced by all people. When we focus on artmaking and what it does, we find that the essential elements are truly universal and minimally influenced by the individual styles and methods of therapy and healing.

"The Creative Space" (1995) was written in response to an invitation from Cathy Malchiodi, the editor of *Art Therapy: The Journal of the American Art Therapy Association*, to contribute to a special issue on the role of the studio in art and healing. My very first day as an art therapist at Danvers State Hospital in March of 1970 involved the creation of a studio environment, and to this day I have sustained this objective as the primary focus of my work with art and healing. The free interplay of people and images within the studio has also been the basis of my work as an art therapy educator and researcher. In "Letting Go in a Safe Place" (1997) I elaborate further on the medicines of the studio, the importance of safety in establishing creative and healing environments, the way in which clinical values of precision

can be tied to studio work, and how the group energy of the studio affects people.

"Embracing Upheaval" (1992) was written as a brief introduction (under the title "Art Is Soul's Medicine") for the catalog of an exhibition called "Healing and Art" at Gustavus Adolphus College in St. Peter, Minnesota. Artists from throughout the state had contributed works that focused on connections between art and healing. In this essay I reflect on how my studio experiences have confirmed for me that disturbance and destruction, together with the overlooked features of daily life, are primary sources of creative expression and renewal everywhere that art is made—from the mental health clinic to the studios of the most prominent artists. The embrace of the commonplace together with the challenging and disturbing aspects of experience were later explored in my books *Earth Angels: Engaging the Sacred in Everyday Things* (1995) and *Trust the Process: An Artist's Guide to Letting Go* (1998).

In the interest of staying close to practice, I have included abridged versions of my first descriptions of therapeutic artmaking in the studio at the former Danvers State Hospital in Massachusetts with Anthony, Bernice, and Christopher (1970–1974). Anthony and Christopher demonstrate how the progressive development of artistic expression can be accompanied by corresponding changes in a person's life. Bernice used art to express herself during an acute emotional disturbance when she was not speaking or interacting with others. As she expressed herself with increased ability and satisfaction, Bernice began to speak again; but her creative expression ended completely when she returned to her more normal life patterns.

My descriptions of the work with Danvers patients were published in many places. In this selection I return to the original materials, integrating them from my current perspective. The accounts of my work in a mental hospital are in some ways quite different from what I do today in my art and healing work with people from all sectors of society. I include these accounts in the present volume because they provided the basis of my early vision of how the making of art can change and improve a person's life. In these cases the artists changed not only their own lives but also the lives of others, including myself. What differs so significantly from my work then in a mental hospital and today in a more open studio is the environmental context. The process of making art and being healed by it is absolutely consistent. I trust that we can all find inspiration in different aspects of the expressions of Anthony, Bernice, and Christopher.

"The Art Therapist as Artist" (1982) is a brief statement that I gave on a panel with fellow artists that was connected to an exhibit of our art in Philadelphia at the Annual Conference of the American Art Therapy Association. The overall process of the exhibit and panel departed significantly from the formal presentations that had until that time characterized national conference sessions. I took advantage of the opportunity and approached my presentation as performance art.

As I read the text today for the first time in over twenty years, I am surprised at how it engages me, succinctly expressing an important moment in the emergence of my work with art and healing, and returning me to the emotion and vision of that time in my career. It was a period when I was dedicated to the alchemical powers of artistic expression. Prior to the conference, I had exhibited the same paintings (which concerned my struggles with having to attend meetings) in shows called "Art Alchemies" at the Addison Gallery of American Art and the Josselyn Gallery at the Hartford Art School.

These exhibits were the beginning of a process whereby I began to publicly present my own artmaking as a demonstration of how art heals. The spirit of artistic holism and unity that has pervaded every aspect of my work with art and healing is present in the terse statement of "The Art Therapist as Artist." The paintings that I made were strongly influenced by the art of patients in my Danvers studio, especially Christopher. Looking back at my first experiences in the mental hospital studio and the support offered to us by the staff at the Addison Gallery of American Art at Phillips Academy in Andover, Massachusetts, I see clearly how they shaped both my art and my life's work.

Although other art therapists had shown their art publicly, it was always in a context separate from their therapeutic identities. Their personal work in the studio was considered distinct from what they did with others in art therapy. This separation still exists within many sectors of the art therapy community. I, in contrast, longed for a more complete integration of my personal artmaking and the art therapy process. I wanted to offer an alternative to the disconnection I felt when art therapists did not apply their methods to themselves. Christopher Cook (director of the Addison Gallery at that time), Don Burgy, and other conceptual artists in Boston were working on similar themes related to the integration of art and life during the 1970s, and they became important colleagues in helping me advance ideas about art and healing. These collaborations with

artists underscore the necessity of close ties between art therapy and the community of artists committed to healing. Art therapy will be consigned to future obscurity if it selects the extreme of professional specialization over a process of co-creation with artists.

An exclusive focus on case studies of the work that I did with other people was limiting. I needed a direct, firsthand encounter with the healing qualities of art. Unless I explored these practices in my own life, I knew that my work with others could not fully flourish.

This brief essay was the first step toward the ultimate publication of *Art-Based Research* (1998) and the creation of books in which I used my own art as the material for inquiries into how art heals: *Depth Psychology of Art* (1989) and *Art as Medicine: Creating a Therapy of the Imagination* (1992). Art therapists now so regularly integrate their art within their practice, teaching, conference presentations, and publications that it is easy to forget how unusual it was for me to begin doing this in the early 1980s. It was a definite risk within a field that had spent so much of its energy focusing only on how artworks expressed the pathology of their makers and at a time when art therapists presented their work almost exclusively in the most formal academic presentations.

What the pathology seekers might see in my art did not concern me as much as the possibility that the art therapy community would view my use of personal artistic expressions as self-serving. As art therapists we share a profound concern for the well-being of others, and I was apprehensive that my colleagues might not see that I was trying to use myself and my art as vehicles for learning more about how art heals and how we can use this knowledge to help others. Ultimately, there was an overwhelming positive response to the heuristic examination of my own art-making, and the method has been widely adopted and advanced in many new directions by colleagues such as Pat Allen, Lynn Kapitan, Robert Landy, Stephen Levine, Bruce Moon, Cathy Moon, Cathy Malchiodi, and others shaping the future of art and healing. As the pendulum now swings in the direction of this type of inquiry, we need to make sure that we never lose the edge, the tension, and the question as to whether or not we are publicly exploring our personal expressions to benefit others and the overall well-being of the work of art and healing.

A larger circulation of participants will further art's healing powers. As healers we need to keep healing ourselves and to stay immersed in the medicines we want to bring to others.

I complete this section with a new essay, "Aesthetic Meditation," which reinforces the view that everything we do with art and healing will always be based on the simple process of looking at creative expressions and reflecting upon them. Before exploring ways of relating to images through various forms of creative and imaginative expression, I want to emphasize that the most natural, universal, and satisfying way of engaging an artwork is through silent contemplation. These meditations are often permeated by the experience of beauty that is rarely acknowledged and discussed in relation to art and healing.

I use my own art to convey how the process of aesthetic contemplation takes place and how it affects the artist. When we are immersed in the process of trying to understand an image, its relationship to the artist who made it, the way it influences people who look at it, and its ability to stimulate further creative expression, it is easy to get ahead of ourselves and to shortchange the meditative process of just looking at an image without any goal or purpose. I want to make it very clear that all of the creative methods of responding to images discussed in this book will never take the place of visual contemplation of artworks, of breathing with them in the present moment.

Aesthetic contemplation is the basis for all of our other methods of interpreting and engaging artistic images. This essay reminds us that when people start interpreting images according to psychological formulas and theories that reduce an image to a linear narrative, they have left the realm of art. Interpretation can itself be approached as a process of aesthetic contemplation that moves from pure reflection to the communication of whatever feelings and insights emerge from the experience. Interpretation is essential in the art and healing process, but we have to keep reminding ourselves that it flows from and informs the process of aesthetic contemplation. Beware of any approach to artistic interpretation that closes the door on mystery, on the unexpected, or on the unique responses that individuals have to images.

# 2

*The Creative Space*

## THE COMMUNITY OF CREATION

My career as an art therapist began at a state hospital in early 1970. Before even meeting the staff, and the patients, who lived in a huge Victorian brick and granite building constructed in the 1870s, I was introduced to an old wooden building in a field at the east end of the hospital grounds. There was an identical building at the other end, almost a quarter of a mile away. The empty building was to be used exclusively for my art therapy groups. It was called the Art Cottage, and its partner at the west end of the hospital was the Music Cottage.

It was an era when patients were institutionalized and there were few treatment opportunities other than psychiatric drugs and the use of restraints; but considerable "space" was being made available for art. I was untrained, and the hospital offered no instruction on the practice of art therapy. The possibilities were as open as the empty rooms of the cottage. In retrospect, it was a perfect way to begin. I met the space first, and it told me what to do: it wanted to be filled with images and people making art. The medicines of the process would find their ways through the souls of the people and things involved.

The non-instructions from my supervisors at the hospital were actually quite clear. Their actions said, "Put this place to work." My career

began to take shape around the creation of a workplace, a studio for soul work. Rather than focusing exclusively on the individual problems of patients, I was oriented to a physical space that called for their involvement. We began with the need to fill a space with images and life. I could not do this alone. I needed to work together with the patients to establish the sense of the place and its function within the hospital.

The cottage had two large rooms with high ceilings, joined by an equally large foyer. It was situated at the crest of a large hill with fields below, a beautiful natural environment that characterized mental hospitals designed during the post–Civil War era to expose disturbed people to the "medicines" of the physical world. The 1870s advanced the idea of humane treatment for those with emotional difficulties, and these practices grew from the American Renaissance of the mid-nineteenth century in literature, philosophy, religion, and utopian living. The cottage had windows everywhere, and on its southerly side an enclosed porch ran along the entire length of the building. The two cottages were probably first built for tubercular patients who needed to be housed separately from the main building, and whose treatment was primarily focused on fresh air and light.

It is fascinating to imagine the therapeutic qualities of our art studio being connected in an elemental way to the healing methods practiced in the old TB cottage. The animating principle in both TB treatment and art is inspiration, the inhalation of airs and spirits. One of the meanings of *inspire* is to draw air into the lungs, to breathe, and *spirit* derives from the Latin word for breath, the breath of the gods. Just as the tubercular patients needed good air, the soul benefits from stimulating airs, poetically known as an atmosphere, ambience, or aura. My first art studio was set up according to this natural sense of what the soul needed—creative breezes, breaths, and emanations flowing from a place.

The emptiness of the large space was a stimulus for my work with the patients. The task was uncomplicated; I was to fill the cottage with people, images, and creative energy. The space served as an alchemical vessel for the transformations wrought by the artistic process. Many things happened within the cottage, and it quietly accepted them all while sheltering everyone involved. It was an asylum within the asylum because of its separation from the main hospital complex. Patients entering the studio environment literally passed into another world, possessed of distinctly different qualities than what they encountered

on the wards. Culture and soulful creation radiated from every part of the place.

Many years later, I see that my art studios are still keeping the rituals initiated by the first weeks in the Art Cottage. We always begin in an empty space that we fill with people and images. The place is transformed and ensouled as soon as the images arrive and as we relate to them with empathy and imagination. Guided by the values of deeply felt experience, we establish a community of creation through the most basic actions of working together and reflecting on one another's expressions.

## A SANCTUARY OF SOUL MEDICINE

The images are what carry transformative spirits into our studio groups. Their sensory qualities and energetic auras have a visceral impact on everything they touch. The environment transmits creative forces and becomes a primary agent of transformation. My lifelong practice within the studio was constructed in those first days of "beginner's mind" that accessed the ancient continuities of a *participation mystique*—we relax our self-consciousness and become part of a larger group expression. A place presented itself to me, ready to be inhabited by the creative process and the intimate relations it engenders.

My group therapy supervisor at the hospital was a psychiatrist who felt that the most important therapeutic work occurred within groups and communities. He was deeply suspicious of the medical model in mental health, and we didn't have to look far in the hospital to see its failures manifested by the "bureaupathic" ways people treated each other. He was open to what was happening in the Art Cottage, and the two of us learned about this new, or very old, therapy through his questions and my experimentation.

We looked at the making of art from the perspective of community interactions and he introduced me to the ideas of Maxwell Jones, who wrote influential books about therapeutic communities in mental hospitals, beginning with the one he created in London after the Second World War. Though I started a therapeutic community on one of the hospital wards and ran a number of different groups in locked areas of the hospital, I now see that the creative ideals of the therapeutic community were happening spontaneously in the Art Cottage. There the patients, the many volunteers, and my life were being influenced by the creative milieu. We had to get out of the hospital to establish a sanctuary of soul medicine that functioned ac-

cording to a totally different vision of treatment. Within the hospital, institutional forces swallowed every attempt at change. The planned therapeutic community paled in comparison to the one that simply happened within the Art Cottage environment.

As with Jones's experiments with self-help, we discovered that empowering the patient artists as decision-makers and creators increased their sense of belonging and responsibility. Jones felt that creative transformation was stimulated by a "social ecology" involving flexible and open interaction, listening, the sharing of decisions, learning from mistakes, trust in people, and a pervasive sense that process was more important than the goal itself (1982, 144).

Just as Jones, a psychiatrist who began to call himself a social psychiatrist and ultimately a social ecologist, pondered whether medical science was the proper vehicle for his community practice, I have often reflected on the relationship between my studio practice and art therapy. Since so many of my colleagues are expressing a similar commitment to making art in healing environments, it seems that the discipline of art therapy is able to expand itself in order to hold and support the breadth of our interests. There are many of us who have enlarged the radius of art's healing function to community and organizational life, public health, and social well-being. When the discipline of art therapy is defined in a way that reverberates with the eternal healing functions of art, there are no limits to potential applications.

### THE UNPREDICTABLE INSPIRATIONS OF STUDIO WORK

In recent years my original vision of art and healing has been affirmed by writings of Pat Allen (1992, 1995) and Bruce Moon (1990, 1994, 1997) that honor the studio as a vessel of creative transformation. Moon's sense of the sanctity of art and Allen's vision of artists-in-residence suggest that it is the *presence of the creative process* that transforms life. If we imagine healing as an energy of creative transformation, then our goal becomes the cultivation of the salubrious force that finds its way to people in different ways. More recently, Catherine Moon has called for strengthening the art therapist's identity as an artist (2001). Lynn Kapitan has expressed that a return to the studio by art therapists will further the reenchantment of art therapy itself (2003). We never can predict what we are going to receive from a studio, and this quality of the unknown is what most clearly differentiates medicines of the creative spirit from scientific

ones. But we go to the studio with a sense of anticipation that we will engage a creative vitality and spirits that will manifest themselves in different ways during each session.

From the studio we learn that the agents of transformation are more likely to be in the atmosphere or ambience than within the person. This is why healing through art is so closely identified with spiritual traditions that focus on one's relationship to something other than the limited self.

Within the studio, the expressive qualities of the environment act upon us. The carefully calculated and replicated procedures of scientific medicine are far removed from the wily and unpredictable movements of creation. Art is forever breaking down structures in order to make new ones. The creative ecology works in ways that parallel Jones's descriptions of open social systems. Patterns and themes run through a person's and a community's creations but the effects of a creative process can never be known in advance.

Art's medicines are based on surprises, unlikely twists, and the infusion of fresh contents into our lives. Years of working in studios have repeatedly shown me that these contents come upon us when we least expect it, and frequently against our wills. I never know in advance what a person needs to receive. I try to get people involved in the creative process in a way that opens to a deep personal dialogue with images and feelings that instinctively present the needs of the soul. It seems that I am forever being surprised by the unexpected results of people's work in the studio.

New participants in my studios often have difficulty adjusting to the freedom of exploring materials without a particular goal. A man recently said that he felt as if he were returning to kindergarten. He said to himself, "Why am I taking hours from my day to do this? I need to get out of here." He stayed with the group, however, and opened himself to the general atmosphere of the studio. As the day went on, he marveled at what began to emerge from his expression. He discovered the ancient truth that the journey will take us to surprising and unexpected places if we submit to it and that the most significant discoveries cannot be planned in advance. He also discovered that resistance, doubt, and even annoyance can contribute to the overall chemistry of the creative process, which often does some of its best work with the extremes of emotion. This situation also underscores the importance of respecting and accepting an individual's misgivings and allowing them to be part of the group process without trying to fix or challenge them in any way.

The studio accepts us where we are and invites us to work with whatever happens to be moving through us at a particular time.

As a "keeper" or "caretaker" of the studio, my primary function is to kindle the soul of the place, to maintain its vitality and its ability to engage people in highly individual ways. I might carefully plan what materials we are going to use or how our time is structured, but the distinct features of the process cannot be predicted: this is what most thoroughly distinguishes the healing qualities of the studio from medical science.

## WHAT PLACES AND MATERIALS DO

Art's medicines consist of forces generated by the distinct substances and physical spaces that are present within any art therapy studio. Different materials and environments will elicit creative expressions in keeping with their structures. Although the materials and studio space are involved in constantly changing relationships with artists and groups, both have a relative constancy of expression. For example, watercolor with its free-flowing nature evokes distinctly different psychic states than thick oil paints. Sculpture made from wood and metal will arouse different feelings than clay constructions do. The materials influence us in ways that correspond to their physical qualities. The same thing applies to studio spaces. A small but well-organized workplace full of people will generate a crowded energy that moves creation in a distinctly different way than a large and open space. One is not necessarily better than another.

For years I have said that research about the arts and healing should stay closer to the studio, where we can experiment with these different material expressions and spirits like physicists or chemists in their labs. In diverse parts of the world, indigenous peoples believe that the cures for internal ills are found in external things. If we apply this principle to art, we ask how particular kinds of creative expressions and materials influence the people who engage them. Do clay, stone, thick oil sticks, flowing water-based paint, and other materials have qualities that affect people in relatively consistent ways? Do intimate and cozy spaces, spacious and open lofts, bright sunlit rooms, have medicines that correspond to their physical qualities? What are the particular medicines and healing qualities of these different kinds of environments? How might a bustling studio with the sounds of people talking and working affect us in contrast to a silent, meditative environment where we hear only the movements of brushes on paper? To what extent do people's reactions

vary in response to these conditions? Are there more similarities than differences, or vice versa?

Does it really matter whether or not people respond to environments and materials in consistent ways? Is the fact that these physical phenomena act upon people and generate responses reason enough to use them? Is healing an endlessly variable process through which people establish their unique relationship with materials and places? Will there always be a range of similar and relatively consistent responses to particular phenomena as well as different and idiosyncratic reactions? Is the latter aspect of variability more likely to characterize creative expression?

These questions and many more can open us to vast new domains in the practice of art and healing. For most of the twentieth century, with the exception of unique studies of the therapeutic effects of media in Holland and the studio-oriented work of individual art therapists, psychology has focused largely on what the art object says about the person who made it. When attempting to reveal hidden states of consciousnesses according to a particular psychological construct, we not only project our views onto the artwork but also overlook what it presents and how its expression influences us. Similarly, this way of reducing whatever appears in a person's expression to inner conditions obstructs sensitivity to how external conditions affect and change the person. The most significant influences typically come from expressions of our own that act upon us as they take physical form in the external world. So much of therapeutic culture has been concerned with the technical fixing of problems; yet the real work of art and healing may have more to do with what the Romantic poets called flying sparks, which jump from person to person, image to person, person to image, and image to image in unpredictable ways.

It may be very important in our research and practice to avoid an exclusive focus on the person who makes the art object and to expand our attention to the relationship among people, materials, and spaces. What do these things do to us? Art as healing is based upon the introduction of physical and expressive phenomena into the therapeutic process, yet we have done so little to explore their qualities and effects.*

---

*Chapter 14, "The Effects of Different Kinds of Art Experiences," explores the issue of materials in more depth.

## A THERAPEUTIC COMMUNITY OF IMAGES

In my studios, art leads the way. The images and movements are always a step ahead of the reflecting mind and its pronouncements. My practice draws heavily from psychotherapy and depth psychology, which help us access the medicines of images and groups. What I do today in studios with art therapists, artists, and what we call "healthy people" is not far afield from my work in the mental hospital more than thirty years ago. I have stayed with the medicines of the studio, bringing them to a broader spectrum of participants. My work is also focused on healing the healers who engage so many others in their practice of art therapy. I have worked to recharge art therapists with the energy of art.

As I reflect on what we did in the early 1970s, I see that a community emerged from the making of images. I am doing the same thing today, as I work almost exclusively with groups. Little has changed within my essential studio practice, where rituals of community and creation continue to happen spontaneously through the group's actions in a particular place. After the first session of a studio, I am always in awe at the transformation of the space and the way the soul opens as soon as the images arrive.

Every studio repeats the experience of beginning in an empty space that soon becomes populated by creations. I tell participants that our group includes the many images we make, as well as ourselves. Even in small groups this rich multiplicity takes us into the realm of community. I have stayed with group practice in studios because I see it working deeply on people year after year. I keep saying how the group mind is more intelligent, creative, and resourceful than any one of us. My leadership style involves a careful watching of the group process, in both art and interpersonal interactions, with a faith that soul will treat itself if given the proper environment and support. Like Maxwell Jones and other early group therapists, I believe that what we need to express will naturally emanate from our interactions if we can stay open, committed, and patient; affirm each other; let go; and trust the process.

The group-studio chemistry is based upon the paradox of individual people performing the intimate and individual rituals of painting within a communal environment. We are drawn together through what I call the principle of simultaneity, in which the solitary activities of the visual arts are accompanied by the parallel creations of others. In addition to the shared energy of working, participants give attention to each other.

We witness and receive the expressions of others and open to what the images have to say. It is this process of making art together and then bearing witness to the arrivals in a sacred way that furthers the healing qualities of the studio environment.

As a leader my primary functions are protection and inspiration. I keep the sanctuary and maintain the space for the participants. I set up the creative environment in which the process takes people where they need to go. For years I avoided using the expression "trust the process" because it seemed like an outrageous cliché, but now I see that it is the fundamental quality of the work. The freedom of the studio allows the creative imagination to move according to its purpose.

I try to keep the structures and procedures elemental because I have found that depth and simplicity are bound together. "The simpler the deeper," I like to say. Perhaps a clear and sustained focus helps us to let go of our distractions and become immersed in the creative imagination. As the French scientist and philosopher Gaston Bachelard wrote, "The simpler the image, the vaster the dream" (1994, 137).

If we overcomplicate the purpose of art, we interfere with the wisdom of the process. I keep returning to the image of the simple, empty space of the Art Cottage as the foundation of my work. I prepare an open studio that receives the participants who fill it with their art and souls. Within the studio each person goes on a distinctly personal journey, yet all paradoxically travel together and construct a therapeutic community of images. Although I have worked alone with many patients in studio settings, my experience of the strongest creative medicine is associated with groups. When we gather to look at images and work with them, the atmosphere changes from that of a conventional art studio to something that conveys a healing and spiritual community. We look at the pictures through the eyes of soul. This way of viewing art does not impair aesthetic quality and technique—to the contrary, it tends to make images more expressive, authentic, free, unusual, and passionate. There is a respectful and sacred sense of witnessing rather than an orientation to analytic judgments. People respond to one another, and to the images, from the heart.

One person's artistic expression stimulates an equally soulful response from another. There is a creative flow in the group, an ongoing stream of creative emanations wherein one artistic expression follows another. Verbal explanations have their place in the studio, but they do not dominate

the atmosphere. We find that responding to art with body movement, improvisational sounds, poetic statements, and performance gives everyone a much deeper and clearer sense of how the person is affected by an artwork. We also share dreams that come the night after painting, to interpret our works in ways inaccessible to the waking, reasoning mind. The introduction of dreams and other artistic expressions into the studio enhances the psychic environment and expands its resources.

In a therapeutic studio the overall sense of presence, the soul of the place, grows from the people and images while simultaneously acting upon them. As a keeper of the studio, my function is to maintain the creative and healing energy of the environment. I do this through example, support, and constant guidance.

### IMPERFECT ENVIRONMENTS

Often the places where we work generate very unattractive auras and disturbing environmental forces. I have constructed many hundreds of nomadic studios throughout my years of practice. I feel like a Bedouin traveler who keeps putting up and taking down his tent. In my travels I don't think I have ever worked in an ideal studio. There is always something that could be better organized in the space. I have contemplated constructing an ideal place, but maybe I should not. The perfect studio could establish an unrealizable standard for others. It may be better for me to keep working with whatever materials I find in the different places I visit. In this way I demonstrate to others how the studio can be set up anywhere.

Groups repeatedly teach me how to maintain a spiritual presence amid the din of a work area. If the keeper of the process relaxes, this helps everyone else to do the same. The reverse is also painfully true. Everything depends upon our concentration and faith in the process.

Although I prefer to work in the best space possible, I have repeatedly discovered that the vitality of a studio has more to do with the creative presence generated than the physical features of rooms. I do not mean to discourage architects and interior designers from becoming involved in the art and healing movement, and especially the important work of "universal design" striving to create environments and technologies of communication that accommodate all people irrespective of their physical abilities. We want to have the best spaces possible, yet we must also work with whatever we have, especially when bringing the arts to places with limited financial resources.

Distractions and imperfections may even perversely feed the creative spirit because they are not unlike our often-disheveled lives. There may be a wondrous medicine released when a group fills an unattractive space with imaginative expressions. When we creatively transform unappealing places, the change of attitude has a corresponding effect on how we perceive ourselves and the world.

## WHERE DOES SOUL'S STUDIO BELONG?

Before I encountered art therapy, my interests were focused on the sacred functions of art and the relationship between creation and depth psychology. When art therapy first appeared in my life, our interests merged. To the extent that art therapy embraces the diverse and unpredictable ways of creation, I have felt deeply attached to the profession. In my formal artistic education, I was taught technique and concepts; the emotional depths of expression were not addressed. My studios encourage a more integrated approach to all facets of the art experience.

Art therapy has been most useful in providing me with a community of colleagues who serve the same mission. Even though the mainstream of the art therapy community appears to be increasingly committed to the healing function of art, the pressures of clinical regulation, written examinations with multiple-choice questions, and a general distrust of imagination may ultimately restrict the free spirits of the studio; and they will migrate to places more hospitable to the ways of soul. If we are to keep the soul in art therapy, we must preserve the studio as the practical and spiritual base of our praxis while finding ways to addresses issues such as licensure that sustain our core identity. Within the ideal art studio there is a freedom of expression that embraces all approaches to art and healing. I feel confident about the future vitality of art therapy if the medicines of the studio are the foundation of a collective vision.

Art therapy is at a historic point of definition. For over two decades the profession skillfully maintained an inclusion and respect for every conceivable way of imagining what it could be. As the American Art Therapy Association now prescribes and evaluates courses of graduate study, nowhere in all of the regulations is there a requirement that art therapists be involved in an ongoing studio experience during their training and professional practice.

Don't read this criticism as a plea for a new requirement. I prefer a discipline that is perfected through inspiration, and I repeatedly discover that

I am stimulated and invigorated by studio environments and the artistic images within them. In studios we learn through subtle suggestions and influences. The impressions are not always conscious, but they work on us nevertheless.

The profession of art therapy will benefit from increased practice within studio environments where the unique medicines of the creative process can be cultivated. We need to give more attention to how studio environments influence people. The idea of therapeutic change has been restricted to what happens between a patient, a therapist, and the artwork with which they interact. My experience indicates that there are so many other forces at work within a milieu, and the notion of a therapeutic studio embraces this diversity of possibilities.

### LED BY THE SPACE

In this chapter I reflect upon the practice of art therapy from the perspective of the physical space, instead of from the more conventional assessment of a patient's problem. When I look back at the beginning of my practice, the space is a formative force. I don't wish to dismiss the treatment of symptoms and complaints; I am only trying to show how a profession loses its way when it tries to accommodate itself to something other than its essential being. Rather than a genesis myth that says, "In the beginning was the symptom," art therapy might try imagining itself from a nonmedical perspective of "In the beginning was the space" and "In the beginning were the art materials and the people who used them."

Symptoms are of course welcomed, and they are vital players in the creative process. But they can be engaged from the perspective of art, or within the studio model versus the medical model. What does the space do to us? How does it move us to create an environment that becomes the primary carrier of the therapeutic process? As a therapist or leader, I am one of many agents within a more comprehensive gestalt or presence. The art studio functions like a spa, a watering place for the soul. The elements of the therapeutic studio are never limited to the patient, the artwork, and the therapist. As the therapeutic properties of the spa are discovered, people will come to it with a sense of what they need. Or they will come with an open and flexible mind, knowing only that they are in need, and that the therapeutic environment has many things to offer. The treatment will emerge through the process of a person's interaction with the place.

We reframe the practice of art therapy by focusing on what the studio does, what the materials do, and how artworks created by ourselves and others affect us. When we look at art therapy from the perspective of creative imagination, we see an ecological field of forces, a total presence of creation for which the linear language and concepts of behavioral science cannot account. The mainstream of art's medicine will always flow from the studio.

**REFERENCES**

Allen, P. 1992. Artist-in-residence: An alternative to "clinification" for art therapists. *Art Therapy: Journal of the American Art Therapy Association* 9 (1): 22–29.

———. 1995. *Art is a way of knowing: A guide to self-knowledge and spiritual fulfillment through creativity.* Boston: Shambhala Publications.

Bachelard, G. 1994. *The poetics of space.* Boston: Beacon.

Jones, M. 1982. *The process of change.* Boston: Routledge & Kegan Paul.

———. 1953. *The therapeutic community: A new treatment method in psychiatry.* New York: Basic Books.

Kapitan, L. 2003. *Re-enchanting art therapy: Transformational practices for restoring creative vitality.* Springfield, IL: Charles C. Thomas.

Moon, B. 1990. *Existential art therapy: The canvas mirror.* Springfield, IL: Charles C. Thomas.

———. 1994. *Introduction to art therapy: Faith in the product.* Springfield, IL: Charles C. Thomas.

———. 1997. *Art and soul: Reflections on artistic psychology.* Springfield, IL: Charles C. Thomas.

Moon, C. 2001. *Studio art therapy: Cultivating the artist identity in the art therapist.* London: Jessica Kingsley Publisher.

**3**

---

*Letting Go in a Safe Place*

My studio practice with other people emphasizes a depth of expression that follows the movements of the creative process, which are complex, meandering, often chaotic, and without fixed goals. Depth can never be planned in advance in terms of specific outcomes. We can prepare the space, but we can never know what will appear. The studio environment allows the complicated spirits of the creative process to work in their natural ways.

Although this studio-oriented practice differs from traditional psychological methods, I don't want to abandon the classical clinical values. To me, the term *clinical* conveys being precise, attentive to what's going on, responding to the needs of another person, and being observant and present. This is what I do as a keeper of the studio. There is no irreconcilable split between art and clinical care. The major difference between what we do in the studio and what is done in the clinic has to do with control and letting go. In the studio, I favor a more nurturing model of cultivation over the conventional leadership mode of direction. The studio approach is attuned to the ancient spiritual disciplines that emphasize listening, being present, and letting go of tight controls so that things outside our current awareness can come forward. I see my role as one of serving, maintaining, and tending, rather than strategizing and intervening.

People always ask what the leader needs to do to create a space that allows people to let go in this way. When a liberating atmosphere is experienced in my studios, people ask themselves, "What's he doing to make us feel so free and uninhibited?" Since there is so little formal direction being given and everything seems so natural, people begin to wonder why things are emerging from them in such a spontaneous and satisfying way.

A woman who participated in a studio wrote me to describe the "magic" of the creative connections she experienced in all the aspects of the space, and how grateful she was that the sacredness of the space was not violated by explanations and other intrusions. This focus on the role that the space plays involves a shift in the way we think about art and healing. Explanations and other intrusions from outside the process of creating interrupt, interfere, control, limit, and defend against the natural depth and flow of expression. The art process is intuitive, labyrinthine, and welcoming of uncertainties, risks, and dark places.

After a studio in Netanya, Israel, the group continued to communicate about the special sense of safety that was created, enabling them to open in ways that were far removed from the pressures of their daily lives. One of the women, who had studied the writings of psychoanalyst D. W. Winnicott on safe environments, called me a "good-enough mother," referring to the way the leader takes on the role of protector of the group while establishing a sense of direction and purpose. It was a mature group with considerable life experience, and they strongly emphasized how a totally safe space, free of judgment, enabled them to explore challenging areas for the first time.

When we are truly present with one another and open to whatever needs to be expressed, this pervasive sense of safety and even sacredness can emerge. This is the most fundamental quality of the healing studio. Creative powers are exercised when people feel safe. A film director once described how he tries to help actors feel secure, safe, and supported so they can make themselves emotionally naked. No matter how talented the actor may be, there will not be a depth of expression unless all of the creative channels are open and flowing freely. Fear, distractions, and environmental intrusions block the flow.

Yet as described in the previous chapter, I've never worked in a perfect environment. There always seems to be something that could be better—the light, walls, available space, acoustics, sinks. I often find myself in conference rooms where we have to cover and protect the furniture and other

contents so we can paint freely. In Switzerland we've set up studios in retreat centers where everything is sometimes just "too beautiful"—perfect wood floors and large windows with wondrous views, which can actually be distracting when we are trying to go inside ourselves. From Zen practitioners we learn to start where we are, engaging the unique qualities of any environment.

Limitations can paradoxically fuel creative expansion. For this reason, the most difficult spaces can often be the most powerful forces for transformation. The act of making difficult spaces into healing spaces definitely has a corresponding effect on the psyche. Whatever the physical space may be, I try to make it into a *temenos*, a sacred place that acts as a vessel of transformation. My favorite metaphor for this is the witch's cauldron, a cooking vessel in which we shape raw material into new forms.

If we are to create safe places that allow our most authentic expressions to emerge and grow, we may need a revolution in the way we think about artmaking. My research into the *temenos* suggests that the sacred space is always set apart in some way from what Mircea Eliade called the "profane" world. We truly *enter* sacred space to do this work. Even working outside in nature, people throughout time have designated the sanctuary with a circle of stones or some other delineation. The healing studio needs boundaries that mark off the space. Thus, whether we are working in a bland hotel conference room or in a carefully designed art room, the space becomes a temple of creation, holding people in a protected yet challenging enclosure.

I emphasize the importance of group leadership in creating the sanctuary. The leader focuses on shaping the consciousness of the group, which becomes the strongest force in creating safety. Groups are capable of generating much more energy and power than a person acting alone. The leader activates the energy of community, setting in motion a dynamic interplay among the people, the space, the images, and the spirits of expression. This creates the atmosphere of authenticity and healing only available in a safe and sacred space.

# 4

---

## *Embracing Upheaval*

In my experience, healing the soul has always been a process of finding the remedy in the materials of ordinary life. The healing agent is often a debased thing that I begin to see with a new appreciation. It may be the painting that I covered because it was upsetting, or the conflict that I finally see as the purpose of my life.

Although I have spent my career making positive statements about the way art heals, I am intrigued by the way it disturbs. If we follow the dictum of "trusting the process," then disturbance is essential to the psyche's purpose. In the mid 1970s when I tried to prove that art brings order and equilibrium to our confused psyches, the conceptual artist Don Burgy told me how he makes art to achieve disequilibrium. Like many other artists, Burgy strives to agitate and penetrate to areas of experience that we may be reluctant to engage. Paradoxically, artists like Burgy show how artmaking may generate conflict and discomfort in the pursuit of wholeness. Art's healing function may at times require shattering the artist's state of mind in order to make it anew.

Art itself may need to enter the crucible of creative destruction that forms new relationships. Appreciation of art's need for disintegration offers an alternative to pressures to fix and eliminate problems. As a therapist, can I trust the psyche's desire for fragmentation rather than unity? And mustn't

I always be wary of asserting that this or any other particular way of operating *is* art's healing function? For in other situations the perspective may be reversed with expression desiring integration. The psychic terrain is predictably uncertain, and art is our best tool for charting the course.

Art does not profess to rid the world of suffering and wounds. It does something with them, realizing that the soul is truly lost when afflictions cannot be put to use. Creativity engages breaking points and fashions fresh life from them. The big transformations are rarely planned and arrive in their own time, often contradicting the artist's intention.

Emotional conflict and art have had a productive and long relationship. Diagnostic interpreters have for years seen pathology in images, which they literally identified with the artist's psyche. Labeling artworks in this way errs in reducing creative expressions to the personal histories of those who make them. If I paint an aggressive figure, I may express the aggression that lives within me *in potentia*, but the traits of the figure in the picture are not necessarily mine. This can be likened to the actor who plays a troubled or disturbed character. For example, King Lear has an autonomous identity that individual actors explore within themselves. The actor becomes immersed in the person of Lear, but ultimately they are two separate beings, who are, however, intimately involved and merged during the artistic process. The two need each other in the collaborative process of creation.

Artists are not always healed people, but they can teach us how to engage the transformative aspects of emotional upheaval rather than experience the madness that occurs when imagination turns against itself. Art shows how the difficulty can contain its cure if channeled into life-affirming expression.

In my studios people often are initially reluctant to engage their discontents. They say, "I'm blocked"; "I'm confused"; or "I don't want to get involved in these feelings of being inadequate and afraid."

I always respond, "The only way I know how to deal with this is to stick with the feelings you are having. This is where you are, and if you connect with the confusion, the fear, the stuckness, or even the disgust, it will take you where you need to go in the studio. Tap into the energy of the problem."

More often than not, people will look at me with expressions of doubt or annoyance, and I can do nothing but stand back and let them decide what to do. It's never easy and I don't enjoy this part of the work. As a

leader I have empathy for their uneasiness, but I also experience the renewal and transformation that they feel when the process begins to work for them.

Repeatedly I observe that fear and resistance signal the presence of rich veins of creative discovery. Usually tied to painful past experiences, these emotions carry so much personal history for all of us. Those who take on leadership roles need to make it possible for people go into areas of vulnerability, where precious resources of expression and learning can be accessed. People need to be affirmed and protected when they risk entering these realms. Art therapy may ultimately make significant contributions to the larger realm of creative expression through its ongoing attempts to understand these dynamics and to create safe places for exploration and learning.

# 5

*The Early Work, 1970–1974*

**ANTHONY, BERNICE, AND CHRISTOPHER**

**ANTHONY**

I first met Anthony in 1970 when gathering men from a locked hospital ward to form an art group. At thirty-four, he was by far the youngest person on the ward of chronic patients. Hospitalized from the age of fifteen, he spent his days either pacing the length of a room or sitting and lying in isolation with his eyes to the floor.

Getting Anthony involved in our art group was particularly difficult. It required a great deal of encouragement from me for him to attempt a picture. When he finally did so, he filled the page with a three-second contour drawing of a human figure that resembled a gingerbread man (figure 1).

In our subsequent sessions he drew the same figure over and over again. Before making the quick drawing, he spent a great deal of time making sure that the bottom edge of the paper was square with the edge of the table. I tried to help him vary his expression by suggesting simple and familiar motifs. I alternatively suggested a tree, house, and car. Anthony then made three- to five-second representations of these images (figures 2 and 3). As with his gingerbread men, the drawings filled the entire page and were intelligent and simplified symbolic representations of the subject matter. However, they were frustrating to me since I was trying to involve him in more sustained artistic expressions. My frustration was heightened

Figure 1. *Gingerbread Man,*
by Anthony.

Figure 2. *House,* by Anthony.

Figure 3. *Car,* by Anthony.

Figure 4. *Circles*, by Anthony.     Figure 5. *Paint Jar*, by Anthony.

by Anthony's immediate return to drawing gingerbread men after rendering the tree, house, and car.

I continued to meet with Anthony and encouraged him to try different forms of artistic expression, but he persisted with the gingerbread man. It became clear that verbal encouragement was useless, and in one of our sessions I spontaneously held Anthony's wrist as he finished drawing the half-dollar–sized circle that always made up the head of his figure. I asked him to perform the simple but different task of filling up the entire page with circles like the one he had just drawn. He made four orderly rows of three circles from the top of the page to the bottom—all in blue tempera paint. I opened some orange paint and asked him to elaborate on his drawing by coloring in the circles with it. He did this with surprising aesthetic sensitivity, painting a solid orange circle inside the blue circle, with the white paper providing a separation and ring between the two (figure 4). Anthony's invention made for a pleasing visual effect; but, as I feared, he returned to drawing his gingerbread man in our next meeting.

The frustration of my work with Anthony continued for another month until our remarkable breakthrough session, when he came to the group and, with no stimulation from me, sat down and opened a jar of blue tempera paint and painted a picture of the jar (figure 5).

This self-initiated change was amazing in itself, but equally significant was the precision and accuracy of Anthony's representation of the jar.

Anthony started the drawing with a simple contour of the jar and then stopped working. I encouraged him to draw the label and the cap resting alongside of it, and then to apply color. These direct requests were needed to get him to move beyond the quick contour drawing.

Capitalizing on Anthony's new interest in drawing things from his environment, I urged him to draw other objects in the studio. It is important to note that Anthony himself set the course of his artistic expression. By drawing pictures of the things around him, he was working toward the extension of his perceptual awareness—a very significant development for a person who had not established extended eye contact with people and things for so many years. When drawing, he closely observed the structural features of the objects and expressed these qualities with great clarity in his work (figures 6 and 7). In the beginning he would always stop after quickly drawing the contour of objects, and I had to request that he represent details and apply colors. As the drawing process became more familiar, Anthony worked with greater autonomy and made highly differentiated pictures with little direction from me.

It became clear to me that Anthony would benefit from more than the

Figure 6. *Fan*, by Anthony.

Figure 7. *Urn*, by Anthony.

Figure 8. *Portrait,*
by Anthony.

ninety minutes a week that we spent in our art group, so I started to work with him individually outside the group. He continued to perfect his expression by spontaneously drawing portraits of other people in the studio (figure 8). As always, he captured basic pictorial qualities of the subject's appearance in his simplified artistic manner so that it was clear who the person in the picture was. Anthony went on to draw other people in the studio, including myself.

On the day that he did my portrait, I asked him—as I did each day—what he would like to draw. Usually he had to be pushed to make a decision, but on that day he surprised me by saying: "I want to do you." Sitting in the studio and watching him paint a picture of me, I for the first time felt the energy and power of his concentration in working. He looked at me with his eyes squinting and studied my face intently as he drew.

Another important factor in Anthony's artistic progression was his movement from essentially monochromatic pictures to images of rich and varied color. His latent sensitivity for color was released when I exposed him to the expressive potential of violets, crimsons, and greens.

I kept inviting Anthony to draw more challenging and complex subjects.

Figure 9. *Three People in the Studio*, by Anthony.

Figure 10. *Interior*, by Anthony.

Figure 11. *Car Outside Art Cottage*, by Anthony.

He went on to make a self-portrait by looking in a mirror, a drawing of a person from memory, and a picture of three people in the studio (figure 9). After this series of portraits, I suggested outdoor scenes and more complex interiors in which Anthony was given the opportunity to further enlarge his artistic expression and perceptual awareness (figures 10 and 11).

Artistic accomplishments stimulated corresponding changes in Anthony's overall behavior. He began working regularly in the hospital laundry and moved out of the locked ward and into a therapeutic community program for men and women.

After being totally nonverbal for so many years, Anthony began to speak with other people. The first time he spoke spontaneously to me, he leaned his face toward mine and said, "I can talk to you." He held his fingers to his throat and felt the vibrations of his long-dormant vocal cords. Later when Anthony was writing and speaking about his childhood friends, tears came to his eyes. He looked directly at me and said decisively and with great clarity, "Who are you? You're so cruel."

A few minutes later he said, "I've been dead for a long time, but I'm alive now."

Reflecting back on my experience with Anthony beginning thirty-four years ago, I see how he helped shape my life's work. We had a close relationship that grew into friendship. I worked with him for a total of eight years, four years in the hospital and four years through a special therapeutic program at the Addison Gallery of American Art.

There was no question that his life changed as a result of what we did together with artmaking as the basis of the relationship. He reconstructed his life through art and gave me a glimpse of a new role that art can assume in the world. Yes, I may have helped Anthony, but it seems now that he gave so much more to me. He was a companion, a partner, in a process of creative discovery that began in the bleakest of environments, the back ward of an aging mental hospital. What I learned about the healing, transformative, and life-creating powers of art could never have been found through solitary experimentation. My experience with Anthony taught me how the creative process can be a way of making life.

**BERNICE**

The experience of Bernice in the art studio differs from Anthony's in that it encompasses a relatively brief period of three months. When I first met Bernice, she had withdrawn from all contact with other people and sat in a motionless state on the hospital ward. She was referred to the art studio with the hope that it might help free her from the stupor in which she was immersed. Bernice was able to walk to the art studio for our first session where she sat completely mute, staring straight ahead. After much encouragement, she made a loosely arranged and floating composition of biomorphic shapes (figure 12). Bernice showed some degree of interest in what she was doing and began to come regularly to the art studio.

In one of our early sessions Bernice did a remarkable picture of a contorted figure with a grimacing face and arms locked in against its sides

Figure 12. *Biomorphic Shapes*, by Bernice.

Figure 13. *Grimacing Figure*, by Bernice.

Figure 14. *Face*, by Bernice.     Figure 15. *Figure in Mouth*,
by Bernice.

(figure 13). Vibrating lines extended out and repeated the contours of the body, heightening the inner tension and confinement expressed in the picture. When I asked Bernice to write her name and date on the back of this picture, she wrote, "Nobody, August?, 1970."

During our next few meetings Bernice did not break her silence. I saw that her pictures showed considerable artistic potential. She worked totally from imagination and began to produce both purely formal and figurative compositions that expressed surreal qualities. This involvement in artwork contrasted to her more general withdrawal. I urged her to keep coming to the art studio and tried to increase her self-esteem with honest statements about her artistic accomplishments.

Bernice continued to work in the art studio with considerable motivation and returned each day with pictures that she made on the ward in the evenings. As her art developed, she started to talk to me and to others. Whereas Anthony was gradually emerging from twenty years of withdrawal and regression, Bernice was using art to work through the conflicts and tensions of an acute disturbance. Bernice later explained how art gave her the opportunity to express the anger and sadness that she had previously held inside.

When Bernice first drew either the human figure or a portrait, she

created forms from imagination within the center of the paper surface. After producing a typically realistic representation of either the entire figure or a portion of it, she elaborated and built upon these basic forms. The ornamental designs around the figures resulted in expressive and sometimes bizarre configurations resembling the images in Hans Prinzhorn's collection of art created by European psychiatric patients during the early twentieth century (figures 14 and 15). When Bernice emerged totally from her withdrawn state, she did not elaborate upon her figure drawings or portraits in this manner and appeared to lose interest in the process of ornamentation. Ironically, her artistic discipline and focus were not sustained when she got better.

Many people will perhaps react to the pictures that Bernice produced at this time as representing the distorted view of reality of a greatly disturbed person. Instead of attributing "schizophrenic" qualities to her art, I was more concerned with the positive nature of her artistic motivation. Rather than being expressions of pathology, the design elaborations that she constructed were essentially aesthetic and an extension of her concentration and full immersion in what she was doing.

I believe that Bernice found art to be aesthetically and emotionally pleasing. Her pictures and the process of making them were positive and life-affirming expressions that may have helped her gain a greater sense of control and vitality within herself. In addition to the obvious advantage of being able to express herself when she was incapable of doing so verbally, Bernice was organizing experience through the artistic medium. She was able to build feelings of confidence and competence through successful resolution of the many problematic situations presented by her art.

The critical-thinking operations demanded by artistic activity may have helped awaken Bernice's more general cognitive faculties. As the level of her artistic problem solving increased, she felt a compulsion to speak about what she was doing. Bernice had found something very interesting to think about and share with others.

As Bernice began to speak, she simultaneously started to use vivid colors in her pictures (figures 16 and 17).

The complexity and sophistication of much of Bernice's artwork has always been impressive—especially so in light of the fact that she had no artistic training or any real awareness of art history and contemporary trends in art. The quality and depth of her artwork can perhaps be

Figure 16. *Ornamental Design*, by Bernice.

Figure 17. *Design Face*,
by Bernice.

viewed as a successful activation of the archetypal artistic consciousness that lies dormant in all of us.

Attempting to keep Bernice's artistic development alive, I urged her to produce a painting on canvas from one of her pencil sketches. She sketched out the basic structure of this picture, but found the application of color extremely time consuming, difficult, and tedious. At this point, other people involved in the art studio came to her assistance and worked cooperatively in completing her picture.

Bernice stopped drawing altogether when her functional level was back to normal. Toward the end of her time in the art studio she became quite verbal and found it difficult to concentrate on her artwork. At this time, she went home for a week's visit; when she returned to the studio, all she could manage was a stereotypic Christmas scene (the date was November 30) with a house and decorated tree in front (figure 18).

Soon after producing this Christmas scene, Bernice left the hospital. Her disturbance had abated, but when she met with me again she wondered why she was no longer able to draw.

It is important to understand that emotional disorders are no substitute for artistic ability. Mental illness is generally recognized as an impediment to expression rather than as a source of creative enhancement. However, the acute turmoil of emotional disorders can create needs for expression;

Figure 18. *Christmas Scene,* by Bernice.

and in the case of Bernice, a latent talent was manifested as she expressed her turbulent feelings. Emotional crises can open creative and expressive sensibilities that may be shut down or simply unused during periods of relative equilibrium.

During her disturbance, Bernice withdrew from the world and did not communicate with others. She had considerable pent-up energy and emotion that was channeled into art. The making of art stopped when she began expressing herself in her customary ways. Making art gave Bernice a definite boost in her self-confidence; she speaks with pride about what she did during that period of her life.

From these experiences with Bernice, I discovered how emotional states profoundly influence expression, how art may be an expressive lifeline in periods of crisis, and how difficult times and emotional upheaval offer a gate of access to the archetypal flow of artistic expression and its medicines.

## CHRISTOPHER

Christopher, who was fifty-eight when I first met him, had been a resident of Massachusetts state hospitals for close to thirty-five years. In describing how he first became a mental patient, Christopher tells the story of how he was walking by another state hospital and stopped to have a smoke with a group of patients standing outside on the grounds. He describes how he was taken into the hospital by the attendants with the others and was never released. As reported in the hospital records, the history of Christopher's original admission was somewhat different. Yet the files show no true indications of severe emotional disturbance. The records document that Christopher was arrested for vagrancy in New York, placed for an extended period of time in jail, where he began to act aggressively, and then sent off to a Massachusetts state hospital where he has remained to this day.

Hospital records indicate that a lobotomy performed on Christopher in the early 1950s resulted in no changes in behavior. With good reason, Christopher soon began to perceive himself as a lifelong mental patient. His major emotional difficulty became his low self-esteem and lack of motivation to change the circumstances of his life.

When we opened the art studio at Danvers State Hospital in 1970, Christopher was one of the first people to become involved. He stopped by every afternoon while taking lengthy walks about the hospital grounds. At first he stayed on the periphery of the group activities in the studio and

Figure 19. *Christmas Image*, by Christopher.

Figure 20. *Mandala Image*, by Christopher.

Figure 21. *Bugler Tobacco Design*, by Christopher.

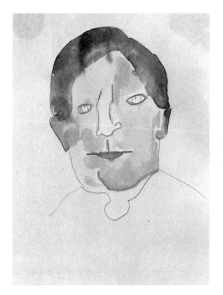

Figure 22. Untitled painting
by Christopher.

Figure 23. *Self-Portrait,*
by Christopher.

initiated his own projects while I led group sessions with other people. He had not drawn since grade school and inconspicuously began making childlike scenes from memory and other pictures involving numerous repetitions of mandala-like geometric designs (figures 19 and 20). His work in the art studio was totally self-initiated, as I was involved with more dependent people.

Christopher's first pictures show universal characteristics exhibited by other adults and adolescents beginning to express themselves in the visual arts. He chose to test his artistic ability and build confidence in his powers of expression by imitating the visual configurations on his tobacco packages and other commercial designs as well as reproductions of works of art (figures 21 and 22). However, his work differed from stereotypic copying in that a personal style of expression was conveyed from the start. Once Christopher's distinctive style was perfected through developmental stages of imitation, he began to move away from the relatively safe process of working from other people's art. He initiated a major change in his work by attempting representations of real people and things in his surroundings, as well as self-portraits (figure 23).

Without any real knowledge of the art world, Christopher made pictures from his innate expressionistic tendencies. His ability to simplify the complex configurations of visual experience into unique graphic interpretations revealed a definite intelligence that had gone unrecognized for many years of institutional life. At the same time, the expressiveness of his representations of nature reflect a sophistication comparable to major twentieth-century expressionistic painters. This resemblance is remarkable when considering Christopher's minimal elementary-school level of education and many years of isolation within state institutions.

The distortion of appearances in Christopher's images creates a penetrating and expressive tension. He concerns himself less with literal representation and more with inventing striking configurations of forms and colors to convey the feeling he gets from a subject. As he began to enjoy his art, Christopher worked with confidence and seldom hesitated in creating pictures distinguished by a boldness of line and color.

Asked to describe his spontaneous way of making art, Christopher said: "I just draw them quickly and then leave them alone. I usually see mistakes, but I don't want to ruin the picture." He believed that his portraits often bring out "the real inner self" of subjects and that in certain cases nobody could do better. When asked what he liked best about his art, Christopher replied, "That's a tough question. I like it when people say they enjoy my pictures. That keeps me doing them."

Christopher's striking development of competency in artistic expression was paralleled by enhanced skills in relating to people. The two processes supported each other in strengthening his sense of self and personal worth. The sustained sense of mastery and creativity that Christopher gained through the unfolding of his artistic expression no doubt contributed toward the development of a more positive self-image. He began to see himself as a person who could act upon and change the world while at the same time engaging in a form of communication that has meaning to others. Since so many emotional disturbances are either caused by or result in problems with self-esteem together with an arrest of creativity and development, the growth of artistic skills can help generate more comprehensive therapeutic outcomes.

As Christopher's art developed, he began to talk regularly about leaving the hospital and living on his own. On two occasions he demonstrated this new interest by walking away from the hospital for four to five days at a time. I and a hospital social worker who was working closely with

Christopher supported this changing attitude by regularly taking him with us whenever we had to travel away from the hospital on business. Needless to say, it was embarrassing to occasionally return to the hospital without Christopher. However, we were successful in convincing our fellow staff members that running away was a good sign in that Christopher was showing an interest in the world as well as a strongly independent spirit—both of which would be needed if he were ever to leave the hospital for a sustained period of time.

Christopher ultimately left Danvers after more than thirty-five years, to live with his family in a nearby community. He continued his involvement with art in the community art therapy program conducted by the Addison Gallery of American Art. Soon after his release from the hospital, we organized a major showing of Christopher's art at the School of the Museum of Fine Arts in Boston. The show was well received by art critics in all of the Boston newspapers, and the *Globe* critic selected it as one of the city's finest exhibitions for the year 1974.

### SUMMARY

Whereas Bernice used artistic expression to release feelings during a period of crisis and Anthony painted his way back to life in relationship to other people, Christopher worked more independently in developing expressive skills and an identity as an artist. But even Christopher's sometimes strikingly individualistic self-expression needed a place where it could be cultivated, witnessed, and affirmed by others. The healing and life-enhancing powers of art are closely tied to relationships with other people.

Art heals by transforming isolation and connecting us to others, to places, and to ourselves in life-affirming ways. We support the creativity of others and their healing through art by establishing environments where this interplay can take place.

Anthony, Bernice, and Christopher reveal three ways that art can heal in our lives through the release of emotion, the making of bridges to vital experiences, and the actualization of our creative potential. All three artists underscore the human need to connect to life experience in expressive and transformative ways. They also demonstrate the importance of aesthetic sensibility in regenerating an appreciation of others, the physical world, and ourselves.

**6**

*The Art Therapist as Artist*

As an artist committed to healing, I cannot begin to be of use to others until I am attentive to the transformations of the healing and creative process within myself. Every day I rediscover that the things that annoy and disturb me are potential sources of creative power, and even satisfaction.

Let me offer an example from my life. In my work as a college dean during the late 1970s, I was constantly attending meetings on our campus and at conferences. The time spent in meetings was taking me further and further away from my identity as an artist and therapist. I was only infrequently in my studio. My frustrations grew, and I considered doing what many had done before—leaving my administrative work because it was estranging me from creativity and healing. Then it occurred to me that the cause of the estrangement was not the work, but myself. The job was a plentiful resource of energy, manifesting itself in conflict. I was not, however, responding to it creatively. I told myself that, if I truly believed that art could transform tension, I should apply this principle in my own life. My "studio" could be anywhere, even a hotel conference room. If I could make art from those tedious sessions and still participate actively in them, then my theory of transformation would prove itself to be true.

I began by making drawings during the meetings, representations of

what I felt and saw. The drawings were then developed into paintings. The process built a bridge to my studio at home. I went there more often and began to integrate the negative energy of the meetings with art. I created hundreds of paintings and drawings in a series that continued through a two-year period. I was amazed to find that I began to enjoy the meetings and actually looked forward to them. After a summer vacation at my home by the sea, a haven for artists, I began to sharpen my pencils for the fall schedule of meetings. I was transforming a real source of conflict into art. Rather than interrupt concentration during the meetings, my drawings helped me to become even more attentive. I was focused, in a much deeper way, upon the total context, the purpose of the gathering, the nonverbal gestures, the body language and, most importantly, the people present.

In my journal writing I tried to deepen the insights that I received by transforming the meetings into art. I kept telling myself that conflict defines what needs attention in our lives; that the strongest forms are forged in the most intense heat (the alchemist's fire and furnace); that the power of conflict is one of the great continuities of human history; that I must plug into the power of my pain and anger and express them—get them out!

I put art's medicine to another test, this time in my home, when insulating a confined attic crawl space with rolled fiberglass. This experience provoked far more acute anxiety and tension than did the ongoing tedium of meetings at the college. At the peak of my agitation, I began to perceive the process aesthetically, as a work of art. I photographed rolls of insulation in the evening light together with the tools I was working with, and documented the various stages of the process, dismantling a completed section in order to create "before" and "after" pictures. I was even able to appreciate the form and textures of a hole I made in the ceiling when my foot slipped off a beam. As soon as I approached the unattractive task as a work of art, everything changed. The energy of irritation was channeled into an enjoyable aesthetic experience.

Over and over again, I tell my students, and remind myself, that conflict is the subject matter of our work and that we are training to learn how to engage it in others and ourselves and to creatively transform it into new forms of life. In some cases, the tensions can flower into art. The most difficult situations have always presented the greatest opportunities for transformation, both collective and individual. Without conflict and pain, one

never reaches the depths of being, the most intense and formative places. So rather than blunting the awareness of my conflicts through avoidance, I try to stay close to them, to directly engage their power to transform.

Artists throughout history have shown that creativity comes from conflict. Psychotherapists have had an equally great concern for conflict, but they have not so universally appreciated its positive, transformative powers. It is the artist, the creator, who can teach us how to engage the energy of conflict.

Observing nature and studying history help one to appreciate how trauma and loss give birth to new forms of life. Generation after generation of artists have understood how emotional discomfort makes very good spiritual compost. As James Joyce suggested, "It is strange from what muddy pools the angels call forth a spirit of beauty." Thoreau advised that the apparently banal home front, sometimes full of conflict and boredom, is the best place to find beauty that exists "wherever there is a soul to admire. If I seek her elsewhere because I do not find her at home, my search will prove a faithless one." He realized that the noblest subject matter for creativity and transformation is the commonplace: "To affect the quality of the day, that is the highest of the arts."

During this period of discovering how to creatively transform ordinary and tedious life experiences into art, I wrote in my journal: "I can take a dive into the depth of a cup of coffee or tea, into the sunrises and sunsets, into sleeping and awakening, into the infinity of each day. There are unlimited possibilities for action and transformation. I must connect strongly to my experience, believe in it, delve into it, dramatize it, learn from it, transform it. I must not be afraid of great tensions, for I see that nature is strongest, most passionate, and at her best when expressing radical extremes. The skill in being an artist of each day lies in the ability to place all of my transformative energies into the moment, in such a manner that I move sensitively from one relationship to another, from this moment to the next."

# 7

*Aesthetic Meditation*

## THE SIMPLE PROCESS OF LOOKING

A friend who was leaving the university called to thank me for the loan of a painting that she had kept in her office. Her voice message described how calming the picture was for her. A woman seated on the ground with an animal companion has her back to the viewer and gazes into the distance at a Middle Eastern city.

"It is the most calming piece of art," my friend said. "It was great to be able to turn around, my back to the computer, and get focused and centered by looking at a very calm person who is doing the same thing."

I was intrigued by how my friend used the painting for contemplative purposes. She was calmed by the calmness of the painting. The image was a helper and supporter in times of stress and tension.

As a person who has spent his life paying attention to how art heals, I had never given serious consideration to how my own paintings could act upon people in this way. I have been more involved with studying the more active process of how art heals by directly engaging conflicts and doing something with them.

Aesthetic and meditative reflection on an image had been at the forefront of my work during the 1970s, when I was working with people suffering from severe emotional disturbances. I applied the ancient

theory of healing correspondence (like produces like) to the contemplation of images. I discovered how people could feel internal balance, serenity, energy, and other salutary states by contemplating these same qualities in the visual configurations of their artworks. What we saw outside in the world could be taken inside as a source of healing and well-being.

Not wanting to become restricted to a one-dimensional approach to art as healing, I expanded beyond my early meditations upon the physical qualities of images and explored more active approaches such as responding to images through poetic dialogue, movement, vocal improvisation, performance, ritual, and other creative communications. This expansion was motivated by the realization that people needed and wanted different expressive options when relating to their images. I tried to make my work more complete and comprehensive, and the process was driven by my own desire to learn and master different forms of creative expression.

But I never stopped looking at my paintings in contemplative ways. In my studio workshops I always encourage and give time for silent meditations on images. I say, "The simple process of looking is the most innate way of responding to art. This is what we do when we visit a gallery or museum. Sit down with your art and take the time to contemplate its visual qualities. Take these expressions inside yourself. The pictures carry medicines, energies, creative spirits, and vitality that they will give to you freely. Open yourself to them and let them soothe your emotions and activate your passions."

In addition to encouraging private contemplation of images in my group studios, we make time at the conclusion of our work for what I call an "exhibition," when we look collectively at each person's art in complete silence. Either individuals bring all of their art into the center of the group or, if we have a large gallery space, we hang the art and visit each person's work. Looking together as a group heightens the energy of contemplation and generates an effect that is distinctly different from solitary contemplation. These group meditations energize the art and further its impact on us.

Yet looking alone at an image is the most common and reliable way of being influenced by it. I do it all of the time myself. I arrange my studio so I can sit and look at many different paintings. I probably spend nearly as much time in the studio looking at the pictures as I do making them.

Taking the time to look closely at an object or an environment always makes me aware that most of my time is spent in highly focused activities that channel my thoughts and perceptions and result in my missing the opportunity to perceive experiences with greater mindfulness. My garden offers the classic example. Whenever I am focused on a particular task or attentive to how certain plants are progressing, I miss the larger visual display offered by the garden. The time I spend contemplating the garden doesn't begin to match the time I give to working in it. Of course the physical immersion in the labor of the garden, the tactile dimension and close encounters with plants and soil, are also primary and aesthetically stimulating modes of engagement. But all too often I become immersed in a specific chore or concerns with a particular area or group of plants and completely miss the colors, the new blossoms, and the changing face of the whole environment. There is a tremendous contradiction in how I labor extensively to create beauty and then take far less time to contemplate the outcomes.

Photography can help us become more aware of our environments. When I walk with a camera searching for images for my paintings, I observe how this process helps me look more closely and deeply at my surroundings. The camera has a unique ability to hold moments of perception and thus to help me see the endless possibilities for perceptual awareness within the movement of time. It also concentrates perception and draws us into more immediate relationships with objects and places. The same thing happens when we paint an object or describe it in writing. If we don't begin to direct our attention in this way, we miss the infusions of perceptual awareness and energy offered by the object of contemplation.

To receive the benefits of aesthetic contemplation it is necessary to take the time to look attentively and to gaze with heightened visual awareness. This can be a challenging thing to do on a regular basis. Aesthetic contemplation, like sitting meditation, is a discipline that is enhanced through regular practice.

When looking deeply at things, we get outside ourselves and become immersed in the object of contemplation. This meditation brings new and vital energy into our lives. We stop running from one thing to another and become completely present to the process of reflection.

I have learned that the process of "not looking," of being unaware of my

environment, has an important place within the whole of my contemplative experience. There is a rhythm to moving in and out of contact. My preoccupations and distractions lay the groundwork for the powerful feeling of realizing what I have all of the time and do not see. The lapses in appreciation are the necessary preconditions to aesthetic awareness. Rather than eradicate my many distractions, I try to accept them and watch how they transform themselves into sources of perceptual renewal.

Losing the object of contemplation is a necessary step in regaining it. The process is cyclic and regenerative. Perception, like everything else in experience, moves and shifts from one instant to another. We cannot stay locked into a particular mode of engagement. In this way, the loss of one thing provides the opportunity to engage something new.

### BEAUTY

The telephone message about the painting in my friend's office helped me become more aware of how I create images wishing to express something visually stimulating and perhaps beautiful. I don't assume that my pictures are "beautiful," or that they express beauty, but I do intentionally focus on themes that I find aesthetically pleasing. It gives me pleasure when another person experiences the paintings as beautiful. The whole process involves a circulation of feelings about beauty between people and images.

Beauty can be defined as what pleases the senses and acts upon the perceiver in aesthetically stimulating ways. Without challenging idealized images of beauty, we can also find it in the most common qualities of life, expressing the particular characteristics of a person, thing, place, or artwork. We can enlarge the classic idea of beauty as perfect form, to an appreciation of the unique nature of a particular thing or gesture that cannot be compared to anything else. This approach to becoming aware of the essential qualities of a person, object, or experience shifts the emphasis from judging the relative merits of phenomena to the ability of a person to perceive distinctive features.

My friend's perception of tranquillity in my picture renewed my contact with the painting, and her observations immersed me once again in the mood of the image and the feelings I had when I made it. I have always found that others help us to become aware of what is happening within the images we make, and this is why I give so much attention to the process of talking about what we see and sharing perceptions with

one another. One insight sparks another, and I need these varied vantage points in order to see an image more completely. The responses of others help me tune into the subliminal aspects of my art, the things I do without conscious thought or intention.

Neither I nor my art therapy colleagues have given sufficient attention to the healing qualities of colorful and pleasant paintings. We have been attentive to expressions of pain and trauma, transformations of difficulties, and discoveries of hidden conflicts while giving far less consideration to how beauty nourishes, balms, and restores the soul. Perceiving beauty in a particular thing brings an overall sense of renewal, wonder, and passion, all of which generate life-affirming energy.

Since healing involves soothing discomfort, lessening fear, and learning how to live more effectively with difficulties, it would seem that the uplifting effects of beauty have much to offer people wanting to assuage these and other forms of pain and suffering. The disciplines of therapy and healing, perhaps in keeping with the larger society's current values, have discontinued the discussion of beauty. The cultural identification of beauty with practices such as judging and being judged according to physical qualities seems to be shutting down our sensitivity to a much larger and richer domain of aesthetic relations.

Whereas beauty is conventionally associated with notions of perfect form, I am more apt to find it in lowly, humble, and close-to-the-earth expressions. Sister M. Kilian Hufgard, in her study of the twelfth-century French abbot Bernard of Clairvaux, writes that he felt that "the true and proper beauty of anything needs no help from other sources." Sister Kilian continues that "beauty emanates from the very nature of a being and the beauty of one thing cannot become the beauty of another thing" (2001, 14–15).

Sister Kilian is giving us a concept of great aesthetic and healing significance: beauty is the unique and authentic nature of a particular thing. With this understanding, we can cease our neurotic chasing after something other than what we are. This notion of beauty emphasizes a person's ability to perceive, rather than an absolute quality that is imagined to characterize some people, places, and things more than others.

Now the aesthetic and therapeutic task becomes one of appreciating the uniqueness and the truly authentic nature of ourselves and of the people and things in our environments. In so doing, we truly advance healing in the world.

There has always been a strong aesthetic dimension to my work with art and healing, but it is easy to lose contact with this aspect. Art therapy literature contains little mention of beauty and its healing qualities; thus the larger environment within which I work has not always reinforced my original instincts about art and healing. Throughout the twentieth century, the dominance of the medical model has guided psychotherapy, including art therapy, to focus on trauma, pathogens, and threats to well-being. The experience of beauty has not fit logically into this larger scheme. In addition, analytic and strategic therapeutic operations do not lend themselves to the more contemplative and intuitive experience of beauty. Even artists concerned with healing tend to focus on the expression of their wounds, illnesses, and tensions; their aims often include catharsis, transformation, and even celebration of their difficult circumstances. I value all of these approaches as essential to art and healing, but I also realize that an exclusive orientation to pain and conflict may limit other ways that art heals.

When healing through art is located within the world's contemplative traditions, aesthetic meditation takes on a more natural role. Beauty and aesthetic reverie have a vital place within the process of meditation; there, healing can be viewed in terms of stress reduction, relaxation, and an overall integration of body, mind, and spirit.

The New Age movement is to be credited for realizing how various aesthetic conditions, such as musical harmony and the comforting effects of light, smell, touch, and other sensory experiences, influence consciousness and bodily functions. Likewise, Waldorf schools—founded on the teachings of Rudolph Steiner—are keenly attuned to aesthetic phenomena and their influence on behavior. Along with their overtly spiritual ethos, the cult-like practices of the Anthroposophical movement have obstructed a more complete and universal acceptance of their contributions. The exclusive focus among followers of Rudolf Steiner on the bright and light aspects of experience, at the expense of the dark and difficult, offers a good example of how people can cultivate ethereal philosophies and ideas that do not engage the whole of experience and the larger circulation of the creative process.

When I speak of an aesthetic approach to art and healing, I welcome all of experience—the spectrum of colors from light to dark, and the full range of ways that individuals experience beauty and sensory significance. I also want to acknowledge that others may perceive the images that I find pleasing, soothing, and energizing in very different ways.

Aesthetic experience has a powerful effect on us, but we tend to go through life without being fully aware of its place within our lives. We don't generally give much attention to the healing and soothing aspects of aesthetic contemplation even though we might experience these beneficial qualities on a daily basis.

My friend's telephone voice message made me aware of one of the most essential aspects of art and healing, and evoked the sense of "Aha!" that comes with a significant dream. I realized that everything I do with art and creative expression flows from a common source of inspiration and renewal, though I may not always be aware of it. We need others to help us see what we are doing in the world and how we are influencing people.

Many other people at the university, as well as friends from outside of work, have my paintings hanging in their offices and homes. They seem to be giving me a message that I have been slow to receive: the pictures stimulate them in pleasing ways. In light of my colleague's message, I began to look more closely at the images I make, examining how they might soothe viewers. More broadly, I started to investigate how this healing quality of artistic contemplation can be more fully appreciated and used.

I will give an example of this aesthetic exploration by reflecting on two of my paintings.

## TWO PAINTINGS: THE INDIVIDUATION OF THE IMAGE AND THE ARTIST

There is a large 52″ × 47″ painting in the room where I am writing (figure 24). It has been hanging in this space, a prominent room in our house, for almost ten years, so I am apt to look at it often. When guests are in the room, they often comment about the picture and ask questions like "Where is the scene?"

I tell them it is an imagined place with qualities of my memories of the west of Ireland, the American Southwest, Swiss chapels, and the white houses in the Cape Ann village where I live. The man with the broad-brimmed hat has possible Hasidic and religious connections. A familiar figure in my paintings, he travels among the different realms that I create.

Looking at the painting, I realize that it gives me aesthetic pleasure and a sense of calm, which is in keeping with the relaxed and contemplative position of the man seated on a stool, the grazing animals, the open space, the intimacy of the village buildings, and the general realm of imagination from which it came. I am also stimulated by the cadmium orange and yellow sky and hills. The warm colors are also in the foreground, and

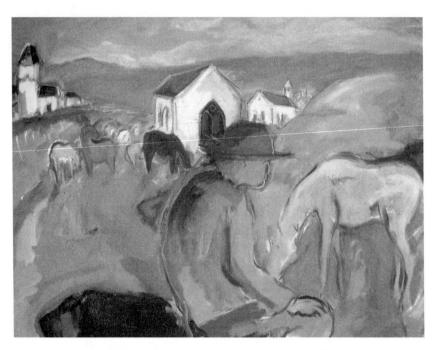

Figure 24. *Seated Man*, by Shaun McNiff.

they blend with the greens, grays, alizarin crimson, and other hues. Most of all, I enjoy looking at the free and spontaneous gestures. I made the picture quickly, and many forms and shapes appeared without plans of any kind.

The contemplative posture of the man, his reflective sitting, encourages me to feel what he is feeling and to be more like him. I feel the same way about the animals and the open space.

When I make a painting like this, I generally draw upon familiar figures. This one emerged from a series of spontaneous movements that I made on the canvas. I had nothing particular in mind at the start. I was doing a series of paintings involving men with broad-brimmed hats and animals. The process of making the pictures was peaceful and calming. I remember spending lots of time just looking at the finished pictures, absorbing their qualities, what I call art medicine.

I like it when people say they enjoy the picture, that they find the colors and subject matter comforting, or that they want one for their homes. The comments have no doubt positively influenced my relationship with

the painting, but I have never taken the time to consciously reflect on the image in an in-depth way, other than just looking at it from time to time.

Maybe this nonconscious way of being together with images is part of their healing qualities. We select things instinctively, and even make them intuitively, and live together with them in sensory relationships that exist outside the domain of rational thought.

This subliminal dimension of aesthetic experience may be a source of its healing power; it gets under the radar of conscious thought and nourishes the soul in a purely sensory way, like the animals in the picture who seem to be enjoying the field and the grass without having to think about what they are doing and why they are doing it. The man seems to be like them. He gazes as they graze. This is how the aesthetic experience operates; it takes us humans as close as we can get to pure sensory experience.

I just finished making another large 54″ × 50″ painting in my studio (figure 25). It is part of a series of pictures focused on sailing. Although I live on the ocean in a sailing community, I tell people that I do these pictures because I like the shapes of the sails, the triangles, and the opportunity to convey movement in the pictures. My daughters sail, but I just

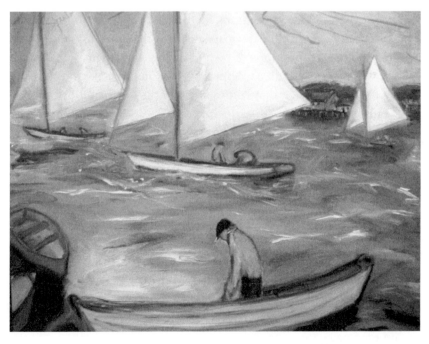

Figure 25. *Squam Sailing*, by Shaun McNiff.

watch and kayak. The boats are ubiquitous in our region, part of the landscape.

I started making these pictures in response to the ocean view I had from my office window when I was the provost of a nearby college. The vista was magnificent but I rarely looked up from my work. On summer evenings there were often fleets racing out of Marblehead, and I would stop for a moment to look. The shapes of the sails and spinnakers, the colors, and the overall sense of movement appealed to me, and I started to work on these images in my paintings, making many expressionist images of the boats. It was as if the paintings were making up for all the time I had neglected to contemplate the view from my office window.

The repetition of the forms of sails and the perfect curves of boats becomes a pleasurable visual/kinetic mantra. I believe that the pleasure we receive from making forms, colors, and movements is an important part of art's healing effect.

These particular sail riggings are from the early twentieth century. I love the grace of the old wooden boats with their large canvas sails. There is definite nostalgia in this image, a harking back to an earlier time. The man bending over in the dory in the foreground of the picture is a familiar figure who appears in many of my paintings. He is someone who works close to the earth like the man sitting in the previous picture.

I like the relaxed positions of people sailing, how their bodies make contact with the boats. It seems especially pleasing to make these images during the winter, when they infuse me with the warm and bright spirits of summer.

As I reflect on this painting, I grow more aware of my lifelong relationship to the ocean. This series of pictures has given me a way to become immersed in the spirits of water, wind, and open space while continuing to paint expressionistically and from imagination. I might work from photographs to get a sense of a boat's rigging, sail configuration, and structure; but I then go on to imagine the overall scene, placing boats and sails wherever they seem to work best in terms of the overall composition and movement of the painting.

It feels much more satisfying to freely create these scenes in response to what is happening on the canvas than to literally represent a scene from life. The healing effect comes from spontaneously making new life within the image.

Looking at the painting makes me increasingly aware that I make these

images as an extension of my daily contemplation of the sea and as a way of becoming more deeply attuned to the spirits of the place where I live.

This picture is restful for me. It calms me the way my friend was calmed by the woman outside the Middle Eastern city in my painting. The blue blues me (as I like to say with echoes of Martin Heidegger's way of turning nouns and adjectives into verbs). As I meditate on the water, I feel myself becoming attuned to its qualities. The way the boats move on top of the surface, carried by the wind, also has a soothing influence. I feel myself being swept along by the picture in a very positive and affirming way. The wind, water, and boats give me energy. What really gets to me are the graceful lines and movements of the sailboats, carried completely by natural forces. I never make pictures of just water and land. I need the group dynamic of boats' sails, and of human beings interacting with nature.

I also like the way the man in the dory keeps his balance. If you have ever spent time in small boats, you know how you must stay centered and attuned to the overall sense of buoyancy. I can feel the movement of the sea under him as he stands there working. These are some of the subliminal aesthetic forces that influence me as I create these pictures and look at them afterward. They are healing images in my life. My own needs for art medicine are no doubt the primary reason why I have committed my life to this work.

The images and the process of making them help to balance me when I am off, to be more buoyant when I feel that I am sinking, to incorporate the natural force and movements of the wind and sea, and to be carried through life situations by the inherent energies within any given place. Sailors have to travel with whatever wind and water conditions they encounter. They respond to what is moving within an environment. We are never in complete control. We have to be as sensitive as possible to what is present and then go with it.

Literary sources affirm that aesthetic meditations on natural things and elements, like the ocean, further well-being. In the opening to Herman Melville's *Moby Dick*, Ishmael declares that "meditation and water are wedded for ever." Whenever he feels a "damp, drizzly November" in his soul, he says, it is "high time to get to sea as soon as I can."

Ishmael's "ocean reveries" affirm what Gaston Bachelard describes as the eternal union between the imagination and the material world: "And could an image of full depth ever be obtained without a meditation in

the presence of deep water?" (1983, 52). Healing through art involves more than pure reverie. The artist blends contemplation with action. "Art is grafted nature," Bachelard says (ibid., 10); and from the joining of the material world and the imagination, many ways of healing emerge. When I make art, my present and past contemplations of the material world integrate with expressive gestures, generating new offspring. This convergence of forces renews and energizes me in ways that I do not experience in the stillness of quiet meditation.

Art heals through the engagement it requires, the awareness it expands, and the resulting connections I perceive between what I see and my life as a whole. There is also the feeling of gratification that comes when I make something that seems just right. Work is a fundamental necessity in my life, something I need to do for my well-being, and it is wonderful when labor is based upon the process of aesthetic contemplation. Art's unique and powerful medicine flows from this integration of fundamental human needs.

As I contemplate the two paintings shown in this chapter, I become intensely aware of the grafting process, how I take my aesthetic perceptions of landscapes, water, and figures and combine them with the idiosyncrasies of my personal style. The individuation of the image furthers the individuation of the person who creates it. We remake and revitalize ourselves as we make new physical things, and perhaps this is the basis of the pleasure connected with bringing a new image into the world.

When I look at the painting I made years ago, it still conveys this organic and physical aspect of creation. The older picture holds memories, including my history of interactions with it, and yet it is still fresh when I look at it. The new image is actually still drying as I write this. It's a new friend that I will get to know better.

Distance from the original act of creation enriches the reflective process by opening me to ideas and influences other than my immediate motivations for making the picture. Yet I am amazed at how close I can feel to old images, as though they were just made. Maybe this accounts for the special powers I have experienced in reflecting on my own art as contrasted to images made by others. In my studios we always open ourselves to aesthetic reflections on one another's art, and we all benefit significantly from this process; but I am realizing here that there is a special depth in relating to our own images. They are offspring who can help us appreciate our most individual and personal experiences and expressions.

My artistic images help me to become more like them, to incorporate their expressive and imaginative traits. Rather than approaching images negatively, as indicators of what is wrong with me, I prefer a more imaginative attitude that views the image as a step ahead of the reflecting mind, as a guide who shows me where I can go and what I can be.

I also realize here that when I meditate on my pictures and write about them, I communicate differently, perhaps more in keeping with their spontaneous or physical expression. Or maybe their personal, idiosyncratic, and original nature encourages me to write in a corresponding way.

Every painting generates wellsprings of possibilities for reflection, with each of us establishing our unique personal relationships through the process of contemplation. All we need to do is look with sustained attention and open to the feelings and responses that emerge.

**REFERENCES**

Bachelard, G. 1983. *Water and dreams: An essay on the imagination of matter* (1942). Trans. Edith R. Farrell. Dallas: Pegasus Foundation.

Hufgard, K. 2001. *Bernard of Clairvaux's broad impact on medieval culture.* Lewiston, NY: Edwin Mellen Press.

# Opening to Images and Media

The problem of art interpretation has had a profoundly practical and academic influence on my career. The first time I heard psychologists say that colors, forms, and compositions reveal the particular pathologies of the people creating them, I felt something was amiss. It seemed that no matter what people drew or painted, it would be used against them in some way. The systems of art diagnosis were built upon narrow and typically idiosyncratic psychological theories according to which the expressions of art were reduced.

I recall once receiving a number of complimentary copies of books dealing with diagnostic interpretations of art. I threw them in the trash, only to realize later that they were primary reference materials offering me a treasure chest of information for lectures and writings.

Why do we have this need to label people and experiences? How can otherwise intelligent people reduce complex experiences to the most literal and simple-minded psychological constructs—"Black colors indicate depression"; "Red connotes anger"; "Large eyes reveal paranoia"? Are we so desperate for explanations that we accept the idea that artistic images operate

like medical scanning devices? What effect do these practices have upon artistic images and a person's motivation to make art within a therapeutic context? Are they good for art? For healing?

My objections to certain kinds of art interpretation have offered great opportunities for asking a new set of questions about how we respond to art. Do images contain medicines that we can access through interpretation? Can we understand images more completely and intimately by responding to them in creative and imaginative ways, by interpreting art with art? What happens to images when we label them and reduce them to psychological concepts? Do the expressions of visual and kinetic images lend themselves to description by verbal narratives? Or are creative responses that are more closely tied to their expressive structures better suited to illuminate them? Do the visual arts, movement, and sound have more to do with transmitting expressive energy than with psychological concepts? How can we access this energy? Heighten its effects? Do the expressions of images generate healing qualities?

These questions and many others have been a source of inspiration for me since my first days of experience with art and healing. The essays in this section present theoretical and personal inquiries into how we respond to images and how they act on us. This understanding of how we interact with images is a basis for furthering their healing powers.

From the many papers I have written on the process of interpreting art, I have selected "The Interpretation of Imagery" (1987) in a newly condensed form to present an overview of how literal-minded psychological interpretations often amount to a form of image abuse that obscures the deeper meanings of art expressions and blocks their healing powers. Labels shut off the energy-generating capacities of images and defend the controlling minds of interpreters from the uncertainties and surprises that an open engagement with art inevitably produces. When we accept that our different interpretations are openings to the world of experience, interactions with artworks take on a new excitement and vitality. We recast the tired subject-object relationships of psychology into a more imaginative realm that affirms the otherness of phenomena. When we seek greater depth and accuracy in our communications with others, the discipline of interpretation shifts from explanation to empathy.

After years of criticizing the foibles of art interpretation, I realized that I had to start moving in a more positive direction by suggesting alternative ways of relating to images. From my first years of practice in the

Danvers State Hospital, I have always emphasized how we instinctively tell stories in response to our art. Eventually these responses grew to encompass poetry, drama, movement, voice, and other expressions that emerged naturally when looking at images, contemplating them deeply, and letting them act upon our thoughts and feelings.

In "Treating Images as Persons and Dialoguing with Them" (1991), I consider the ethical consequences of how we treat images, suggesting that we give artistic expressions their autonomy, see them as distinct from ourselves, and learn how to relate to them in more imaginative and therapeutic ways. This emphasis on affirming the image's place in the world as an independent phenomenon led to my embrace of the practice of imaginal dialogue, informed by James Hillman's post-Jungian archetypal psychology, Buddhist thinking, and phenomenology. The idea that the image communicates to us, expressed most vividly by Martin Heidegger's notion that the "thing things," was perfectly matched to my formative work with Rudolf Arnheim and his emphasis on how images express themselves through their perceptual and structural features. This essay, originally published as "Ethics and the Autonomy of Images," was well received, and it anticipated my book *Art as Medicine: Creating a Therapy of the Imagination* (1992).

To reinforce how the healing process sometimes requires creative turmoil and struggle, I have included a brief reflection on "The Challenge of Disturbing Images" (1993). In my work, people have greatly appreciated support and guidance in relating to upsetting expressions. They are especially encouraged by my belief that the images of our dreams and art never come to harm us. Rather, our own energy adopts menacing guises to gain attention, showing us where we are out of sync with ourselves, others, and our environments.

After the positive public response to *Art as Medicine,* I was invited to address a plenary session of the American Art Therapy Association's 1993 national conference in Atlanta. James Hillman would be giving the keynote address directly afterward. I took this opportunity to present a challenge to the imagination and practice of art therapy in a talk called "Images as Angels." The conference presentation and the subsequent essay, published in 1994, attempt to transform the way we relate to pictures and art objects by treating them as living things and intimate guides.

Please do not take me literally when I analogize images to angels. I am presenting a way of looking that empowers images with significance and

mystery. This viewpoint is based in imagination, as is the process of making the images themselves. Experience has shown that creative and imaginative ways of responding to artistic images help us to develop a much closer relationship to them and a greater understanding of their expression.

This emphasis on the angelic and helping nature of images led to my book *Earth Angels: Engaging the Sacred in Everyday Things* (1995). "Angels of the Wound" is a chapter in the book that aroused interest and was published separately in other collections. In it, I show how afflictions of the soul carry healing remedies within themselves if we open to the depth of experience they convey. The essay also explores how we can re-vision our most familiar images and discover healing qualities within them. I describe how my uneasy adolescent relationship with the crucifix may be approached in a new way, as an opening to the soul. Changing our habitual attitudes and practices renews the way we view the world and ourselves.

In my ongoing work with people in the art studio, I tend to talk about paintings as paintings, movements as movements; the orientation is not heavily toward angelic dimensions. My links between images and angels are metaphoric and intended to stimulate us to think and act more imaginatively and deeply in response to artworks. The same applies to *auras*, a term I infrequently use in the studio, where we are more apt to speak about cadmium red, yellow ochre, cobalt blue, and how artworks express themselves. I encourage people to use whatever metaphors and terms best convey their relationships to these expressions. However, analogies to the angelic realm have a special value as we continue to explore and expand the use of the arts as ways of healing. I approach angels as figures of the creative imagination, the very real realm that is the basis of art and healing. This way of thinking about images, relating to them, and imagining them keeps us close to the source.

Images generate stories, imaginal dialogue, and other forms of artistic expression, but they also act directly on our bodies, minds, and senses. In "Artistic Auras and Their Medicines" (1995), I explore the physical expressions of images and the ways in which they influence us. The expressions of pictures are determined by their structural qualities, which have a corresponding effect upon people who view them. The very real energetic expressions, or auras, generated by images are a major frontier for art and healing. All of us have been so focused on our narrative descriptions of artworks that we have missed their more direct physical expressions and the way they can minister to the soul.

In this essay I try to go right to the heart of the "aura" issue and show how what some people disparagingly identify as New Age mysticism can take us to the most practical and "brass tacks" elements of art and healing.

As important as interpersonal relationships are in therapy, they have sometimes obscured a more comprehensive inquiry into how people are influenced by various media and different types of artistic action—the different effects resulting from drawing with an ebony pencil versus oil pastels; drumming with a deep and resonant instrument versus a shrill one; and so forth. I have written a number of essays over the years dealing with arts methods within the creative arts therapies. Space does not allow all of these writings to be included in the present collection, so I have written a new essay that strives to articulate core theoretical and practical issues regarding the role of artistic media in the art and healing experience. "The Effects of Different Kinds of Art Experiences" explores the reciprocal relations between physical actions and internal states. I use the principle of correspondence, "like produces like," as a basis for this inquiry and suggest that so much more can be done to understand and utilize the healing effects of varied forms of artistic expression. This new essay continues the discussion initiated in "The Creative Space" and "Artistic Auras and Their Medicines" and focuses on the elemental processes of artmaking so often overlooked in our psychological reflections on art and healing.

In "The Effects of Different Kinds of Art Experiences," I present two different categories of media, preexisting images and unformed materials, as a basis for reflecting on the healing qualities of the larger range of artistic experiences. A comprehensive reflection on the specific effects of particular media is beyond the scope of this study, but I strongly encourage all who are interested in this subject to explore how different art media influence emotions and well-being. The principle of correspondence applies to what we do when applying all forms of artistic expression to healing.

I believe that focused attention on media research will enhance the growth and depth of art and healing practices. For example, we see how the practice of Jungian active imagination has been significantly expanded through the systematic use of sand-tray methods. As more and more people become involved with shaping configurations in sand with small toys, objects, and figures, we learn more and more about how these media are able to further the process of creative expression and healing. The same applies to the growing use of family photographs and personal

objects in therapy and to methods that focus on the direct use of the hands with paint, clay, or other media, and to the archetypal process of creating mandalas.

The future growth of art and healing is closely connected to this expansion of our understanding of media, art processes, and what they do.

# 8

## The Interpretation of Imagery

**THE PROBLEM AND THE OPPORTUNITY**

As a beginning art therapist I was incredulous when first exposed to catalogs for the interpretation of art, which reduced images to negative character traits and various forms of psychopathology. Drawings and paintings were analyzed according to narrow theoretical frameworks. The resulting interpretations were simplistic and literal, imposing a caricatured and laughably pornographic sensibility on the individualized expressions of patients. With an insistence on finding hidden conflicts and motives, they dissected imagery and gave no attention to the sensibility of the artist. Everything was assumed to be something other than what it was. Artists were debased, and the healing effects of the art experience were disregarded.

Sometimes the interpretations were imaginative and even humorous. I should actually be thankful to them since they have provided me with provocative lecture material throughout my career. I marvel at a mind that sees the phallus in every tree, serpent, or projectile; the vagina in every opening, lake, and circular configuration; sexual repression in closed doors and crossed lines; oral deprivation in vacuum cleaners; masturbatory guilt in smudged hands; obsessive-compulsive tendencies in detailed compositions; and toilet conflicts in the color brown.

When Georgia O'Keeffe saw that her critics were reducing her evocative paintings of flowers and landscapes to these psychosexual clichés, she said, "They're talking about themselves, not me."

When will we realize that interpretations of art are the projections of those who make them? The diagnostic interpreters are revealing their own preoccupations and fixations.

Artworks are also interpretations of experience that reveal or project the consciousness of the artist. The interpretation of the image by another person does the same thing. One interpretation follows another; they dialogue with one another through their intersubjectivity, and it is impossible for one vantage point to objectively judge or label the other. Otto Rank felt that interpretation is an ongoing process of relating to an artwork or an experience, and the poet Percy Bysshe Shelley celebrated imagination as the instrument of morality in that it enables us to identify with other people. The psychologist Gordon Allport said that if we really want to know what people are thinking and why they act in certain ways, "Ask them."

With regard to the projections of interpreters, I do not want to discourage imaginative and personally revealing interpretations. I only want them to be seen for what they are. Creative interpretations suggest new ways of looking at things and provide fresh metaphors for re-visioning old situations. A therapist's interpretations might give a sense of illumination and inspiration that supports another person in taking risks and making changes. But sometimes our appraisals miss the mark. Whenever two or more people are relating to one another and an image, there will be different interpretations.

Comparative and differing evaluations of a situation are invaluable in problem-solving situations; they expand our thinking, help us see things we deny or overlook, and spark new insights and syntheses of ideas. This creative process is hindered when one person's viewpoint is assumed to be definitive. As the psychologist Jerome Kagan said to me in the early seventies when we were discussing the process of interpretation, "There are no absolutes in psychology."

The most outrageous interpretations, even those that I have just described, are not necessarily wrong. I cannot judge what works for another person. Something that I find unattractive might be just what an individual needs. And the abuses of interpretation have generated a one-sided insistence that only artists can interpret their own work. The interpretations of others can enrich my appreciation of what I make and what I see in it.

What is wrong in art interpretation is the unquestioning acceptance that a person can say, authoritatively, and according to a particular theory or personal judgment, that "This is what it means." It is the psychological labeling of images, a particular kind of interpretation, that has little validity.

In my experience it is better to say, "This is what I see." The person who made the picture can accept the interpretation as my point of view, something that comes from me, as an offering. If my interpretation does not click for the person, then it is clear that it belongs to me. When interpreters assume the ability to explain images, the personal perspective is not acknowledged.

If the person who makes the interpretation is in a position of authority, the maker of the image might think, "Who am I to question what this expert says?" Many never question the "authoritative" interpretation. Others rebel against it.

All of this confusion can be avoided by acknowledging the personal aspect of every interpretation, by distinguishing the interpreter's evaluation from the image and the person who made it. We also have to maintain the independence of the image and make sure that the apparently knowledgeable and professional interpreter does not simply appropriate it.

Literary and artistic masterpieces have been subjected to many abusive interpretations, often presented by people who casually studied the artworks and use them to further their theories of interpretation—such as Sigmund Freud's analysis of the smiling faces in paintings of women by Leonardo da Vinci. Fortunately the position of the masterpiece in history is typically larger than or equal to the stature of the interpreter, and serious damage has not been done. This is not the case with the artworks of children and mental patients. When a great work of art is subjected to a highly projective interpretation, there is a pervasive attitude that this is the position of the interpreter or the theory that is being used. There is an assumed dignity that is attributed to the well-known artwork, a respect it is accorded.

Average people, especially children, whose art is being analyzed through various psychological protocols, do not have these protections. They are more vulnerable to being affected by inappropriate interpretations. Images made by mental patients are totally defenseless against the process of clinicians using them for diagnosis. Even though psychologists will assure us that they are operating with a desire to help people, there is typically a presumption of pathology in their procedures. None of the standardized

assessments, still widely used and taught today, start with the desire to affirm a person's creative expression or the life-affirming features of images. The art is consistently engaged through a negative lens that is far afield from the more general values of our society. In the psychological interpretation of art, beware that whatever you paint or draw will probably be used against you.

## THE NECESSITY OF INTERPRETATION

A new beginning point for art interpretation might be one of humility and awe as contrasted to authority and omniscience. The fundamental problem is the assumption that the psychological interpreter's task is to diagnose a person's inner condition as manifested in the image, usually according to mechanistic principles that do not resonate with the complexities of the person and the image. These practices can be replaced by values that view interpretation as part of a dialogue in which interpreters who acknowledge their personal situations and values, strive to relate with greater empathy to other people and images.

Some art therapists, reacting against the image abuse of art interpretation, view interpretation as inherently destructive. I feel that the process of interpretation is an essential element of art and healing. Art therapy is itself an ongoing process of interpretation through both visual expression and spoken dialogue. In our everyday lives, interpretations form the basis of our orientation to the world. As Nietzsche said: no facts, just interpretations.

Even the act of seeing involves an interpretation of what we see. According to the research of Rudolph Arnheim, visual thinking operations are interpretative, involving an interaction between the person and the perceptual stimulus. Thus, simply looking at an artwork is an active and dynamic interpretative process.

Arnheim and the philosopher Susanne Langer are two people outside art therapy who have had a great influence on the discipline. Arnheim shows how vision and the other senses involve thought and interpretation without the mediation of language. With the publication of Langer's *Philosophy in a New Key* (1942), the arts had a theoretical champion who declared that the making of symbols is "a basic human need." She emphasized the importance of making symbols in the arts as well as within language and science. However, there are still many people in art therapy who do not appear to understand Langer's declaration that the symbols of art

are "untranslatable" and "bound" to the various sensory forms in which they are manifested. In keeping with Langer, I do not believe that an artistic symbol can be literally translated into language. However, Jung's practice of active imagination demonstrates that we can imagine symbols "further" and respond to them through language, always realizing that an interpretation is an interpretation, another creation in the episodic process of contemplating an image. Language and visual images can be viewed as working together as partners in the process of interpretation.

Sometimes our obsessions with meanings and the story behind the image block our ability to see, and thus interpret, what is before us. By immediately labeling a red picture as aggressive or a black picture as depressive, we sacrifice a more in-depth exploration of our thoughts and feelings about red and black. In this case we leave the aesthetic relationship with color, texture, and shape behind and replace them with stereotypic clinical concepts that might have very little to do with the original stimulus. If we quickly assume that grass is pubic hair, we lose the sensory connection to grass and miss the opportunity to ask what this kind of interpretation says about the person making it. The same applies to interpretations that reduce animals to various forms of human sexual conflict. These interpretations disparage animals and ultimately sever us from the healing forces of creative expression and nature.

Try to abstain from attaching meanings to images. Just look, openly and naively, at the visual configuration, with the goal of improving your capacity to see. Relax your need to know, explain, and perform. Do your best to get beyond the psychological literalism that permeates the interpretation of art. Open yourself to the artwork as completely as you can, putting aside thoughts, associations, and theories. Simply look at the image and let yourself be influenced by its expressive qualities. This preliminary withholding of meaning actually helps to deepen involvement with the image and its interpretative possibilities. It helps us experience fresh illuminations and influences. Quick interpretations do the reverse, packaging the image into the framework of the interpreter, restricting its ability to work on us in new ways, avoiding its mysteries and challenges, and protecting the interpreter from surprises that challenge control.

### DEEPENING THE RELATIONSHIP WITH STORIES

People looking at images tend to leap quickly after meaning. In this way they arrest the contemplative process, closing off deeper inquiry. The

more we look without jumping to judgment, the more we will see and experience. By withholding attachments to meaning, one does not impede the basic human desire for understanding. In fact, art can be partially defined as a search for meaning and relationship to the world. The process of withholding judgment is simply a method we use to more deeply understand what images mean to us.

The search for meaning in a painting is a manifestation of a desire to connect more completely to our experience. But sometimes our zealous searching after meanings suggests an inability to simply accept the presence of the image and its expression. I try to begin my interpretative relationship with an image by accepting it for what it is. This is particularly helpful when I am puzzled about "what a picture means." Rather than try to explain the picture, I relax with it and look more completely.

I find that the depth of my work with art and healing corresponds to an ability to operate without an interpretative formula. I try to convey a commitment to both the person and the image and to maintain an authentic interest in discovery. I have been delighted to see that the more I empty myself of preconceived notions, the deeper our work becomes. Students have been startled by this principle since it reverses their most fundamental preconceptions about professional education and expertise. They see that what we study and learn is ultimately most useful when it becomes incorporated into our natural way of responding to situations. The expert is recast as the one who has the ability to say, "I can't say what it means. Let's reflect upon it together."

When it comes to talking in response to artistic experience, I often liken artists to travelers who return from journeys with stories to tell. This storytelling dimension becomes a core feature of interpretation. People often seek out healing experiences in order to tell their stories and have them heard by others. The people that I work with have always had a need to talk about what they do. When they are given the freedom to say whatever they want about their pictures, they usually tell stories. The verbal images that they use are poetic and personal and rarely analytic or scientific. There is always an eagerness to tell how the pictures came into being and how they relate to the feelings and lives of their creators. Personal stories further our ability to get close to images and understand them better.

I have found that depth often has as much to do with how we say something as it does with what we say. When we know that we have time,

support, and a completely open and safe environment, we plumb greater depths in our reflections and dialogue.

Viewing interpretation as a storytelling process helps us to see the inevitable multiplicity of meanings that an image suggests. The variety of possibilities is an expression of the picture's vitality and ability to engage people. This perspective helps us to distinguish whether the story being told belongs to the artist or to someone else. It also avoids the confusion caused when the stories or projections of interpreters are presented as psychological facts.

As with stories, excellent interpretations convey imagination and insight. They open up new ways of viewing pictures and warm them with human contact. Art and healing are inseparable from the process of interpretation, but this wonderful medicine has been misused for many years.

Interpret, interpret, and interpret. But please, for the sake of the images, the people you are trying to help, and for your own sake, do it in a more mindful and creative way, always sensitive that you are in a dialogue with experience, that you are simply a person who offers a point of view and never an absolute explanation.

**REFERENCES**

Arnheim, R. 1954. *Art and visual perception: A psychology of the creative eye.* Berkeley & Los Angeles: University of California Press.

Langer, S. 1942. *Philosophy in a new key: A study in the symbolism of reason, rite, and art.* Cambridge: Harvard University Press, 1942.

Rank, O. 1950. *Psychology and the soul.* Philadelphia: University of Pennsylvania Press.

# 9

*Treating Images as Persons and
Dialoguing with Them*

## A PSYCHOLOGY OF CREATIVE RELATIONSHIP TO OTHERS

In this era of ethical vigilance, little consideration has been given to the rights of images, gestures, and other expressions created within the therapeutic context. The mental health field has generally viewed the fruits of expression as raw material, fossilized substances from the subterranean id, which are used as resources to fuel therapy's advances.

Viewed through a diagnostic lens, the "X" configurations appearing in a painting that I make become an expression of "my" sexual repression. The belly button in the figure I draw represents my dependency needs. The animal that emerges from my performance while crawling on the floor and making sounds is an indication of my poor impulse control. The ethereal movements in my dance with air express my instability. In each of these cases the particular gestures and images of artistic expression are replaced by abstract concepts. Living, sensory expressions are turned into explanatory labels designating the pathology of the artist.

Psychological interpretations of art have generated projective confabulations cloaked in the guise of scientific precision. As degrading as these interpretations have been to artists, there is also the issue of what they do to artistic expressions. At the root of the problem is the belief in a controlling mind or theory that can explain experience from its perspective

of the world. Rather than seeing its position as a bias through which interaction with other perspectives occurs, the frame of reference is projected onto the world as certainty and diagnostic accuracy.

Reflection on experience suggests that life is an interactive process and ongoing dialogue between perspectives, a global and personal ecology between many participants. This principle applies to our relations with other people and cultures as well as images. In his introduction to Hans-Georg Gadamer's *Philosophical Hermeneutics*, David Linge suggests that understanding comes when we realize that we are in a dialogue with the world, when the interpreter learns how to open to the image or gesture "by listening to it and allowing it to assert its viewpoint. It is precisely in confronting the otherness of the text—in hearing its challenging viewpoint—that the reader's own prejudices (i.e., his present horizons) are thrown into relief and thus come to critical self-consciousness" (1977, xxi).

We must temper the tendency to see images as part of the artist who made them. To this end, the artist needs to be re-visioned as a co-participant in creation, rather than as the center of artistic activity. This decentering of the ego is not an attack on its existence, but an attempted opening to the ecological interplay of expression.

In response to my methods of dialoguing with images as a mode of interpretation, people constantly say, "Aren't you doing gestalt therapy?"

Recognizing that this dramatic, dialogical, here-and-now, and phenomenological approach to interpretation shares many processes with gestalt therapy, I clearly distinguish my methods from the assumption that all of the aspects of an expression are "parts" of the artist, as proposed by Frederick Perls: "I believe that every part of the dream is a part of yourself—not just the person, but every item, every mood, anything that comes across" (1971, 130).

With its gritty focus on the present moment, gestalt therapy helped to liberate psychology from an obsessive focus on the past. However, its belief that everything in personal psychic experience is part of the self has contributed to our era's monomania and the loss of the imaginal other. Gestalt therapy made intimate connections between dream images and the psyche of the dreamer, but then took this wonderful relationship and reduced it all to a fixation on the self.

I recognize how gestalt therapy's relevance and appeal comes from its orientation to "what is," as contrasted to the "catastrophic expectations" of neuroses. My concern is directed toward its restrictive imagination of

"what is" and its emphasis on the centrality of the ego. Symbols, the vast treasury of cultural memories, the archetypal processes of psychic experience, and the autonomous existence of the multifarious and distinctly individuated things of the inner and outer world, are consumed by this egocentric fantasy that sees the world as part of itself. Before long, as Hillman cautions, we will see the gods as parts of ourselves. The daimonic world is eliminated, what C. G Jung described as the "determining power that comes upon man from outside" (1958, 27). The resulting condition is nothing less than an ecological disease.

Perls encouraged staying "in the center of our world," where "the end-gain is the primary thing." He said, "If you are centered in yourself, then you don't adjust any more" (p. 32). These assertions sweep away collaboration with others within our physical and psychic environments as the basis of creation and health. Nothing creative exists in complete isolation. Artists, like shamans, draw their medicine and inspiration from highly individuated relationship to familiars—themes, figures, methods, styles, and materials—that interact with the artist throughout the creative process.

Gestalt therapy clouded the tradition of classical "gestalt psychology," which explored how expression is not restricted to human emotions. Rudolf Arnheim, a member of the original community of gestalt psychologists, described how these psychologists considered "it indispensable to speak also of the expression conveyed by inanimate objects, such as mountains, clouds, sirens, machines" (1972, 52). Arnheim's reflection on pictures "bestows upon the images the natural dominance they claim perceptually" (1989, 224).

Antiquity advises against seeing the self as the center of existence. In *The Collected Dialogues of Plato*, Socrates makes it clear to Theaetetus "that nothing is one thing just by itself, but is always in process of becoming for someone" (Hamilton and Cairns 1961, 862). He affirms the reality of imagination and suggests how autonomous agencies act upon us and produce "offspring" that are unique to that particular engagement and "can never meet with someone else and generate the same offspring . . . for when it brings to birth another thing from another person, it will itself come to be of another quality" (ibid., 865).

It is imperative to liberate images from ourselves, give them more creative autonomy, and restore the reality of imagination as a procreative and life-enhancing function. If we can step out of our self-referential psychologies for a moment and imagine our dreams, pictures, poems,

dramas, music, and movements as partners, a new basis will be established for therapeutic ethics and methods. Consideration of the rights of images does not replace our moral responsibilities to the patient, community, and profession. Recognition of the autonomous lives of artistic expressions simply adds another dimension to the social context.

Carl Jung established the psychological basis for viewing artistic expressions as independent entities and embracing imaginal figures as necessary and spontaneous contributors to psychic life. He described how these "autonomous elements" are manifestations of "the unalterable structure of the psychic world whose 'reality' is attested by the determining effects it has upon the conscious mind" (1958, 108).

Contrast gestalt therapy's view of every part of a dream as part of the self with Jung's statement made in his 1947 letter to a Mr. O, in which he suggests treating the image as a person: "You must talk to this person in order to see what she is about and to learn what her thoughts and character are." People do not always find it easy to truly listen to another person, and it can be even more challenging to do this with an image. Yet I always find that the benefits correspond to degree of effort that a person makes in trying to relate to images.

How we treat an image often reflects how we treat other people. The discipline of personifying images helps us to become more sensitive to the feelings of other people, and vice versa. Life is an ongoing practice of sensitivity and cooperation in which imagination and the physical world influence one another.

Our "person-centered" therapies can benefit by expanding their range to the persons of expressions. Personifying is an imaginal process that has always been the basis of poetic consciousness, and it remains fundamental to the spontaneous expressions of the arts, dreams, and imagination. Personifying images, gestures, and other artistic expressions enables them to act as "agencies" of transformation rather than simply as "illustrations" of the psyches of their makers. Within this context, images take on real healing powers; they revitalize, guide, and enlarge our lives. The treatment of pathologies through art involves an empathic and imaginal engagement of the problem as a generative force, and not just a sign that something is wrong. Art therapy in particular has concentrated too much of its resources on conceptual analysis and not enough attention on the potential of passionate expression to renew and reconstitute psychic life through spontaneous events.

When artistic expressions become agents of change, we not only find ourselves concerned for their well-being and protection, but also deepen our social interaction with them through feelings of gratitude for their assistance and delight in their presence. We might even find ourselves slipping into archaic patterns of propitiation and creating hospitable environments that welcome their visitations.

Some will say, "These persons you are talking about are all part of your imagination." I reply, "Yes, they are imaginal figures, but the imagination is not 'mine.'" I do not possess it, or its personages. The literal mind approaches imagination as outside reality whereas I see it as another reality with which we interact. The notion that the figures who appear in dreams and artistic expressions are parts of ourselves is itself an imaginal perspective, a point of view, one that in my opinion makes the personal psyche a very overcrowded and self-centered place.

Jung urged people to become aware of the myths they are living. Our culture generally lives the myth of the heroic and self-sufficient ego rather than one of collaborative and ecological creation. We unconsciously act out the heroic script in our dealings with the world, conquering adversaries, actualizing personal potential, and practicing self-reliance. Creative collaboration is decentered rather than heroic, imaginal rather than literal, and spontaneous rather than planned.

### ENGAGING THE IMAGINAL OTHER

A therapy of the imagination creates relationships with the imaginal other through dialogue. The "imagining ego" interacts with figures of the imagination rather than denying their presence. This therapeutic perspective, or drama, experiences depth and meaning by staying with the characters of imagination, letting them speak, reveal themselves, and emerge according to their respective natures.

Citing Wallace Stevens's "Credences of Summer," Mary Watkins says "the characters speak because they want to speak." Rather than experiencing imaginary figures as unreal and pathological, Watkins perceives the task of therapy as "the articulation of the imaginal other." This orientation to therapy is grounded on what I have called "theory indigenous to art" (1986). When the methods and guiding concepts of the creative arts therapies are subservient to psychological theories that are not aligned with art, creative expressions lose their primacy and they literally serve another master. This loss of immediate presence distances the image or gesture from its

generative context, and the resulting alienation sets the stage for its depersonification and lost vitality.

By contrast, therapeutic methods that stay close to the expressions of art and enter their world demonstrate how everyone benefits by encouraging the full emanation of imaginal figures. Mary Watkins shows how a true therapy of the arts is based on both artistic methods and theory.

> The development of depth characterization corresponds to the development of the character's autonomy. As the character becomes more autonomous, we know about its world not just from external observation or supposition but from the character directly. The author or narrator becomes less omniscient and can be surprised by the other. Observation of the character's actions can be supplemented by his or her account of thoughts, feelings, and wishes through which the imaginal other gains interiority and depth.
> . . . Thus, rather than pathology having to do with an overarticulation of an imaginary being and a weak ego or "I," pathology coincided with shallowness in the characterization of the imaginal other and marked egocentricity in which the imaginal other is known only insofar as it affects the "I." (1983, 26)

What a contrast this creative collaboration with the other provides to our tendency to exclusively reduce psychic reality to ourselves. Healing and well-being as well as a more insightful emotional intelligence are generated by cultivating the expression of the imaginal other.

Perls offers the antithesis of imaginal psychology: "My formulation is that maturing is the transcendence from environmental support to self-support" (1971, 30). His philosophy of being "centered in yourself" rejects the complementary need to diminish the self in order to see the other, thus reinforcing our culture's dangerous fantasy of transcending the environment.

I must emphasize how difficult it is for most of us to speak imaginatively from a perspective outside the habitual ego position. We have large gaps in our education and have to relearn the child's instinctual ability to poetically dramatize the figures of imagination. James Hillman has described our self-inflicted diseases of personal and cultural egocentrism as an "education in psychopathy."

Descriptions of psychopathy, or sociopathic personalities, speak of their inability to imagine the other. Psychopaths are well able to size up situations and charm people. They perceive, assess, and relate, making use of any opportunity; hence their successful manipulations of others. But the psychopath is far less able to imagine the other beyond a fantasy of usefulness, the other as a true interiority with his or her own needs, intentions, and feelings. (1989, 170–171)

Hillman's psychological vision calls for the individuation and personification of the imaginal other. He urges us to "doctor" our outmoded and sick stories and "sustaining fictions" rather than focus exclusively on changing the complex and elusive being we call the self. In *Healing Fiction* he establishes a foundational theory of artistic therapy by encouraging us to re-vision and improve the stories according to which we organize our lives (1983). We are stuck and mired in a pathological condition when we fail to approach it in a new way. Hillman's method is based on the conviction that "no psychic phenomenon can be truly dislodged from its fixity unless we first move the imagination into its heart" (1989, 180).

If we change the particulars of our expression, we will change in correspondence to them. Therapy becomes a creative collaboration with imagination and the world from which it issues. The process generally requires us to relax the self and move it out of the way so that imagination can treat itself within the context of its innate wisdom.

### SHAKING COSMOLOGIES

In my training studios I consistently see how simple exercises such as speaking as a figure or gesture in a painting meet with considerable resistance, fear, and feelings of ineptitude. The inability to speak imaginatively from the perspective of a thing, or another person, is then projected onto the method. We tend to "judge" the relevance of a process based on our personal comfort with it.

An art therapist at a workshop I gave at Harding Hospital in Ohio revealed the nature of the difficulty in personifying paintings when she smiled and said to me, "You are shaking my cosmology."

Although the art therapist was keenly interested in dialoguing with the colors, gestures, and figures in her paintings as autonomous entities offering something fresh and outside her existing self-concept, her notion of

herself and of the art therapy profession was based upon the view that the image is always an expression of the artist who made it. She was accustomed to looking at everything in her pictures, dreams, and imagination as parts of herself. Rather than having the picture speak to her, she was accustomed to explaining what it was. The difficulty she had in approaching intimate images as autonomous beings was connected to attitudes and orientations that are so deeply rooted in all of us that she imagined them as a cosmology.

Our language structure restricts the "I" to the perspective of the speaker and reinforces the tendency to approach the self as the center of consciousness. Objects and things are labeled "inanimate," and the painting that I make is designated as an "it." In English, as contrasted to other European languages, nonhuman forms of life and objects are neuter, without gender, and thoroughly depersonified.

In addition to constructing experience around ourselves, we limit the person to a singular frame of reference, the ego or "I," when in fact each of us is composed of varied perspectives and vantage points, as well as the potential to imagine from the perspective of things other than ourselves.

Shaking the foundations of ego reveals the illusory certainties of theories and self-centered fixations. I was delighted by the response of the Ohio art therapist because of the way it articulated the nature of the unconscious resistance to dialoguing with images. The process involves re-visioning our self-centered preconceptions of existence and engaging the world from the perspectives of imaginal others. The reluctance to personify is largely based on the inability to relinquish control and act as an agency for something outside our established concept of who we are.

Personifying images is generally a gentle and intimate experience, although there are times when spontaneous and unexpected expressions can shake up the existing order. Poseidon, the "Earth-shaker" of Homer's *Iliad*, similarly aroused humans to see that they do not have complete control over their destinies. In keeping with shamanic and mystical traditions, healing experiences demonstrate how illumination often occurs when we feel alienated and estranged from the world. These moments of crisis bring the transformative dissolution from which fresh visions emerge.

For many people, however, personifying involves a subtle shift of consciousness rather than a shattering of worldviews. The process might simply awaken a dormant animism within the soul.

I do not deny that a picture or dream is closely associated with the inner life of its maker or dreamer. They carry messages, entertain, guide, and sometimes caution. This relatedness is furthered rather than restricted by viewing expressions as autonomous forms of life. I imagine artistic expressions as offspring, and like children they are related to but separate from their makers. Artistic offspring flourish when viewed as individuated forms of life, co-participants with us in life, whose rights are to be carefully protected. Neither children nor artistic expressions are statements about the psyches of their creators.

Imagining expressions as offspring, as recommended by Socrates, actually increases their intimacy and psychological significance. The word *offspring* suggests how one thing springs from another in a kinesis of eternal emanations. Creation's movement is denied through labels and attempts to analyze expressions as descriptive of the persons through which they emanate. Labeling according to established categories not only suggests an inability to creatively examine experience, but it is also a defense against creative uncertainty, life's mystery, and the reality that nature will always deter attempts to enclose and restrict her primal movements.

The concept of "offspring" must also be modified to ensure that the image is not overly identified with the artist through whom it emerged. No single position, name, or attempt to grasp the nature of psychic movements is ever final. As soon as I appear to have a grasp on the process, it becomes a phantom and shifts. The "related but separate" basis of the connection between creator and image can be reversed with artists imagining themselves as expressions of archetypal processes that move through us. These universal forces take on endlessly particular and individuated forms as a result of our interactions with them.

A friend recently looked at a dreamlike painting I made of two flying figures, a man and a woman, with a dog on the ground, and asked whether Marc Chagall was an inspiration to me. Chagall's work was never particularly significant to me until after I began to make figures flying in space and many people drew my attention to the similarity. I began to feel that the archetypal process of flying figures was moving through me as it moved through him.

Art history can be reimagined as an archetypal and protean process rather than as a tidy chain of individual human inventions and direct in-

fluences. Images such as labyrinths, flight, dark openings, mystical spaces, crowded patterns, simple symmetries, embracing figures, and aggressive movements are eternal, recurring, and constantly rediscovered through an artist's journey into expression where images present themselves and pass into individuated forms as a result of the meeting.

If we ask the flying figures in my painting what they think about this issue they say, "We do not belong to Chagall. We engaged him as we are now engaging you, others in the past, and those to come in the future."

A similar problem occurs when we refer to psychological involvements with cultural continuities, myths, and symbols, as "Jungian." I can imagine these phenomena saying, "The archetypes are not Jungian."

Jung interacted magnificently with these forces, and reflection on his work inspires and guides others to establish direct access to them without being required to pass through him. As my colleague Paolo Knill believes, we find ourselves in the mad and derivative position of imagining a situation as we imagine Jung or Freud imagining it.

Archetypal movements cannot be exclusively identified with one person. Their very nature and purpose encourages us to look at art, history, and existence outside the framework of a single person or tradition.

### DIALOGUING WITH IMAGES

Because images do spring from our inner lives, personifying enables us to dialogue with feelings and concerns that are not easily accessible to conventional thought.

As in relationships with other people, dialogue takes us into a deeper, more intimate and creative exchange. We move beyond explanation and the controls of one-way speech and open ourselves to the surprises and discoveries that occur through interplay. In order to dialogue with an image, we have to acknowledge its interdependence as a partner, a personified other. This can be difficult.

I encourage people to begin by first speaking as themselves and imagining the image as a person.

"Look at the picture carefully. Look deeply," I say, "as if you are watching another person. Begin to speak by telling this 'other' what you see in it. Describe what you see in detail. As we engage the picture as a partner, we enter the imaginal realm."

Speaking to the picture in this way serves as a warm-up to shifting roles

and letting the picture speak to us. It is relatively easy for most people to describe what they see in this responsive fashion, and the simple process of beginning to speak freely opens up other dimensions of conversation. Talking is a form of thinking in which thoughts take shape through the interaction of participants. As soon as we enter the flow of creative communication, it becomes easy and natural for the images to express themselves. We start to act like poets who move freely within a personified world where everything has the ability to speak and offer its unique perspective.

The artist responds as the picture's "speaker," a term we take from shamanic cultures, where the mask that the person wears, or the object that is held, is considered to be alive but incapable of speaking alone. They require the presence of humans, who function as their speakers. The same thing applies to dreams. Humans enter the imagination of the image, or event, and speak for it, rather than as themselves. This natural interaction is quite different from our contemporary belief that we project ourselves in everything we say. If we are captive within ourselves, we may in fact function in this way. Animistic cultures can teach us how it is possible to discipline, educate, and sensitize ourselves to become agents of another's expression. The results can be liberating and an excellent treatment for our self-referential excesses.

Some artists participating in my studios for the first time are unable to speak for their paintings. They discover how they are stuck in their preconception that paintings do not talk, and they are further hampered by demands they place upon themselves to be "imaginative," "profound," and "psychologically clever." They actually describe how they are afraid to dialogue. They fear ineptitude. The expressive imagination can be trained and supported in taking risks, in exposing its vulnerability. What we do has much in common with poetic speech; and, like poetry, the process of speaking from a perspective other than the habitual self tends to improve through practice and cultivation.

The painting may come to the speaker's assistance when asked what it needs:

"I need to be looked at for what I am. Let go of yourself so that you can see me. You cannot speak for me because you are stuck in yourself, fixed like glue to yourself. You don't have to think up something that expresses your deepest feelings through me. If you can experience my unique nature

and simply describe what you see in me, you will begin to feel emotion within yourself. Articulating my feelings will help you experience yours. You get confused when you try to find something within yourself and use me to present that to another person. I need you to experience me in order for me to enter the world. I need you for this. I come to life through you and maybe I can do the same for you."

An artist in my most recent studio found that her picture expressed desires for autonomy when asked what it needed: "Let me go! Don't worry. I will be fine. I do not need you seeing me as part of yourself. I am separate from you. Can you see me? If you can appreciate me, I will be free from your control. You know that if you cannot let me go, you will be caught again in clinging. I need to be let go for my sake and yours. I can help you practice letting go. You hold on to me like a possessive parent. I need to be seen as a separate person. Your desire to take care of me gets in the way. Your need to see me as part of yourself does not help either of us."

These dialogues may be analogous to the life experiences of the artists. However, comparison is different than the reduction of one entity (picture) to another (artist), which results in the image's loss of a distinct identity. Analogy implies separateness as well as relationship and therefore fits our concept of the connection between artist and image. When analogizing, I say that my red painting can be likened to my aggressive nature; but I cannot say that because I paint red, I am aggressive. Red is not aggression. The color does not have a psychological meaning. Red is red, a particular shade of red, a specific texture in a context that can be differentiated from other environments. If I make analogies between the color and my emotions, one does not subsume the other. The red continues to exist as itself while provoking my imagination.

Encouraging images to express themselves through dialogue does not deny the visual and kinetic communications of paintings. I do not argue with the notion that depth is on the surface of the painting, and we certainly must improve our ability to perceive what is there. Rudolf Arnheim's writings articulate this education of "the creative eye" and guide us through the process, cautioning that the language of dialogue can sometimes be "inferior to that of the image" (1989, 149).

In addition to talking about, and with, images in my art therapy studios, we respond through performance art, presenting ourselves as images

through movement, environmental constructions, and sound. The possibilities are endless as one image interprets another in continuous succession.

Psychotherapy has shown itself to be an essentially dramatic process, a ritual of storytelling. Drama is the genre through which all creative expressions, even within the context of a painting studio, complement one another and aspire toward the full unfolding of the intelligence of imagination. Dreams and emotional conflicts reveal how the psyche in fact chooses "spontaneous" drama as its primary medium into which all of the other arts are naturally drawn.

Creative arts therapy is a complex discipline with vast and unexplored depths, all of which can function simultaneously within our profession without striving for integration into a single framework. Dialoguing does not replace visual contemplation, and it is not a more advanced state of experience. It simply engages another aspect of art and imagination that happens to enhance the therapeutic experience. This attentiveness to the imaginal other—its rights, needs, and desires—will establish the basis of a new vision of art and therapy, not mine or yours alone, but that of the imagination engaging us all.

**REFERENCES**

Arnheim, R. 1954. *Art and visual perception: A psychology of the creative eye.* Berkeley: University of California Press.

———. 1972. *Toward a psychology of art: Collected essays.* Berkeley: University of California Press.

———. 1989. *Parables of sun and light: Observations on psychology, the arts, and the rest.* Berkeley: University of California Press.

Gadamer, H-G. 1977. *Philosophical hermeneutics.* Trans. and ed. D. Linge. Berkeley: University of California Press.

Hamilton, E., and H. Cairns, eds. 1961. *The collected dialogues of Plato.* Bollingen Series 71. Princeton, NJ: Princeton University Press.

Hillman, J. 1983. *Healing fiction.* Barrytown, NY: Station Hill.

———. 1989. *A blue fire: Selected writings of James Hillman.* Ed. T. Moore. New York: Harper and Row.

Jung, C. G. 1958. *Psyche and symbol.* Ed. V. de Laszlo. Garden City, NY: Doubleday.

McNiff, S. 1986. An artistic theory of mental health and therapy. In *Educating the creative arts therapist: A Profile of the Profession*. Springfield, IL: Charles C. Thomas.

—————. 1989. *Depth psychology of art*. Springfield, IL: Charles C. Thomas.

Perls, F. 1971. *Gestalt therapy verbatim* (1969). New York: Bantam.

Watkins, M. 1983. The characters speak because they want to speak. *Spring: A Journal of Archetype and Culture*, 13–33.

# 10

---

*The Challenge of Disturbing Images*

In response to the suggestion that images contain medicine, the skeptical person might ask, "I understand how a person can feel better by looking at a Renoir painting, but what about disturbing images?"

Ironically, it is work with disturbing images that best demonstrates the value of opening to the expressiveness of an object or imaginal figure. The disturbing image is the unlikely savior who may in some cases offer more emotional support than the pastoral landscape.

To those questioning the therapeutic wisdom of welcoming disturbing figures, I can say that I have never encountered an image in an artwork or dream that came to harm the person experiencing it. A student once said to me, "It may come to show me where I hurt, but it doesn't want to hurt me." The images in art and dreams are psychic figures that live within the reality of the imaginal realm. I am not speaking here about images that come to us from the media or actual threats and bad experiences encountered in the world. The agitated psyche of the artist will frequently generate pictures that seem unpleasant to some, but the ability to make an artistic expression correspond to troubling feelings can bring the artist satisfaction and relief.

Often we are stunned and disturbed by images, especially in dreams

where they come upon us with a great intensity of emotion. We do not have to quickly befriend the disturbing image in our expression. But it may be helpful to view it as an intimate, a familiar figure within our psychic lives that might be trying to get our attention through its provocations.

If an image in a dream or an artwork agitates the person who generates it, it is likely conveying a message that needs attention. Personal demons have a way of eluding conscious awareness and the more I deny or avoid a problematic feeling living within me, the greater its shadow power becomes.

When Rudolf Arnheim was supervising my work as a graduate student, he emphasized the innate tendencies that organisms have with regard to both the heightening and reduction of tension. He was greatly impressed with Carl Rogers's discovery that groups move naturally toward cooperation if given the proper support. Jung similarly observed that even the most upsetting and difficult manifestations of the psyche were part of a life-affirming purpose. Likewise, I find in my professional and personal lives that tension and conflict help to define problems so that something can be done with them. The same thing happens with pains in the body, which make us aware of how conditions have to change.

Rather than repress tension, one must respect its role. Healing cannot occur without the manifestation of problems. Regarding the ancient Greeks, Nietzsche wrote, "their secret was to honor illness like a god." By "ennobling" whatever their condition might have been, the Greeks "turned diseases into great beneficial forces of culture" (Nietzsche 1984, 128).

That one person can find fascinating what another finds upsetting leads me to conclude that the nature of an image can never be labeled. In both my group and individual work with art and healing, there is an attempt to respect each image, stay with it, and give it the opportunity to reveal itself over time. My intention while sitting with a picture is to suspend judgment, or to watch myself in the process of making judgments and then to engage the material that emerges. I might ask the image if it sees itself as disturbing, and then consider why I attach this quality to it.

In our efforts to treat images with the resources of creative imagination, performance art is useful because of the way it engages the body as

a mode of interpretation. In a recent performance piece, two colleagues helped a woman to confront frightening demons from her dreams and paintings. She discovered during the performance that the demons were familiar spirits whom she would actually miss if they left.

Another performer had dreamed of a frightening figure coming at her. She talked about the dream, painted it repeatedly, and made a mask of the figure. Despite these efforts, her relationship to the figure did not change. Finally, she did an aggressive dance while wearing the mask and felt exhilaration in the power of the movement. Only through physically enacting the experience, getting behind the mask instead of having the figure come at her, was she able to fully receive and embody the message of the dream demon, which was to accept the forcefulness of her expression rather than turning it against herself.

Performance was used in both situations as a mode of inquiry that furthered an understanding of images. We saw how psychic transformation occurs when we empathize with the threatening images, take on their vitality through imagination, and express them through the body as well as the mind. The performers discovered that the role of victim is only one of many perspectives on the situation. Engaging the disturbance through the creative process helped them to "reframe" the perceived problem and to relate to it in a different way.

A colleague in one of my studios affirmed that the troubling image wants empathy and does not need to be "explained." Speaking as an image, she asked the people around her: "Can you be uncomfortable with me silently and feel what I am going through. I don't want explanations. They don't help. If you feel the discomfort with me, that helps."

Healing occurs when we open to the expression of an image and do our best to be present with it, understand it, and accept it, rather than attempting to fix it, resolve it, or eradicate it. Just as actors strive to feel the emotions of the characters they portray, tapping into memories of similar experiences, we try to establish empathy with the troubling image and discover what it can reveal to us.

The disturbing image intrudes and threatens the existing order. Even when we welcome abrupt changes, the psyche might need the assistance of disturbance in order to realign itself. Quickly attaching a positive value to a disturbance may compromise its essentially negative function and the upheaval it brings. Rather than improve the image or repair it, we try to appreciate the purpose in its expression. The process is rarely

easy. But if we trust and support the creative imagination, it will help us engage forces of healing that may exist in the most improbable places.

**REFERENCE**
Nietzsche, F. 1984. *Human, all too human.* Trans. M. Faber with S. Lehmann. Lincoln: University of Nebraska Press.

# 11

## *Images as Angels*

**HOW WE ENGAGE THE IMAGE**

The figures we know as angels have many names—daemons, spirits, jinii, faeries. They are a way of looking at things, a perspective, a poetic view, or what Jung would call a "psychological fact." Japanese rituals acknowledge the ghost of the teapot, and indigenous communities everywhere imagine spirits inhabiting hills, rocks, and trees.

When I view my creations as angels, imagination is welcomed. Reason is not abandoned, but it steps aside and invites other participants. This chapter is not advancing a supernatural view of images. Rather, it is about looking at things metaphorically, something serious artists and poets do all the time. Developing this capacity allows one to relate more creatively and expansively to artworks. If the idea of images as angels seems strange at first, don't be deterred. Most people are unaccustomed to looking at the world in this way.

Rather than calling them pieces, works, or pictures, try to imagine images as angels for a while and notice what happens. Approach this "metaphor of a metaphor" (Bachelard 1987) as a way of bringing more imagination to the way you view art. The last thing I want to do is have this kind of speech adopted by others in some type of literal fashion. Ultimately, I would like to see people using their own creative language and

metaphors, what Owen Barfield calls the "speaker's meaning" (1967), to help us all become more imaginative in responding to images. The great advantage of the angel metaphor is that it personifies the image and brings it to life in a way that opens up many new possibilities for inter-action. If this particular metaphor doesn't work for you, you can of course invent your own language and methods of deepening your rela-tionships with images. All of these creative methods require one to estab-lish an empathic connection with the expressions of an image.

When a person is ready to acknowledge an image as a living partner in dialogue for the first time, it often goes something like this:

(Speaking to a picture) "I don't know what you mean. You're a puzzle I can't solve. What do your symbols and colors mean?"

This challenge to the image sounds like interrogation. It suggests that the person doing the talking is still operating from the vantage point of translating pictures into concepts. The imaginative discourse has not yet begun.

James Hillman says, "Do you ask the person who arrives at your door, 'What do you mean?'"

In extending hospitality, we greet the person, spend time together, talk, enjoy each other's company, and afterward feel enriched or ensouled by the visit. Can't we extend this courtesy to the images we make?

Solving a picture is not likely to open the soul. As Jung said, "the bird is flown" when we try to explain an image. The "puzzle perspective" on art keeps us stuck in our heads. Even when this process is moving in a lively way, it is still little more than mental gymnastics.

Rather than interrogating images and trying to decipher "what they mean," I suggest welcoming them and simply reflecting on their expres-sive qualities, saying something about what we see and how we feel in their presence. Whenever someone begins to talk with pictures in this more intimate way, the conversation moves from the head to the heart.

I imagine the images loving these engagements. They say, "Art thera-pists, put your heads aside for a while, keep our mysteries, feel our vibra-tions, our visual qualities, our beauties and provocations. Dance with us in different ways." Sadly, we art therapists are so fearful of being labeled "touchy-feely" that we have repressed the feeling function—art's active ingredient of healing—in our work.

When images express themselves and act upon us, they are behaving in ways that correspond to the figures we call angels. If psychology can accept

a correspondence between a picture of a lawnmower and castration fear, then it should not strain credulity to liken images to angels.

Approaching images as angels suggests new ways of relating to them and implies that they carry medicine. The angelic nature of an image transmits its medicine through cultivation and relationship. Everything depends upon how we engage the image and what values guide our interaction with it. In his *Book of Life,* the Italian Renaissance writer Marsilio Ficino, one of archetypal psychology's inspirations, said cultivation warms up the image so that it "penetrates the flesh of someone touching it."

Here's how I began my reflections on artists and angels in my book *Art as Medicine*: "If we imagine paintings as a host of guides, messengers, guardians, friends, helpers, protectors, familiars, shamans, intermediaries, visitors, agents, emanations, epiphanies, influences, and other psychic functionaries, we have stepped outside the frame of positive science and into the archetypal mainstream of poetic and visionary contemplation."

### DISTURBING IMAGES WANT TO BE FELT AND NOT FIXED

Angels are enjoying a revival throughout popular culture in bookstores, card shops, garden centers, theaters, and mail-order catalogs. The images of angels that we see are anthropomorphized cherubs and Botticelli-like female figures with rosy cheeks, strawberry blond hair, and flowing garments, all displaying idealized Northern and Central European racial characteristics. I love Botticelli, but I also hear D. H. Lawrence howling from the other side about "this angel business," the pretty and vaporous spirits masking the soul's dark and sensual life.

Our contemporary culture of angels is exclusively oriented to light figures. I do not dislike these representations of aerial spirits. I am simply lamenting a cultural imagination that neglects the earth angels, the spirits of matter, fire, stone, and darkness. Such a one-sided vision excludes the powers of nature, the transformative energies that live within each moment and ourselves. Healing does not happen when we cut ourselves off from this world, but when we immerse ourselves in it in new ways.

Outside contemporary Western culture—in India, ancient Greece, and old Europe—troublesome and sinister figures, the dark angels, live alongside the sweet and proper ones in a healthy ecology of spirits. This embrace of the full spectrum of experience, and especially the transformative powers of the unknown, is a distinguishing feature of art and a source of its healing power. Our maladies can renew us when we open to

them through art. I personally find that what irritates me most usually has the most to offer. The disturbing image is typically the one that delivers the most important messages. It wants to be seen and respected. If I deny its efforts to communicate, it ups the ante, increases the pressure, in order to burst through; or it may patiently wait around for years, appearing in recurring dreams and paintings until I am ready to engage it. Typically, it furthers my compassion for the places in others and myself where the soul is wounded, suffering, or confused. I call these images "angels of the wound."

Art as a spiritual discipline entails paying attention to images and opening ourselves to their unique expressions rather than trying to fix the problems we think they represent. The unsettling image is an ally of the soul that helps me reframe how I am looking at life and living it. When my attention is fixed on distant desires, a dream dog may gently bite at my back, wanting me to turn around and pay attention, to look in all directions, and to see what is right at hand. My tendency is to brush the biting dog aside, tie it up, cure its biting, make it submit to my control. So the dog intensifies its grip, and I increase my resistance. In this way I turn the soul's messenger into an adversary. The dog will come again and again, becoming more monstrous and nightmarish, trying to break through my repression.

### THE ANGEL AS A PERSON IN EVERY THING

Classical philosophy maintains that every thing has an essential "substance" that constitutes its being (Aristotle, Metaphysics, VII, 1). The spirit or quality of a thing is the basis of its character, something that emanates from its material nature, what Rudolf Arnheim describes as the expression of objects. Things present themselves to us and expression, as Arnheim says, is embedded in their structures. Depth is on the surface we do not fully see. The arts affirm that every object or gesture has a spiritual as well as a physical nature and that these depend upon each other. Henry Corbin, my guide to the psychology of angelic phenomena, has described the angel as the person in every thing—"beneath the appearance the apparition becomes visible to the Imagination" (1977, 29). Active imagination is the faculty through which "beings and things" are transformed "into their subtle state." It is a process of interpretation closely related to meditation and prayer.

Esoteric doctrines have a profoundly practical application to creative expression, where matter, body, and consciousness are infused with spirit,

transformed into new forms, stories, and experiences. As colors and forms move and change, our psyches experience corresponding effects. The materials and movements are shaping us. When will we see that healing through art is a discipline of imagination rather than an exact science?

There is a paradox at work in Corbin's reference to the spirit of an image "beneath the appearance," because the angelic nature of an image is experienced through reflection on its physical form. The angelic perspective affirms both the immediate form and its spiritual counterpart. They appear simultaneously. This is different from believing that the true or deep meaning is hidden behind a form. If I look for something underneath the physical expression, I overlook what is immediately present.

The angel is the uplifting feeling I get when looking at Charlotte Salomon's paintings, from which colors, imaginary scenes, and mysteries fly out to the viewer. Last night a dream told me there were angels in the sweeping gestures of Franz Kline's big black strokes. "The spirits are in the motions," the dream said. "They're in there, for those with the sensitivity to see and feel them when they look at a picture and when they're making one."

These physical expressions and the spirits they convey are the medicines of art. They infuse us with their energy and ignite our spirits, and we respond to them with new cycles of creation.

### IS ACTIVE IMAGINATION CRAZY-MAKING?

Interpretation is an ongoing active imagination, and creative transformation is the energy of healing. Art heals by cultivating imagination with a trust that a revitalized spirit will treat its own disorders.

I play a drum in my studios to help people paint from the lower body, from the back and shoulders, to physically enact imagery from the feet and thighs as well as the fingers, arms, and head. The angel is a spirit moving through us, never fixed, a force of transformation that is healing. My studio participants love to engage finished images, but the primary experience is always artmaking. Visual art cannot be separated from movement, drama, performance, and the sounds of creating. The angelic perspective rejects tidy compartments of specialization. Spirits are forever crossing disciplines within the fields of imagination. As a farmer in Connemara once said to me, "Can't fence anything with wings."

It is useful to reflect upon how we relate to images. To what extent do

we even begin to access the imaginative expression and potential of the art that is the basis of our work? As I say in *Art as Medicine*, I need ways to respond to pictures that correspond to their spirits. I emphasize *Gesamtkunstwerk* (total expression) because fresh, non-habitual expressions—such as singing or moving in response to what we see and feel in a picture—renew the imagination. The angel is the surprise, the infusion of spirit that arrives unexpectedly. For many of us, talking is the most effective avoidance, the essential mode of control. Angels are more likely to arrive when we get up out of our chairs, out of our controlling heads, shutting off talk for a while and finding new ways of engaging pictures.

This view predictably alarms some therapists, who say, "My patients are hallucinating constantly, suffering from delusions. Your methods encourage this. It's crazy-making. It will make them worse."

If a woman talks to a specific color, picture, or texture, empathizing with its nature, moving or singing in response to its expression, isn't she making contact with the immediate and physical world? Maybe it's safer to talk to a painting than to a person. And even if there is an element of poetic madness involved, homeopathic medicine suggests that it may be good for this person. Imagination offers new versions of old stories and forms an unlikely alliance with cognitive and narrative therapies. As in creative problem solving, the controlling mind relaxes its grip and allows spontaneous expression to form itself into fresh structures.

### INTERPRETING IMAGES THROUGH THE BODY

Many people find it easier to respond viscerally, with their bodies, to the raw energy in a painting. There is a direct expression conveyed by the painting to the body of the viewer, a charge that stimulates an equally physical countercharge that usually corresponds to the movement and energy that shaped the painting. People are often speechless before their image, sometimes feeling overwhelmed. I frequently see people who fear the energy in their pictures and sculptures. Someone might say to a picture, "You're all over the place; you're too much." Or, "You have so much power, no boundaries, chaotic. I'm afraid if I take you into me, I'll lose control. I'm afraid of what I'll do. I'm afraid of your power."

Talk alone doesn't work in these situations. It often serves to increase the discomfort. When the artists use physical expressions to communicate with the energy of their images, the situation becomes more workable. Uncontained fears are embodied within the artists' movements and actually

become sources of creative expression and energy. Putting the fears to good use may be the best way to lessen their negative influence on us.

I often encourage people to begin relating to their images through visual reflection and mindful breathing. "Breathe the image in and breathe it out," I say. "Look at the different qualities of the image, then focus on something particular that attracts your attention; take its expression into your body through your breath, and let it go with your breath. Move on to another aspect of the image and do the same thing. Feel the movement in your body as you do this. You are already moving with your image. If you like, expand these movements by simple shifts of movement with your head, hands, and arms. Slowly step closer to the image, or move away, to the side."

Use this breath method as a simple beginning to creative movement, as a reminder that you are moving all of the time, even when you are still. Moving with an image is a simple process of doing what you already do, but in a more mindful and creative way.

An artist in one of my studios dreamed of a frightening place and could not find any satisfaction in talking about the dream, which only seemed to increase her agitation. But when she enacted the dream physically, entered and explored the space that frightened her, her relationship to it shifted. The space, with all of its qualities and the feelings it generated, became her partners in the creative enactment. She created together with them and got to know them in a completely different way. The threat became an ally, and she actually enjoyed exploring the previously frightening space.

The way we move with an image depends upon our needs at that moment. The process extends from simple breathing with colors, forms, and figures to enacting them with the full force of our emotions. But in all cases, I like to begin and end the work with silent attentiveness to our breath and the shifts we make in moving from one thing to another.

Physical movement helps us take the spirits of our pictures into our bodies. As we interpret the gestures of our paintings through movement, we go through yet another phase of making them our own, instead of the intellectualization, distancing, dissociation, and fear that we sometimes have in response to our own pictures.

Art and pictures convey energy, but we tend to view them, even in the process of poetic and imaginative dialogue, exclusively from the perspec-

tive of what can be expressed in narrative speech. Responding to pictures through movement can be a more direct method of accessing the expressive energy of images. The simple process of "mirroring" the expressive movements and gestures in a picture can enhance their impact and fill the person with creative energy.

## TALKING *WITH* THE IMAGE

In my studios I repeatedly discover that people experience intimate and surprising relationships when they talk *with* an image rather than *about* it. A woman made a small clay angel with an open chamber that contained a heart. She held the figure lovingly in the palm of her hand but did not speak directly to it.

She said, "It has a heart and an open space. I feel the emptiness now and that troubles me."

She felt stuck, and the talking did not go further.

I asked, "Do you want to try a different way of talking?"

She said, "Yes."

I said, "Rather than speak about the image as an 'it,' speak to it as a person, as a 'you.' You can repeat what you said, but just try saying it in this more intimate way."

She continued, "You have a heart and open space. I feel the emptiness in you and it troubles me. I like the way you feel in my hand; and your heart, it's so open. It wants company. There's space in you for others. I wish I could close you."

I said, "You can."

She tenderly closed the flap opening over the angel's chest and massaged its edges. "I closed you," she said, "but in a way that you can be opened again."

Let me offer an example of image dialogue with one of my own paintings (figure 26), enacted live at an art therapy conference:

*An Image Dialogue*

I've got a picture that wants attention.

Picture speaks: "So you've got a problem with fair-haired feminine angels flying in space?"

I say, "I like you but I want to see the spirit in every thing—in the animal, the person under the tree, the odd trees, the imaginal

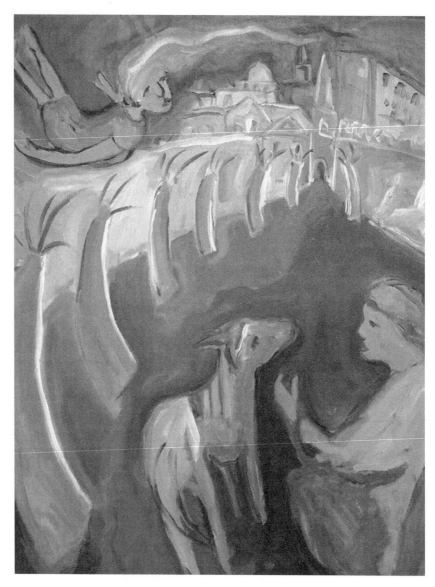

Figure 26. *Flying Girl*, by Shaun McNiff.

city, the red cloud, the dark sky, the paint, the colors, every gesture, the movement of the trees, the wind blowing through you."

Now something personal to the picture: "I didn't put you in *Art as Medicine*. I wasn't comfortable with you. You seemed strange. I didn't want to show you, yet you're the one I hang in my house on the biggest wall.

"You disturbed me because you brought something new . . . so red, the bleeding door, menstruating streets and skies, those weird trees dancing. My wife liked you immediately, and our daughter said, 'There's magic in the red cloud and the girl knows how to find it.'" The human figure, the man or woman, sits with the animal. The figure is still right now.

The crazy trees whisper, "Everything will move if you can sit still."

As I settle down and breathe with the painting, it feels like a vortex of energy. I begin to lose me, and spin in its world, its imagination.

I ask myself: "The painting is a magical environment, but am I safe here in the place from where I look? Can I let go in front of these people? The more I look, the more your color, movements, and spaces penetrate me. If I'm going to travel into you, I need to relax and feel safe, protected."

"Come," the girl says. "All you have to do is sit and you will travel. Listen to the trees. They will guide you."

I begin to identify with the seated figure and feel one of my daughters hovering above. The picture is reframed from the perspective of the girl, who speaks *Annie Hall*–style, through mental subtitles: "I can't believe he's sitting still. I can go to him, but will he get up the minute I arrive, and say that he has work to do? He may be ready for me today, and the intimacy I bring."

The animal says nothing and just feels the presence of the person and comes close, smelling, looking, and sensing.

But now the animal feels like my dog, or spiritual director, who says, "Hey dude, sit . . . sit, SIT. Isn't that what you're always telling me? You need it more than I do. Breathe in and breathe out. Sit."

The trees speak, or do they sing?

They move and make sounds.

I hear words now: "Play for us. Watch and play. Hold the space for us. Play."

The human figure says, "Yes. I sit and play, drumming and making rhythms on a mbira for the painters and dancers."

"Play," the trees say. "It's time to stop talking."

I respond by making music with my kalimba.

This dialogue is representative of what we do in my studios. We cultivate the spirits of the image; we do more imagining and less explaining; we let go and immerse ourselves in the art process, which transforms everyone involved. Today I identify with the seated figure. Next time it may be the girl, or the animal, or the red. Every day I have a new relationship with the image.

When I hold the space for an artist and the images, other members of the group sit as witnesses. They are invited to respond after the artist's dialogue, but there is an essential rule: no questions, and all statements are to come from the heart. If the image disturbs someone, of course they can express this. The sanctuary is maintained when a response—even a negative one—is presented as an authentic personal feeling, rather than as an analysis or judgment that does not acknowledge its bias. This exchange of feelings and soulful expressions within the space where the art is made is what gives our work its sacred quality and distinguishes it from the conventional studio. The witnesses expand imagination and its medicine by speaking to the image, as the image, or to the artist. Artistic responses through movement, sound, or ritual enactment are welcomed, and they always seem to give the artist more satisfaction than do explanations or conversation.

Maybe the angels of art and healing are saying to us, "Give us more art, feed our souls with images."

**REFERENCES**

Arnheim, R. 1954. *Art and visual perception.* Berkeley: University of California Press.

Bachelard, G. 1987. *On poetic imagination and reverie.* Trans. Colette Gaudin. Dallas: Spring Publications.

Barfield, O. 1967. *Speaker's meaning.* Middletown, CT: Wesleyan University Press.

Corbin, H. 1977. *Spiritual body and celestial earth.* Princeton, NJ: Princeton University Press.

Ficino, M. 1980. *The book of life* (1489). Trans. Charles Boer. Dallas: Spring Publications.

McNiff, S. 1991. Ethics and the autonomy of images. *The Arts in Psychotherapy* 18 (4).

———. 1992. *Art as medicine: Creating a therapy of the imagination.* Boston: Shambhala Publications.

**12**

*Angels of the Wound*

In treating physical injuries, we know that symptoms, however uncomfortable, often function as messengers. They have stories to tell about how we live our lives and how sensitive we are to the body's needs. The pain in my stomach is a messenger who comes to help me look at the way I eat or how I handle stress; a broken ankle and its resultant condition of dependency may force the "in control" person to sit back and accept the assistance of others.

I distinctly remember how my childhood illnesses and accidents changed the pattern of daily life. I was a constantly active child, but when suddenly forced to lie down and miss school, I had a different kind of contact with my parents, based not on checking in to ask permission for various adventures but on conversations about my physical state as well as on quiet time together. The wounded condition made it clear that people need each other; it taught me how to ask for help, how to receive and appreciate it. My wounds also taught me how to minister to others when they are injured.

According to folk wisdom, the malady contains its own remedy, and wounds generate agents or "angels" of their own transformation. This also happens when we suffer wounds to the soul. In my therapeutic work, I see that the angels swarm in when a person admits vulnerability

and acknowledges wounds. I am speaking of angels in a metaphoric and imaginal sense, rather than as literal appearances of supernatural beings. The angel of transformation might take the form of another person who offers support and guidance; it might manifest itself as an inner feeling or vision from which we draw sustenance, or an artistic expression that suggests another way of imagining our lives.

The key to this approach is that the person who has suffered the soul wound must admit to the injury. This can be challenging for those who deny emotional wounds and resist the loss and pain that they bring. However, when a wounded person denies the affliction, it does not diminish; it grows. Unable to reach the person in whom it resides, the demon of the denied pain turns its energy and need for attention onto others. This is how cycles of soul wounds work their way through families and generations of families, through troubled societies, and finally through nations. The neglected wound tends to continuously up the ante, the pressure, and the risk, screaming for attention, until it bursts into consciousness in a way that stuns and humbles the afflicted person and softens the soul for transformation. The creative work of angels is paradoxically dependent upon the conflict-inducing demons who prepare the soul for change and healing.

My most vivid experience of denying a soul wound came when my grandmother died when I was a teenager. Although we were very close, I did not cry. I remember staring out of my bedroom window, feeling a stoical and still emptiness. Perhaps the loss was too much for me. At that time in our culture, boys were not supposed to show their feelings. In fact, denial of emotions was considered the basis of our progression into manhood.

Years later, immersed in a love relationship, I often burst into primal tears when my feelings were touched. It seemed strange and mad to completely lose control of my emotions in this way, but I soon realized that I was finally purging what had been held inside since my grandmother's death. This release was only possible within the safety of a relationship where I could feel the depths of the loss and the wounding of the soul.

While, in my art and healing studio, I am accustomed to encouraging others to give expression to their most personal images, however uncomfortable this process might be, a recent experience reminded me of the importance of such an approach in my own life.

I was scheduled to give a lecture on the idea of angels of the wound and

decided to use images of wounds from art history as a way of making my thoughts tangible. Going through the slide collections of various Boston museums, I was stunned to see how frequently the Crucifixion motif appeared and how often the figure of the dying Christ was surrounded by angels who cared for his wounds.

The Crucifixion didn't enter my mind as a possible example when I began my search for wound images. Nor did I expect to see angels ministering to the wounded Christ or literally attending to an afflicted person. I imagined people on sickbeds, perhaps injured animals or soldiers. I thought that if I showed such pictures, my audience would respond with a compassionate sensibility—as in group therapy, when a wounded person expresses pain or fear and others empathize with the condition and offer support. I also observed, in my studios, that someone who is suffering might begin by expressing the hurt in a picture, but then in subsequent pictures treat and transform the condition. In this way the pictures themselves could function as angels who minister to the wound.

I saw both of these patterns in the Crucifixion pictures I uncovered. I found pictures that formed a sequence, with the dark, isolated, and agonizing images of the suffering Christ followed by images of him surrounded by angels at the moment before death or just after he was taken down from the cross. In addition to the winged figures, who are often portrayed holding cups or goblets that collect the blood running from Christ's wounds, the Crucifixion images also frequently depict another kind of angel: sympathetic human figures surrounding the cross or the figure of Christ after he is taken down. Christ is always presented in a supine posture, and the attending people are portrayed with bodily gestures and facial expressions that correspond to those of angelic figures within the paintings. In these images the wound arouses a loving response from others, whose actions take on angelic qualities.

Collecting the Crucifixion images triggered a complex of emotions in me that I did not readily understand. Although the images were perfect illustrations of what I wanted to say about soul wounds and their angels, I was reluctant to show them in my lecture. I was censoring because it felt too provocative, possibly offensive to many. The audience might think I was proselytizing and that religious images should be kept out of the public discourse. But I have no difficulty showing images from religions other than the one in which I was raised. This shows how we tend to censor our

most intimate experiences. Less personal images and situations are easier to engage with a clinical disinterest. The Crucifixion motif goes to the core of the archetypal wound in Western civilization and my personal life. It was this image, drawn from my Catholic upbringing, that was causing me trouble.

I have always said that the most provocative images are the most useful in stirring the soul, but I was shying away from the crucifix and its embodiment of the archetypal wound. The image was too close to home. It has taken me two years since first confronting these Crucifixion images to work through feelings about the cross. My experience affirms that vexing images are often the ones that can open unaccessed regions of the soul. Sticking to this image has not been easy. I keep moving toward it and away from it.

I was raised in a household with a crucifix over every bed. As an adolescent I didn't want a crucified Christ over me at night, so I took it down.

My mother respected my personal things, rarely touched them, and generally stayed away from my room, but the crucifix was another story. It seemed only a matter of hours before it was back on the wall. I took it down again, and she put it back up. I tried hiding it in my closet, but somehow she managed to find it and restore it to its former position.

We never spoke about this.

If I were more inclined toward the supernatural, I might say that the cross kept returning itself to the wall. Perhaps it did communicate to her in ways that were beyond my comprehension. For no matter how well I hid it, the crucifix always reappeared.

I made an unspoken truce with my mother and stopped trying to re-structure the sacred things in our house. The crucifix stayed out of my closet, but I took it down from the wall at night and put it back up again in the morning. When I moved out of my parents' house, I kept crucifixes out of my homes.

From the telling of this story I see how actively involved I was with the image. Rather than living passively and unconsciously with the crucifix, I had a complicated set of negotiations with it, an indication of how much it affected me.

I repeatedly tell my students that what disturbs you the most has the most to offer: that's where the creative spirit can be most vital. Yet I offered this idea to them over and over without consciously making connections

to my childhood religious experiences or my own struggles with what were to me the most disturbing aspects of Christianity.

I remembered, too, that I did deviate from my earlier rejection. I kept in my home a crucifix I bought in Mexico. The way the object was made tells me something about the nature of what I had been fighting in the earlier image. In the Mexican crucifix, both the cross and the Christ figure were made of straw. It wasn't so literal, and I enjoyed it as an artwork. I liked the shape, the textures, its lightness, and the way Christ and his cross were one; there was not such a horrible dichotomy between the person and the wood and the nails. As a child I had little trouble imagining the horrific suffering of the crucifixions of Christ and other people; I just couldn't accept it as my primary religious symbol.

I loved the Mexican cross because it was a "particular," an image whose specific and handmade qualities were strong enough to distinguish it from the impersonal and mass-produced symbol. I see that my rebellion probably may have had something to do with the emergence of my artist identity. I had an aesthetic dislike for the machine-made crucifix over my bed, and this specific aversion to the image corresponded to my feelings about impersonal religious practices.

I wonder if I would have felt the same way about the crucifix if it had been carved by someone I knew, or if the motif displayed more cultural ornamentation and imagination, as we see in Celtic or Eastern Orthodox crosses. The universal symbolism of the cross is not lost in these presentations. The particulars of an expression make a symbol more subtle and intimate. I felt the historic reality of the Crucifixion in the Mexican cross, but it was personalized and spiritualized through the qualities of the specific image and the expression of the artist.

My conflict was without doubt also related to how I associated Christianity with the repression of sensual life. As an adolescent, I was beginning to enter into an adult sexuality inspired by a mystical imagination of the world. It seemed perverted to have Christ hanging over my bed. Such suffocating darkness had no place in my reveries. Now I realize how the image of Christ had been obscured by institutional interpretations. I had to go to the cross as an adult and find my own interpretation; only then could I welcome the image of the Crucifixion into my home.

I also find inspiration in other interpretations of this image of soul-wounding. In the novel *Mr. Noon* (1985), D. H. Lawrence embraces the image of Crucifixion and reframes its meaning. The title character,

Gilbert Noon, is traveling on foot through the Austrian countryside, where he comes upon crucifixes carved by villagers and displayed along the side of the road. In the roughly made icons, Gilbert feels the presence of pre-Christian "tree-dark gods." Lawrence writes of his character's encounter with the crucifix: "Gilbert's heart stood still. He knew it was not Christ. It was an older, more fearful god, tree-terrible . . . dark mysticism, a worship of cruelty and pain and torture and death: a dark death worship."

Lawrence felt the vestiges of ancient Europe in the Christian crucifix. The image of Christ on the cross has become so conventional that we are no longer moved by the details of the figure, by the soul qualities specific to the particular image. When Gilbert Noon reflects on the varieties of crucified images that he sees, a whole new world of belief and imagination opens up for him. There is a sense that the theme of the cross can be adapted to the suffering of whoever meditates on it aesthetically.

Lawrence continues, "And startlingly frequent in the gloomy valleys and on the steep path-slopes were the Christs, old and young. Some were ancient Christs, of grey-silvery aged wood. Some were new, and terrible: life-sized, realistic, powerful young men, on the cross, in a death agony; white and distorted."

The painters of the Italian Renaissance imagined the Crucifixion in more extraordinary and lavish ways than the simple wooden crosses described by Lawrence. Renaissance painters frequently portrayed the body of Christ with ideal, beautiful proportions, being comforted by figures with equally splendid bodies, all of whom were painted according to the highest standards of academic perfection. This idealization of the human form creates a sense of distance between the emotional horror of the event and its remembrance through art.

Without judging these representations as avoiding the "reality" of the Crucifixion, we can see how they express different aspects of the ways in which we might respond to soul wounds. The Renaissance versions idealize suffering, imbue it with beauty and grandeur. Such an approach can open us to the sacred level of our own suffering, to the gods in our wounds; when we see that God's son is not spared the agony of earthly pain, our own pain is elevated to the divine realm. On the other hand, the indigenous effigies encountered by Gilbert Noon portray the suffering Christ as a member of the particular, local community. The Christ on those crosses

is both himself and not himself, both the Son of God and an extension of every villager before and after Christ.

In art history, we constantly see how scriptural figures and angels are dressed in the style of the period in which they were made. This reflects how people have continued to identify with religious imagery throughout the centuries. The wounded Christ is an archetypal figure, a living presence in the life of any person or era imagining his suffering and theirs. He brings comfort, love, and healing through the realization that wounds and suffering are both particular and universal. They are pains that we all share in varying degrees and that bond us together.

In the 1970s I worked with the New York City "folk" artist Ralph Fasanella, who made a series of paintings of his father as a crucified figure. The elder Fasanella, who worked as an iceman, was portrayed nailed to the cross with the picks he used every day, his ice tongs clamped to his temples. The son felt compassion for his father's struggles and suffering and used the Crucifixion motif to amplify the pain to a transcendent scale.

Fasanella, D. H. Lawrence, my mother, and I all have our personal stories to tell about the Crucifixion motif. There are others, of course— the pietàs of those dying of AIDS being held in the arms of loved ones, the starving children in countries ravaged by war, grieving families everywhere. The wound is individual and universal, mine and yours. Like all archetypal images, the Crucifixion is lodged in the personal and world psyche. With each individual interpretation and re-visioning, we grow simultaneously closer to the power of the image itself and closer to an understanding of how our own souls have taken it in and understood it.

The significant symbols of a culture can feel distant unless we personalize them in some way, unless they carry the particular marks of our interactions with them. They need to be liberated from institutional interpretations and intimately connected with our lives. The angels of our soul wounds cannot flourish without individual imagination and freedom of expression.

Images survive when they embody the deep and common veins of every psyche. In order to continue living, the image must be reimagined and transformed through continuous interpretation and individual relationships. When a meaning is fixed to something, it no longer transmits vitality and new life. The child who reflects upon the cross becomes an angel to its wound through compassionate feeling and personal interpretation: "He didn't do anything wrong; why such a painful death? It's

ridiculous the way they killed him. What would the world be like if he didn't die?"

Yet negative feelings toward an image, such as I had toward the crucifix in my room, also need to be welcomed. Examining the full spectrum of my reactions to the crucifix images, both positive and negative, helped me to access a deeper sense of the Christian mystery. The goal is not to find an easy, clear explanation—a "cure"—for our reactions to the images that most affect us. The goal is to continue to work with them deeply and imaginatively, in order to uncover what our emotions may be trying to teach us.

James Hillman says that attempting to cure the symptoms of our wounds "may also cure away soul, get rid of just what is beginning to show, which at first is tortured and crying for help, comfort, and love, but which is the soul in neurosis trying to make itself heard." Hillman suggests that "what each symptom needs is time and tender care and attention." Soul wounds cannot be denied, put aside, or easily cured. Rather it is "the prolonged occupation with suffering" that can provide us with "a humiliating, soul-awakening experience" (1991, 55–56).

Just after I began to study the Crucifixion images I was working with a group of ministers in Chicago at a theological seminary who talked about how their churches have difficulty with the imagery of the Crucifixion and prefer the spirit of the Resurrection. So my reluctance to publicly engage images of the Crucifixion does not seem to be unusual; even the Christian churches have trouble opening to it. The strongest and most authentic bonds are established by going through difficult experiences with others. Yet most people are reluctant to acknowledge the effects of wounds. Denied our attention, these wounds erupt from unconscious depths into our daily lives, demanding—sometimes violently—that we notice them. As Hillman suggests, they humble us and awaken anesthetized feelings. We seek out help when afflicted, when wounds, losses, setbacks, failures, and disappointments forcibly pull us down and into the life of the soul.

Healing may appear through simple incidents in daily life that revive our spirits: a smile from an unknown person when I am feeling depressed, an uplifting story, a telephone call from a friend. The world of incidental happenings is full of meaning that passes through our lives unobserved. New insights rarely appear in the forms we expect, and so expectations blind us to the way things show themselves. It is often the

apparently inconsequential action that transforms a situation and renews the soul with its qualities. A friend used to tell me how, after filling his car with gas, he would have a fresh perspective on the world. He felt its fullness within himself. Help often appears in the least likely forms, such as discovering how paying attention to little things may change everything we do.

The medicines of creativity come from reimagining the way we view our lives and re-visioning our chronic conditions. I had long hidden and repressed the wound of the Crucifixion; I did not want it ruling my life. But the wound must be given its place within the life of the soul. We will no doubt all have periods when, for whatever reasons, we choose to deny wounds. But we can also trust the healing opportunities that life brings— such as when my search for lecture slides led me to an examination of my own complex relationship to the crucifix—to help us open to our wounds and receive the medicine they offer.

**REFERENCES**

Hillman, J. 1991. *Insearch: Psychology and religion.* Dallas: Spring Publications.
Lawrence, D. H. 1985. *Mr. Noon.* New York: Penguin Books.

# 13

## Artistic Auras and Their Medicines

### THE EXPRESSIVE QUALITIES OF THINGS

> Chase it and it always eludes you;
> run from it and it is always there.
> *Huang-po, ninth-century Chinese Zen master*

The lines above from Huang-po touch on what I see as the paradoxical conflict that people experience in relation to auras. They are "always there" when we deny their existence; but when we try to grasp and substantiate them into spiritual sciences and techniques, they elude us.

I define an aura as a distinctive presence of any person, place, thing, or expression. Within the aura's sphere many elements emanate at the same time, some of which are subtle and others more obvious. In keeping with the origins of the word *aura*—which in Latin means "breeze"—situations, people, and even pictures give off airs to those who contemplate their presence.

An artwork's aura is its sensory expression, the outward extension of its physical presence and distinctive qualities, the airs or expressions that it casts toward the person who perceives it, a pervasive spirit that cannot

be encapsulated in words and concepts. These effects occur within the realm of perceptual experience (Arnheim 1954).

My years of experience with the arts and healing have convinced me that creative expressions generate rays, energies, vibrations, forces, and spirits that influence people who contemplate them. All of these qualities of expression, what I call "art medicines," are thoroughly practical entities that constitute the healing impact of the arts on an individual person or a group of people. I am constantly exploring how we can best access the expressions generated by images, the process of making art, and the more general studio environment, all of which convey spirits both bold and delicate that people experience as psychic remedies.

I have never separated art from clinical practice. In fact, I find that clinical precision declines when we move away from the actual expressions of art and start to interpret them according to a theory that has no direct relationship to the event. Creative arts therapy has from its inception sought legitimacy by basing its clinical work on psychological theories rather than close examination of the actual phenomena of the arts.

In this chapter, I intend to show that a tangible medium and its expressive spirits are inseparable. As soon as we face the physical being of an expression, we are presented with its aura.

There are people who conceive of auras as energy fields that can be perceived and worked with via specially attuned senses, which are "psychic" in nature. I respect the diversity of ideas about auras in popular culture. Though I personally do not see light radiating from people, I have no interest in arguing that my personal perspective is the truthful and objective view. My conception of auras derives from the classical idea that objects convey expressive spirits, thus influencing the people who contemplate them. This experiential notion requires neither believers in the supernatural nor skeptics to modify their beliefs.

Working with the visual arts has been my primary stimulus for thinking about the effects of expressions as auras. When in the company of a painting or sculpture, I am always aware of how its total presence acts on me in a way that words can only suggest. The artwork stands as a relatively permanent and autonomous presence, so there is always time to carefully contemplate its impact. I can return to it over and over again and study what it does to me. Expressions in the other arts such as dance and music are more fleeting by comparison, and therefore so are their auras. Yet everything I have observed about auras in the visual arts per-

tains to other modes of expression. The expressions of the relatively stable presence of objects help us understand the auras of gestures, sounds, and other ephemeral media. Although the practical aspects of this chapter deal mostly with painting, the fundamental ideas I present about auras apply to all of the arts.

## THE INFLUENCES OF LANGUAGE

There are certain qualities transmitted by every creative expression that cannot be communicated by descriptive or poetic language. Martin Heidegger twisted words in order to expand habitual conceptions of reality and to demonstrate how language makes an object into a "nonentity." He experimented with poetic language to become more attuned to the expressive frequencies of phenomena. Nouns become verbs, thus inverting assumptions about animate and inanimate life. In Heidegger's word play, "the thing things" and expresses its "essential nature" by "presencing itself" (1975, 174).

The blue blues; the chair chairs; the blue chair blue chairs and chair blues; space spaces. Different things gather into compositions in pictures and collectively act upon us. Everything is active within a world where language opens the power of expression to a total participation. We begin to acknowledge expressions that were not available through conventional speech.

Psychotherapy has remained ever faithful to its origins as a "talking cure." Because creative arts therapy has drawn its very grammar and syntax from the most conservative scientism, the introduction of the arts into psychotherapy has done little to challenge the dominance of abstract theoretical language in the field. The language of behavioral science can convey neither the subtle qualities of creation nor even the most obvious and basic characteristics of an expression, such as the way it moves or vibrates. Thus these aspects of experience are excluded from the standard psychotherapeutic discourse.

Carl Jung described how scientific materialism brought "the death of all things psychic" (1966, 9). In creative arts therapy, the interplay between spiritualized matter and materialized spirit is lost as people converse in a foreign language. How ironic that a therapy of material spirits is promulgated in a language and psychological perspective that does not acknowledge their reality.

In our popular language we talk about "vibes," a term that harks back

to the ancient idea that things throw off their spirits to people. According to Homer and Lucretius, rays fly out from objects to touch other entities in the environment. The ancients were attuned to the subtleties of vibrational communications. During the Italian Renaissance, Marsilio Ficino wrote, "A spirit inside the worldly body, spreads out through all things that are under the *anima mundi*. It especially infuses its power into those which draw its spirit the most" (1980, 89).

In my art studios people talk about and instinctively open themselves to the energies transmitted by pictures. They try, in keeping with Ficino's statement, to become more adept at drawing in the expressive powers of images. Talking is a vital part of our interactions with paintings, but I have seen over the years how spoken language can be restrictive if it is the only way we respond to art. Quiet contemplation is, of course, the natural way to open to the expressions of an artwork, but our work in creative arts therapy is based upon expanding solitary creation into participatory ritual with other people. Bill Wilson, the founder of Alcoholics Anonymous, discovered that he could not keep his sobriety unless he shared it with someone else. Likewise, therapies of the soul are based upon gathering together with forces beyond ourselves. In my experience, expanding the scope of interactions with images furthers the vitality of the engagement. In addition to talking, we respond to images with body movement, sound, performance, and other expressions that feed the spirit and keep it free from confinement to one type of communication.

Even within a single mode of response, such as language, there are a variety of ways to respond to an image—explanation, story, dialogue, poetic play, and so on. Art therapy can be more inventive in its use of language. We can further the artistic medicines and spirits of the studio by encouraging an organic way of speaking about what we perceive through our senses, focusing more on the interaction of figures, forms, colors, movements, textures, spaces, styles, and other qualities. If we keep returning to the images themselves and their objective qualities, using language to help us see them more completely, then we are operating in a way that affirms the healing qualities of expression.

Language can be a flexible ally that assists us in seeing what an image has to offer. There is never a final and fixed label or meaning attached to an image through words. The words and pictures continuously interact like dance partners, generating new ways of appreciating their respective expressions. The therapeutic objective is to further imagination while

opening to the influx of its powers. Attunement to the subtle expressions of things outside ourselves is the way to access their medicines.

Words and pictorial images are distinctly different modes of expression, and one will never contain the other. Despite this fact, creative arts therapy has become too comfortable in reducing art to the concepts of psychological language. I prefer to emphasize the necessary and creative interplay between words and images, with each response to a person's picture or performance contributing to a total expression that is more than the sum of the parts. This *Gesamtkunstwerk* (total expression) transmits auras that act upon the soul.

Wallace Stevens described the interchange between poetry and painting as "migratory passings to and fro, quickenings, Promethean liberations and discoveries" (1951, 169). One expressive mode can never explain or contain another, but they can enjoy an expansive interaction.

I am not calling for the creation of a new therapeutic language, which would be as disagreeable to my ears as behavioral science jargon. If we all began to talk in the same way about how the blue blues, and how the treeing of the forest interacts with the brooking of the waters and the redding sky, a certain way of being poetic would be systematized into codified speech. Speech also generates auras, and I have found that any standardization of language eliminates the power of creative and personal speech to deepen my engagement of an artistic expression.

In responding to creative expressions, I try to use spoken language in a way that augments what I experience through my senses. When a person describes a personal encounter with a work of art, this invariably helps me to experience it in new ways. I move from habitual identifications of figures, forms, and objects to a more pictorial sense of the way they contribute to the overall composition. I become aware of shapes and patterns that I did not see before, and this always brings an infusion of creative vitality.

### SPIRITS IN ART

The teachings of Rudolf Steiner have generated long-standing spiritual approaches to the arts in therapy and education. In 1920, Steiner described how the spiritual world "fires us when we paint." Steiner's emphasis on how people are affected by the spirits of artistic expression is close to many things that I see happening in creative arts therapy. But there are at least two major areas where his methods and those of his

followers distinctly differ from my sense of the medicinal auras generated by the arts.

First, his "spiritual science," known as anthroposophy, explored how spirits, rather than molecular structures, are what really exist "behind the sense world." Like psychoanalysis, anthroposophy focuses on what is behind the physical realm, behind the expression, rather than recognizing that spirits and expressions are conveyed by immediate sensations. When we place ultimate value on what lies behind expressions, we tend to disparage the expressions themselves. We need not choose between molecules and spirits: we can appreciate both.

My second and most significant disagreement with anthroposophy concerns the way it polarizes the realm of auras into good and bad states. Steiner was strongly influenced by Goethe's notion that the soul lives in colors and moves through them, an idea that offers fascinating possibilities for creative arts therapy. In her book on an anthroposophical approach to art therapy, Dr. Margarethe Hauschka describes how Goethe felt that color lives between the heavenly illuminations and earth's dark matter. The anthroposophical method of therapeutic painting opens the soul to ethereal rays that treat its disturbances. This opening to the medicines of expression is progressive, and it challenges the current boundaries of creative arts therapy. But after inspiring us to receive the influx of the "etheric" breath, the anthroposophic method becomes fundamentalist and negative in asserting that its ultimate objective is a "future when the therapies will become more liberated from matter and more spiritual" (Hauschka 1985, 15). The soul is seen as freeing itself from flesh and earth. Disembodied and invisible spirits are valued in opposition to the soul of things and the *anima mundi* (soul of the world), which accounts for the highly intangible qualities associated with anthroposophical practice.

I am sympathetic with many of Steiner's values—the importance of the complete spectrum of artistic activity, the healing power of expressive forms and colors, the essentially spiritual dimensions of healing through the arts, and the need to treat the soul as well as the body. Paradoxically, his principles and methods—and those developed by his followers—prevent the full embodiment of these values, artificially restricting the innate capacities of the creative process by excluding dark and earthen substances. In anthroposophical practice, the therapeutic sphere is limited to a pure and almost antiseptic realm of spirits. Such highly controlled and manipulative methods have no place in depth psychology or

any therapy that opens to the soul's pains, pathologies, and transformative conflicts.

Disturbing images demand our attention and give us the opportunity to break through our controls and repressions. A therapy limited to the positive effects of bright colors denies the soul's often twisted, offensive, and inverted expressions. Creation thrives on the interplay between angels and demons, on the "polymorphous perversity" that Sigmund Freud revealed as one of the psyche's most natural and rudimentary qualities. Exclusive identification with light and goodness keeps us in an artificial realm of spirituality and denies access to the core homeopathic medicines of irritants. In art, we need the nasty spirits as well as the nice ones.

## COLOR

Artists are the best sources for understanding the psychic effects of creative expressions. They typically stay close to the physical qualities of arts rather than using them to advance a theoretical position.

Claude Monet said that he "had a horror of theories," which he felt interfered with his direct relations with nature and his attempts to paint impressions of the "fugitive effects" of color, light, and atmosphere. His fascination with sensations, or "impressions," generated by things corresponds to my sense of an aura as the relatively objective ambience and feeling imparted by an experience.

Wassily Kandinsky's classic text, *Concerning the Spiritual in Art* (originally published 1912), provides a perspective on painting that is sensitive to the material process of artistic creation and to how images influence the people viewing them.

According to Kandinsky, a painting expresses itself through "1. Color. 2. Form" (1970, 46). He goes on to say how form "can stand alone, as a representation of an object" and color cannot because it needs specific boundaries. Artists are always talking about color, atmosphere, and other painterly elements that do not receive adequate attention in the art therapy literature. And although color is vital to my personal art and my practice of art and healing, I too have forgone discussions of color in my publications. The cost of including color plates is prohibitive, and I have felt that to discuss color in the absence of its actual phenomena would not do the topic justice. However, I now feel that the dangers of not discussing color at all far outweigh such concerns.

Almost every instructional text on art therapy and professional journal

article lacks color illustrations. Although this absence can be explained simply in terms of financial constraints, we must be mindful of how the content of published materials affects and even determines our sense of the work we do. Failure to consider important topics like color limits our access to the medicines carried by images. If we felt truly deprived by the exclusion of color, we would demand its presence and call for instructional materials in formats where it can be made available easily.

I believe that our relative inattentiveness to color stems from a largely unconscious preference for form and objectification in our language, theories, culture, myths, and published materials. We are drawn to that which can be contained in regular communications with hard edges and shy away from essential artistic elements that transcend the limits of such communications. We interpret pictures as conveying narratives and concrete messages that fit prevailing modes of communication. When contemplating a painting in a museum, in the artist's studio, or on a wall in a house, we have little difficulty opening to a reverie that embraces all of the painting's expressive qualities. Yet art therapy remains immured within language, concepts, and theories, closing itself to the primary qualities of artistic media.

The failure of art therapy to address something as fundamental as color illustrates how the field bases its methods of practice on psychotherapeutic conventions rather than on the qualities of art. Even as I try to create a more imaginative and artistic psychology of therapeutic practice, I find myself paying far less attention to color than form.

But in my practice, people are acutely sensitive to color both when they make art and during their reflections on the images. We constantly talk about the energies generated by images and how they affect our thoughts, emotions, bodies, and responses. Color and texture are the principal carriers of emotion and feeling in my studios. They act directly on our sensibilities without needing to be translated into words and concepts.

There is a discrepancy between what occurs in my practice and what I have previously reported in my writings. In my art therapy studios, painting is the primary activity; participants feel the strongest emotional connections to this process and the spirits it generates. Painting has flourished as a medicine in my studios, presenting none of the problems I have encountered with regard to the psychological labeling and interpretation of imagery. As a result, I write far less about artmaking than about the process of engaging images once they arrive. My experience

mirrors the pervasive lack of attention to expressive auras in all of the creative arts therapies.

As I look at my experience with color, the absence of any attempt to systematically grasp or describe its healing qualities has not in any way hindered how it acts upon people. The auras of colors are constantly influencing us. I remember my painting teacher Theodoros Stamos saying to me, "When I look out at the world, I see alizarin crimson." Artists like Stamos are more visually attuned to the expressions of the world than most of us. They bring sense perception into a lively interaction with imagination, and thus can help others to perceive things that usually go unnoticed.

If what Stamos sees is in fact present, then nature is constantly displaying fields of alizarin crimson, cadmium green, burnt umber, and other colors. And when we look at the world, these fields of color and gradations in hues are infusing us with their energetic qualities without our even realizing it. But rather than following the lead of artists like Stamos, creative arts therapy maintains its bias toward positivistic science and conceptual language, accepting only what is already established in thought.

Nothing in visual experience is more kinetic than color, which constantly changes in response to the influences of its environment—light, shape, placement, quantity, and so forth. Far more elusive than form, color is less likely to be identified as a concrete thing. In his classic text, *Interaction of Color*, Josef Albers made it clear that when it comes to color we must learn how "to see," because the expressions of color cannot be conveyed through scientific procedure. He wrote, "In visual perception a color is almost never seen as it really is—as it physically is. This fact makes color the most relative medium in art. . . . It is necessary to recognize that color deceives continually. . . . One and the same color evokes innumerable readings" (1971, 1).

Although color tends to be a less bounded quality than form, its specificity, as Albers indicates, emerges from particular interactions and instances. Therefore, the perception of color requires sensitivity to subtle expressions and how something can be doing more than one thing at the same time. Color demands that we deal with the simultaneous interaction of different elements that cannot be grasped in a single and fixed concept. Colors are forever moving and influencing one another, participating in an ecology that cannot be discussed in a way that overlooks the kinetic interplay of the entire perceptual field.

In the Middle Ages, Hildegard of Bingen described spiritual healing as

"greening." Echoing Hildegard's vision, Kandinsky spoke of how the perception of colors stimulates a corresponding "spiritual vibration" in the "sensitive soul" (1970, 44). There are, no doubt, many common and perhaps even biological responses that people have to colors. The vegetal, fertile, and life-giving qualities of green are unquestionable. But like any other living thing, green cannot be reduced to a singular identity. The color is also an indication of ill health and decay—gangrene and turning green with nausea. The color green is ultimately involved with the whole of life and death, not simply a particular phase. Hildegard's "greening" is an evocation of one of green's many aspects. The phenomena of greenness are infinitely variable, and our responses to them can never be reduced to fixed categories of interpretation. What we do is repeatedly open to the particular qualities of the entity before us. Canned meanings will always limit perception of what exists.

I am wary of any attempt to make a systematic science of the healing qualities of color correspondences. My experience indicates that personal responses to colors and their aural expressions are apt to be more individual than universal. Although we can make general distinctions between hot and warm colors as well as airy and earthen hues, clear and constant distinctions tend to end on this level. I have always found black to be mysterious, attractive, and restful, not depressive. Especially appealing to me are deep indigos and umbers, so I would have a difficult time with an anthroposophic therapist restricting me to the beneficial qualities of pastels.

Yet colors are material substances that generate objective qualities of expression. In my practice we strive to be aware of an image's physical features and expressions while exploring the different ways they act upon us.

I do not agree with Eugène Delacroix when he says in his otherwise magnificent journal, "Everyone knows that yellow, orange, and red suggest ideas of 'joy and plenty.'" This attribution is based upon the same assumption of certainty that allows an art diagnostician to say that umber manifests an anal fixation. My experience indicates that the psychic significance of a color varies from person to person and at any moment in an individual's life there are many fluctuations in emotional responses to colors that simply cannot be reduced to stable and predictable effects. Even the physical qualities of colors are highly kinetic and relative, and as Albers suggested, they are constantly deceptive. In keeping with Goethe's sense that there is a spiritual being in every color, we can compare our relationships with them to both interactions with other people and to the quantum view

of relationships between microscopic particles where nothing can be permanently fixed.

## THE INFLUENCE OF CRAFT

Though my practice of art and healing is strongly oriented to the process of making images, I had given it relatively little attention in my writings before the publication of *Trust the Process*. This reflects the more general discourse of the art therapy field, which has not been particularly concerned with sensory qualities of creating. Again we see that the contents of creative arts therapy literature may be significantly removed from the actual forces of the work itself.

Even more than color, craft has been kept outside the art therapy discourse. Such omissions, which also include body movement and the kinetic dimension of painting, create artificial boundaries among art forms. Art therapy overlooks the body and the basis of painting in kinesis because such an orientation challenges the prevailing tendency to solidify experience into predictable concepts. Studying different gestures and how they form images would allow art therapists to encourage a larger range of movements in their clients, thus helping them to express themselves as completely as possible. But this kind of innovation is difficult within a tradition that preoccupies itself with analyzing what a gesture says about a person. When the emphasis is largely on diagnosis, the therapist stands back and tries not to influence what happens. As a result, craft, the therapist's skill with the medium, the aesthetic qualities of expression, and the spiritual impact of the process of creating have been largely overlooked. As our focus expands to encompass the medicine offered by gestures, colors, and forms, craft takes on a new significance, one commensurate with its centrality to art.

Once we recognize that particular kinds of expressions influence people in ways that correspond to their structures, we have to start making aesthetic discriminations about the qualities of pictures and how some will affect us more than others and how the technical crafting of an image influences its impact on the person. When art therapy is exclusively concerned with what the image says about the person who made it, the making of a painting is approached as a test situation, no different than answering a question, doing a series of exercises, or responding to a request for information that will assist diagnosis.

It seems natural that art therapy and the larger domain of art and

healing include two universally recognized features of the artistic experience: the making of art as a therapeutic process and the contemplation of artworks in order to be influenced by their expressive qualities, or auras. Within the artistic environment there are constant assessments of what is being done, what a person emphasizes and overlooks, and what the image needs in order to further its expression. The process of making art is as dependent on the assessment process as the clinical interview is on a person's behavior.

If art is to realize its potential for healing, we need to give much more attention to examining this interplay between the person of the artist and the process of making and perceiving images. As Kandinsky said, "Every object (whether a natural form or man-made) has its own life and therefore its own potency; we are continually being affected by spiritual potency" (1970, 50). He went on to declare that, "If its form is 'poor,' it is too weak to call forth spiritual vibration" (p. 74). Artists like Kandinsky point the way to future research practices in art and healing. One reason why art therapy has been reluctant to explore the relationship between craft and therapeutic value may be the historic ties the discipline has to the psychoanalytic interpretation of dreams. There has been an incorrect assumption that artistic images are made outside consciousness in the same way as dreams. Although intimately related to dreaming, artmaking has many obvious differences, the most basic being how the element of manual craft determines expressive potency.

Art therapy's lack of attention to craft is due in part to a legitimate desire to distinguish itself from elitist traditions and methods of art teaching that value correct standards above individual expressive freedom. Another factor is the reality that many art therapists lack sophisticated technical skills with art media. It is no accident that the egalitarian discipline of art therapy came into existence during the expressionist era of art history, when authentic, idiosyncratic, and indigenous styles of expression were valued and encouraged. However, even in the most primal and raw forms of expressionism, the ability to work effectively with materials and artistic gestures is required.

The better an image is made, the more satisfying it will be. I observe this constantly in my practice with others and in my personal artistic expression. Aesthetic gratification does not mean that the picture generates a good or pleasing feeling. Its potency may also relate to its ability to express disturbing or confused feelings.

The affirmation of craft in art therapy does not require therapists to technically instruct patients like an academic teacher would. The process of creation is inherently educational. Images, colors, forms, materials, and gestures have ways of telling us what they need and where they need to go. Master teachers always affirm how we learn from our personal experimentation with the medium. Monet's advice was to paint often and as well as you can without fear of failure or of the inevitable "bad pictures." In this way, he felt an artist's paintings would perfect themselves.

The nineteenth-century painter William Morris Hunt discussed how the interplay between artists' feelings and their materials of expression makes the difference between an energized picture and a wooden one. In his lectures on painting and drawing, he described how expression gives life and suggests that the painter should *"look through form* for the expression" (1976, 81). Hunt is not denying that structural qualities carry expression. When he says "look through," he is suggesting a deeper, more perceptive gaze into the essence of physical things.

We can learn from dance therapy's emphasis on authentic movement as an indicator of quality, imagination, and depth. And, according to the accumulated wisdom of masters from every artistic tradition, the way to attain this sincerity of expression is through sustained practice. The skilled creative arts therapist helps a person to further expressive qualities by providing the inspirational environment and safety needed to continue working. A legendary high school track coach in my community says that there is an "easy explanation" for the success of his runners year after year: "They've been training. The miracle of training." In my experience, the committed practice of artistic expression will generate the same miracles.

This discussion of craft and quality often turns to people arguing that only those who have the prerequisite artistic skills are qualified to work professionally with other people in the area of art and healing. Based on my experience, I cannot support this exclusionary position. There are always too many exceptions to such rules, and creative expression must have the freedom to transcend limits. But at the same time I agree that artistic skills can immensely heighten a person's ability to help others further their expression. It is also true that people in need of help will generally prefer to work with professionals who have these resources.

The importance of craft in art and healing can be addressed simply by acknowledging its place and how it determines expression. Once its role

has been recognized, craft will find ways to fulfill itself through individual relations with materials and images. The perfecting of artworks is no doubt taking place all of the time in art therapy in a relatively unacknowledged way in accordance with innate aesthetic inclinations that are present in all of us when we set out to express ourselves. Art therapy's gift to art is the celebration of primary and idiosyncratic expression unconstrained by external judgments about what is good and bad. However, in our fervor to protect the personal expression of feelings, we in our field have forgotten that art carries a commitment to craft and a tendency to achieve the most complete expression possible through its images, materials, gestures, and auras.

### THERAPEUTIC APPLICATION

If we acknowledge that expressions generate auras that influence people, the question arises of how—in practical terms—this recognition should inform our practice. Do we follow the medical/diagnostic approach of controlled and strategic interventions, applying a certain type of expression to a particular malady diagnosed by the therapist? It is definitely possible to manipulate the effects of art in this way, as we have seen in the planned use of particular art forms: painting on a small surface when thoughts and emotions are uncontained or, conversely, using a large paper to encourage free gestures; bright colors, dance, music, poems, and stories to alleviate depression; watercolor to stimulate flow as contrasted to a more opaque medium or solid material to facilitate control; work with clay to become more centered or connected to the material world; body therapy to counter intellectualization; large and sweeping motions to further spontaneity; weaving to encourage sustained concentration, relaxation, and discipline; the sculpting of figures to further body awareness; group dance or song to foster relationship to others. Like any other remedy, art can be directed toward desired results.

My experience with art and healing is less prescriptive. I talk to people about their particular needs, options, and interests with regard to expression, media, and subject matter; but my method is one of generating possibilities and then stepping aside. I find that, when given a safe and stimulating environment for expression, the creative process will always minister to itself in a way that is more effective than something I plan. Freedom of movement is necessary because within a relatively short period of time the individual psyche might fluctuate dramatically in its

needs or it might simultaneously call for paradoxical expressions. Creative practice is often perverse, illogical, and totally contrary to what I anticipate. Creating is in this respect close to the inverted ways of dreams. But inversion can never be established as a consistent rule in either art or dreams. When I start to expect the creative path to move paradoxically, it may stun me with the directness of its action.

This orientation to art and healing goes against the dominant clinical preference for calculated interventions. My experience indicates that emotions do not follow the same logic that applies to fixing problems in other areas. I have learned repeatedly that the maxim "trust the process" always offers the best operational advice. The dynamics of creation are often so complex, indirect, contradictory, and subtle that something vital is lost when they are engineered according to a controlled plan.

Healing through art is ultimately about living in tune with the creative spirit. Creative arts therapy is a way of accessing the medicines of artistic expression, which in turn help us become more receptive to the spirits offered every day by the physical world. The salubrious qualities of expression revitalize us when we stay closely attuned to them and open to their influences. Faith in the process must be combined with the advice of master painters to simply keep working. Art is what got art therapy here in the first place, in conjunction with people following an intuition of what the world needed.

The medicines of art are more likely to be accessed through sustained discipline than through one-time technical interventions. At odds with the quick-fix mentality that has driven contemporary health care, the cultivation of expressive medicines more closely resembles the world's spiritual traditions and what artists do in their studios. Until recently, spiritual and artistic approaches could be dismissed as "not clinical," but we now see that the prevailing models of health care are incomplete. Medicine is moving toward a more comprehensive and natural view of treatment. In this new climate, even those who have been most suspicious about the spirits of expression may need to take another look at how art heals.

**REFERENCES**

Albers, J. 1971. *Interaction of color.* New Haven, CT: Yale University Press.
Arnheim, R. 1954. *Art and visual perception: A psychology of the creative eye.*
    Berkeley: University of California Press.

Delacroix, E. 1948. *The journal of Eugene Delacroix (1822–1863)*. Trans. Walter Pach. New York: Crown.

Ficino, M. 1980. *The book of life* (1489). Trans. Charles Boer. Dallas: Spring Publications.

Hauschka, M. 1985. *Fundamentals of artistic therapy: The nature and task of painting therapy*. London: Rudolf Steiner Press.

Heidegger, M. 1975. *Poetry, language, thought*. Trans. Albert Hofstadter. New York: Harper and Row.

Hillman, J. 1975. *Re-visioning psychology*. New York: Harper and Row.

Hunt, W. M. 1976. *On painting and drawing* (1896). New York: Dover.

Jung, C. G. 1966. *The spirit in man, art, and literature*. Trans. R. F. C. Hull. New York: Pantheon.

Kandinsky, W. 1970. *Concerning the spiritual in art* (1912). New York: George Wittenborn. (First published in English as *The Art of Spiritual Harmony*, 1914.)

McNiff, S. 1992. *Art as medicine: Creating a therapy of the imagination*. Boston: Shambhala Publications.

———. 1995. *Earth angels: Engaging the sacred in everyday things*. Boston: Shambhala Publications.

Stevens, W. 1951. *The necessary angel*. New York: Vintage Books.

# 14

## The Effects of Different Kinds of Art Experiences

**LIKE PRODUCES LIKE**

The possibilities for therapeutic treatment in relation to art materials are as broad as the endless array of resources available to the artist. In my work with others as well as my own art, I use a particular selection of media, both new and traditional, that may be broad in comparison to the work of others, but represents only a small fraction of what is available. I am always struck by the very different ways that others work with a particular medium with which I am familiar. These endless variations of style and application are fundamental to the art experience. Artists individuate their work by the way they take the most standard materials and place them into new relationships with one another.

The range of materials for expression that we find in the visual arts is matched by a similar spectrum of sound sources in music, movements in dance, and expressive opportunities in drama, with each imparting its unique qualities to the process of expression. While accepting the endless variations of individual preferences, histories, associations, resistances, and fears in relation to particular forms of artistic expression, we can still research the comparative effects of working with different media and identify general characteristics and outcomes that will help guide future practice.

In this chapter I reflect upon my experience with two types of artmaking activities, creating art objects from preexisting images and expressing ourselves with raw and unformed art materials. These two ways of working with art materials are somewhat arbitrary selections from the larger spectrum of media that exists. My reflections on these art methods offer examples of how specific materials influence emotions in ways that correspond to their expressive qualities and to the nature of the relationships that we have with them. I urge others to expand the exploration of the healing effects of diverse artistic expressions and materials.

Indigenous cultures from throughout the world, as well as homeopathic medicine, have approached healing from the perspective that what we experience in the external world has a corresponding impact on inner feelings and bodily conditions. Variously referred to as the law of similarity, the law of contact or contagion, or the principle of correspondence, this healing doctrine assumes the existence of reciprocal and sympathetic relations between different forms of experience. It is expressed in such ancient maxims as "Like produces like" and "As above, so below; as below, so above." The fact that so many different cultural groups and historical epochs have sustained beliefs in the value of the correspondence principle confers upon it a certain degree of "consensual validation," a term coined by the psychiatrist Harry Stack Sullivan.

The correspondence principle has the potential to revitalize the field of art therapy, offering both a theoretical framework and a practical description of how energies, impulses, and forces are transmitted between people and things and how different kinds of phenomena can physically affect the people exposed to them.

For example, when I listen to a lively and driving drum rhythm, I begin to move my body in direct response to the energy and qualities of what I hear. The same thing happens when I feel tender emotions listening to the soft sounds of a lullaby. Like produces like in all of the arts. The process of healing through art is based on the very practical and real effects of these influences and changed attitudes that are activated by artistic expressions. Some might feel that this line of thinking will lead to generic and oversimplified prescriptions for therapeutic intervention. But there is no conflict between remaining sensitive to the variability of individual engagements with the artistic process and being informed and guided by general assumptions as to the likely outcomes of our work.

The sculptor Henry Moore described how artworks have their own

distinct vitality, energies, and powers of expression that stimulate responses in people. He said that the artwork has "an intense life of its own," distinct from whatever it may represent and that these forces act upon people and generate what Moore called "a stimulation to greater effort in living." The same principle applies to the physical qualities of materials, both formed and unformed, and the process of making art. It is these sympathetic influences that generate the healing powers of art, and it is necessary for the field of art therapy to begin to systematically study the patterns and variations of how particular artistic expressions and materials affect people.

I will offer additional examples of how I have experienced this process in my practice, but what I present can only allude to a deep force that we must engage individually. As Paul Gauguin said, when describing the process of making art, "one must search for suggestion rather than description."

The same principle of suggestion that characterizes the creation of the most evocative forms of art applies to the way art heals and acts upon us. Images, materials, and the process of creation suggest rather than describe what we need to do, what we can feel, and how we can change our lives. The suggestive process gives us ample room to respond and to collaborate with the stimulus in shaping what will emerge from the relationship. It is this interactive process of creation that distinguishes the arts from many other approaches to healing. The vitality of materials, artworks, and art processes exists in a potential state, suggestive of many different healing outcomes that will not be realized unless a person enters into a creative engagement with them.

### WORKING WITH PREEXISTING IMAGES

In a recent group, I asked participants to bring a special personal object to the studio. Before we engaged the artifacts in artistic constructions and performance, we went around the group and gave people the opportunity to tell the story of their relationship with the object. Many of these were deeply moving, involving major losses and intimate personal relationships.

The objects held memories, and they were charged with energy as people spoke about them and the roles they had played in their lives. As in the practices of indigenous peoples, the objects were "alive" with the most intimate connections to the individual person's soul. What I envisioned as an "art" activity quickly became sacred. Our simple focus on the objects

within a group, where considerable trust and safety had been established, created this condition; and the psychological depth and emotion were exclusively based in the relationship that the individual person had with the object.

This example indicates how a particular form of creative activity, engaging personally significant objects, can activate feelings and memories in a way that is less likely to occur when working with a more impersonal medium. For most people, photographs are the preeminent carriers of these personal spirits and emotions (Weiser 1993). In addition to photographs, most of us keep special objects and talismans—stones, pieces of jewelry, and other personal artifacts—that connect us to significant moments, memories, and people. These personal objects have evocative powers that are distinct from those of more impersonal materials.

Most people find it less threatening to work creatively with images that are already present, through such activities as collage and assemblage. When working with preexisting images, the artistic activity involves us in a process of selecting, arranging, and constructing compositions in response to the qualities of the artifacts that we are using.

What is missing in the use of preexisting images is the distinct creative experience that comes when we construct new things from relatively unformed sources of expression and materials. Even with the most artistically inexperienced groups in my studios, I rarely make use of preexisting images, other than in situations like the one just described, where we engage personally significant artifacts. I do from time to time introduce various art activities that lie somewhere between preexisting images and purely new creations. For example, I regularly encourage people in my studios to make objects with materials from nature—sticks, grasses, stones, vines, shells, pinecones, and so forth. In a recent session, a woman described how the use of these materials brings the spirits of nature to the healing process: "The objects already convey expressive qualities through their forms and surfaces as contrasted to the blank canvas or sheet of paper. They bring back memories of time spent in nature and the way I have been influenced by the woods, meadows, streams, and the sea. It is fascinating to take the different features of the nature materials and put them together into a new object."

Repeatedly, I see how a sacred or shamanic dimension is spontaneously evoked when people reflect upon and respond creatively to objects made with materials from nature. It is as though spirits exist within

the wood, grass, stones, and shells. The simple action of holding one of these objects and showing it silently to other members of the group always takes on a certain ritual quality that does not emerge in the same way when we show paintings and sculptures made with traditional art materials. These experiences demonstrate how different media act upon us in ways that correspond to their physical structures.

Fashioning art objects from natural materials can make the creative process accessible to all people, regardless of previous artistic experience and skill. Gathering the materials is often as creatively satisfying as fashioning them into objects. The same applies to working with found objects, discarded materials, and simple building supplies such as wire, tacks, nails, screws, wood scraps, fabrics, and so forth. Whatever the medium, the creative process involves placing things into new relationships with one another.

I have a friend who makes elegant art objects by joining found materials together with simple building materials such as wire, glue, and brass tacks. Working with these cast-aside things, she has established a distinct and recognizable artistic style. The interplay between this consistent style and the variations of the found pieces creates an exciting aesthetic engagement. As I look at her artworks, I imagine the history of the different objects, where they might have been found, the identity of the person throwing them away, and I feel a certain envy for the artist who can go hunting for art and inspiration and find it in the most prosaic, commonplace things. Yet I realize that the artist made a commitment to this process, and established a discipline to fulfill her vision. Likewise, I have dedicated myself to a primary medium—oil paint—and to a particular way of working with that medium. I struggle from time to time with making images from nothing but paint on a blank canvas, and I can imagine how satisfying it must be to be able to find an object that through its very form suggests a new work or series of works.

My friend described how she finds inspiration when working with these objects: "I am a collector by nature and someone who has always seen meaning in the things I find in the world. When I come across something new and exciting, it feels like the world has given me a gift, a small piece of treasure. My art responds to what I find. I never start out with a plan or a theme. I go looking for stuff and bring it back to my studio, where I play around with different ways of arranging things. The materials suggest what I should do with them. They have their own way

of speaking to me about what needs to be done. The process of hunting for things is as important as what I do in my studio. I guess I need this interaction or collaboration with the world. I have to get out of my studio, look for things, and then I respond to them and give them a new place in the world."

Photographers also have the ability to make art by finding images in the world and framing them within their particular creative visions and styles. In their book *Photo Art Therapy: A Jungian Perspective* (1992), my colleagues Jerry Fryrear and Irene Corbit show how instant photos combined with other media through simple artmaking activities can be used to explore archetypal conditions and themes not accessible through words alone. Instant photographs have a unique ability to create immediate images of nature, the self, and others that open us to deep reflections about our lives. Fryrear and Corbit describe how the relatively uncomplicated process of taking instant photographs and attaching them to boxes and other three-dimensional constructions, drawings, and collage images seems to create a spontaneous and relaxed atmosphere that both frees a person's expression and evokes deep emotions.

Overall, we can say that the use of existing images tends to further relaxation, lower inhibition, and increase playfulness, while providing a wealth of evocative imagery. I have found that people welcome the opportunity to gather and arrange significant objects and creations that they make into artistic installations or, as they often call them, shrines. Something magical happens when separate things are placed into relationships with one another, forming larger aesthetic configurations. The drama that unfolds from the interaction of figures can be likened to what occurs in the Jungian sand-tray process. The figures come alive through relationships with their surroundings, and they stimulate our imaginations through their interplay.

The creative process is most actively engaged when a configuration evokes a response yet leaves room for the individual imagination to complete the scene with its own unique expression. Depth requires a certain spaciousness and an absence of directions. Recalling Gauguin, the creative response is based on suggestion rather than description. Perhaps this is why work with simple art forms tends to evoke such penetrating emotions and engagements with archetypal themes. There has to be room for the person to freely interact with the situation and make a personal contribution to the process; and I always find that the quality of a person's concentration

and empathy strongly influences the value of the experience. The task of the leader or therapist is to cultivate this personal focus and engagement from which the healing process flows.

### UNFORMED MATERIALS

Whether making art alone or with others, I prefer to engage the freedom, challenges, and broad opportunities of painting on a blank canvas. The anxiety and fear that empty surfaces arouse, as well as feelings of ineptitude that many beginners feel when exposed to art materials, will almost always be transformed into sources of creative energy if people are supported in their expression and have the ability to stick with the process.

The initial angst that participants in my studios experience is predictably evoked by fear of the unknown and a dread that nothing significant will emerge when we start working with the art materials. I address these potential obstacles to expression by assuring people that whatever they do in an authentic and committed way will have significance to them and to me. Everything depends upon how we look at what we do.

"Feel into the materials," I say, "into their essential nature. Do the same with the empty space of the canvas or paper, or the table on which you mold clay. Rather than looking at the surface in a negative way, approach it as an open realm that invites your expression. Imagine the surface saying, 'I will accept whatever you do, so long as you work with sincerity.'

"Try to relax and move naturally and spontaneously with the art materials. Approach artmaking as movement and let forms emerge that record your gestures. Don't direct movements with your thoughts; let them emerge from the action tendencies you feel within your body. Imagine yourself as Jackson Pollock, and put your whole body and being into the movements that you make with the art materials. View the artmaking activity as an opportunity to express your energy, feelings, and unique ways of moving. Tell yourself that whatever you do is an expression of where you are at that particular moment. Take the harsh critics and judges that you carry within yourself and give them a seat off to the side of the action.

"Analogize the unformed nature of the paint, clay, and empty surface to the open opportunities of life that lie before you. Imagine yourself as the materials and the materials as yourself, each of you carrying essential qualities and potential powers that have yet to be manifested in the world. 'We are one,' you say to the materials, 'you are you, and I am me, but at the

same time we are one, working together here in this place, where you shape me and I shape you, and we create together.'

"View the materials as your partners. Imagine them needing you to help them realize their potential, to get them out of the container and into the world, where they can interact with others and offer something of themselves. Appreciate how creative vitality depends upon an engagement of the materials; otherwise you remain separate and static. 'Take a risk with me,' the materials say. 'You have little to lose since we will accept whatever you do.'

"Are you as malleable as the clay, as open to the slightest movements and pressures? Do you flow like the paint? Do you have the range of bright and earthen colors within yourself that you see on the palette?"

This process of making analogies and connections among the qualities of the materials offers a wealth of opportunities for creative expression and healing. These open-ended explorations with art media reveal where you are blocked or need help in your life. Maybe you are a person who has to plan everything in advance, and the art materials resist these patterns and suggest that you can let go of the need to know where you are going. "Just move with me," the paint suggests, "and trust that something significant will appear and that it will be more useful to you than anything that you could have planned in advance. You need support in opening to what each day can offer and I am here to help."

There are many times when we feel exasperated because we don't have a clue about what to do with art materials and an empty space. "Start where you are," the art process suggests. "Begin by simply breathing and making movements with the materials in response to your breath. Stop after a while, and look at what you have done as a portrait of your natural way of moving, of your breath, as an expression of where you are right now; significant artistic activity does not have to be any more than this. Lower your expectations and raise your aesthetic perceptions. Everything depends upon how you look at what you do. Believe me, it's that easy, as simple as paying attention to your breath. Yet we find it so challenging to act in this mindful way. Ask yourself why this is difficult for you. What can these experiences with art materials tell you about how you live your life?"

All of these interactions with art materials and the creative process are grounded in the principle of correspondence and the way we are shaped by our expressions as well as them being formed by us. This dimension of reciprocity generates healing and understanding of how we relate to

the world. Can you imagine yourself being as open to new influences as the clay, the paint, and the open surface are to whatever we choose to do with them? Can you become more like them? Can you let the materials and the things that they do give a new form to your life?

**REFERENCE**

Fryrear, J., and I. Corbit. 1992. *Photo art therapy: A Jungian perspective.* Springfield, IL: Charles C. Thomas.

Weiser, J. 1993. *Phototherapy techniques.* San Francisco: Jossey-Bass.

# Total Expression

From the start of my studio practice I have consistently worked with all of the arts. My workshop participants and I personally have benefited from the creative energy and challenges offered by the varied forms of expression. This infusion of creativity from new and different sources sustains my learning. Yet within the institutional worlds of the arts, creative arts therapy, and education at all levels, the arts remain thoroughly separated from one another.

The integrated art experience, what Richard Wagner termed *Gesamtkunstwerk* (total expression), is as accessible as the air we breathe, but there are so many obstacles within society and ourselves that limit the free and full range of expression. These restrictions in turn limit the flow of creative energy within the process of healing. My vision has always been one of striving to help the art and healing experience correspond to the movement of creative energy in the world. Of course, creative writing, dance, drama, music, performance, and the visual arts have their distinct qualities, just as different media within these disciplines are distinguished from one another. Yet there has been little emphasis placed on the community of creative expression,

on the common elements and purposes shared by all of the arts. We will travel so much further in a slipstream of the arts than by going it alone as separate domains.

In every aspect of our lives there is so much more attention given to creating separations than connections, and creativity suffers because it depends upon a free circulation of energy and the making of new relationships. Maximum health and creativity occur within environments where the expressions of the body, the senses, and the physical space flow naturally in a vital ecology.

My experience consistently reveals that systems of creative energy are self-regulating if we can only trust the process. The creative ecology needs our active participation and commitment, but with a certain degree of relaxation when it comes to giving directions and approaching new experiences. When we are able to soften our grip on the controls, the essential movement finds its way to natural and unexpected outcomes.

Conflicts between freedom and regulation exist in every human system, creating a necessary and dynamic tension. However, in organizations and individuals, this tension is often skewed heavily toward the regulatory, anti-creative forces of control and separation. Thus we need to do more to encourage freedom and allow interplay among different forms of expression. We can embrace the total range of human expression while still striving toward the best possible communication within a particular medium. I believe that openness to a larger interplay of expressive faculties will augment the powers of specific forms of expression. Expression within the arts can be likened to what happens in creative groups and teams, where the individual feeds off the energy of others and does things that could never be done while working alone. Attention given to specialized functions can be complemented with an embrace of the total range of human expression.

I have no doubt that the integrated use of all of the arts in healing will someday be common practice. In Europe there is a greater commitment to total expression than in the United States, where creative arts therapy specializations are separated by relatively impermeable boundaries. My first book, *The Arts and Psychotherapy* (1981), offered a vision of all of the arts working together, and this approach has been established as one of the ways of approaching art and healing. I presented the "enduring shaman" as the precursor of today's creative arts therapist and described how this figure always engages the full spectrum of expression. Connections to shamanism were well received, and the idea encouraged people

to think more deeply about the healing function of art and the work we do from the perspectives of history, culture, and universal continuities of practice.

In "Pandora's Gifts: Using All of the Arts in Healing" (2001) I give an overview of how I integrate all of the arts in my studios. "A Pantheon of Expressive Arts Therapies" (1987) and "Working with Everything We Have" (1982) present the challenges we face in advancing the integration of different forms of artistic expression in professional practice. These three essays address questions that have defined my career: What is art? What are its limits? Who is qualified to use it in therapy? Is it better to unite the arts around common purposes or continue to separate them? Jung anticipated the creative arts therapies and contemporary practices of art and healing in his practice of active imagination in the early twentieth century. His method of responding to images through "circumambulation" is entirely congruent with my practice of total expression. As we establish different vantage points on an experience and explore diverse ways of expressing its significance, a deeper understanding grows from the enlarged discourse. My review of Joan Chodorow's collection of Jung's writings on active imagination (1998) offers a brief summary of how his work informs everything that we do today in the creative arts therapies.

# 15

*Pandora's Gifts*

## USING ALL OF THE ARTS IN HEALING

### THE INTEGRATING REALM OF IMAGINATION

The idea of using all of the arts in therapy, a source of excitement to many people, provokes fears in others. These differing responses mirror the way the reputation of the mythical Pandora, the "all-giver," changed from being the source of bounteous gifts to the cause of pandemonium (Walker 1983; Gaskell 1960). Pandora's "many things" came to be perceived as "too much." The word *pandemonium*, meaning the universal release of daimons/spirits, became associated with a state of being overwhelmed.

The linear mind does not respond favorably to the stream of images and sensations flowing from Pandora's original "vase," which later became a "box." Within general culture the Pandora image often represents what "we do not want to do": don't open the lid and let everything out; keep it all under control or it will overwhelm you. Those of us who are stimulated by a creative interplay of diverse participants are more apt to welcome the endless possibilities suggested by the original image of Pandora. Paolo Knill, who has created a method called "intermodal expressive therapy," refers to the use of all of the arts in therapy as a "discipline" that can be compared to a more singular focus on painting, piano, poetry, or theater. He emphasizes how we need to pay more attention to "the basic human need or drive to crystallize psychic material; that is, to move toward

optimal clarity and precision of feeling and thought" (Knill et al. 1995, 30). In *Foundations of Expressive Arts Therapy*, Stephen Levine and Ellen Levine observe that even though the "multidimensional approach" to all of the arts has been "accused of eclecticism in the sense of an incoherent collection of approaches" (1999, 11), the process of creative imagination unifies the multiplicity of experiences that often cause our emotional fragmentation.

In addition to fears of Pandora's chaos, there are also valid worries that an approach integrating all of the arts in therapy will dilute the qualities of the different media, and that those who work in this way will be dilettantes and "jacks of all trades and masters of none." But are we not striving in both creation and therapy to integrate the varied elements of our lives? Are we better served by keeping Pandora's contents securely locked inside a box or by learning how to move with them in creative and ever-changing ways? Is the quality of one medium compromised by association with another? Is the most effective exercise of the creative intelligence possible without accessing the many resources of our environments?

One way of responding to the charges of dilettantism and watered-down eclecticism is to train therapists in the process of integrating the arts. In 1974, I founded the first graduate program dedicated to achieving this outcome. Paolo Knill's intermodal expressive therapy and other ways of integrating the arts grew from our community. We studied traditions of the modernized West and indigenous cultures of the world that use different expressive media to further healing (McNiff 1979). However, the potential of integrated arts training will be limited if the only goal is the creation of yet another mental health specialization and "brand name." The more interesting task is the exploration of how all therapists and artists can open their work to a more complete process of expression.

If we think in terms of more universal access to all of the arts in therapy, then we are subject to the valid criticism that untrained therapists are using the media of other professional groups. However, there are many certified art therapists who do not have highly developed skills with the artistic media that they use with clients. Are these professionals subject to the same criticisms?

In this chapter I hope to demonstrate how policing the boundaries of artistic disciplines overlooks how every medium of expression requires multisensory activity. In *The Arts and Psychotherapy* (1981) I also suggested that the natural "integration of the senses in artistic expression" restores a

"forgotten balance" that is a basis of healing (p. ix). So rather than getting caught in arguments about dilettantism, eclecticism, and professional association guidelines for a discipline, I will try to show how the practice of any creative arts therapy discipline requires a more comprehensive understanding of expression through all of the senses.

Can we learn to approach multiplicity as an opportunity rather than as a threat? In environments that support the expressions of creative imagination with both children and adults, there is typically an integration of varied media. We find repeatedly that the ecology of different sensory expressions not only increases the creative vitality of the whole environment but also furthers imaginative expression within a particular medium. I have always chosen to use different arts in my studio practice because the breadth of resources and materials enriches the creative process and furthers the satisfaction of participants.

In my studios I strive to create an environment of imagination that acts upon us through its transformative forces. I find that within a free and safe space the creative medicines of the artistic process find their way to conditions in need of healing. To create this space, I drum and play other percussion instruments as participants paint or work with visual art media. The drumming helps people move more spontaneously, facilitating a high level of emotional release and relaxation. Participants report that the drum enables them to work in a more visceral way. It stimulates a flow of imagery that helps them connect to the forces of creation.

For example, I have discovered that drumming helps people to make bolder and more expressive gestures. In situations where we might encourage spontaneous expression on large surfaces with wide brushes or oil sticks, the drum furthers the use of the whole body. Percussive music has a similar effect on artistic expression on small surfaces and with precise tools. In big and small paintings, rhythm supports movement.

The drum can help sustain expression within the painting, just as the rhythmic element provides continuity for a musical composition. Rhythm enables us to appreciate how the painting process, like music and dance, involves a sequence of expressive gestures that occur within the context of space, time, and kinesis.

Beginning painters use the drum as a source of energy and as a guide. The pulse of the drum activates and supports natural bodily movements and the mind responds. We tend to get stuck in our expression when this situation is reversed. Experienced painters find that the drum and the

expressive energy of the studio help them to let go of restraining habits and stale patterns. The drum takes us out of our heads; or perhaps more accurately, it supports the mind in working collaboratively with other sources of expression.

Paintings can be viewed from the perspective of rhythm. Visual patterns, repetitions, ascending and descending lines, and other features might be identified and connected to elements experienced in the music. When multiple art forms are used, we are more apt to experience ourselves making free gestures within a supportive environment of expression. I believe this use of different artistic media creates an environmental energy, or imaginative realm, that truly acts upon the individual. This differs from the common problem of a person feeling pressure and inhibition resulting from the belief that expression comes completely from within themselves. When we feel empty and blocked, the environment can be a source of stimulation.

My experience with all of the arts began in response to the way in which patients in the psychiatric hospital where I was working spontaneously expressed themselves with poetry, drama, voice, and movement. Was I to say that these communications were off limits? Was I to close Pandora's box? Or was I to allow the different expressions to emerge, trusting that they would find their way to creative integration? Did I have to be an expert in these different media in order to welcome the many things that were expressed naturally in the studio environment? Could I open the art therapy studio and myself to natural expression with a person's media preferences? The different art forms introduced a broader spectrum of expression and they were clearly manifesting needs for communication that could not be met exclusively by the visual arts.

Stories, poems, creative writings, and imaginal dialogue have always played an important role in my practice as ways of engaging visual art imagery. But from the very beginning of my work with art and healing, I discovered how limiting verbal explanations could be. I explored ways of responding to art with more art; and in keeping with Jung's practice of active imagination, I found that we can amplify and focus our engagement of an image by imagining it further. Explanation certainly has its place in art therapy, but I have also experienced how it can arrest the ongoing flow of the creative process. The exclusive use of verbal language as a mode of relating to images tends to keep us within the realm of what I call "explanationism." Even my experimentation with imaginal dialogue

is restricted by the linear structure of narrative. The use of different art forms offers more opportunities for creative responses.

In recent years, my studio workshops have explored how movement, vocal expression, and performance can allow us to more completely access the creative energies manifested by images. Where other colleagues who engage all of the arts in therapy give relatively equal focus to each medium (Knill et al. 1995; Levine 1992; Levine and Levine 1999) I have always used the visual arts as the basis of my practice, "the trunk of my tree." I introduce the other arts to more completely perceive and express the energetic qualities of images.

Sound and bodily movement help us to resonate more closely with the vibrational qualities of images, to approach them as energetic fields of interacting colors, movements, and forms. There is as much physics to a painting as there is psychology, and the energetic medicines have healing powers that are not necessarily accessed through verbal explanation. Pandora's many things are released in this studio atmosphere; and in keeping with the dynamics of the creative process, they are allowed to find their way to areas of need. The healing dynamics of creativity operate in a nonlinear ecosystem that integrates a mix of varied participants into outcomes that cannot always be planned in advance.

My role is to keep the space safe and creative. Rather than relying exclusively on treatment plans for individuals, I try to use all of the arts to provide a creative atmosphere, which is itself the agent of therapeutic transformation. These "process medicines" complement and certainly do not replace the more conventional treatment plan. Within the overall environment of the studio, I adjust and plan according to the unique needs of individuals.

Beginning with my first art therapy experiences, I have focused on the healing effects of groups of people working together in studios (1973). Maxwell Jones's practice of the therapeutic community (1953, 1982) and Rudolf Arnheim's interpretation of Gestalt psychology (1954, 1972) suggested that there is an ecology of therapeutic forces generated by the total environment. Where others might direct their primary attention toward specific techniques for integrating the arts, I am more interested in the larger "ecology of imagination" (Cobb 1977) and the therapeutic community of creative expression that acts upon us.

Even if an art therapist chooses to work only with visual art media, there is a need for deeper appreciation of the interplay among different sensory

modalities within the creative process. All the creative arts inform and enhance one another. The following section demonstrates this, revealing how an understanding of the kinetic basis of painting furthers expression within visual art therapy. Even the most specialized practice in a particular medium is advanced through an understanding of how all of the faculties work together within the process of creative expression.

### THE PRIMACY OF MOVEMENT

In my studio workshops, I introduce painting and drawing activities by encouraging people to move with freedom and relaxation, to move without thinking about what they are going to do next. I urge them, especially at first, to let go of concern about results. As they become immersed in the painting activity, they find that the movement starts to direct itself.

Painting and drawing are demystified when we approach them as movement. When we paint, we are dancing. When we dance, we sculpt forms and create fleeting images.

I try to keep people focused on elemental gestures. Repetition and simplicity are encouraged, with the realization that compositions will emerge from basic motions if we can stay with them and let go of the need to plan everything in advance. We avoid inhibiting ideas about what a painting or poem "should be" by approaching it as movement. And as we improve the quality of movements, our pictures become more expressive.

We have all heard the child or adult patient say, "I can't think of anything to draw." The same poverty of ideas tends to apply to the other arts when they are approached through mental or even visual planning. Movement offers a guaranteed starting point. Rather than focusing on the quality of the visual image, I recommend concentrating on the character of the movement and the creative energy it generates.

When the person says, "I can't think of anything to make," I reply, "That's fine. You don't have to think of things in advance. Just move with the materials. Close your eyes if it helps and feel the movement and the way the art materials make contact with the surface. Imagine the painting as a dance. Focus on the quality of the movement. Don't be concerned right now with the visual features of the picture."

Kinesis and touch cannot be separated from the process of creating a picture. Circulation among varied sensory expressions is fundamental to creation in any medium.

As I drum and use other percussive instruments to create rhythms, people begin to let go and move more spontaneously with their paintings. In some cases the paint is applied percussively and rhythmically through striking motions, slaps, taps, rubs, and other gestures evoked by the music. Painting, music, movement, and tactile sensibilities are naturally integrated in the making of a picture.

The music and sound do not control what the artist does, but simply energize the painting process. People tend to paint in accordance with their natural styles, and the music serves to relax inhibitions and stimulate expression.

By approaching painting as a multisensory activity, we benefit from a more complete circulation of expressive energy. It is helpful to view every gesture as part of an ongoing flow of movement. New strokes simply emerge from the ones that went before them and then become sources of yet another cycle of expressive gestures.

People move from within themselves, from the particular place where they are at the moment. Many find it difficult to act creatively because they try to do too much and essentially attempt to be in a place other than where they are at the moment. They lose balance and the ability to move with the more general forces of the environment that will ultimately support expression. They expect something other than what they are doing at that particular time, or they think that what they are doing is inadequate. They become blocked by and caught up in negative and confusing thoughts.

Any person can make fascinating movements on the surface of a painting when they work with total concentration and abandon. If people need guidance after making their first gestures, I encourage them to simply build upon what they are already doing. When we begin to move in a more relaxed way, the movements not only emerge from one another but they seem to perfect themselves. The improved quality comes from within the movement itself.

Simple experiences with movement help us see how we frequently overdo things in other parts of our lives. I might say to a person in need of direction, "Try to keep moving, don't stop, and trust that a new movement will always come out of the one that went before it. Put everything you have into the movement. Even if you make a slow and delicate gesture with your arm, fill it with all your energy and with total concentration. Identify completely with it. Be aware of your breath, and view stillness as a pause

between movements. Let another gesture come forward and yet another one from it. If you can keep moving in a relaxed way without thinking about what you are going to do next, you will discover that the movement will start to direct itself."

Painting may paradoxically have more to do with the quality of movement than with visualization. Thus, improving our movements enhances the expressiveness of our paintings. If we are able to let go of the need to mentally direct expression according to a predetermined image, we will discover that the movement "happens" to us. When we reach the state of being moved by a force that is more than our conscious mind acting alone, we have entered the realm of imagination. Yet it is our body that is moving, propelled by forces within ourselves and outside of ourselves.

Those who have encountered the powers and gifts of the creative imagination know firsthand that it is usually the overly controlling mind, excessive effort, and narrow expectations that restrict access to the process of imagining, which requires a paradoxical discipline of letting go while staying focused and allowing the creation to emerge.

Nothing will happen, however, unless there is sustained movement from one thing to another. The direction is not always clear and the outcome rarely known at the start of an imaginative act. What matters most is the commitment to beginning and the acceptance of what emerges.

By focusing on the movement basis of painting, the mind follows the lead of elemental gestures. Children's play can teach us so much about the creative process. As Hans-Georg Gadamer insists, the fulfillment of play requires the player to become lost in play (1994, 102). The fear of losing control is a primary reason why many people are reluctant to open themselves to multiple forms of expression.

Rather than letting ourselves go within the creative process like a child at play, we guard ourselves against "pandemonium." These defenses are constructed on the basis of real life experiences of being overwhelmed and confused. Opening to the gifts of Pandora is not without challenges.

**RESPONDING TO IMAGES WITH MOVEMENT, SOUND, AND PERFORMANCE**

Talking about paintings will always be an essential feature of art and healing. But I have found that it can sometimes be more helpful to respond to a painting of swirling lines with movements that mirror, amplify, diminish, or redirect the expression of the visual-art work. Vocal improvisations contribute yet another dimension to our experience of a

painting. These multimedia engagements expand the sensory interplay. We can respond to any visual configuration, scene, or combination of colors through sound and movement. The simplest and most elemental figurative and non-figurative compositions often elicit the most direct and spontaneous artistic responses in other media.

I invite people in my studios to select a painting or sculpture and then engage it through movement, sound, and performance. People inexperienced with artistic improvisation sometimes find it "weird" to respond to pictures with sounds and movements; but once they let go and immerse themselves in the process, they experience new dimensions of their expression. They communicate in ways that they did not know before, and they find that these new expressions give satisfaction and arouse emotions in themselves and others.

Generally the group sits or stands in a circle around the person who is working, offering support and energy by their attention as well as providing safety through the creation of a designated performance space. When we work with partners, one person engages the image and the other acts as a witness who gives support and concentration. Artists say, "I could never have done what I just did without the other person's focus and energy." Groups give another kind of power to the person working with an image, not necessarily greater, but distinctly different and complementary. The ritual dimension that simply happens as a result of our concentration on what we do and our support for one another furthers the depth of the work with partners and in groups.

"Place the image on the floor," I say to the artist, "and let the people in the group take a minute to look at it carefully and reflect upon its qualities."

After the group members look and return to forming a circle around the images, I invite the artist to enter the space with the image. "Before responding to the image, take a moment to contemplate it. Just be with it within the circle," I say, "without being concerned about what you are going to do next. The only mistake you can make is to begin planning your response. Do your best to be fully present with the image and trust that expression will emerge naturally from this state of concentration."

People need support in letting go of the need to know what they are going to do before they do it. When they become present with the image and totally focused, expressions emerge naturally and elegantly. The major obstacle to this emanation of expression is the interference of the

overly critical or calculating mind. The same thing applies to the healing process. We want to let go of controls so that other forces can enter and take us in new directions. These exercises as well as the more general process of creation offer opportunities for the activation of healing energies that infuse the complete body, mind, and spirit.

"As you let go and enter the realm of your image," I continue, "begin to move in response to it while keeping eye contact with the artwork. Interpret the image with your body. Try to keep your movements simple and let them develop a rhythmic pattern. Don't try and do too many things. If you can immerse yourself in a simple gesture, it will take you deeper into the heart of your natural way of moving.

"It is important to maintain visual contact with images when we are responding to them. It is like creating with a partner. When we lose this contact, our expressions have little relationship to the image.

"If closing your eyes for a few minutes helps you move more freely," I say, "that's fine but try to keep the image in your mind's eye and let it inform your expression."

I encourage people to move spontaneously with their images in this way for two or three minutes. With very large groups I invite people to move for briefer periods of time, which can actually be quite liberating since the person becomes immersed in the overall energy of the group. The individual expressions become part of the larger group improvisation, like a circle dance where we move in and out of the center.

I also encourage the use of sounds together with body movements when responding creatively to images. People can be very inhibited when it comes to vocal improvisation. To help offset this, I take time to practice in advance with the group, encouraging members to make sounds together and individually.

I say to a person who is having trouble making sounds, "Give us a sound that you made as a child at play." Almost everybody has these sounds in memory.

I then encourage the person to repeat the sound pattern again and again, to stay with it, and let it develop a rhythm. Fascinating vocal improvisations emerge when people sustain the expression. I invite the group to join in, amplify the sounds, and then diminish their expression so that we can return to the individual artist, who is typically affirmed and inspired by the group involvement and energy.

This type of warm-up helps prepare people to perform with greater freedom. I emphasize over and over again that they cannot fail, that they can simply enter the circle and stand or sit together with their image if they choose, that the most effective expressions are the simplest, that planning stops the process, and that if they can be present with their image without expectation, something significant will always happen.

People find it very helpful when I ask them to select another person in the group to respond to their movement and sound improvisations with another brief expressive performance. The movements and sounds of the other person augment the creative process, take it in new directions, help us appreciate it more completely, and affirm what the other person just did when working with the image. For example, if the artist had just made an explosive and cathartic series of movements and sounds in responding to an image, the person chosen to respond to this enactment might move in more soothing and gentle ways, bringing an overall sense of completion to the process of improvisation.

Over and over again I see that these open-ended expressive activities, making use of all kinds of media and gestures, are characterized by a sense of precision and concentration. The many things of Pandora are fused and flow naturally into the currents of the present moment. We create a space where we are healed and energized by tapping into the deep streams of the creative process, which are fed by the entire spectrum of expressive faculties.

The feedback I've received from participants in my workshops strongly affirms the power of this work with all of the arts. Comments I often hear include: "It was an intensely sacred experience. I've never experienced anything like it before. I felt completely safe and supported by everyone. The expression flowed without me thinking about what I was going to do next. The group gave me energy to do things that I would not have dreamed I could do."

These outcomes result from relaxing the mind and letting it be just one of many participants in a process of total expression. As the body leads the dance, the mind takes on the new role of following and going to unfamiliar places. We discover that the relaxed body and its senses are always resourceful in dealing with challenging and stimulating situations. Unthreatened by Pandora's plethora, they use it as a source of energy and direction, showing us the way to new creation and healing.

**REFERENCES**

Arnheim, R. 1954. *Art and visual perception: A psychology of the creative eye.* Berkeley: University of California Press.

———. 1972. *Toward a psychology of art: Collected essays.* Berkeley: University of California Press.

Cobb, E. 1977. *The ecology of imagination in childhood.* New York: Columbia University Press.

Gadamer, H. G. 1994. *Truth and method.* New York: Continuum.

Gaskell, G. A. 1960. *Dictionary of all scriptures and myths.* New York: Julian Press.

Jones, M. 1982. *The process of change.* Boston: Routledge & Kegan Paul.

———. 1953. *The therapeutic community: A new treatment method in psychiatry.* New York: Basic Books.

Knill, P., H. Barba, and M. Fuchs. 1995. *Minstrels of soul.* Toronto: Palmerston Press.

Levine, S. 1992. *Poesis: The language of psychology and the speech of the soul.* Toronto: Palmerston Press.

Levine, S., and E. Levine. 1999. *Foundations of expressive arts therapy: Theoretical and clinical perspectives.* London: Jessica Kingsley Publisher.

McNiff, S. 1973. A new perspective in group art therapy. *Art Psychotherapy* 1 (3–4).

———. 1979. From shamanism to art therapy. *Art Psychotherapy* 6 (3).

———. 1981. *The arts and psychotherapy.* Springfield, IL: Charles C. Thomas.

Walker, B. 1983. *The woman's encyclopedia of myths and secrets.* San Francisco: Harper and Row.

## 16

*A Pantheon of Creative Arts Therapies*

**AFFIRMING THE DIVERSITY**

The image of the pantheon (a temple that houses all of the gods) can be useful to the creative arts therapies. For me it symbolizes an inclusive community in which the diverse modes of creative arts therapy—art therapy, dance therapy, drama therapy, music therapy, poetry therapy, and so on—can cultivate their distinct identities while weaving together into a richer and stronger whole. Viewed as a pantheon, our field can encourage endless variations within and combinations among the diverse creative arts therapy media. This image accords with the view people outside the creative arts therapies have of the field as a discipline with common qualities that distinguish it from other mental health professions.

Several books have addressed the creative arts therapies as a single profession (Anderson 1977; Knill 1979; Fleshman and Fryrear 1981; McNiff 1981, 1986; Feder and Feder 1981; Robbins 1980). Fleshman and Fryrear describe how principles of aesthetics apply to all of the arts, and they support the historic interdependence of all art forms. Without questioning the uniqueness of individual art forms, Fleshman and Fryrear observe a drive within the arts to "recombine." However, they report that in researching their 1981 book they encountered resistance within the creative arts therapies to the idea of professional consolidation. The same

tendency toward collaboration and integration has historically manifested itself within progressive artistic practices, and it is inevitably countered by the more conservative push for separation.

Professions such as medicine and law have historically flourished when they embraced breadth and the inclusion of different perspectives, whereas narrow specialization tends to restrict longevity. The creative arts therapies have come into existence because of their willingness to respond to creative and expressive manifestations in therapy that are not being answered by other professions. We overlap with many of the primary psychotherapeutic functions of other mental health professions but contribute something unique, something that has not been adequately addressed by our colleagues in other disciplines. However, the different creative arts therapies were established during the 1950s, 1960s, and 1970s, when psychotherapeutic disciplines and schools of thought were sharply separated from one another. Whereas older disciplines like psychiatry and psychology existed prior to increased specialization and were thus able to accommodate some measure of diversity within themselves, the creative arts therapies began within a specialization era and internalized the environment's fragmentation.

In Holland the national government supports creative arts therapy training in schools dedicated to the use of all of the arts and calls the profession *kreatieve therapie*. When the social systems that educate and employ arts therapists encourage this type of integration, collaboration among the creative modalities happens naturally. This contrasts with the situation in the United States, where the separate departmental structures of dance, drama, music, and the visual arts in higher education have had a profound impact on professional policy. Public education represents an even older precedent for separation of the arts, with art education and music education organized as distinct professions and other art forms rarely if ever included in school curricula.

Establishing a professional community of creative arts therapists will serve not only the long-term interests of the profession but also the immediate practice of therapy. However, the educational structure of our society creates major obstacles to putting this model into practice. Advances in interdisciplinary creative arts therapy training have been made primarily within colleges and universities that do not have established fine arts departments. Interdisciplinary approaches to the creative arts therapies have been effective and popular, but our fine arts institutions and higher

education departments are better equipped at the present time to support single modality training (McNiff 1986). Serious collaboration across artistic disciplines simply does not exist within these places, and the educational systems that shape the identities of artists, arts educators, and creative arts therapists ultimately present the greatest impediment to closer cooperation among the arts in therapy and healing.

## THE NATURE OF THE ARTISTIC INSTRUMENTALITY

The creative arts therapies have yet to engage themselves in a serious and open discussion about what we mean by "art."

What are the materials of art, and its limits? Is the practice of art available to every person? These are not esoteric philosophical inquiries, but rather the most pragmatic and material issues related to the practice of art and healing. In the tradition of Nietzsche, the Japanese novelist Yukio Mishima believed that art's relevance depends on transformative action in the world: "Art kept snugly within the bounds of art alone shrivels and dies. . . . If art is not constantly threatened, stimulated by things outside its domain, it exhausts itself" (1977, 19).

When we begin with "questions" as to the nature of art rather than "answers," then it is natural to expand the forms of communication to whatever chooses to present itself. The creative arts therapies have generally been shaped in accordance with the most conservative ideas as to the nature of the artistic process. Too little attention has been given to Otto Rank's insistence that the therapist is an artist who works with the soul and the material of life.

Art is defined by the value we place upon an experience. I saw John Cage in a performance where he taped a microphone to a pencil and presented his scribbling as music. My colleague Christopher Cook ran the Institute of Contemporary Art in Boston for one year as a work of art. Like other conceptual artists in the early 1970s, he was attempting to demonstrate that boundaries need not exist between art and life. Cook approached everything he did during his year as ICA director as part of an artwork. At the end of the year his work culminated in an exhibition where his office was re-created; videotaped and photographic documentation of his activities over the past year were displayed, along with various papers, notes, and artifacts. People attending the show participated in the yearlong artistic project and were invited to continue the process of integrating art and life in their own experience.

The determination of what is art, and what is not art, rests in one's freedom of perception. Might it be worthwhile for the creative arts therapies to reflect the breadth of artistic possibilities and the full scope of the artistic discourse that is taking place within the world today? But as soon as we expand our definition of art to include the entirety of life, we create challenging questions as to who is qualified to use the arts in therapy.

If images and other sources of artistic subject matter are constantly manifesting themselves on their own terms, and in response to the needs of human beings in therapy, should only credentialed creative arts therapists be allowed to work with these phenomena? Or should the arts be viewed as modalities of expression within more generic counseling and health professions?

It is an accepted fact that many competent, and sometimes prominent, creative arts therapists do not have highly developed skills in artistic expression. It is also true that there are gifted artists who have not fared well as art therapists. If therapists have excellent psychotherapeutic skills together with a sophisticated understanding of fine arts media and the creative process, then of course this combination will enhance clinical practice.

Formal artistic skills intensify the expressiveness of specific media. It is critically important to emphasize that this principle also applies to the arts in healing. The highly skilled visual artist or musician will undoubtedly have a far broader range of clinical expertise with these media than the therapist who is not proficient with them.

We can conclude that the ideal profile of the creative arts therapist involves both clinical and artistic sophistication and that the gifted artist without interpersonal skills is inappropriate for work in therapy and healing. It is also clear that there are many qualified clinicians working with the arts who lack advanced skills in the arts but nevertheless work effectively with these media, to the extent that their abilities allow. Whether skilled therapists who lack creative art therapy credentials can do effective work with art and healing is an issue that remains unexplored.

The early period of our field's growth has concentrated on what is unique to us—our varied arts resources and expressive modalities. We have successfully demonstrated how the arts expand and deepen the psychotherapeutic process using images, body movement, rhythm, melody, metaphors, stories, and dramatic enactments. As with any new group establishing an identity within an older culture, we first had to articulate, consolidate, and affirm what is different about our profession and how

these attributes are necessary to the mental health field. Our professional organizations have been established on the basis of these differences.

It is now time to give more attention to the features shared by the creative arts therapies. I have tried to show how the various ways of using the arts in healing are far more similar than different and that mature and influential professions are inclusive of diversity. This comprehensive gathering and sharing of resources has yet to occur within the creative arts therapies. The arts need one another and the psyche needs to have access to all of our natural expressions. Within human experience these varied expressive resources live together, interdependently, without losing their particular characters. Specificity is furthered through cooperation. The same applies to the creative arts therapies.

**REFERENCES**

Anderson, W., ed. 1977. *Therapy and the arts: Tools of consciousness.* New York: Harper and Row.

Feder, E., and B. Feder. 1981. *The expressive arts therapies.* Englewood Cliffs, NJ: Prentice Hall.

Fleshman, B., and J. Fryrear. 1981. *The arts in therapy.* Chicago: Nelson Hall.

Knill, P. 1979. *Ausdruckstherapie* [Expressive therapy]. Suderburg, West Germany: Ohlsen Verlag.

McNiff, S. 1981. *The arts and psychotherapy.* Springfield, IL: Charles C. Thomas.

———. 1986. *Educating the creative arts therapist: A profile of the profession.* Springfield, IL: Charles C. Thomas.

Mishima, Y. 1977. *On Hagakure: The Samurai ethic and modern Japan.* Trans. Kathryn Sparling. New York: Penguin.

Robbins, A. 1980. *Expressive therapy: A creative arts approach to depth oriented treatment.* New York: Human Sciences Press.

# 17

---

*Working with Everything We Have*

The simplest rationale I can give for a holistic use of the arts in therapy is that this approach offers us the opportunity to use all of our personal and environmental resources while relating to the whole of the person with whom we are engaged. Although some might consider the use of all of the senses in therapy to be an extreme idea, I have always thought it to be a sensible and practical position, reinforced by the continuities of history and cross-cultural study. Since people express themselves in many different ways, why not encourage all psychotherapists to develop the ability to work with different forms of expression?

Making use of everything I have comes naturally to me. I relate to daily life with all of my senses, and I have never thought of one faculty being more significant than another. My liberal Jesuit education similarly encouraged the integration of knowledge and disciplines of study. So, yes, I appear to be out of step with today's mental health world, which reflects the values of technical and specialized education. Contemporary Western society has taken specialization to the breaking point. We have lost the realization that a figure cannot be understood in isolation from its ground.

Today's mental health field is to me as bizarre as a chapter out of *Gulliver's Travels*. Unnatural chemicals, replacing the electrodes and injec-

tions of the previous generation, are being introduced into our bodies just as rivers and waterways were spoiled by the narrow technological thinking of prior generations. Problems of the soul are being treated mechanically and without regard for people's uniqueness.

If the American Art Therapy Association wishes to restrict its purview to work with drawings, paintings, and three-dimensional objects, then it might consider changing its name to the American Association of Visual Art Therapy or, as the Europeans do, call the process "picture therapy." This point is far from semantic quibbling. The domain of art and artists has a scope far broader than the borders of a picture. Art by its nature includes everything imaginable, and this is why I have always been proud to be associated with the integration of art and healing. The two need each other. Art, like the healing process, not only includes all of life but certainly the specific elements of gesture, body movement, imagery, sound, words, and enactment. These elements complement one another and cannot be separated in either art or life. Dividing the therapies of art, music, dance, drama, and poetry into specialized professions adds to already factious atmosphere of the mental health field.

Therapy is itself an art, a creative process. It is far from a technical science. No single professional group can claim exclusive title to the "art" of therapy. I am much more interested in perceiving all creatively oriented therapists as fellow artists and exploring how we can cooperatively perfect the artistry of our work. The splits in the mental health field have much more to do with the needs of various professional systems and the industries of professional education. Specialization lends itself to control and regulation, whereas integration minimizes differences. The professions have clearly endorsed the former approach, encouraging policies of exclusion rather than collaboration across disciplines.

The blurring of boundaries among disciplines and professions admittedly creates challenges in terms of public protection and credentialing. Creativity is also furthered by encouraging many different ways of working and new approaches that exist outside the bounds of current practice. In the case of the creative arts therapies, the different national associations focused on media have clearly made contributions based on the gathering of people according to particular artistic interests. I do not deny the validity of commitments to working with specific media in therapy. Power lies in focus, concentration, and discipline. I am sure that there are therapists and healers who do profound work by limiting themselves to elementary

materials like stones or sand. However, I do not think it is wise to take this kind of specialization further by establishing associations, credentials, and education guidelines for stone therapists and sand therapists. My recommendation is that we open ourselves to a vision of the qualities shared by all of the creative arts therapies. Work in any given situation with the arts involves a natural crossing of the boundaries among expressive modalities and the senses. How can we think more creatively about the essential ecology of creation and encourage it in therapy and healing? How can we access the total range of our expressive resources and encourage people to explore the collaboration of the senses in artistic expression?

Perhaps our search for community and a sense of belonging within the helping professions has contributed to increased specialization and separation. Time will reveal whether this pattern has more to do with the needs of therapists than those of clients.

# 18

*A Review of* Jung on Active Imagination
*by Joan Chodorow*

C. G. Jung's formative writings strikingly anticipate the most advanced frontiers of contemporary arts and healing practice. As early as 1916 he made explicit references to the arts as preferred methods of psychotherapy and continued throughout his career to use them as the basis of therapeutic treatment. In 1955 Jung declared that modern psychotherapy "[was] beginning to recognize the usefulness of perceiving and giving shape to the images" through the arts (p. 173). To this day, Jung's practice remains an effective model for using all of the arts in therapy and healing.

The world is beginning to catch up with what Jung discovered many years ago. He is clearly the preeminent pioneer of creative arts therapy, although he did not use this term to describe his work. Art therapists will feel an especially close connection to Jung's descriptions of active imagination, which draw extensively on the visual arts. But Jung also gives special attention to the dramatic dimensions of his methods, including movement and the poetic process of personifying images.

Jung's writings are impressive in their lasting ability to inspire contemporary thought and practice in the creative arts therapies. Sigmund Freud and other early practitioners of psychoanalysis reflected upon dream images and artworks in their descriptions of psychological experiences, but for them creative expressions are approached as objects for analysis. Freud's

experimentation with free association corresponded to the methods of surrealist artists; but Jung went much further in giving primacy to the creative process, which he embraced both as a method of therapeutic treatment and as a way of understanding human experience.

Jung's work is crucial for creative arts therapists desiring closer connections to depth psychology. For in Jung we encounter an articulation of the essential processes of creativity that resonates completely with the practical work that we do and the potential we feel for the future.

Most creative arts therapists are apt to identify Jung with the themes commonly associated with his work, such as alchemy, the collective unconscious, archetypes, anima and animus, introversion and extraversion, individuation, the shadow, persona, and so forth. His ability to generate popular and lasting psychological terminology may obscure his ongoing involvement with the more fleeting process of creation. Because Jung is widely known for his grand and sweeping archetypal theory, we tend to miss the fact that his therapeutic methods are inseparable from what we now describe as creative arts therapy.

In *Jung on Active Imagination* (Princeton, NJ: Princeton University Press, 1997), Joan Chodorow, a past president of the American Dance Therapy Association, has carefully compiled Jung's writings related to our discipline. Her anthology shows how the use of the creative process is the bedrock of Jungian practice. Chodorow writes, "Jung's analytic method is based on the natural healing function of the imagination, so there are obviously many ways to express it. All of the creative arts psychotherapies (art, dance, music, drama, poetry) as well as sand-tray can trace their roots to Jung's early contribution" (p. 1). The selections in this volume show how Jung constantly refers to experiences with the arts as sources for his ideas.

**IMAGINATION TREATS ITSELF**

Jung discovered what he would later call active imagination during a period of personal crisis after his relationship with Freud was shattered in 1912–1913. In keeping with the archetypal process of shamans finding personal visions of healing through the dissolution of previous relationships, Jung initiated his life's work through a process of self-healing. In opening himself to childlike states of play, he found that the imagination has the ability to treat itself, and he used the arts as ways of "giving shape" to difficult experiences he was undergoing. Images appeared spontaneously as

he engaged different types of artistic expression. Rather than let reason control the therapeutic process, Jung gave "the leadership to the unconscious" and formulated what he called the "transcendent function," which integrates conscious and unconscious experience into a third state of adaptation and change. Chodorow documents how Jung often changed the name of his method, which sought to operate in a way that was "identical with the flow of psychic energy"—calling it transcendent function, picture method, active fantasy, visioning, introspection, and so on—before he introduced the term *active imagination* in 1935.

Jung insisted that he was only concerned with discovering how the psyche works: "I write about things which happen" (p. 70). Repeatedly, he emphasizes that the imagination is a psychic reality, a factual realm, an actuality, and that we must therefore find effective ways of engaging it. Creative arts therapists committed to these realities cannot avoid an encounter with Jung's writings on active imagination, not because they should adopt his methods and theories, but rather to emulate his striving to understand and enhance the "natural inborn" process of the creative imagination. This commitment to the native healing properties of psychic life corrects the one-sided preoccupation with strategic interventions and treatment plans that tends to characterize the practice of therapy.

One can learn to trust the process of the psyche and still practice with clinical discipline, as suggested by Jung. His vision of psychotherapy involves a shift to witnessing and following the lead of the creative imagination while staying attuned to a particular image. Jung describes the psyche as "purposeful," faithful to its "inner necessity," and capable of ministering to itself. We interfere with this natural course of treatment when imposing our needs for explanation and our attempts to fix things as quickly as possible.

Jung discovered how "looking psychologically" brings the object of contemplation to life with enhanced meaning. He deemphasizes explanation when working with an image in therapy and encourages active observation: "Give it your special attention, concentrate on it, and observe its alterations objectively. Spare no effort to devote yourself to this task, follow the subsequent transformations of the spontaneous fantasy attentively and carefully. Above all, don't let anything from outside, that does not belong, get into it, for the fantasy-image has 'everything it needs'" (p. 170). Jung repeatedly states that everything "depends upon how we look at things."

The erudite Jung is at his best when serving as an advocate for the imagination, for insights that "cannot be compassed by the rational concepts of the conscious mind" (p. 96). Jung once said, "Active imagination, as the term denotes, means that the images have a life of their own and that the symbolic events develop according to their own logic—that is, of course, if your conscious reason does not interfere" (p. 145). However, in the forty-page case study on Miss X, Jung reveals his tendency toward self-contradiction, offering an intellectualized account of therapy sessions in which every aspect of Miss X's artistic imagery is "explained" and interpreted in the most dogmatic and conventional ways—"leftward movement indicates movement toward the unconscious, while a rightward (clockwise) movement goes toward consciousness. . . . Blue means air or pneuma" (pp. 112–113).

While insisting frequently throughout his career that pictures cannot be reduced to psychological concepts and that he never goes "beyond the bounds of the picture lying before [him]" (p. 160), Jung nevertheless encourages their use in diagnosis because they "express the actual psychological condition of the individual" (p. 153). When writing about "the technique of differentiation," Jung once again interprets a vision described by one of his patients by replacing the specifics of imagery with symbolic, mythic, and alchemical associations (p. 69). This amplification of imagery results in a form of archetypal labeling. As James Hillman once said to me, "There are many Jungs."

Jung's tendency to openly contradict himself is intriguing. When confronted with these inconsistencies, he described how he exhibited the paradoxical nature of life. Yes, there are many Jungs, but the one who appears, for the most part, in Chodorow's selections is thoroughly committed to the way of imagination. The fact that Jung is constantly checking himself on the misuse of analytic reason when interpreting pictures suggests that he was aware of his inclination to stray from the bounds of images when reflecting upon them. We never see Jung expressing similar cautions with respect to the use of imagination.

Perhaps Jung's personal contradictions helped him to appreciate the "complementary" functions of the psyche. He discovered that "the psyche is a self-regulating system, just as the body is" (p. 51), operating on a largely unconscious basis. The purpose of therapy becomes adaptation to the unending flow of life experience. Jung's ideas about the complementarity of

psychic dynamics are close to those of the physicist Niels Bohr and other quantum theorists. Both Bohr and Jung had great respect for Taoist philosophy, which views life as a dynamic interplay between complementary forces or opposites. Yet another reason for the enduring significance of Jung's ideas and methods may lie in his affinity with the tenets of advanced science. His embrace of the dynamics of interplay contrasts with the more linear and mechanical sense of causality that underlies Freudian theory.

## "DREAMING THE DREAM IN GREATER DETAIL"

Jung's 1916 paper on the transcendent function offers a definition of art therapy that compares favorably to anything that has been published since: "Often it is necessary to clarify a vague content by giving it a visible form. This can be done by drawing, painting, or modelling. Often the hands know how to solve a riddle with which the intellect has wrestled in vain. By shaping it, one goes on dreaming the dream in greater detail in the waking state" (p. 57). In order to assure the spontaneous expression of imaginal experience, Jung recommends training in the suspension of "critical attention."

Throughout his writings Jung emphasizes how giving "visible shape" to an emotion may be more therapeutically effective than intellectual analysis. "Fantasy must be allowed the freest possible play," he insists, for "out of this preoccupation with the object there comes a more or less complete expression of the mood." He goes on to explain that "the whole procedure is a kind of enrichment and clarification of the affect, whereby the affect and its contents are brought nearer to consciousness, becoming at the same time more impressive and more understandable. This work by itself can have a favourable and vitalizing influence" (p. 53).

In a 1928 essay Jung further elaborates on his use of the creative process in therapy to show how we can personify images and emotions in order to understand them more completely and to differentiate them from ourselves: "The patient must try to get his mood to speak to him; his mood must tell him all about itself and show him through what kind of fantastic analogies it is expressing itself" (p. 64). When encouraging images and emotions to speak, Jung employs the therapeutic methods of dramatic and poetic speech. In a 1931 essay on "The Aims of Psychotherapy," he once again offers an extensive argument for using art as the basis of practice, focusing on the significance of action, and "actually doing something about it," rather than merely talking (p. 93).

In two letters written to a Mr. O. in May of 1947, Jung offers a concise summary of active imagination: "Start with any image. . . . Hold fast to the one image you have chosen and wait until it changes by itself" (p. 164). Through the techniques of personification and dialogue, he helps Mr. O. relate to a figure that appeared in a vision: "Treat her as a person . . . as something that does exist" (p. 165).

Jung also describes "magical effects" that have rarely been mentioned in the creative arts therapy literature but which I have consistently experienced in my practice. Art therapists might seriously research his suggestion that the picture functions as an idol casting itself back to its maker, infusing the person's "psychological system" with the expression that was applied to its creation (p. 152). Jung's notion that a picture is able to put a neutralizing "spell" on the content it expresses (p. 176) offers yet another intriguing way to integrate contemporary clinical practice with folk healing traditions.

## ALL OF THE ARTS AND CIRCUMAMBULATION

Applying the innate healing processes of the imagination to therapy in the spirit of Jung requires an integrated approach to all of the arts. Active imagination can be viewed as a kinetic and dramatic mode of inquiry that draws together all of the imagination's faculties. In *Mysterium Coniunctionis* Jung describes the basic techniques of active imagination, and the overall process is clearly presented as a dramatic enactment. One "catch[es] hold" of an image or feeling and concentrates attention on it; watches what kind of image is generated from the feeling or what kind of feeling emerges from the image; records how the object of contemplation is altered by the process of giving it attention; feels the sense of animation and psychic energy that are generated by the work; and approaches a person's inner drama in such a way that it demands participation.

Jung gives a compelling account of his personal "confrontation with the unconscious" in *Memories, Dreams, Reflections* (1961). In his work on himself, Jung made use of a wide array of expressive activities: dream work, drawing mandalas every morning, writing, gathering stones, symbolic play, yoga exercises, dramatic personification, dialogues with the figure of Philemon and other images, active fantasy, painting pictures of visions, hewing stone, building imaginary castles and villages, contemplating nature, and enacting personal rituals. Jung experimented by

avoiding theoretical principles and rules, ultimately concluding that "there is no linear evolution; there is only a circumambulation of the self" (p. 39).

What emerges from Jung's lifetime of work with active imagination is a therapy of integration requiring an embrace of multiplicity in order to achieve its outcome. Throughout his writings Jung cautions against "one-sidedness," which inhibits the more general ecology of the self-regulating psyche. According to Chodorow, Jung employed many expressive modalities, including body movement, sound, song, dramatic enactment, and stories. He clearly supported a multimedia approach to active imagination, encouraging the patient to work with whatever expressive medium was most conducive to spontaneous expression.

Chodorow tells us that in Jung's work "one mode often [led] to another" (p. 8). For example, he might have a patient interpret a mandala with a dance or give a voice and a story to a painting. As we contemplate an image during active imagination, the activation of creative energy can inspire a variety of different expressions that flow naturally from the process of reflection. Those who work with different art forms in therapy know how the process of expression naturally calls for changes in media in order to complete itself. At other times shifts occur because we are dissatisfied with a particular medium and need something more responsive to our particular urge to communicate.

Jung encouraged patients to follow a feeling's natural desire for expression in whatever form suits its intent: "We must be able to let things happen in the psyche," he wrote, while understanding that "the way of getting at the fantasies varies with individuals" (pp. 74–75). "Of course everybody gets at it in his own way," he added elsewhere (p. 144); "This, according to individual taste and talent, could be done in any number of ways, dramatic, dialectic, visual, acoustic, or in the form of dancing, painting, drawing, or modelling" (p. 159).

## DISPARAGING AESTHETICS

Although Jung's practice of active imagination corresponds in many ways with our current practice of creative arts therapy, Jung himself was ambivalent toward artistic values. He discouraged a "merely aesthetic attitude," feeling it was necessary to approach creative expressions as "worthless." "Otherwise," he wrote, "my patients might imagine themselves to be

artists" (p. 93). Jung seems to have perceived aesthetic contemplation as superficial, and he distinguishes it from the more highly valued "judgment" and integrating dynamics of the "transcendent function." He assumes that art is opposed to his concern for the "living effect" on the individual person. The problem here may be largely a matter of language and different conceptions of art.

Jung also errs in asserting that formal, aesthetic analysis lacks psychological depth. Perhaps he perceived the aesthetic perspective to be purely formal and disconnected from the authentic expression of the patient. Creative arts therapy as well as post-Jungian archetypal psychology have since shown how aesthetic thinking is a vital component of depth psychology.

When we embrace images through their expressive qualities, we operate aesthetically. In this way, images and aesthetic perception are inseparable.

In retrospect, we can see that Jung was constantly striving to integrate his spiritual, cultural, and imaginative inclinations with the methods and values of science. His experimentation anticipates what would later emerge within the creative arts therapies. His small oversights regarding therapeutic aesthetics notwithstanding, Jung was far more thoroughly immersed in the imaginal realm than the current creative arts therapy profession, which tends to overcompensate in its identification with the scientific "aspect" of the work. As Jung said, "The one-sided, reductive explanation becomes in the end nonsensical, especially when absolutely nothing new comes out of it except the increased resistances of the patient" (p. 47).

In this era when the creative arts therapies are fervently calling for scholarship and research, it must be noted that Jung was at his best when studying his own expressions. He teaches us how to research the self and our personal artmaking experience as well as clinical work. If we use Jung as a model, we see that he got much closer to the truth of active imagination through his direct experimentation with the process.

I also hope that creative arts therapy researchers will follow the example of Joan Chodorow in studying and reviving historic textual materials. Chodorow's personal progression from the practice of dance therapy to becoming a Jungian analyst suggests that those who desire a deeper involvement with the imaginal dimensions of creative arts therapy ultimately find their way to Jung. As a sophisticated creative arts therapist

searches herself and her medium, she encounters Jung who was there before us.

There is so much to be rediscovered in what already exists. *Jung on Active Imagination* illustrates how our community will prosper if we build a future upon the wisdom of the past.

**PART FIVE**

---

*Connections to Shamanism*

In the late 1970s I began to write about the similarity between the methods of shamans and those we were using in the arts and psychotherapy. I never saw the work we did with images and other creative expressions in therapy as a new behavioral science invention, and I was unable to accept the idea that we were another "adjunctive" therapy. I wanted to restore the healing qualities of images, rituals, and other creative expressions, to show that they are indigenous to all people, appearing and reappearing throughout history and in nearly every region of the world.

In 1979 I published "From Shamanism to Art Therapy" in *Art Psychotherapy* and quickly received reprint requests from Russia, Eastern Europe, Asia, Africa, and Australia. Never before or since have I had such a response to a journal article. The lead chapter of my book *The Arts and Psychotherapy*, published in 1981, was titled "The Enduring Shaman." The idea of linking what we do today with the arts and healing with ancient continuities caught on with people, and my work has become closely identified with shamanism. I have never spoken literally about creative arts therapists as shamans nor have I ever presented myself as a shaman. Of greater interest to me is the *idea* of the shaman and how things we do

today have ancient and deep roots in human experience. In the enactments of the shaman I have found evidence that art and healing are forever united in human experience.

This part of the book begins with my first essay on the connections between shamanism and current arts and healing practices. This early article, in which I present a vision of art and healing beyond the practices of the contemporary health fields, anticipated so much of my future work. It was a bold step to align art therapy with the more primal, sacred, and universal processes of indigenous healing, and today I am struck by the radical tone of the essay, which was probably needed to shake up the status quo and encourage a different way of viewing therapy. Art therapy at the time was primarily devoted to using images as "data" to be analyzed according to psychological theories. The shaman offered a different approach to the work, an approach that was received far better than I could have imagined.

"The Shaman as Archetypal Figure" (1989) and "The Shaman Within" (1988) illustrate how the shamanic qualities of experience can be found within all our lives. We do not have to travel to distant places or hunt through the vestiges of the past to engage the phenomena of shamanism. Whenever healing is approached as the return of lost soul to a person, family, or community, the creative methods of the shaman manifest themselves.

The following chapters on shamanism strive to connect the art and healing process to world traditions, present and past. Shamanism carried my work in art therapy to the larger realm of healing. Therapy is a modern practice based on mental constructs. Shamanism, by contrast, is a primary activity deeply rooted in the body, dreams, and myth. It harnesses the healing powers of creative expression and, with a history that extends behind the margin of recorded time, represents one of the most remarkable continuities of human experience.

# 19

---

*From Shamanism to Art Therapy*

## SHAMANISM AND THE NECESSITY OF ART

The therapeutic role of the arts in alleviating human suffering and resolving emotional conflict predates the birth of art therapy as a profession by thousands of years. The novelty of art therapy lies in its merging of these practices with the relatively new fields of psychiatry and psychotherapy.

The earliest manifestation of what we now call the psychotherapist was the shaman, who has been known as a medicine man or woman, one who works with the supernatural, a "technician of the sacred," a master of ecstasy, mystic, healer, priest, and artist. In essence, the work of the shaman involves all of these things. Mircea Eliade, in his comprehensive study, *Shamanism* (1964), identifies the distinguishing quality of the shaman as an ability to create an ecstatic trance through which the soul departs from the body and travels on a mythological journey to spirit worlds: "The shaman is the great specialist in the human soul" (p. 8).

Societies in virtually every geographic region of the world have appreciated the importance of experiencing and enacting dreams and conflicts. Within early communities the shaman was the person who helped the group relate to and maintain a dialogue with inner experience. Claude Lévi-Strauss felt that the shaman's role was developed in response

to the group's need for social equilibrium (1963). Like the artist, the shaman achieves balance by engaging imbalance, tension, and uncertainty (McNiff 1977). Those who participate in and observe the shaman's enactment support the confrontation of threatening elements. People are in turn stimulated and renewed through the process. Émile Durkheim (La Barre 1972, 11) viewed these early shamanic rituals as celebrations of a group's "sacred in groupness."

The skill of the shaman, who generally works with communities of people, was measured by the ability to structure an enactment in a manner that paralleled the configuration of the individual or group conflict. The ritual and symbols had to fit the problem and facilitate its expression. In keeping with the principle of correspondence (see chapter 14), Lévi-Strauss felt that both the psychoanalyst and the shaman must work toward the creation of a healing experience and the formation of a life-ordering system. He believed that the shamanic process and psychoanalytic treatment are in essence the same but that their operational principles differ with the analyst cast as a "listener" and the shaman as a speaker/actor (p. 199). Although I do not question these distinctions, shamans and analysts share many methods and goals. Polarization tends to oversimplify. The contemporary psychotherapist speaks considerably and, in creative arts therapy, engages in action. On the other hand, the shaman's successful enactments are dependent on sensitive listening and empathy.

Traditional shamans were trained in the use of culturally inherited techniques that enabled the group to give tangible form to their dreams and visions. In this way, they were able to become more aware of private experiences and to share them with others. Like those of art, the actual methods and practices of shamans have been characterized by great multiplicity and individual styles. Contrary to the standardization of religious traditions maintained by priests, shamanism is tied to the particular personality of the shaman, whose techniques of transcendence relate to the unifying myths and beliefs of the community. This cultivation of individual healing styles characterizes both shamans and contemporary psychotherapists.

Because of misleading associations of the behavior of the shaman with madness and schizophrenic hallucinatory states, the essentially constructive role of the true shaman has sometimes been overlooked. Eliade has stressed the discipline and skill of the "professional" shaman, whose formative crisis can be likened to the initiation into other religious vocations.

He feels that the shaman was separated from the group by "the intensity of his religious experience" and not by psychopathology. This position is confirmed by the extensive field studies of S. F. Nadel (1946), who never observed the disintegration of the shaman's "professional hysteria" into emotional disturbance.

Eliade writes, "The shaman and mystics of primitive societies are considered—and rightly—to be superior beings. . . . The shaman is the man who *knows* and *remembers*, that is, who understands the mysteries of life and death" (1958, 102). There were, of course, female shamans as well. In describing Siberian shamanism, Maria Antoinette Czaplicka (1914) noted that although at times it was virtually a male profession, evidence suggests that shamanism in Siberia during earlier epochs was primarily a female cult (p. 30). E. O. James (1955) reports that in Africa, Indonesia, and America, female magicians and shamans are sometimes more numerous than their male counterparts.

Although the shaman's vocation is purportedly revealed through experiences of hysteria and what we refer to as "psychotic episodes," the initiate must be able to work through the crisis and resolve the various psychological tensions before becoming a shaman. It is likely that in many cases the shaman's crisis was more mystical than psychopathological. Nevertheless, if shamans were able to heal themselves and others, it is because they understood the process of emotional disturbance. It is likely that shamans experienced the same kind of existential life crisis that precipitates emotional disturbance today, but the cultures in which they lived were perhaps more capable of accepting behavior expressive of psychological disturbance.

Andreas Lommel (1967, 25) describes the shaman as "a doctor" in the realm of the psyche. Observers note that the shaman practices a form of group therapy in which the entire community participates. The shaman's technique is often one of enacting the forces and life dramas that are disturbing "the patient," so that the invisible tensions can be directly confronted and dispelled with the goal of retrieving the abducted soul. This methodology is comparable to the psychoanalytic process of transference, where the patient unconsciously projects onto the therapist the qualities of a parent or other person who is a source of conflict. The enactment of the psychological conflict parallels the contemporary process of psychodrama, which dramatizes problematic situations in a therapeutic context.

The struggle of the shaman to find meaning and order within the flux

of experience is akin to the artistic process. Like the dramatists of later cultures, the shaman attempts to attach spiritual significance to unsettling and tragic circumstances. Contact with intense emotions such as grief and psychological states of anxiety, depression, or isolation awaken the shaman to transpersonal forces that affect experience. According to Eliade, "The total crisis of the future shaman, sometimes leading to a complete disintegration of their personality and to madness, can be valuated not only as an initiatory death, but also as symbolic return to the precosmogonic chaos, to the amorphous and indescribable state that preceded any cosmogony" (1958, 89).

The shaman is able to engage the irrational and primary emotions and then return to more controlled behavior. The journeying of the shaman can be likened to Freud's description of the artist moving between unconscious and conscious realms. The immersion into turbulent experience and its transformation brings renewal both for the shaman and the community that is vicariously engaged. In making a comparison of shamanic trance to schizophrenia Julian Silverman suggests that psychological upheavals are sometimes life enhancing: "If one conceives of the total psyche as a self-regulating system, the eruption of ordinarily unconscious (dream-like) imagery is, under such crisis conditions, absolutely necessary for restoring balance and wholeness to the system" (1967, 28).

Silverman emphasizes that community support was the key catalyst enabling shamanism to heal group and individual problems. Psychic disturbances were accepted and accommodated in the social environment of early cultures, which used ritual and dramatic enactment to work through conflicts within communities.

The parallels between shamanism and the field of art therapy seem to lie in the commitment of both to work with psychological conflict and struggle through creative action and enactment. Just as society today has a low tolerance for the expressive and aberrant behavior of the person in emotional crisis, it has shown a similar lack of empathy for emotionally charged artistic statements that deviate from cultural norms. Thus, as Ruth Benedict states in *Patterns of Culture* (1934, 270), the dysfunction of individuals in society is not necessarily a result of their "abnormality," but is more likely due to the lack of value that the society places on their behavior.

Rather than attempting to tranquilize eruptions of psychological ten-

sion by external means, the artist and the shaman go to the heart of the inner storm and enact its furies in a way that benefits the individual and the community. The end result is not just emotional catharsis but deepened insight into the nature of human emotion. In contrast with the expectation that people in civilized societies will follow a relatively straightforward and predictable behavioral script, the artist and the shaman maximize the social and transformative value of upheaval and unpredictability. They see that struggle gives significance to existence. Life is perceived as a dynamic system that proceeds to a natural order and expands if allowed to do so (Arnheim 1971).

In their study of shamanism, Dennis McKenna and Terence McKenna (1975) reaffirm the need today for "doctors of the soul." The McKennas regard contemporary artists—with their understanding of the flexible, evolving nature of consciousness and identity—as the modern shamans. The artist, like the shaman, demonstrates how one can live with heightened sensitivity and how art heals by restoring soul and by transforming our actions and our perception of life.

Like those of the art therapist, the personality, experience, techniques, and training of the shaman have a direct effect on the quality of the healing process. In his book *The Shaman's Doorway*, Stephen Larsen says that "even the intrepid shaman does not venture into the realm of primary meaning without a myth in mind" (1976, 34). Through the agency of a guiding myth, the internal drama of the person being healed is connected to the continuities and patterns of the community, and the shamans use their expressive and evocative powers to guide the group. Virtually every form of shamanism alters consciousness through drumming, costuming, or other tools of transcendence that assist in bringing about a separation from routine existence. Eliade feels that the skillful shaman rarely depended upon hallucinogenic drugs to achieve ecstasy, whereas the McKennas maintain that hallucinogens were a natural feature of all forms of shamanism.

As cultures evolved, the practices of shamanism developed into established patterns and belief systems, and further evolved into standardized religions where priests, rather than shamans, led rituals related to spiritual beliefs. As Larsen states, there occurred "a victory of the principles of a socially anointed priesthood over the highly dangerous and unpredictable force of individual endowment" (p. 161).

Within our technological era, psychotherapists and psychologists, who operate according to principles of behavioral science, have been dealing with many of the life crises once handled by shamans. In keeping with the tenets of contemporary schools of psychotherapy, many people believe that emotional problems can be corrected through psychological explanation. That is, if we can simply understand and analyze the unconscious causes of our problematic behaviors—most often imagined to be past instances of trauma or deprivation—then relief will result. However, there is a growing realization that conceptual treatments are of limited value in healing problems of the human spirit. Ernst Cassirer, in his *Philosophy of Symbolic Forms* (1955), supports the role of the arts and myth in the development of consciousness and self-awareness: "To the factual world which surrounds and dominates it the spirit opposes an independent image world of its own—more and more clearly and consciously it confronts the force of the 'impressions' with an active force of 'expression'" (p. 23).

Today the various roles of the shaman are divided among different professional groups—physicians, psychotherapists, artists, and priests. With regard to the creative transformation of emotional conflict, this role fragmentation has diffused the shaman's source of power, which lay in the integration of body, mind, spirit, and art.

Creative expression brings the psychotherapy process into contact with the continuities of healing through art, ritual, and ceremony. It allows the direct communication and expression of personal imagery and bodily sensations. Expressive arts therapy can be viewed as a modern manifestation of shamanism, sharing common emphases on the fundamental necessity of the human spirit to seek transcendence and intensify sensory experience, strivings for balance between the individual and the community, needs to react creatively to existential fluctuations and change, and the desire to participate in life-affirming rituals.

The expressive arts therapist is appearing in the mental health field at a time when society has few unifying myths and when fragmentation of the mind, perceptual confusion, loss of the drive for self-fulfillment, and inability to appreciate the struggle of existence are typical characteristics of emotional disturbance. As the expressive arts therapist begins to take on the role of healer in our time, we can find precedents for these practices beyond the horizon of psychiatry in the ancient continuities of art healing and shamanism.

In the recent history of art psychotherapy, influential thinkers have advocated methods consistent with the indigenous practices of shamanism.

Early psychotherapists, including C. G. Jung, J. L. Moreno, and Otto Rank, were keenly aware of the artistic and spiritual roots of psychotherapy. Rank spoke of the analyst as "a new artist-type, such as has not existed since the Greek period and had not been needed since the Christian era began. The type of artist who works in living human material, who seeks to create men not like parents, physically, but spiritually like God" (1959, 272–273).

Rank was disheartened by the growing materialistic tendencies of psychology that in his mind tried to destroy the soul. Beginning with, and including Freud, depth psychology has attempted to explain subjective experience with concepts, thus eliminating the spiritual content that Rank felt gave birth to psychology. He believed that, despite depth psychology's attempts to avert its theoretical gaze from them, issues of death and immortality remain the determining factors of adult consciousness. The psychoanalytic terminology of the unconscious tried to take the place of the soul, and contemporary psychology has gone even further in attempting to reduce experience to scientific concepts. "Psychology is the soul's worst enemy," Rank asserted, "because in creating its own consolation for death it becomes compelled by the self-knowledge it creates to prove that the soul does not exist, thus it becomes both a scientific 'psychology without a soul' and a kind of overburdening of the inner spiritual self which, with no support from an inherent belief in immortality, goes to pieces in a way the neuroses show so well" (1950, 31).

Extending the artist metaphor further, Rank reacted against the determinist theories of Freud by emphasizing the importance of the conscious will and the potential of each person to act as an artist who can creatively shape his or her own character. Rank's position was reminiscent of Nietzsche's belief that existence could be justified only through aesthetic perception. Nietzsche declared that each person could reach self-transcendence by giving new "valuations" to experience through art. Thus advocating liberation of the conscious mind, Nietzsche anticipated humanistic self-actualization therapies as well as creative arts therapy.

The dramatic implications of therapists and clients acting together within an artistic process were taken further still by Moreno, who intro-

duced creative action modes to the psychotherapeutic experience. Moreno's contributions continue to exert a major influence on contemporary therapeutic approaches. His techniques of role-playing and role-reversal, as well as his emphasis on the enactment of the drama of each person's life, form the basis of many gestalt therapy techniques and other recent psychotherapeutic practices. Moreno's innovations grew out of his frustration with orthodox psychoanalytic therapy, where the slightest suggestion of acting out was discouraged and where the therapist and client (lying on a couch) attempted to verbally resolve unconscious conflict and tension. Observing the lessons of theater and other healing rituals, Moreno realized that only through spontaneous action, and getting off the couch, could a person re-create and work through emotional problems, which are rooted as much in the body as in the mind. Moreno's work, along with that of Wilhelm Reich, Alexander Lowen, and other body-oriented therapists, has led many psychotherapists to see the fallacy of the Cartesian separation of mind and body that permeates classical psychoanalytic techniques.

The psychodramatic approach appreciates that healing comes from action, from bringing about the complete artistic catharsis first described by the Greeks. Moreno's system of real-life enactment of psychic conflict is tied to the ancient continuities of art healing, where the community or group enacts its uncertainties under the guidance of the shaman. The shaman's enactments were the beginnings of theater, which grew increasingly distant from immediate life experience with the progressive development and enlargement of civilization. Through his psychodramatic explorations, Moreno also helped the contemporary theater to rediscover its artistic roots in the emotional intensities of each person's life (Bentley 1970). As Heraclitus said in 500 B.C.E., "Man is estranged from that with which he is most familiar."

With a keen appreciation of Nietzsche, Moreno emphasized the creative godliness in each person and the importance of making art from everyday life. His therapeutic work grew from the assumption that spontaneity in the present moment is the basis of creativity and that distinct lines cannot be drawn between therapy and aesthetic experience. Healing takes place when people revisit life experiences and play them out in new ways. "Every second time," Moreno would say, "is the liberation from the first" (1973, 91). Emotions and the conflicts that triggered them were relived, replayed, and transformed, requiring an embodied dramatic experience versus a

"talking cure." Although Jung's earlier practice of active imagination introduced creative action to psychotherapy, the intensity of Moreno's methods were closer to the ecstatic qualities of classical shamanism.

Psychodramatic methods more closely resemble the practices of shamanism than those of any other form of creative arts therapy. Like the shaman, the psychodrama director is the one who is most completely "possessed" by whatever situation is being enacted, and this empathic engagement becomes the basis for disciplined leadership. The director is immersed in the drama and takes cues from whatever emerges from moment to moment. The emergence of this method was quite a departure from the classical psychoanalytic stance of a removed and impersonal analyst, a stance that has been adopted by many creative arts therapists. Like the shaman, Moreno was an ecstatic, an artist who believed completely in the healing power of emotion, spontaneous action, and creative sensitivity. In developing psychodrama, Moreno reached beyond the prevailing ideas of talk therapy and behavioral science into the ancient continuities of dramatic enactment, thus giving the twentieth century an approach to therapy that was completely rooted in the creative process and the restoration of soul.

### A NEW ARTISTIC CULTURE INFORMED BY THE WISDOM OF THE PAST

Through research and ongoing experimentation, we can continue to explore the specific ways in which the present methods of the creative arts therapies are culturally interchangeable. Rather than take on adjunctive relationships to the disciplines of psychology and psychiatry, we can utilize the fields of anthropology, art history, and religion to explore the primary therapeutic use of the arts in our society.

Research will indicate that, often unawares, we are reviving ancient shamanic practices. For example, drama and dance therapists find themselves spontaneously creating rituals of passage to celebrate people's confrontation with and overcoming of obstacles. Chanting, rhythmic drumming, cathartic expression, and group participation typify their work. Poetry therapy encourages "naming" and personalizing the physical environment. All of the arts sanctify the place where they are practiced and make profane aspects of experience sacred through symbolic transformations. Shamanic journeys of ascent and descent characterize active imagination experiences and other creative activities that reenact the traditional myth cycle of "separation-penetration-and-return." Dramatic

improvisations and visual art expressions often border on totemism, with participants identifying themselves with animals that personify both desirable and malevolent attributes. Tutelary spirits, familiars, power animals, and talismans are created in art activities expressing needs for support and protection. In all of these manifestations of contemporary art and healing practices, essential qualities of the human spirit are expressed in a manner that bears a striking resemblance to shamanism.

The task ahead is vast in that the arts need a cultural environment that supports personal artistic exploration for the average person. Advances in this direction have been made in the many places and lives where art and healing practices are taking root. Just as the shaman creates an interpersonal and physical space that facilitates transcendence and heightened perception, so too must contemporary healers construct spaces that help people to creatively transform their conflicts and tensions.

This vision involves nothing less than a new artistic culture informed by the wisdom of the past. In accordance with the mythic pattern, the spread of this work will occur as more and more people *separate* from their habitual ways of approaching problems, *penetrate* the deeper and eternal shamanic realms of creative expression, and *return* to daily life with a felt awareness of how art heals.

**REFERENCES**

Arnheim, R. 1971. *Entropy and art: An essay on order and disorder.* Berkeley: University of California Press.

Benedict, R. 1934. *Patterns of culture.* Boston: Houghton-Mifflin.

Bentley, E. 1970. Theatre and therapy. In *Theatre of war*, by Eric Bentley. New York: Viking.

Cassirer, E. 1955. *Mystical thought.* Vol. 2 of *The philosophy of symbolic forms.* New Haven: Yale University Press.

Czaplicka, M. A. 1914. *Aboriginal Siberia.* Oxford: Oxford University Press.

Eliade, M. 1958. *Birth and rebirth.* New York: Harper and Row.

———. 1964. *Shamanism: Archaic techniques of ecstasy.* New York: Pantheon.

James, E. O. 1955. *The nature and function of priesthood.* Glasgow: Robert Maclehose.

La Barre, W. 1972. *The ghost dance: Origins of religion.* New York: Dell.

Larsen, S. 1976. *The shaman's doorway.* New York: Harper and Row.

Lévi-Strauss, C. 1963. *Structural anthropology.* New York: Basic Books.

Lommel, A. 1967. *Shamanism: The beginnings of art.* New York: Harper and Row.

McKenna, D. J., and T. K. McKenna. 1975. *The invisible landscape*. New York: Seabury Press.

McNiff, S. 1977. Motivation in art. *Art Psychotherapy* 4 (3–4): 125–136.

Moreno, J. L. 1973. *The theatre of spontaneity*. New York: Beacon House.

Nadel, S. F. 1946. A study of shamanism in the Nuba Mountains. *Journal of the Anthropological Institute of Great Britain and Ireland* 76: 25–37.

Nietzsche, F. 1917. *Thus spake Zarathustra*. New York: Macmillan.

Rank, O. 1950. *Psychology and the soul*. Philadelphia: University of Pennsylvania Press.

———. 1959. *The myth of the birth of the hero and other writings*, ed. P. Freund. New York: Vintage.

Silverman, J. 1967. Shamans and acute schizophrenia. *American Anthropologist* 69:21–31.

**20**

*The Shaman as Archetypal Figure*

> *The images themselves immerse us in the shamanic*
> *dimension. Shamanism has come to art therapy through*
> *images and not through the art therapist's desire to be a*
> *shaman.*
>
> *Shamanic callings are archetypal experiences, not limited*
> *to a chosen few, but universal and available to all.*

The archetypal perspective locates the shaman in the imagination, a
realm that in our society often seems as distant, foreign, and primitive as
the tribal communities we describe as shamanic. These communities de-
fine illness as a loss of soul. The shaman, acting as an intermediary, trav-
els between worlds to find and return the souls of sick people. I believe
the figure of the shaman is appearing today to help us restore soul to the
contemporary world through direct and vital contact with the life of the
imagination.

## A POETIC PERSPECTIVE

The archetypal perspective is poetic, metaphoric, and often imaginary.
It embraces history, contradiction, multiplicities, and the sacred. Like art,
it moves, shifts, and opens to the existence of phenomena without need-
ing to define them. It moves freely among anthropological, artistic, and
religious perspectives on shamans.

According to James Hillman, the archetypal perspective is "a consistent psychological attitude," not a theory. If images and artworks resonate with and enrich our inner experience, we do not have to rely on abstract theories to explain them. Thus the archetypal method is fundamentally aesthetic, and its precision is characterized by an ability to stay with and perceive the particular qualities of each situation.

Focusing exclusively on the literal figure of the shaman limits our direct access to shamanic experience. Since real-life shamans are fully engaged with the poetic and imaginal world, they also embody figures that exist within imagination itself. The archetypal perspective helps us see manifestations of shamanism within the routine of our daily lives. The emissary of soul thus becomes the embodiment of soul; and through the presence of the shamanic figure, the lost soul of ordinary life is restored.

Although it is important to respect and learn from cultures that are closer to the essence of the shamanic tradition, cultures whose links with archaic sources remain relatively intact, there are dangers in locating the soul in a place that is foreign and inaccessible. When we exclusively identify the shamanic role with its particular manifestation in a foreign culture, we become estranged from inner shamanic figures. A European colleague of mine traveled to the American Southwest one summer looking for the acclaimed medicine man Rolling Thunder with the hope of studying with him. When my colleague finally found him in Nevada, Rolling Thunder told him, "I have nothing to teach you. You will find these things within yourself. Go and look." My friend heeded Rolling Thunder's advice and began to intensively explore himself, like Heraclitus, Socrates, and Saint Augustine before him.

The archetypal figure of the shaman is to be found within each of us. Believing that they must travel to foreign countries to discover their own depths, many Westerners keep a direct experience of soul beyond reach. Searching for the shaman can become a metaphor for traveling into the realm of imagination and discovering what is native to the self. Of course, we can deepen shamanic experience by visiting other cultures and learning from them, but the primary process will always be awakening to the shaman within. Saint Augustine confirms this immanence in his *Meditations*: "I have gone astray like a Sheep that was lost, seeking thee with great anxiety without, when yet thou are within, and dwelleth in my soul, if it desires thy presence. I wandered about the Villages and Streets of the City of this world, enquiring for thee everywhere, and found thee not: because

I expected to meet that abroad which all the while I had at home. . . . I came home at last, descended into myself."

If the shamanic figure is to help us save the soul of our ordinary lives, it is necessary to locate the source of renewal within the commonplace. The search for the shaman in exotic locales and archaic times is an expression of our desire for a relationship with this sacred figure as well as an unintentional devaluing of the shamanic dimensions of our present lives. Jung recognized the way the divine "appears unexpectedly in the most unlikely places." He said that "the savior is either the insignificant thing itself or else arises out of it."

The social structure of certain tribal societies mirrors that of the archetypal world, with the community forming a self-contained, cooperative embodiment of the psyche. People in such communities take on specific psychic roles, with only one or a very few people executing the shamanic function. Many of us yearn for such tribal life in our utopian fantasies. Yet this traditional model cuts all but a few people off from direct shamanic experience, creating an environment that is far from egalitarian. In the end, it is the spirit and not the letter of shamanism that is so powerfully alive. Mimicry of what is done by indigenous people in the Amazon, Africa, Australia, and Arizona will not invoke this spirit. The shamans we encounter in museums, anthropology books, novels, and weekend workshops may inspire us but will not necessarily awaken us to the shamanic qualities of our own communities and lives.

In the early 1980s Paolo Knill and I were in Cambridge, Massachusetts, working with Mamfred Kaulity, a Kiowa healer from Oklahoma. Paolo's paternal ancestors came from the Appenzell region of Switzerland, where native healing methods are still commonly used. Mamfred had an interest in European culture that matched Paolo's desire to know more about Native America. When Paolo spoke to Mamfred about coming to visit in Oklahoma, he was told: "Go to Appenzell."

Mamfred was always encouraging people to work with the materials of their locale, both in terms of their culture and actual physical setting. When working in Massachusetts, Mamfred tried to make use of objects and herbs from that environment. This is yet another metaphor for finding shamanic resources within the self and the immediate community. Mamfred did not use the word *shaman* to refer to himself. In his region people simply called him by his name. In his view, *shaman* is an anthropological word.

The process of imagining the shaman as an archetypal figure is based upon a poetic state of mind that opens us to the reality of figures of imagination. Those with a nonpoetic perspective are more apt to view the shaman according to the classification systems of behavioral science, which view shamanism as a primitive practice that is foreign and external to our culture. When we try to literally transfer these practices into contemporary psychotherapy, we will probably be viewed as weird or at least disconnected from how people operate today within the mental health field.

Perceiving the shaman as an archetypal figure offers us something distinctly different. This perspective does not interfere with the sanctity of shamanic practices in closed tribal societies, and it does not attempt to expropriate them for use in the West. It assumes that each part of the world and each community will make contact with the sacred in its own way. The shaman is a universal figure, interpreted in endlessly varied ways by the different cultures of the world. Emphasis on cultural differences sometimes obscures the common qualities of human experience.

In the postindustrial West, we overlook the fact that we still have complete access to the native world of soul and nature. D. H. Lawrence tried to tell us this. In his explorations of soul, the underworld, darkness, nature, human passion and animal instinct, sexuality, and our pagan origins, Lawrence engaged the primary principles of shamanic practice with the goal of restoring the lost soul of Western society. Lawrence's mission and his imagery were fundamentally shamanic without his ever making reference to shamanism. He established direct contact with the archetypal figure of the shaman while remaining grounded in his own culture. He saw how his culture suppressed the gods of darkness, the instinctual and dream underworld, the human proximity to animal life and nature, and the rhythm of the drum as an expression of blood pulsations. In the shamanic worldview these elements take their place alongside the deities of light.

Lawrence's novels often focused on materialism's imprisonment of soul. In *The Plumed Serpent*, Cipriano tells Kate that Navajo women do not want to weave their souls into the blankets, and therefore provide a place in their finished blankets to free the soul. England, he said, weaves its soul into its textiles and everything that it makes and that the soul thus begins to exist only in material goods. According to Cipriano, "The soul is also a thing you make, like a pattern in a blanket. It is very nice while all the wools are rolling their different threads and different

colours, and the pattern is being made. But once it is finished—then finished it has no more interest any more."

The soul must maintain its freedom of movement. The lost and imprisoned soul becomes overly attached to the things it creates. Curing the soul is thus based on sustaining creative expression and movement.

## IMAGES AS SHAMANS

Although I respect Lawrence's advice with regard to materialistic identification with the objects of creation, in my experience it has been the images that we make within the art studio that immerse us in the shamanic dimension. The objects have been agents of shamanic renewal.

Shamanism is more likely to come to art and healing through images than through the therapist's desire to be a shaman. In my studios, whenever we make art with materials from nature, the spirits of shamanism immediately enter the room. The same thing happens when paintings are made freely with vibrant colors and gestures. I have personally come to shamanism through my exploration of these images, through my responses to them, and through my efforts to relate to them as completely as possible.

The images are generated by the soul's sensibilities; and when they express emotions, figures of the imagination, dreams, struggles, transformations, travels, and longings, they transmit palpable shamanic qualities. Every person's artistic imagery can be an opening into the shamanic world if we can endow our creations with this significance. The image becomes a doorway to the soul when we respond to it with imagination and interest, when we appreciate its expression and mystery, and when we respect what it gives to us.

The revolutionary classicist Jane Harrison described how a hardening takes place where there is a "segregation of the image from the imagination that begot it." I witness such hardening whenever people do not endow their expressions with personal meaning.

The open interplay and dialogue Harrison envisions between souls and images takes place in the art and healing process when it is guided by sacred and shamanic values. "The only intelligible meaning that ritual has for me," she writes, "is the keeping open of the individual soul—that bit of the general life which life itself fenced in by a separate organism—to other souls, other separate lives, and to the apprehension of other forms of life. The avenues are never closed. Life itself, physical and spiritual, is the keeping of them open" (1966, 53).

In keeping with Harrison's observation, I have discovered that the shamanic qualities of art and healing are most completely activated when we create together with other people and open to one another's expressions, and when we see ourselves as part of the overall expression of nature.

**REFERENCES**

Harrison, J. 1966. *Epilegomena to the study of Greek religion and themis.* New Hyde Park, NY: University Books.

Lawrence, D. H. 1926. *The plumed serpent.* New York: Knopf.

**21**

*The Shaman Within*

Students and colleagues over the years have repeatedly asked certain questions that have helped to clarify my thoughts about the relationship between creative arts therapy and shamanism. I would like to give a sense of these questions and my responses to them by re-creating them in dialogue form.

QUESTION: Did you go into a tribal society to study with a shaman?

SHAUN MCNIFF: No. I found the shaman within myself, within the people that I work with, and within the things that we do together.

Q: Do you work as a shaman?

SM: I do not refer to myself as a shaman.

Q: Then how do you use the term?

SM: I see the shaman as an archetypal figure, a universal aspect of art and healing that helps to deepen and expand the image of the creative arts therapist. *Shaman* has become a cross-cultural term that gives a common name to indigenous healers throughout the world.

Q: Is the term useful?

SM: It draws attention to the universal aspects of life, like the identification of illness with a loss of soul.

Q: What do you mean by soul?

**sm:** Soul is something very old, mysterious, deep, and perhaps eternal. It can be imagined as the essential nature of a person, place, event, or thing. I think that the idea of "the unconscious" is a secular attempt to replace soul with a scientific name. I prefer to use the word *unconscious* as an operational term that refers to things outside awareness. Soul manifests itself through the arts and religion, and perhaps even through illness. The shamanic, artistic, mystical, and ancient philosophical traditions have all acknowledged the existence of soul and the skills needed to engage it.

**q:** Do you train shamans?

**sm:** For years I gave courses on shamanism and the creative arts therapies. I was pleased by how the title of the course attracted committed students. These people were generally interested in spiritual aspects of psychotherapeutic work and healing. They affirmed my belief in the interdependence of shamanism, the arts, religion, and psychotherapy. Occasionally I ran into difficulties with people who thought I was giving an anthropology course on rituals or instruction in shamanic techniques. Right now I do not use the term *shamanism* in describing my courses because the phenomenon of the shaman has become completely integrated into everything that I do. I find the shaman in the group, the images we make, and in myself. The term is so strong that it can bias people's perceptions of what we do together. I am more interested in the phenomena themselves and not so much in what we call them. The term *shamanism* refers to an important universal aspect of the process of art and healing.

**q:** Do you think that it is a good idea for people to present themselves as "shamans" to employers and clients?

**sm:** We can call ourselves anything that works. Some people are helping others by referring to themselves as shamans. The term attracts many, but it is likely to put off public agencies, hospitals, clinics, and other institutions run according to secular and scientific values. However, it would be delightful for me to someday discover that this prediction is wrong. Anything can happen. I never imagined thirty years ago that the art and healing field would be what it is today.

**q:** Has shamanism furthered your understanding of the creative arts therapies?

**sm:** Profoundly. Shamanism focuses on experience more than concepts and it has helped me go much deeper in the practice of the work. Studying the connections to shamanism has shaped my depth psychology of creative arts therapy.

For five years my colleague Paolo Knill and I worked with an experimental shamanic group in which communication took place through drumming, movement, the free use of the voice, enactment, touch, visions, trance, and other expressive activities associated with shamanism. Over time I noticed that the rhythmic pulse of drumming and chanting were what most powerfully evoked the visions and enactments that typify a shamanic ritual. Sometimes our group resembled a primal theater, and at other times it was like a meditation circle. Whatever needed to be manifested came forward and was engaged by the group. Experience with the underworld, with realms outside the scope of reason and narrative communication, is a primary element of both shamanism and depth psychology. Our emphasis on spontaneous expression, rather than analysis, gave the group its shamanic character. Analysis stops the process.

Q: You work in various countries. Have you found that some cultures are more responsive to shamanic influences than others?

SM: In my experience, people in Finland and other Scandinavian countries have been highly receptive to shamanism. I think that this may be a result of their close relationship to nature and their relatively intact indigenous cultural heritage. However, it is difficult to generalize about cultures. There are cultures within cultures, and I have found that every country has groups of people who are keenly interested in reviving indigenous healing practices.

Q: What readings do you recommend on shamanism?

SM: Mircea Eliade's *Shamanism: Archaic Techniques of Ecstasy* (1964) is the seminal work. Students and colleagues respect the writings of Michael Harner (1982), Richard Katz (1982), Lynn Andrews (1985), Stephen Larsen (1976), and Carlos Castaneda (1972). Women have been enthusiastic about Andrews's female role models. I think that we have all been impressed by the intelligence and lasting power of Castaneda's books. Harner is the most recognized teacher of the application of classical shamanism to contemporary counseling.

Q: Can you give an example of a shamanic technique that you use?

SM: I frequently urge therapists to learn how to "eat" the pain and illness of other people. Shamans will "suck out" illness from the body of a sick person. The idea of eating pain resonates with therapists. It is an active metaphor of how to effect transformation, alluding to an intersubjective process that is very primary and visceral. We must learn how to take nourishment from difficulty and let it pass through us. Illness and all kinds of

emotional maladies occur when pain gets stuck or congested. Rhythm and a balanced relationship with nature are principal metaphors for health within the shamanic tradition. I prefer the language of shamanism to abstract psychological concepts. On a daily basis my work is most closely tied to shamanic uses of rhythm and the core idea of moving between worlds in search of the lost soul.

I have also metaphorically applied the shaman's battles with evil spirits to the creative arts therapies. The shamanic image of battle has a physicality that fits with the active work that we do, and with the struggles involved in the creation of an artwork. We frequently wrestle with the aggression within ourselves. Shamanic metaphors for healing are imaginative.

And, in a more general sense, we constantly see how a person's or group's artistic expression embodies conflicts and tensions, uses them as fuel for expression, and takes them to new places that we cannot reach with words. The creative process integrates all of the separate and sometimes opposing forces. This happens all the time. It is magical, and it is the primary way that art heals.

**Q:** How do you lead this kind of group?

**SM:** First of all, I have to take the lead in establishing and constantly maintaining the safety of the space so that people can work freely. Clear and supportive leadership is crucial.

Shamanism has helped me to become committed to the eternal therapeutic structures of rhythm, movement, storytelling, ritual, dreaming, free vocal expression, performance, and image-making. They are classical shamanic phenomena that can be engaged directly and without contrivances. I am a purist when it comes to action. We begin with as little direction as possible. The shamanic structure is always present within us. We learn how to let it freely manifest itself. The simplicity and openness of my approach to the arts and my interest in ritual and the entire gamut of expressive phenomena may be my closest links to shamanism.

I use drums and other percussion instruments while people paint. The rhythms help to liberate creativity and summon imagery. Drums encourage vocal improvisation, movement, performance, and the full pantheon of artistic imagination. The use of more than one art form is as natural as the simultaneous actions of breathing, walking, listening, and looking.

**Q:** You seem more comfortable with the shamanic tradition than with much of what happens today in therapy.

**SM:** Because shamanism honors the use of sacred and imaginal forces in healing, I suppose I feel more connected to these practices than to the scientism pervading much of contemporary therapy. However, therapists are very pragmatic people. They tend to be open and respectful to what people bring to their sessions. Indigenous and modern approaches to healing are united in their striving to help people with their afflictions. But the ideas and theories that inform the therapeutic professions and their educational institutions are often limited, lacking any appreciation of or alignment with the historical phenomena of healing. Many people want to see professionals who quickly diagnose their problems and then offer a treatment plan. Although the strategic approach can be helpful and necessary in treating certain medical problems, I find it less appealing when dealing with afflictions of the soul. In keeping with the human need for meaning, the shamanic loss of soul may be attributed to the absence of sacredness and imagination in a person's life. A yearning for these qualities is what underlies the increased interest in shamanism that we see today.

**Q:** How would traditional shamanism differ from conventional psychotherapy in its approach to an image—an animal for instance—in a dream or an artwork?

**SM:** Within the shamanic context an animal that appears in a dream may be approached as a source of empowerment or as a guide. The sacred perspective enables us to see the animal as something distinct from ourselves. Generally the animal is respected, and it can take on an almost angelic quality through the attention we give it. Shamans and many contemporary therapists of the imagination might encourage us to talk with the animal, travel with it, and maybe adapt its sensitivities to our lives. We will also pay careful attention to the type of animal and to its specific qualities, establishing analogies between these features and other parts of our lives. The shamanic approach, with its closeness to nature, carefully observes the specific and unique qualities of phenomena, being wary not to generalize about images. This imaginative and phenomenological embrace of the particular animal image is very different from psychological practices that use stock concepts and generalizations to reduce artistic and dream figures to some aspect, usually pathological, of one's character.

**Q:** How can a creative arts therapist become involved in shamanism?

**SM:** I don't encourage casual connections between shamanism and creative arts therapy. Since the indigenous shaman exists inside every as-

pect of human experience, the best way to become involved is to pay more attention to what is already present. This is one of the great teachings of native cultures that closely observe and respect the qualities of nature, including dreams and the images of our inner worlds. Therapists might study these archetypal aspects of healing and begin to look at what happens in their work from this perspective. Everything depends upon how we look at experience. Although some people may want to become involved with the practice of traditional shamanism, and I respect this commitment very much, I recommend a shamanic *perspective* on therapy, healing, and our own experience as the most effective starting point.

Q: How does the shamanic description of illness as a loss of soul apply to our lives today?

SM: The idea of the shaman presents imaginative and helpful metaphors for what we do in therapy and healing. Shamanic cultures throughout the world define illness as a loss of soul. I find this definition appealing and very relevant to our contemporary maladies. The arts speak the languages of the soul, and they have the ability to manifest and return soul to our lives just as the shaman does. The arts express, engage, and heal the soul. It is this realm of soul that draws together the arts, therapy, shamanism, and contemporary spirituality. The artistic process and the images that emerge from creative expression are shamans that return the abducted soul to persons in need. I see the artistic image as a shaman, a guide and helper, returning soul to the world. Since these images emerge from within us and in response to our interactions with the world, the shaman appears in the same way.

Q: Do your shamanic interests set you apart from other art therapists?

SM: There are many art therapists who identify with these archetypal features, considerably more today than when I began to work with art and healing. And although the majority may remain more comfortable explaining what they do according to contemporary psychological constructs, I feel very close to all art therapists. We share a commitment to the healing power of artmaking and a respect for images and their medicines. These commonalities really go much deeper than differences. The sacred dimension is probably more unconscious in the work of art therapists who don't pay attention to the presence of universal shamanic qualities in the creative process.

Q: Do people fear the shamanic dimension?

**SM:** Many do, because the shamanic state requires us to let go and give up a certain degree of control. Nothing exemplifies this more than the responses that we have to sustained rhythm and drumming. Classically perceived as a means of travel "between worlds," the drum is "the shaman's horse." For me, the drum is a way of becoming immersed in the rhythms of creation, entering the zone of creative imagination. It energizes people and helps to dissolve their mental blocks. Rhythm is the most ubiquitous of shamanic qualities. The drum summons the movement basis of creativity. With this support, we start to express ourselves more spontaneously from the body. The creative streams thaw and begin to move freely.

**Q:** Can people do these things alone?

**SM:** Yes, but what distinguishes professional therapeutic practice from solitary art-healing experiences is the presence of one or more people who are trained to facilitate the process. We are more apt to let go and descend deeply into the sustained rhythm when we feel protected by an experienced guide. As I say to my students, there are no road maps and the shamanic journey cannot be planned in advance. Shamanism, like art therapy, is based upon the energy that is generated when people create together in a ritual way.

**Q:** What are some of the things that the guide does?

**SM:** The most fundamental task is keeping the rhythm and protecting the space. Beginners find it difficult to sustain a steady pulse whether with a drum or with other modes of expression. They have to realize that resistance and boredom are gateways to deeper penetration. When these distractions and doubts appear, I tell people that they are coming close. The resistance and boredom are tests of endurance. When we pass through them, we reach a deeper consciousness. Parallels can be drawn to trance. The unchanging pulse of the drum leads to deeper release of conscious control. I discourage drummers in this setting from indulging in clever and complicated technical variations, which serve only to distract people from the drum's invitation to let go. Shamanic drumming demands endurance, discipline, and submission to a continuing rhythm that rises and falls in relation to our breath and feelings. The drummer always serves the sustained pulse of the rhythm. Experienced guides help us to relax, feel confident, and open to the rhythm when the inevitable fears and feelings of distrust arrive. The group increases the power of the shamanic process with its energy, and it becomes the tribe. We make contact with something other than the individual ego.

Q: What do you do when fear escalates?

SM: I breathe mindfully and encourage others to do the same. As meditation teachers advise, breathe in and breathe out and stay in the present moment. It sounds simple but it can be difficult to do, to truly surrender to the breath and the sense of presence that it brings. This is why Buddhist teachers have continued to give the same apparently simple message throughout the centuries. I also tell people, as mentioned in chapter 10, that the images that appear through creative reverie and artmaking—even the disturbing ones—never come to hurt us. They are intimate figures of our psyches. We get hurt by how we respond to what emerges naturally—when we try to force things, when we lose our rhythm and breath. Others can also hurt us deeply, and this is why I work hard to create an atmosphere of safety and respect in my groups. I work on establishing a group rhythm, breath, and attentiveness to the present moment and to one other.

Q: How capable is the average person of making contact with these shamanic dimensions?

SM: My experience with many ordinary people, including myself, indicates that it is totally accessible to all of us. It's just a matter of letting go and opening to what is within us. But it is not always easy to do this, even if we want to let go. In his novel *The Plumed Serpent* (1926), D. H. Lawrence offers a vivid description of the powers of shamanic rhythm and how a person becomes immersed in it. The character Kate at first feels stiff when drawn into a group of villagers moving to a drum—"Shyly, awkwardly, she tried to tread the dance-step. But in her shoes she felt inflexible, insulated, and the rhythm was not in her. She moved in confusion."

As the drum continues a change occurred. "She was not herself, she was gone, and her own desires were gone in the ocean of the great desire. . . . How strange, to be merged in desire beyond desire, to be gone in the body beyond the individualism of the body, with the spark of contact lingering like a morning star between her and the man."

The rhythm helps dissolve resistance. Kate lets go—"Her feet were feeling the way into the dance-step. She was beginning to learn softly to loosen her weight, to loosen the uplift of all her life, and let it pour softly, darkly, with an ebbing gush, rhythmical in soft, rhythmic gushes from her feet into the dark body of the earth. Erect, strong like a staff of life, yet to loosen all the sap of her strength and let it flow down into the roots of the earth. She had lost count of time."

Lawrence vividly conveys what people experience in the art and healing experience and how the process has deep connections to the shamanic realm. Most of us are reluctant to let go of our tight controls and move into the unknown, especially the dark regions of ourselves and others. There is always an element of risk and fear involved when we surrender to the unexpected, but this is what both art and shamanism require. The resistance is as universal as the healing that the shaman brings. We probably can't have one without the other. It's not supposed to be easy. The challenge will always be there.

**REFERENCES**

Andrews, L. 1985. *Jaguar woman*. San Francisco: Harper and Row.

Castaneda, C. 1972. *Journey to Ixtlan: The lessons of Don Juan*. New York: Simon and Schuster.

Eliade, M. 1964. *Shamanism: Archaic techniques of ecstasy*. New York: Pantheon.

Harner, M. 1982. *The way of the shaman*. New York: Bantam Books.

Katz, R. 1982. *Boiling energy: Community healing among the Kalahari Kung*. Cambridge: Harvard University Press.

Larsen, S. 1976. *The shaman's doorway*. New York: Harper and Row.

Lawrence, D. H. 1926. *The plumed serpent*. New York: Knopf.

## PART SIX

*Reflections on the Source*

This part presents three theoretical chapters that explore the underlying dynamics of art and healing. The first two chapters explore the foundations of art and healing in terms of physical experience and consciousness. "The Basis of Energy" reflects upon how art heals through the transformation of energy. Traditionally basing itself on psychological histories and narratives, art therapy has given comparatively little attention to the core energetic and healing features of the art process. As we shift our therapeutic focus from the analysis of images to healing through creative expression, the phenomenon of energy gains new relevance, even primacy.

Some art therapists have been quick to dismiss any discussion of creative energy as "mysticism," a response that mystifies me since I am trying to make contact with the very physical experience of creative energy and encourage empirical studies of its healing potential. And if there is a mystical tone to these musings, I humbly accept any identification with the tradition of mystics who try to look more deeply into the world, to open more to its expression, and attempt to understand how physical phenomena act upon us and influence our spiritual well-being.

The palpable effects that artistic expression has upon people's physical and mental experience suggests a rich future for research focused on documenting healing outcomes. The absence of this outcome research can be attributed, at least in part, to art therapy's early emphasis on trying to determine a person's inner state through the analysis of creative expressions. This approach, in its various forms, was based upon subjective and idiosyncratic theories, making it impossible to conduct valid and replicable research. As we shift our attention to how art heals through directly engaging the body, mind, and spirit, opportunities for research in collaboration with medical science will begin to present themselves.

"The Healing Powers of Imagination" continues the exploration of how the healing qualities of art transcend linear analysis. The creative imagination is the undeclared intelligence that informs the art and healing process. Linear psychological systems based upon a logical sequence of causes cannot account for the complex and often unpredictable dynamics of art and healing. A new language and psychology of creative experience is needed to express how art heals, and I offer these reflections as first steps in what must become a far more comprehensive exploration.

In my experience, rhythm is a primal source of creativity and healing. "Surrender to the Rhythm" (1980/2003) is an updated version of a paper that I presented at an American Psychological Association annual conference in Montreal. At the time I was becoming increasingly aware that prevailing psychological theories failed to explain how art heals. I wrote this essay as an initial attempt toward creating healing theories and practices "indigenous to art." My experiences in the arts suggested that the discomfort caused by a loss of rhythm can be likened to the shamanic definition of illness as lost soul. Like the shamans who retrieve lost souls to stimulate well-being, artists heal through the restoration of healthy life rhythms. The idea of rhythm as a basis of healing did not take hold in 1980. Perhaps we are now ready to acknowledge rhythm's primacy. For, as Confucius declared, "Those who have rhythm have it all."

**22**

## *The Basis of Energy*

> *... at once to pour erect into the air a rain of energy, a column of spray, looking at the same time animated and alive as if all her energies were being fused into force, burning and illuminating ...*
> —Mrs. Ramsay in Virginia Woolf's
> To the Lighthouse *(1927)*

The transformation of energy is the source of both artistic expression and healing. As we engage others and ourselves in the process of art and healing, we strive to create, transmit, and circulate this elemental force. Yet little has been done to further our understanding of the energetic basis of art and healing or to explore how ideas from the natural sciences, especially modern physics, may resonate with what we experience.

Psychological ideas and theories with their developmental narratives have not always been effective in describing how healing takes place through artistic activity. Healing can be defined as making whole, as transforming tensions and problems into affirmations of life, as doing the best we can with the conditions of our lives, and as living in sync with the larger movements of nature.

The philosopher Rudolf Carnap warned against the confusion that results when principles established within one intellectual framework are applied to problems in another discipline. In keeping with Carnap's position, I do not wish to encourage a superficial holism that blurs boundaries

between physics and art. Yet science illustrates how playing with ideas and images from outside the boundaries of one's field can be a productive source of creative discovery. What the scientist sees in an artwork or a perception of nature may stimulate innovation in other areas. Good ideas often fly beyond the boundaries of their discipline of origin. So rather than try to fit art and healing into the framework of science, I am urging cross-pollination among disciplines and a more creative exchange of ideas.

## THE POWER SOURCE

The energies of expressions, groups of people, and places are real and palpable phenomena that we have overlooked in our attempts to understand human experience. In art therapy there have been misguided attempts to assess what is happening to a person by deciphering graphic expressions according to idiosyncratic psychological theories. Meanwhile, the successes and failures of the therapy work we do are closely connected to energetic qualities that we have yet to even acknowledge. We need to study what this energy does: how it can be cultivated, how it circulates through people and environments, how it might be described and assessed, what effects it has upon people, and how it finds its way to areas in need of transformation.

The circulation of energy within the art and healing experience is the most practical and effective feature of the work we do. This sense of artistic energy is closer to the discoveries of modern physics than to spiritualist beliefs about invisible healing energies.

One's energy can be defined as the quality of animation, the vitality of expression, and the vigor and passion displayed by one's actions. In physics, energy is defined as the ability to do "work" on another entity, to change its position in space. When this work is done on something, there is a transfer of energy to it. The fundamental transformations of life in the physical world involve the conversion of energy from one form to another. Both physics and art involve an ongoing interaction of forces, and it is intriguing how concepts of work are essential to both.

Physicists view work as energy in motion and the result of force applied to an object. The continuous application of force on an object does not necessarily generate work in physics since there must be movement to achieve this outcome. Therefore effort is not always work. In art, work is perceived to be both the process and product of creation—artists do their work and create works.

The finished artwork, as in physics, is a carrier of the energy transferred to it through the process of creation. In the practice of healing we strive to understand the expressive effects of artworks on people. We also continuously explore ways of accessing and circulating their energies and medicines (McNiff 1992, 1995). Energy is generated by focused attention, and it is dissipated when concentration is lost (Csikszentmihalyi and Rochberg-Halton 1981). This phenomenon has been studied for the past twenty years at Princeton University's Engineering Anomalies Research Laboratory. Rigorous experiments there have shown that when people focus their attention on machines specially designed to generate random output, the information content of the machines' output increases to a statistically significant degree. In these experiments, all variables other than human consciousness have been carefully eliminated (Dobyns, in press, 2004). Thus these scientists have reached a conclusion that is antithetical to their training as mechanical engineers: the human imagination participates in the creation of material reality.

Accepting that people's attention to the things around them contributes to the making of energy, we must also appreciate that the process is always reciprocal. The objects of the world carry energy and express it through their structures. When we concentrate on them, we open ourselves to their expression and contribute to the larger circulation of energy within an environment.

Creativity and healing are manifestations of the same essential energy. In my practice I continually witness how both of these processes convert problems into affirmations of life; and when they are joined together, their effects are amplified. I have also observed how environments and groups have the power to activate creative energy in people. The idea of "fields of energy" from physical science helps to explain how this contagion of creation occurs. Gravitational and electromagnetic forces exist in the spaces in which we live, and they influence our actions. Every object is located within a field of some kind, which will influence what happens within it. Therefore, the integration of creativity and healing within a group context is likely to generate considerable energy that can be channeled into the process of transformation.

Physics also informs us that dissolution is a necessary condition of growth. Loss and gain are tied together in every aspect of life. Order must be lost so that it can be regained, and nothing is constant within this formative flux. Chaos theory has revealed that fragmentation leads to new and

higher levels of organization, which is practically a definition of the creative process. This scientific discovery is also uncannily similar to how shamanic traditions view the symbolic dismemberment of the shaman as a prelude to healing and renewal.

Stephen Levine of York University in Canada and the European Graduate School in Switzerland (1992) has demonstrated the necessary role of chaos and dissolution in creative and healing processes. In keeping with the self-regulating functions of natural systems, he emphasizes how we must allow ourselves to "go through the experience of disintegration" in order to refashion ourselves (p. 22). "Break, break, break," as Nietzsche said, in order to create anew.

There is probably nothing more helpful to a person going through crisis and breakdown than the realization that this breaking apart may be a necessary step in the healing process, that certain things need to break down in order to achieve renewal. The same applies to struggles in the process of making art. We discover that the energy of destruction can be a prelude to the realization of a greater purpose. What seems to consistently help people is the positive embrace of a fear with the understanding that it is a carrier of tremendous life-giving energy that can be channeled in new directions.

## THE PRIMARY MOVEMENT OF ENERGY AND THE INFLUENCE OF GROUPS

Nature acts as a self-regulating system, putting every aspect of experience to use within the overall dynamic of creative transformation. Energy is lost and renewed in a necessary exchange. Enervation and depression are precursors to renewed vitality. A spontaneous and random dynamic exists at the basis of existence, so the process of creation will always have its chaotic moments. Constancy is impossible. Every system in nature is subject to the ongoing loss and gain of energy.

Acceptance of this interplay is a necessary condition for maximum utilization of creative energy. We learn how to align ourselves with the larger energies that exist within the self and the environment, and we push against the grain when change is required. Tension and conflict are necessary partners in creation, causing the friction and loss of equilibrium necessary for new growth.

Art therapy will be radically transformed if we begin to look at what we do from the standpoint of energy circulation rather than through the lens of psychological narrative. Of course, the use of the former does not

deny the importance of the latter. As with any creative exercise, it is helpful to examine experience from multiple perspectives.

Imagine art and healing sessions as an interplay of energy. What kind of energy field does your studio space convey? What kind of energy do you personally generate? What is it that produces truly transformative experiences? How open are you to the energies that others transmit to you? How are you affected? How sensitive are you to the energetic qualities of your own expressions?

My work with art and healing has always depended upon groups of people as the primary sources of creative energy. I feel energized when I am in a studio environment where people are expressing themselves freely. The expressive qualities of people in my studios reciprocally interact with the level and quality of energy I bring to the space. How we do things and present ourselves to others often has a greater impact than what we say. We often think, and fervently believe, that we are encouraging others to create, not realizing that our tone and style may militate against their creativity.

Satisfaction and positive outcomes in my studios most often result when the energy in the space is dynamic, inspirational, and compassionate. The same is true in meetings, group presentations, and intimate relationships. As William Blake suggested two hundred years ago in *The Marriage of Heaven and Hell*, "Energy is the only life, and is from the Body." The kinds of energy we generate, and do not generate, have a tremendous impact on others.

In team sports, the quality of interpersonal energy is a decisive factor impacting player performance. Baseball players often describe how the energy of their teammates or of a particular game can carry them to new heights of achievement. The same thing happens in the group art studios that I lead; people are always describing how the energy of the group acts upon them and helps them to do things that they cannot do alone.

Skill in working with creative energy requires both an understanding of its natural flow and circulation and an ability to sustain its movement. As with unused muscles, creative reflexes atrophy when they are not used. Regular exercise of creative energy sustains healthy circulation.

In the practice of creativity, we benefit from environments that maximize opportunities for movement. Sustained motion promotes the circulation of creative energy. In painting, writing, dance, music, and even in the process of creative perception, a person must start moving in order to

make things happen and activate creative energy. Nothing happens in the creative process unless a person chooses to connect to the energy source moving and waiting within the self and the environment. Once the energy is activated, the process will often take on a life of its own, with one expressive gesture leading naturally into another.

## POSITIVE ENERGY AND FEAR

For the beginner, creative expression can be like a delicate flower—tender, vulnerable, and easily destroyed. We feel fear when expressing ourselves in the presence of other people because we instinctually know that negative responses can easily shut down the energy of creative expression. Another cause of fear is the uncertainty we feel as we prepare to express ourselves creatively. There is always the possibility that the energy will not flow and that the force of creation will abate at a particular moment. Moderate fear before a creative performance is a natural reaction that activates and stirs the creative energies circulating within us. As with other tensions and conflicts, fear can be engaged as a vital energy to be transformed by the creative process. Try to receive fear as a sign that the creative moment is important to you, that you desire to express yourself as fully as possible.

Approach fear as a chemical catalyst, as a sign that the creative moment is important to you, and that you desire to express yourself as completely as possible. As with other tensions and conflicts, fear can be engaged as a vital energy to be transformed by the creative process. The physical sciences suggest that creativity, like any other natural energy, is generated through an interplay or exchange of forces involving two or more entities. Creative energy is transferred and transmitted among people. We give energy to the objects of creation through the "work" we do with them; and once completed, they give this energy back when we actively engage them.

Moving together with another person is the best example of how this energy exchange takes place. The dance method of contact improvisation allows us to give energy to and receive energy from another person. A simple touch from a partner can stimulate me to move in new and creative ways, and what seems to matter most in these exchanges is the pleasure and satisfaction received from the exchange of energy. I approach all sorts of art materials with this emphasis on giving and taking energy, and I find that the materials often lead me as much as I lead them.

## CO-CREATION

Relationships with others are the physical and spiritual basis of creative energy. Nothing is further from the truth than the popular notion that we create alone and in isolation from the world.

As with the multitude of species in nature's ecology, every aspect of our lives, including fears and complaints, is necessary for the circulation of creativity. As suggested throughout this book, unpleasant and difficult materials are apt to contain particularly strong energies that intensify the relational process of creation. You might try approaching these troublesome situations as reservoirs of energy. Rather than being intimidated by them, view them as catalysts and potent sources of creative action. "Conflict is good," says the experienced and skilled creator. "It is the subject matter of my work." Our tensions and conflicts can be viewed as partners in creation.

Like the scientist who seeks to maximize the creation of energy through the conversion of one material to another, the artistic creator works with materials and relationships that are likely to generate the most forceful movements. Scientists and artists know that particular "fields" and environments are likely to create more energy than others, and both disciplines have their ways of appraising the energies in these places.

Creativity, like chemistry, is based upon what happens when different elements interact with one another. Sustained movement, raw materials, flow, circulation, vital connections among participants, tension, a certain degree of chaos and destruction, and conversion are required to yield energy in both the physical and the creative worlds. Like a chemist, the artist gathers varied elements or participants into a space whose conditions facilitate the participants' transformation into new forms. The power of the creative energy is always determined by the dynamic nature of the mix.

There is a great deal that we can do to design and construct environments that enhance creative energy. Conversely, the design and operation of spaces, communities, and organizations can inhibit creativity. Creativity is an energy that emanates from relationships. As in physics, some materials are better conductors than others, and there are also forces that resist and neutralize the flow of energy.

## CREATIVITY AND HEALING

Creative energy flows through every environment together with other essential elements of life. When the circulation of creative energy is

blocked and diminished, the environment loses life-sustaining nourishment. The same thing happens within our bodies, relationships, families, and organizations when negative and harmful forces arrest the free movement of positive energy. This theory of illness and health originated in ancient China, where it was believed that vital energy, or *chi*, flows through paths or meridian lines within the body. Obstructions of this movement cause illness, and therapeutic treatment seeks to restore the natural flow.

This restoration of flow is often achieved by transforming the negative and disturbing energy into an affirmation of life. Healing environments cultivate creative energy and help people to open to its presence in their lives.

Acceptance of the conditions we face is necessary if we are to transform the energies present in our lives. We cannot convert our difficulties into affirmations of life until we open to them. This opening often occurs when we move beyond a sense of personal victimization and helplessness. Jung observed that his personal healing took place when he realized that the pain he was experiencing was not his alone. He perceived pain as an archetypal presence that challenges every person.

Pain and suffering, along with creativity, are necessary participants in the process of energetic conversion underlying the flow of life. Creative healing methods welcome the dark and troubling qualities of life, trusting that they will find their way to transformation. Attempts to resist the basic conditions of our lives through control and denial block the flow of creative energy. Art therapy is a discipline that encourages us to create from the difficult places in life, and the skilled art therapist helps us to openly engage the most challenging conditions with a confidence that the creative process will transform conflicts into something new.

The healing process is based upon an acceptance of what is happening at the present moment. Letting go is often described as a basis of healing. By abandoning the need to control every aspect of our lives, we open ourselves to the total complex of creative energy that exists within the present moment. In this respect healing involves a compassionate embrace of life as it is. Through the creative imagination's sympathy with other people and life situations, we realize that others share our suffering. We are taken outside ourselves and connected to the creative energy that moves through all of life. In this way, the greatest threats to our existence affirm participation in the human community and its ongoing circulation of creative energy.

Acceptance of our conditions does not mean that we become complacent, abandoning efforts to transform our circumstances. On the contrary, acceptance of what exists is a prerequisite of creative transformation. Nietzsche describes how art heals by turning "nauseous thoughts about the horror or absurdity of existence into notions with which one can live" (1967, 60) and by affirming that life is ultimately "powerful and pleasurable" (p. 59). Our life situations are what they are, and the creative process enables us to live with them in new ways. If we bring creative energy and a life-affirming spirit to difficult situations, this condition is contagious. Others are influenced and inspired, and the creative environment cross-pollinates from the circulation of energy.

Experience with creation teaches that the strongest forms are often forged through the most intense heat. Although destruction and tension may be necessary in order to create anew, the transforming and regenerative forces of creation are threatened by the complete dominance of negativity.

The deep movements of creation differ from attempts to attack symptoms and eliminate them through control and subjugation. Creative energy requires a complete mix of life's essential ingredients—tension as well as calm. As I emphasize in previous chapters, healing approaches that embrace only the "light," in an attempt to dispel the "dark," limit the powers of creative transformation. There is a respected place on the palette of creative expression for dark and brooding colors; they take us to the essential depths of our earthly corporeal experience. Be wary of those who advise reflection exclusively on the bright hues of the air and sky. We need the complete spectrum of colors and emotions in order to bring all of our resources to bear on the task at hand. The creative experience teaches that dark and troubling experiences are sources of the most important and life-enhancing expressions and insights. Darkness and light are necessary partners, and a realistic perspective on creativity welcomes all the aspects of experience with the realization that they energize creative transformation.

Healing can be conceived as allowing creativity—the most elemental force of nature—to do its "work" in our lives. Our challenge is to find ways to open more completely to the circulation of creative energy that already exists in every life situation. This appreciation of what is happening in each moment of our lives, of how even the most difficult situations can be powerful sources of expression, will take us to the deepest and most complete forms of practice in both creativity and healing.

**REFERENCES**

Csikszentmihalyi, M., and E. Rochberg-Halton. 1981. *The meaning of things: Domestic symbols and the self.* London: Cambridge University Press.

Dobyns, Y.; B. Dunne; R. Jahn; and R. Nelson. In press, 2004. The MegaREG experiment: Replication and interpretation. *Journal of Scientific Exploration* 18, no. 2.

Levine, S. 1992. *Poiesis: The language of psychology and the speech of the soul.* Toronto: Palmerston Press.

McNiff, S. 1992. *Art as medicine: Creating a therapy of the imagination.* Boston: Shambhala Publications.

———. 1995. Auras and their medicines. *The Arts in Psychotherapy* 22 (4).

Nietzsche, F. 1967. *The birth of tragedy and the case of Wagner.* Trans. W. Kaufmann. New York: Vintage.

# 23

## *The Healing Powers of Imagination*

**OVERLOOKED WISDOM**

Art heals by activating the medicines of the creative imagination. Yet we know little about the "intelligence" of the creative imagination, for the subject has been overlooked and even disparaged by many.

The widespread view of imagination as merely idle fantasy and make-believe has been a serious deterrent both to its exploration by researchers and its full engagement by individuals. When cast as a trivial activity, imagination is cut off from the energies that allow it to reach its full potential. But when honored and cultivated, imagination can work closely with reason and science to solve problems and transform the conditions of group and individual life.

For example, dream images gather together and synthesize emotions and concerns from the complete spectrum of our experiences. A dream, like an artwork, is a dynamic expression that is complete within itself and can never be reduced to a single interpretation or meaning. The expressions of imagination are more complex, dramatic, comprehensive, and insightful than other approaches to understanding experience. A young man striving to integrate his different interests in life described how recurring and unsettling dream images of fractal, fragmented patterns

changed one night into an image of a revolving and unified circular con-
figuration illuminated with moving light. Soon after this he dreamed
that two men running toward one another on a bridge merged into one
person. He marveled at the dreams, felt good about them because the
conflict experienced in the previous dreams was transformed. The subse-
quent dreams brought a harmonious feeling and a dramatic sense of per-
sonal integration.

Dreams and other expressions of the creative imagination communi-
cate and embody the deepest concerns that we have. Their healing pow-
ers lie in this ability to integrate diverse experiences in ways that may be
mysterious, pleasurable, and unsettling. Disturbing dreams typically ap-
pear to help us become more aware of what lies beyond our awareness
and needs attention. I say that the dream demons come to get our atten-
tion, to show us where we need help, understanding, and change. The
work that I do with these images focuses on spending time with them,
becoming more accepting of them and more comfortable in their pres-
ence, describing them as completely as possible, encouraging them to
communicate with us in many ways, imagining them further, examining
the new perspectives they offer, and rejoicing in the infusions of energy
that they bring.

We have truly arrived in the realm of imaginal healing when we can ap-
preciate our most upsetting dreams as helpers who come to show us where
we lack balance in our lives. What I call shadow dreams startle us into
looking at things we do not want to see, areas that we need to change.
During periods when our needs for control become extreme, our dreams
may depict frustrating and even fearsome situations where we cannot
control anything.

Imagination dramatizes, exaggerates, and inverts. It sometimes helps
by giving the appearance of hurting, and all of these enactments are, as
Jung said, purposeful. They help us to look more deeply and creatively at
our lives. Dreams take our personal struggles with control and give them
an archetypal dimension, linking our solitary experience with larger
mythic patterns. There is healing in the realization that we are not alone
and that our tensions are part of world experience.

Enigmatic dreams infuse our lives with mystery, making us aware of
the limits of reason. Rather than trying to solve the mystery or explain
what it means, I strive to become more aware of it, more appreciative of

its imagination and the fascination that it brings to me. These expressions of imagination are complete within themselves. We need to spend more time and creative energy getting to know them, rather than attempting to reduce them to pat concepts or solutions. There is so much more to life than explanations, and dreams can help us live more fully if we accept their invitation into the imaginal realm. Imagination heals by putting our lives into a larger and richer context, by connecting us to powers and creative sources that go unappreciated in our lives.

## HOW DOES IMAGINATION OPERATE?

Creative vitality can be viewed as a condition in which all of a person's or a community's resources simultaneously generate stimuli and insights without necessarily following a logical or linear sequence of actions. The imagination is the intelligence that integrates and guides the creative transformation of what some might perceive as an unlikely mix of participants. In 1804 the German novelist Jean Paul Richter described the imagination as the "faculty of faculties," likening it to the process of pollination: "In genius all faculties are in bloom at once, and imagination is not the flower, but the flower-goddess, who arranges the flower calyxes with their mingling pollens for new hybrids" (1973, 35). Always open and receptive to new possibilities, imagination is the conductor of creative action, forging fresh links between previously separate entities. Imagination encourages the creative interplay of diverse forces both within the individual psyche and among people in groups.

Richter's sense of the imagination, generally accepted at the beginning of the nineteenth century, grew from a century and a half of philosophical discourse in Germany and England. In the mid-1600s, the pragmatic philosopher Thomas Hobbes proposed that imagination is a connecting power that functions organically rather than by mechanistic chains of thought. In Hobbes's view, the formative power of imagination integrated all faculties and ways of knowing—the arts, science, reason, perception, memory, and emotion.

Empirically minded Hobbes and the mystical Romantics alike viewed imagination as a mediating intelligence. In 1744, the English poet and physician Mark Akenside described the imagination as a "middle place" between perception and reason. Likewise, Samuel Taylor Coleridge, poet and leader of the British Romantic movement, emphasized imagination's

role as an "intermediate faculty" (1907). These descriptions of imagination suggest a state of consciousness in which multiple perspectives and participants can meet, influence one another, and create new patterns of interaction.

During the twentieth century the intelligence of imagination has been overlooked by education and psychology in spite of the testimony of such luminaries as Albert Einstein, who declared that "imagination is more important than knowledge." Our increasingly complex modern lives give new relevance to the idea of imagination being capable of gathering and fusing infinitely variable materials and ideas.

The vitality of the imagination is frequently experienced within groups and communities that are given the freedom and support to create, and in which the energizing forces of creativity act upon the participants. As the Romantic poets observed, an environment where "flying sparks" pass among people and ignite new ideas furthers the life of imagination. This interactive and participatory dynamic also occurs within the individual imagination.

We speak often about the creative imagination as the basis of genius in the arts and science, and of happiness in daily life, but little has been written about this intelligence in psychological literature. What has been published often bears no resemblance to the actual experience of imagining. Perhaps this is because psychology and imagination are based on very different languages and worldviews. The latter requires a constant flight outside the limits of what currently exists, and the former exemplifies the methodical rigors of operating "within the lines" of currently accepted inquiry. The sequential patterns of conventional psychological thought simply do not correspond to the more circuitous and paradoxical ways of imagination. Conventional dichotomies, such as the split between reason and intuition, polarize the study of the creative act. Psychology imagines itself as an empirical and analytic science, and it is not surprising that it is reluctant to recognize and seriously investigate an intelligence located beyond its current sphere of activity. Imagination's identification with fantasy has no doubt contributed to its marginal status as an object of research and its complete exclusion as an accepted tool of inquiry.

Edith Cobb, author of *The Ecology of Imagination in Childhood* (1993), theorized that when people enter into "reciprocal relations" with the natu-

ral world, they access creative energies that are generated by the ecology of forces moving within environments. She perceived the space between the individual and the object of desire as the realm from which "imagined forms" are created by the instrument of "mind" (p. 56) through the "power of creative synthesis" (p. 80). In Cobb's view, imagination is the interplay between the individual person and the "otherness" of the external world, and our private reveries freely make use of perceptions of the natural world as sources for creative play.

## A MIDDLE REALM

Imagination is a "middle realm," where the interplay between inner and outer worlds takes place. It is an open and dynamic zone where narrow fixation is discouraged because it interrupts the ecology of creative relations and dulls a person's sensitivity to new influences. The middle realm is not a static center of equilibrium and is not to be confused with a tepid "middle of the road" stance or with compromise. Gathering the strongest possible elements and allowing them to interact freely within a safe environment, the imagination integrates and transforms ideas into new relationships.

Imagination's middle realm is thoroughly immersed in the experience of the world but open to new perspectives, unfettered by fixed ideas, and always longing to create anew. It is a kinetic and dynamic area corresponding to the ancient Celtic conception of "thin places," where movements between matter and spirit occur with relative ease. Being in the intermediate realm of imagination can also be compared to what athletes experience when they are "in the zone." There is a relaxed but totally focused flow from one thing to another. As with the aesthetic perception of beauty, the person is wholly engaged and detached at the same time.

The middle realm accepts contradictory principles, encouraging their individuation while enabling them to interact with one another and find a creative way of integrating their energies. There is no attempt to take the edge off a strong position within the middle realm. However, identification with one aspect of an oppositional relationship is discouraged. As soon as the mind becomes fixated on a singular position, it loses the ability to see the creative interplay and benefit from it.

The absence of an intermediate realm between polarized positions can create a tight squeeze that is both restrictive and dangerous. When there is

little room between opposing positions, each is likely to perceive the other as a threat, rather than as a partner in the larger interplay of creation.

The most polarized people probably cannot imagine life without their discontents, cannot conceive what they would become without their self-defining antagonisms and fears. Letting go of the adversarial relationship is a fundamental threat to their existence and power. The middle realm is committed to stepping away from one-sided insistence. Rather than stifling conflict, it embraces William Blake's notion that progression requires a free exchange among contrary positions. They need one another in order to exist.

### TYPES OF REALITY

It might be asked whether there is an "unreal" aspect to the workings of imagination. For those who see imaginative reverie as simply another form of reality, a distinctly imaginative presence that can be distinguished from the structure of physical things, there is a constant need to differentiate the varied types of reality. The conventional view of reality is limited to so-called facts and hard data verified by the perceptions of "reasonable" people. In my work at a state mental hospital in the 1970s, I observed that patients labeled psychotic or schizophrenic were caught in a bind when it came to self-expression. Contents that they presented in their art or in their conversations that deviated from the most literal definitions of the external world were often viewed as confirming that they were out of touch with "reality."

It seemed natural to me to view a person's inner experience as simply a form of reality that differs from what exists in the material realm of consensual experience with others. When a patient made a painting or a poem expressing personal feelings, they were creating reality within the context of their individual relationships with the media. The experience of psychosis, approached as a disorder of imagination, involved an inability to distinguish among the different aspects of reality that might be interacting with one another in a particular situation.

The mind is disoriented by psychosis and unable to move from one type of experience to another in a way that is congruent with the experiences of other people. A person afflicted by this condition no longer makes the subtle distinctions between inner and outer experiences that characterize healthy relations with the world. In psychosis the purely imaginal, but nevertheless real, phantoms of the inner world are experienced literally, as

though they were material beings existing in the external world. Perhaps the one-sided belief that only "hard data" are real is equally out of touch with reality.

This dichotomy between the real and unreal is obviated in the middle realm, where different vantage points on experience are welcomed and where emphasis is placed on the ability to differentiate among various types of reality. The intelligence of imagination skillfully moves among worlds, gathers resources, and integrates them into new creations.

## CREATING SPACES THAT ACT ON PEOPLE

My experience affirms that healing energies will always find their way to areas of need within a person or group. The defining attribute of the creative imagination is its ability to operate outside logical thought and operations. Discoveries, insights, and changes occur through the "complex" of imagination, which integrates and sometimes makes use of unlikely sources. The first step in accessing the medicines of imagination involves the creation of spaces for practice.

In ancient Greece, people went to the temple of Asclepius to sleep and seek healing through dreams. The dedication of the temple space to this purpose no doubt focused the energy of the worshipers, heightening the significance and power of their dreams.

When it comes to the use of the arts and other intentional activations of creative imagination, we discover that environmental structures, timelines, and even constraints have an important influence on expression. The realm of imagination is not without strict organization and expectations. An artist friend of mine carefully organizes her creative space. "I can't create in a chaotic place," she told me when I was visiting her studio. "I need order, a certain predictability that grounds me and lets me go wild in my expression."

Therapeutic and healing spaces are established with the goal of providing safety and support, together with the spaciousness needed to engage challenging emotions. Within the imaginative state of mind, we connect with problematic situations and fears in new ways and use them as sources of creation. As people immerse themselves in the creative process, the environment generates energies and ideas that cross over from one realm to another. Creations are contagious. Results achieved in one area can spread beyond its borders to any other domain of creative discovery. We enrich the process of creativity with diverse in-

gredients and the ability to let them interact freely, always trusting that the intelligence of imagination will find its way through the most challenging situations.

Creative imagination is a very real energy of the body and spirit, passing from one place to another via inspiration; it can sweep through a group like a pulsating musical rhythm. The transmission of imagination cannot be encapsulated in the planned outcomes of linear causes and effects. The life of imagination is based upon an unpredictable flow of ideas and the creation of new relationships.

The creative imagination is propelled by the urge to cross over from one object of contemplation to another. The deterrents of imagination are mechanical guidelines imposed on thought and expression. Imagination does its best work in disciplines such as the arts, where rigor is wedded to sensitivity.

In reflecting on how people come to creative insights, the psychoanalyst D. W. Winnicott, known for his work in establishing safe environments for personal discovery, describes "how much deep change" was "prevented or delayed" by his interventions. "If only we can wait," Winnicott said, "the patient arrives at understanding creatively and with immense joy, and now I enjoy this more than I used to enjoy the sense of having been clever" (1981, 25).

Those of us who are committed to enhancing creativity in the world need to focus on making environments and caring for them in a way that allows imagination to do its work. This task requires a new kind of leadership, one that cultivates and prepares a space, but then knows how to give freedom of expression and support to others and allows unexpected forces to emerge and complete themselves. It is not enough to simply say to a person or a group, "Take this time to imagine and create." We need reliable, safe, and inspiring places that will promote the growth of imagination. I am convinced that the deepest forms of healing will emerge from the creation of these environments, but only if we have the ability to let go and open to the unpredictable workings of imagination.

**REFERENCES**

Akenside, M. 1744. *The pleasures of imagination: A poem in three books.* London: R. Dodsley.

Coleridge, S. 1907. *Biographia literaria* (1817), ed. J. Shawcross. London: Oxford University Press.

Cobb, E. (1993). *The ecology of imagination in childhood* (1977). Dallas: Spring Publications.

Richter, J. P. 1973. *Horn of Oberon: School for aesthetics.* Detroit: Wayne State University Press.

Winnicott, D. W. 1981. In Davis, M., and D. Wallbridge. *Boundary and space: An introduction to the work of D. W. Winnicott.* New York: Bruner/ Mazel.

# 24

## Surrender to the Rhythm

> *I know what the answer is: it is to give up, to relinquish,*
> *to surrender, so that our little hearts may beat in unison*
> *with the great heart of the world.*
>
> —*Henry Miller*

**TIME TRAVEL**

In preparing this book, I revisited a paper called "Metaphysics of Rhythm," presented in a symposium at the 1980 American Psychological Association (APA) Annual Convention in Montreal. I had great hopes for this presentation, but there was little response. To the world of psychology my ideas about healing rhythms seemed esoteric. Even in my studios people often wondered aloud why I used drums and painting together. There is a pervasive sense that an art studio, the primary place of my practice, should be concerned with making art objects and then talking about them. But as soon as the drumming begins, people experience how it helps them paint more spontaneously; and when I stop for a break they miss its presence. Those who at first resist the rhythm of the drum, mbira, and other instruments are often the ones who ultimately find it most useful.

After the APA presentation I continued to use rhythmic expression as one of the most fundamental elements in my studios. I describe to studio participants at the beginning of our work how rhythm will help them to express themselves with their bodies and not just their minds. I encourage them to set aside mental judgments. "Let the source of expression flow

down from your head and into your whole body," I say. "You can't use all of your resources when you stay in your head, disconnected from everything else. Express yourself rhythmically, from the body, and let your thoughts go."

Expression emerges from the body, from movement, from our rhythmic engagements with materials, places, one another, and the world. Over and over again I discover in my studios that this rhythmic immersion in the streams of expression is the primary source of change, renewal, and revitalization in people. Art heals through the making and circulation of creative energy, and rhythm is the wellspring.

## HEALTH AS RHYTHMIC FLOW AND TRANSFORMATION

The principle of rhythmic well-being is validated historically by different cultures. The striking consistency of the healing practices found throughout diverse regions and historical epochs reflects the universal ability of rhythm to express and work with the life energy of individuals and groups. Dionysian rites in ancient Greece symbolized the universal cycle of life, death, and rebirth as it corresponds to the procession of the seasons. Heraclitus spoke of eternal flow and becoming, while Eastern cultures past and present have viewed health as a rhythmic movement of energy through the body. Illness, as discussed in chapter 22, is attributed to blocked energy, and the healing process focuses on restoring its free circulation. Mystical traditions throughout the world link the flow of life energy through the body with the larger movements of nature and the heavens.

The artist's flow is one of transformation and release. Like medieval European alchemists and aboriginal healers in all regions of the world, the artist goes into other realms of experience to free the soul. Indigenous healers viewed illness and emotional disturbance as an abduction of the person's soul by evil spirits. With the soul separated from the body in this way, there was a loss of fundamental life rhythms. The goal of treatment was the retrieval of the soul and the reunification of body and spirit. Throughout history, shamans and native healers have used group enactment, chant, rhythmic music, and movement as sources of power enabling them to travel and mediate between spiritual and earthly realms. These group rhythms evoke precisely the vital and rhythmic conditions the healer seeks to instill in the person being treated. Medieval alchemists envisioned the soul as gold imprisoned within base matter. Alchemical ritual thus had as its goal the transubstantiation of "sick" metals into substances of value, and

this process was viewed as corresponding to transformations that occur within the human spirit. Aboriginal and contemporary artists alike view themselves as freeing the spirits that lie within the materials they use, whether these are paints, ceramics, found objects, musical instruments, or the body of a dancer moving in space. And today, as we try to access our personal creative expressions, the soul is imagined as locked inside a self that does not realize its potential for expression.

Though the metaphors used for the soul's prison change according to the values and mental set of a given era, they retain essential similarities. The abducted soul, the lost soul, the soul imprisoned within inanimate matter, the soul bridling against an exploitative society, the soul immured within the self—all are expressions of how things are not right when the rhythmic flow of life is restricted, when we are not creatively transforming our environments and ourselves in ways that correspond to the natural rhythms outside and inside our bodies.

Throughout history, well-being has been linked to the ability to use adversity as material for creation. As Nietzsche wrote, "Unless I can discover the alchemical trick of turning this muck into gold, I am lost." Art is alchemy. It makes one thing from something else. It takes the worst experiences and turns them into life-enhancing expressions.

### LOST RHYTHM

When the rhythmic flow of life through an individual is interrupted or blocked, the consequences are tension, depression, and an overall loss of vitality. The tension created by this blockage is important in its own right, for it is the fuel that drives future transformations. There is thus an ebb and flow in the maintenance and loss of rhythm. Acute emotional disturbance results when a person can no longer transform tension and becomes overwhelmed.

Throughout my years of involvement with the mental health field, I have felt uncomfortable with definitions of psychosis that emphasize how people thus diagnosed "lose touch with reality." Descriptions of this kind presuppose that there is a clear and consistent definition of "reality" that is universally accepted. In my experience the nature of reality is far more complex. Throughout history, and particularly in the modern age, the number of perspectives and epistemologies have proliferated, both among and within people. Many of these are apt to conflict with one another, leading to hostile confrontations on small and large scales. This

fundamental nature of perceptual and conceptual bias has been over-looked by linear psychological theories, which cannot contain and creatively orchestrate the contradictions and complex interplay of reality.

Rhythm, however, can accommodate these multifarious contents and conflicting elements. Within the context of rhythm, the contrary forces and counter-rhythms are necessary; they contribute to the overall quality of the creative mix. Like an effective leader, rhythm holds the tension and maintains the dynamic interplay among the participants. It does not divisively pit one aspect against another as verbal argument does. Flowing within a rhythmic meter, differences are welcomed: they create together and augment one another.

My experiences with the arts have consistently shown that rhythmic expressions in all media bring about feelings of well-being. A person who feels agitated or tense before making art invariably feels relaxed and revitalized by rhythmic expression. The same cannot be said about painting, creative writing, and other art forms whose very process of creation can sometimes cause turmoil. The disturbing aspects of art experiences play a necessary role in the healing process, which often requires upheaval in order to bring new insights and change. Yet rhythm, even in its most intense and driving forms, is a reliable mode of integration. It draws things together into a steady pulse.

Although I regard with suspicion many conventional mental health beliefs and diagnoses, I have observed firsthand the chaotic reality of psychosis. But instead of perceiving severe emotional disorders exclusively as some kind of chemical imbalance, I see them as resulting from a fragmentation of essential life rhythms. The chemistry of the body, just like a person's creative energy, emerges from a primary rhythmic pulse. From the tempo of breath to the movements of water and planets, rhythm is the palpable basis of nature's reality.

Psychosis and mental disturbance can thus be viewed as an acute loss of synchrony with the ongoing rhythm and flow of nature. The individual loses the ability to act in a rhythmic and focused way in relation to the self, others, and the environment. In the case of psychosis, these rhythmic and perceptual powers are overwhelmed by a cacophony of sensations. The person becomes a chaos of emotions, and the rigid bodily expressions that one observes in a person experiencing psychosis are attempts to hold this *massa confusa* together.

In my work with people afflicted by psychosis, I often found that their

agitation and confusion would temporarily lessen when they became immersed in rhythmic expression. However, some floridly psychotic patients were beyond the reach of this relaxation.

The disruption of life rhythms is not a phenomenon endemic to psychiatric patients. In the lives of "mentally sound" people, obstacles to fluid and rhythmic expression include excessive perfectionism; fears of risk, uncertainty, and spontaneity; muscular rigidity; and an inability to respond creatively to change. All of these militate against the fundamental flow that I have described. They shut down the natural and rhythmic movements of expression.

The best way to loosen the grasp of these constraints is to practice a rhythmic discipline. The mode of practice can be as simple as breathing together with mindful and rhythmic walking. The use of percussive instruments and voice can amplify the effects of rhythm through the vibrations of sound and body movement.

I have found rhythm to be unique in its ability to generate feelings of well-being. Yet I often feel unwilling to let myself drop from my present state of mind into the flowing current of rhythm. This happens even though I know, based on extensive past experience, that I will feel better when I surrender to the rhythm. Arising from the universal fear of change, resistance to beneficial and healing expression happens to all of us, whether we know the process intimately or are being introduced to these experiences for the first time.

Even within the supportive and stimulating environment of my art studios, people often have difficulty moving in free and rhythmic ways. Their minds are full of bad memories, expectations, judgments, and feelings of inferiority that block the flow of creative expressions, which potentially can be as effortless and fluid as breathing. But when the rhythms of our minds and bodies are obstructed, even the simple process of breathing freely becomes difficult. If we can use breath as a starting point, it will provide the foundation for a more complete experience of healing rhythm.

**BREATH AS A BASIS**

The life rhythm is never static or completely constant. It changes from moment to moment, flexibly adapting to the peaks and valleys of our experience. An important key to health lies in simply becoming aware of each instant, relating to it, and surrendering to the changing flow.

The arts serve as intermediaries between the rhythms of the body and

those of nature. The pulse of creatures throughout the world, the sounds of the sea and of the woods at night, the cycles of the moon—all confirm the existence of what I call the "metarhythm" of life, the rhythm that exists behind all others. Emotional vitality depends on our ability to become synchronous with these rhythms. Just as rhythmic fragmentation characterizes psychosis, rhythmic synchrony characterizes health. The enduring power of the arts can be attributed to their ability to heighten the essential rhythms of life, to bring them to a more complete level of awareness and community participation.

In my work and personal life I constantly see how the process of breathing rhythmically and mindfully in the present moment is the basis for the healing powers of rhythm. I became aware of this truth as I listened to the audio teaching sessions of Thich Nhat Hanh in my car. I was struck by how this master teacher spoke only of such apparently simple methods as observing oneself breathing in and out, attending to the present moment, and walking with precise awareness of the lift, swing, and fall of one's feet.

I broke out laughing at a stop light in heavy traffic—Thich Nhat Hanh encourages us to welcome red lights like meditation bells that call our attention to the present moment—and realized that he keeps saying these things over and over again because although the method is simple, it is difficult for most people, including myself, to do. Listening to the rhythm and tone of his voice, I began to realize that the way he expressed himself may have been having even more of an effect on me than what he was saying.

When I relate the practice of mindful breathing to what I do in the art studio, I see a common emphasis on simplicity, repetition, and rhythmic flow. I am always saying to my groups:

The simpler, the deeper.
Don't try and do too many things.
Try not to think about what you want to do before you do it.
Start where you are with a simple movement and stay with it.
Be as present as you can to the qualities of the movement; let the
    next movement emerge naturally from it.
Don't be concerned with cleverness; be as authentic as you can with
    your movement; immerse yourself in it completely; let it take you
    where you need to go.
Trust the process, it knows the way.

Creative discovery is not planned in advance.

Breathe with the movements; repeat the simplest gestures and marks and watch how they naturally vary themselves and expand your expression.

Breathe with the tensions and they will find their way to transformation. Let the rhythm take you; surrender control to it.

Feel deeply into the rhythm of your movements; listen to what they have to say to you.

Paint from your body and relax the mind's control.

Expression is a stream that never stops; let it carry you; there is nothing to grasp; everything is already in the stream if you can open to it; let it lead you.

Welcome your chaos, your fears, and your resistance—they are signs that you are getting close; let the rhythm emerge from all of them.

Stick with the process.

The images never come to hurt you; get to know them better; the disturbing images are trying to get your attention.

We hurt ourselves when we panic and lose our breath.

When you get frightened, balance your body and focus on your breath. Your breath will keep you safe and it will always carry you to where you need to go.

Listen to your breath and your body's simple movements and don't chase after all of the expectations in your mind.

Watch out for too many thoughts.

Stuck is being somewhere other than where you are.

Like meditation students, people in the art studio constantly need to be reminded to return to the most basic and rhythmic elements of the process.

Adult beginners in my studios typically start paintings by making bold and free gestures when I urge them to just move with the paint in a repetitive and rhythmic manner and to let the movements of the brush emerge from the whole body and in sync with the rhythm of the drum that I play. But, after these bold beginnings, many people shift to tighter and more conceptual images. I have to keep repeating the importance of returning to and sustaining the rhythms of the most natural and personal movements. For these are what will take us to new and rich places in our expression.

Performance art, movement, poetry, and vocal improvisation also show

# Using New Media to Expand Creative Expression

Since the first years of my practice I have maintained active involvement both with traditional art media and with newly developed modes of expression. In the early 1970s I collaborated with the Addison Gallery of American Art at Phillips Academy in Andover, Massachusetts, to offer a museum-based art therapy program in which the artistic use of videotape played a primary role. We integrated video and photography with our use of more traditional media and expressions in the other arts, with each medium making its unique contributions to the overall environment of the studio.

Over a six-year period we offered hundreds of sessions to children and adults from various mental health programs. Our work revealed that videotape, albeit a fascinating and flexible medium, was most powerful when integrated with other artistic media. Video and photography make it possible to encounter not just a finished painting, sculpture, or other artwork, but to document and contemplate the artmaking process itself.

"Video Enactment in the Expressive Therapies" was futuristic when it was originally published in 1981, and perhaps it remains so today. The spirit of exploring new media persists with little

modification even as the technologies dramatically change. Jerry Fryrear, one of the editors of the book that included this essay, together with his colleague Irene Corbit, and others have pioneered the use of new technologies in art therapy. Thus I have been fortunate to have a community of collaborators in advocating the use of the widest possible range of artistic media.

The activities we did with groups during the 1970s are surprisingly in sync with what I am doing today. The values and methods presented by this formative work have changed very little over the years. In some ways I can see myself always striving to stay close to the authenticity of the original vision. My collaboration with Christopher Cook and his staff at the Addison Gallery of American Art, together with the participation of our team of graduate students from Lesley University, enabled me to bring the private and solitary work that I was doing in the art studio of a mental hospital to a larger community, whose support and resources dramatically advanced the acceptance and credibility of my work. The program received international attention and was featured in the 1977 book *The Art Museum as Educator.*

The presence of videotape in the sessions that I led during this six-year period seemed to naturally elicit creative expression in all of the arts. Dance, dramatic enactment, vocal expressions, and the reading of poetry always seemed to just "happen" as a way of creatively interacting with the camera. These spontaneous instances of total expression have had a life-long impact on my practice of art therapy. This chapter also shows how the process of using the camera was itself an important form of artistic expression within our group. Whereas prior experiments with video in therapy focused on the use of stationary camera perspectives, our video-making was thoroughly artistic, conceiving of the person behind the camera as part of a community of artists in which each person makes individual contributions to the whole.

Over the past decade my experimentation with technology has embraced computers. Digital cameras have brought a new immediacy and flexibility to artists' efforts to reflect aesthetically on their environments and interactions with others. In my personal work the digital camera has been especially useful as a tool with which to record and store images, document the process of creating an image, and share my creations with people in distant places. To my delight, digital imagery makes high-quality color images immediately available, providing an alternative to color print-

ing in conventional forms of print publication, which can be prohibitively expensive.

The art therapy field has not even scratched the surface of the possibilities and opportunities offered by digital imagery. From my initial explorations I can attest to the importance of these new technologies in relation to art and healing, and I urge my colleagues to experiment with them and research their use in healing.

Many of my colleagues keep technology at bay, feeling that it cannot match the benefits of working with the more sensual media of paint, clay, body movement, and so forth. In addition to the phobic reactions that many people have to new technologies, there exists a strong anti-technology sentiment among many members of the art and healing community. These people feel that sensuous experiences with the arts are an antidote to the alienating effects of our technological culture. While embracing the sensuousness of artistic expression and the traditional methods of art, I encourage my colleagues to expand their vision of creative activity and to realize that all the different forms of expression can have a place within our community.

I wrote "A Virtual Studio" in 1999, when I was immersed in the process of making paintings on a computer and working in a community that offered me many opportunities to explore and learn about the digital realm. I discovered new dimensions of color, brightness, graphic flexibility, and expressive spontaneity by painting on a computer with a mouse. The tools of the computer augmented and complemented what I would normally do within the studio and gave me the opportunity to make serious art within the compact world of a small machine. For those of us who do not always have easy access to the studio, the computer offers an intriguing alternative that can keep us close to the creative process wherever we find ourselves.

Computer technology holds enormous potential to make the creation of art more accessible to people who cannot physically work with traditional media. New technologies are making it possible to craft images with bold gestures and colors through the movement of a single finger or of any other source of movement in a person's body. People previously denied access to certain forms of artistic expression can now become involved as a result of new technologies and the ongoing efforts of the universal design movement to place computers within the reach of all people.

I urge us all to cultivate an ever-expanding relationship to art and its healing powers. The future vitality of our work is inseparable from our willingness to be changed by the materials and experiences of artistic creation. The promise of the digital realm lies in its ability to enhance the classic and abiding medicines of the traditional studio, whose materials, smells, objects, images, and general ambience of creativity remain the primary source of healing for me and the people with whom I work.

**25**

*Video Enactment in the Expressive Therapies*

During the early 1970s, Christopher Cook, director of the Addison Gallery of American Art at Phillips Academy in Andover, Massachusetts, became intrigued with the art therapy program that I was coordinating at Danvers State Hospital. After organizing a major exhibition of the patients' art, he wanted to become more involved in our work and make the museum environment of use to the various mental health centers in its community. At that time Addison Gallery was a leader in showing the work of artists working with new media and art ideas. After experimenting with the use of video in our hospital art therapy groups, Cook thought that a museum-sponsored video art therapy program could offer a new service to neighboring hospitals and clinics and involve the Addison Gallery with its community in a bold new way. He was also interested in working with me to research the artistic application of video to therapy. We believed that a creative use of the medium could greatly expand the role of videotape in psychotherapy, which at that time was quite narrow and conventional. As a result of this collaboration, I had the unique experience of having virtually every expressive therapy session that I conducted over a six-year period (1973–1978) recorded on videotape.

The Addison Gallery program provided extraordinary opportunities for research. Every week we had at least two Portapaks, the predecessor of

today's camcorders, available for our use. The gallery also hired a skilled videotape operator and editor to work in cooperation with our expressive therapists. In addition to these technical resources, we were able to save all of the significant tapes that we made over the six years for the purpose of studying the development of our work. The attractive environment of the museum and the outside grounds of the academy were supportive of artistic approaches to video. This visually evocative context helped to inspire artistic responses within our expressive therapy sessions. Virtually all of our work was done within groups. With the assistance of graduate student interns from Lesley University, however, we were able to also work individually with people. Since the Addison Gallery program has been documented within the book *The Art Museum as Educator* (Newsome and Silver 1978), attention will be focused here on the general operational principles that we discovered about the artistic use of videotape in therapy.

### SELF-CONFRONTATION

As with many other forms of video therapy, a fundamental element of our expressive art therapy work was the process of self-confrontation by client and therapist alike. The basic emotional response that most of us have when engaged with videotape is the feeling that we will be "seen" by others and by ourselves. This anticipation tends to arouse the emotional polarities of self-disparagement and self-interest. We are either attracted to the monitor, as Narcissus was to his mirror image, or we find it very difficult to look directly at our behavior. Although there might occasionally be a person who encounters his or her videotaped self-image with dispassionate objectivity, I only rarely observed this in working with hundreds of clients, graduate students, and professional clinicians. Videotape playback arouses strong emotions in virtually all people who are unaccustomed to seeing themselves on a television monitor.

Self-confrontation is the basis of video therapy. The immediate replay of real-life process made possible through video technology allows this confrontation to happen in a way that cuts through verbal defenses, perceptual denial, wishful and idealized self-images, and inaccurate perceptions of group process. Because of its ability to forcefully penetrate a person's defenses, videotape self-confrontation can be a threatening and potentially shattering experience. This threat makes it essential to consider how the medium can be introduced gradually and with respect for the feelings of clients as well as therapists.

The arts offer many opportunities for desensitizing people to videotape by progressively introducing them to different aspects of self-confrontation. We will often first expose people to videotape by recording hand movements during a dance therapy session, or by showing hands at work creating visual art objects, writing, or making gestures during a conversation. Typically, people's curiosity and desire to see more are sparked as they find themselves trying to determine whose hands are being shown and as they watch for their own. For the person who is intimidated by a camera, hand gestures tend to be less threatening and less difficult to express in a graceful fashion. We have found that this first exposure to videotape inspires most people to become more aware of the nonverbal communication and expression constantly taking place within the group.

Participants must feel validated, especially in the initial stages of this work, if they are to participate spontaneously in the videotaping of the ongoing expressive therapy process. Therefore we have our first sessions recorded by a skilled cameraperson who understands the video therapy experience. To foster familiarity and comfort with this medium of self-analysis, we try to avoid confronting people with less desirable behaviors in the beginning sessions. Too much emotion early in the process makes it difficult, sometimes impossible, for people to sort out and understand their feelings. In our first sessions we try to emphasize the supportive role of videotape. We use it to validate expression rather than to create further inhibitions and obstacles to artistic spontaneity. Throughout all of our experiences with videotape, we have consistently found that the playback procedure intensifies the emotional process either positively or negatively and that these feelings become the content of the discussions we have when viewing the tapes.

The self-confrontation of the therapist during the video therapy experience is as real as that of the client. Within an expressive arts context, therapists have the opportunity not only to evaluate their personal behavior but also to assess their effectiveness in either furthering or inhibiting the artistic self-expression of others. Observing myself working on videotape year after year had a profound impact on my self-learning. The videotape playback allowed me to closely study my facial and bodily expressions when interacting with people in both comfortable and stressful situations. I was also able to evaluate my tone of voice, the texture and rhythm of my speech, and the continuity of my behavior from session to session. Videotape provided the opportunity for a very intense

and penetrating form of self-supervision that confronted me with both unattractive and effective aspects of my style of interacting with others, traits that conventional forms of supervision and training had not addressed.

## THE ARTS AS VIDEO SUBJECT MATTER

Within my expressive therapy work, videotape has primarily been used in the service of the other arts. Dance/movement therapy, music/sound therapy, dramatic improvisation, and other, more process-oriented expressive therapies can be greatly assisted by videotape. Through the playback experience we can evaluate behaviors and time-dependent experiences that before the introduction of recording media could be reviewed only in our self-edited memories.

Because the expressive arts therapies are based in the physical movements of the body acting alone or together with others, they have benefited extensively from videotape recording. Videotape has also served as a bridge between the different arts, integrating movement, language, sound, and visual expression into the video enactment. Therapists who are recording only the verbal interactions of clients and therapists within conventional psychotherapeutic procedures can greatly extend the scope of self-confrontation and observation by engaging other expressive modalities.

The many forms of expression exhibited within a brief videotape of an interpersonal interaction present an extensive body of information. The research of William Condon (1966), who isolated individual film frames of behavior to trace the body messages that are given within otherwise unexamined expressions, has shown that careful scrutiny of short intervals of the film/video recording will reveal important information about the individual.

I have often felt that a ten- or fifteen-minute playback to a small group of people can present an excessive amount of perceptual data for analysis, and we have had to select certain aspects of the tape upon which to focus our attention. This ability of videotape to offer extensive and ever-different information perhaps accounts for why our groups using the equipment in session after session rarely tired of the playback experience. We have worked with chronic adult hospital patients who, after six years of video therapy experience, still find the process to be of personal interest. As therapists, we find that the videotaping of sessions is an ongoing form of self-learning and that over time both clients and therapists have become more

perceptive in viewing the playback of their expressions and interactions with others. Our lives are constantly unfolding, and videotape offers us a mirror in which to view the process of expressive therapy and enhance it.

## THE RITUAL OF PLAYBACK

Viewing tapes of our group activity was an intimate ritual that over time became the focal point of our work together. The playback structure offered a reliable and predictable time during which we could view and reflect upon what we had done within the studio session. We knew that even if we went off and worked completely on our own, the camera would probably record some aspects of our artistic expression that could be shared with the group.

Playback became a lively mode of group communication and a dependable closure for each meeting. We routinely began our group sessions by coming together to introduce visitors and discuss the various art activities that we would be doing on that particular day. The group then broke down into subgroups that pursued different forms of artistic expression. Some people would choose to work alone. After an hour or more of artistic activity we reassembled to view the playback. The videotape became an important reinforcement of group identity and cohesion; no matter how separate our individual activities were, we all contributed to the more general artistic and interpersonal process that was unified through the playback. For a person working in a music or poetry subgroup it was gratifying to be able to watch the dance, dramatic improvisation, and visual art activities of group members who had worked in a separate room.

Playback took on a particularly significant role in our larger groups of adult clients. Some sessions would involve twelve to thirteen clients, six to eight graduate student interns, the group leader, and a video technician. In these large groups a video summary of the day's activity, using descriptions of group interaction as well as intimate close-ups, helped to bring individuals in touch with each other and the group as a whole, in a way that was not possible through discussion within a relatively limited amount of time.

The structure of our sessions enacted the mythic cycle of separation, penetration, and return. Within this schema the playback was a rite of passage that helped participants make the transition to closure and a return to group consciousness after individual artistic activities. In this way we were able to reinforce both individual and communal expression. We would usually discuss the playback experience and focus our attention

on those situations where the videotape opened up feelings that needed further analysis and support. Often, however, discussion of the playback was unnecessary. The simple act of watching it as a group precipitated strong feelings of solidarity and community. During these silent play-backs we were visually and auditorily reflecting on our group experience. There were times when talking about what we were viewing, or what we had done, would have taken away from the intensity of the feelings that were provoked by the playback. I also found the discussion could in certain cases dull the impact of the aesthetically and emotionally moving expressions we were witnessing. There are clearly times when we need to be silent in response to an artistic expression.

### THE ART OF VIDEOTAPE

When using videotape within an expressive therapy context, the varied scope of artistic expressions—including body movement, sound, visual imagery, poetry, and enactment—necessitates that the videotaping process be pursued from an artistic perspective. When recording a session, the person with the camera is provoked by the aesthetic and dramatic action and must respond in a way that will absorb and transform this artistic emotion.

In his description of the Gestalt theory of expression, Rudolf Arnheim (1972) observes that perceptual forms are dynamic and contain expression within themselves. Applied to videotape, Arnheim's theory suggests that the perceptual quality, structure, and clarity of the image will determine its expressive impact. We have repeatedly discovered in our clinical work that the poorly organized, fragmented, out-of-focus, and rambling videotape not only fails to hold attention but also tends to elicit unsettling and negative feelings from the viewer. Conversely, the well-organized, aesthetically pleasing, succinct, and emotionally coherent tape stimulates a structurally parallel emotional response in most people, so long as the person is capable of sensitively perceiving these expressions.

Our experience shows that the quality of a videotape directly influences the quality of the response. Quality is gauged in terms of aesthetic coherence, emotional authenticity, and communication of the uniqueness of a particular moment, and not solely on the basis of technical proficiency. In light of our experience we place a large emphasis on the value of skill and artistic resourcefulness in creating videotape for playback.

Within these sessions we involve clients in the artistic process of creat-

ing videotape. When viewing the production of videotape as an art form, it is assumed that there will be differences in style, perceptions, and personal interests. What we omit in the recording of an experience can be as significant as what we choose to record. Videotape, like photography, projects viewpoints of individual artists and is far from being a neutral medium. This subjective element is often obscured by the presumption of objectivity that people associate with the technology. In creating a videotape, the artist selects from a variety of visual emphases—close-ups, distant shots, group activity and interactions, individual expressions, or a combination of all of these—and fashions a personal vision of the activities being recorded.

In light of the impact that a poorly produced videotape has on a group, we will often view the playback privately with clients when they are learning how to operate the equipment. Clients appreciate this private viewing, which allows them to refine their work so that they can become emotionally and technically prepared to exhibit their videotape recordings to the group.

Many clients will first become engaged with the relatively simple activity of operating a camera fixed on a tripod and kept in constant focus on an individual person or a group activity. This stationary-camera approach typifies much of conventional video therapy. A more demanding and artistic orientation to the medium involves the client in learning how to work with a Portapak, framing stationary and moving images, changing focus, adjusting light, and constantly accommodating the equipment to changes in spatial position. When working with a Portapak, in-camera editing and a more artistic approach to the composition of the tape are required. In my experience only a small percentage of our clients have gotten seriously involved in this more technically demanding dimension of videotape. The majority of clients appear to be more interested in self-confrontation and viewing their expression in various art modalities during playback. [The technology of the 1970s, when the essay was written, has been vastly improved and simplified, making many of these technical challenges obsolete.]

Within an expressive arts group of adult psychiatric patients conducted at the Addison Gallery of American Art, one of the participants became interested in the equipment and became quite adept in using it. After nine months of participation in the group as a client, he returned for three years as a volunteer. He recorded sessions and helped to demonstrate the

use of the camera and other taping units to clients and graduate students who were participating as interns. This man, who was in his early thirties, became involved with video by first observing his rigid and virtually catatonic behavior during playback. In subsequent sessions he noted how he was gradually able to become more expressive and spontaneous during group activities. At the beginning of his work with us, he complained of severe bodily pains that restricted his movement. When he began to use the camera, he observed how the pains subsided and disappeared as he concentrated on operating the equipment. This relief, together with his aesthetic and intellectual curiosity about the hardware, drew him into a serious artistic relationship with videotape recording. Every week he worked at improving his skill and took great pride in his increasing technical competence. Over time the pains no longer bothered him, and he became one of our most sophisticated and expressive video artists.

### THERAPEUTIC ADAPTATIONS OF THE MEDIUM

Working with severely disruptive children between the ages of eight and eleven, we discovered that the playback experience must be focused on the individual child if we are to hold their attention and use the viewing of the videotape as a way to help them control their emotions. When we showed tapes of group activities to the children, they would continually act out in a disruptive way during playback. In the beginning of our work, they could not relate to themselves as part of a group. We found sequential "portraits" of each child to be very effective in holding their interest. During playback they studied their own behavior as well as the individual mannerisms of the other children. We would at times have to resort to showing the portraits of the most unruly children at the end of the playback; the anticipation of seeing themselves was the only way to keep these children from interfering with the playback experiences of their peers.

The video portrait was also very effective with adults, albeit in a different way. We found that the portraits helped to create focus on individual members and differentiate them from the group as a whole. The portrait was extremely useful in allowing more withdrawn and silent members to communicate with the group. With a microphone clipped to their collars and their facial expressions being recorded in sensitive close-up shots, people who had never been truly heard and seen were given the opportunity to enter into a close relationship with the group.

## TECHNOLOGICAL SHAMANISM

There exists a striking and surprising congruity between ancient shamanic healing practices and the use of videotape in psychotherapy. In *Gates of the Dream*, the Hungarian anthropologist Géza Róheim identifies "the fundamental mechanism of the dream" as being "the formation of a double, the dream image of the soul" (Róheim 1979). Shamanism as a mode of healing grew from the enactment of dreams. Aboriginal communities believed that illness and emotional disturbances were caused by the estrangement of the soul from the body. During dream states the soul was perceived as leaving the body, wandering about as suggested by dream imagery, and returning again when the person awakened. If the soul did not return, personal difficulties would ensue, and the shaman was called upon to go in search of the person's soul. The standard shamanic procedure was the enactment of the person's dream, or source of conflict, with the shaman entering an ecstatic state that allowed access to the dream consciousness and the domain of the spirits who were holding the person's soul. Today we experience similar healing processes when we enact our dreams and interpret them through our bodily expressions. There is a much more complete sense of integration when we embody the dream.

I believe that much of the psychotherapeutic power of video therapy, particularly its more artistic and dramatic forms, derives from an essential similarity with shamanic practices. Videotape playback creates a "double" of the person's art, spirit, behavior, or whatever terminology one prefers to describe the action that is recorded on the tape. Similar to the practice of shamanism and the process of dreaming, the viewing of a videotape is often characterized by feelings of surprise, wonder, and magic. The videotape is a reliving of life experience, an enactment process similar to that of the shaman, who dramatically recreates an experience to make it alive in the present for group members.

Both the shamanic enactment and the videotape playback function as bridges between different spheres of consciousness, time, and space. They are intermediaries between present and past, linking our waking experience with our dream space.

The shamanic dimension is, in my opinion, the factor that separates the artistic and dramatic uses of video in the expressive therapies from more conventional approaches to video therapy. The expressive arts therapies allow for the experiencing of intense emotions within the supportive structure of art. The discipline of art safely holds the intensities of

feeling while furthering their external expression and communication to others.

Through videotape, expressive experience can become more completely visible to the self, and the process of playback allows our expressions to emerge into even clearer focus. As with dreams and dramatic enactments, videotape transforms the original experience and presents it from a new vantage point, in this case from the perspective of the medium as well as the person operating the camera. The perceptual dissonance between the video representation and people's memory of the event compels them to perform reality checks on their self-images and perceptions. We also learn more about the nature of reality and how it is linked to endless varieties of personal perspectives.

People who are fearful of confronting their self-image and who are afraid that the videotape playback will destroy the idealized identities that they have constructed for themselves usually experience discomfort when given the opportunity to view themselves. Others, who are truly open to self-observation and curious about the visual, aural, and kinesthetic configurations of their expressions, and those of other people, tend to become emotionally aroused and excited by the self-confrontational aspects of videotape playback.

The classic shamanic conception of the body separating from the mind or soul can be applied to video therapy. As with shamanism, video therapy provides imagery of bodily action taking place within another temporal sphere. The observing mind then experiences videotaped expressions within the realm of the present and it is also stimulated by television's magical transformation of time and space. I believe that this factor accounts for the invariable eagerness of clients to watch videotape playbacks of their behavior. The process of reflecting upon the playback, like shamanic healing, is focused on integrating the expressions of the body with the person's sense of self. The playback experience can thus be likened to shamanic soul retrieval.

The video playback can become a source of "empowerment" if the viewing experience helps the person to renew a sense of personal spontaneity and affirms a belief in the value of expression. But if the videotape reinforces negative self-appraisals and fails to validate the person's humanity, the reverse can happen.

The effectiveness of the videotape playback can be evaluated according to the same criteria that one would use to assess the power of the

shamanic enactment: dramatic coherence; emotional depth and honesty; aesthetic appeal; the ease with which the participant can identify with the action portrayed; and the extent to which the enactment parallels the emotional configuration of the dream, illness, or other condition being examined.

## THE FUTURE

At present, videotape plays an essential role in helping both clients and therapists to understand the psychodynamics of creative action in therapy. As the expressive art therapies continue to grow and reunite psychotherapy with its shamanic origins, videotape will assume greater importance because of its unique ability to let us relive the process of experience. Since our early experiments in the 1970s, advances in technology have greatly increased access to videotaping and simplified operation of the equipment.

Video is used not only in clinical practice and research but also as an essential component of supervisory and training programs for expressive arts therapists. Movement and dance therapists require videotapes of a person's work as part of the evaluation procedure for professional registration. Perhaps the other mental health professions will begin to show a similar sensitivity to the evaluation of a person's interpersonal skills in the licensing and registration procedures of psychotherapists.

As videotape becomes an increasingly familiar part of psychotherapeutic training and practice in all disciplines, greater emphasis will be placed on the artistic and creative use of the medium. Once the basic properties of this form of communication are understood, the future lies in the exploration of its expressive capacities. Videotape is only a means to an end. It is valued in relation to its ability to further the humanistic goals of our work in the arts and therapy. The danger of videotape and other psychotherapeutic technologies lies in losing this human perspective. Caution is advised in depending too much on technical tools as forms of therapeutic reinforcement and communication. Video therapy, like television, can become addictive and may encourage the kind of passivity that characterizes overdependence on television viewing as a substitute for personal expression. The value of videotape in therapy resides in its ability to serve art, communication between people, and personal insight. To the extent that its unique properties further these goals in psychotherapy, it cannot be ignored.

**REFERENCES**

Arnheim, R. 1972. *Toward a psychology of art.* Berkeley: University of California Press.

Condon, W. S., and W. D. Ogston. 1966. Sound and film analysis of normal and pathological behavior patterns. *Journal of Nervous and Mental Disorders* 143 (4).

McNiff, S., and C. Cook. 1975. Video art therapy. *Art Psychotherapy* 2 (1).

Newsome, B., and A. Silver, eds. 1978. The Addison Gallery of American Art: Video for special audiences. In *The art museum as educator: A collection of studies as guides to practice and policy*, prepared by the Council on Museums and Education in the Visual Arts. Berkeley and Los Angeles: University of California Press.

Róheim, G. 1979. *The gates of the dream.* New York: International Universities Press.

# 26

## *A Virtual Studio*

I am always exploring what media do within the process of artistic expression, how they affect us differently, what qualities they convey, how they influence the circulation of energy in spaces and in people, and how new media and innovative interactions among existing media improve practice. The emergence of computer technologies has ushered in a major expansion of the visual arts. Although the digital revolution has to date had its greatest impact on the commercial field of graphic design, independent artists are beginning to adopt the new media. Art therapy, frequently limited in its physical resources and generally conservative in its approach to media, has been slow to explore the opportunities offered by the digital era.

Computers facilitate a diverse array of expressive activities, including scanning and modification of images made in conventional art media, digital still photography, digital video, and so forth. But of greatest interest to me is the ability to create purely digital images by painting "with pixels rather than with pigment" (Evans 1999). In the early 1980s I experimented briefly with the black-and-white MacPaint program on the original Macintosh computer but found it limited and unable to convey the qualities of the artist's expression. Every image looked like it was made on

a computer. When introduced to Adobe Photoshop a few years ago, I was astonished by how far computer art programs had come.

For those unfamiliar with graphic art software, Photoshop is a program that offers comprehensive painting tools—brushes, colors, and other new image-making devices—as well as the capability to manipulate and alter photographs. The latter functions of Photoshop have been more widely used than the painting software. This trend, coupled with the program's name, have somewhat diminished public awareness of its painting possibilities.

In the commercial art field, Photoshop's painting function is often used in conjunction with the program's image-manipulation capabilities. Photoshop enables the artist to paint, draw, and add text on and around photographs, and it offers endless possibilities for collage. Digital cameras obviate film processing, therefore making it possible to immediately work with photographic images in Photoshop. Traditional photographic images are scanned from print or negative into the computer and then manipulated.

Digital cut-and-paste tools used in Photoshop have radically transformed the graphic design industry over the past decade. Painstaking and labor-intensive procedures of constructing images were immediately replaced by Photoshop, which makes everything about graphic design freer, quicker, and far less costly. Mistakes can be corrected in seconds with no loss of materials, creating time for artists to experiment with a greater range of ideas.

Photoshop gives me constant and immediate access to comprehensive painting tools that take up just a small portion of space on my desk. Digital artmaking in this virtual studio complements the work I do in my personal and art therapy studio environments.

The virtual studio will never replace traditional media, which have a sensate appeal that is eternal. I do not anticipate a future in which my studio retreats and training groups will be offered in entirely computerized studios, although I do not want to exclude this as a potential alternative venue for art therapy practice. A studio setting with computers for individual artmaking and image-projection equipment for group sharing might well have a role in future practice. The practice of art therapy in diverse artmaking facilities will ultimately enable our discipline to fully realize its art-based medicines and powers.

My personal experiments with artmaking on the computer have con-

vinced me that digital media have important potential applications in art therapy. They offer new ways of making art, showing it, and sharing it with others. Although digital artmaking involves some familiar operations, such as drawing and painting, it possesses an expressive flexibility that is novel and liberating.

I spend considerable time each day interacting with a computer for writing, official work, and communicating with others. This preexisting rapport allowed me to quickly adapt to digital painting. What keeps me coming back to the medium, however, is Photoshop's ability to generate high-quality color images and to enhance my expressive style. The Internet has been another great boon to my work, allowing me to instantaneously share images with people all over the world through Web pages and e-mail.

Digital technology enables me to more completely realize my guiding idea, for both art and art therapy, of creative expression as a circulation of transformative energy and imagery in the world. The logical extension of this belief is that the circulation of images and creative forces needs to be as complete as possible. The sensory qualities of a medium determine its particular therapeutic effects; and in the case of digital art, the medicines are in the pixels.

Practical considerations of time and space have helped to secure my interest in Photoshop. Over the years while working as a college dean and provost I have considered making a section of my office into a studio, but my movement patterns and habits within that space are more oriented toward text, phones, conversations with people, and the computer. Technology has enabled me to bridge these worlds and interests. At the same desk where I carry out my duties as the provost of a college, I can now also paint with an infinite spectrum of colors requiring no preparation or cleanup. Additionally, I can show visitors to my office a complete portfolio of my work with a few clicks of the mouse.

A primary influence on my use of digital media has been the academic environment in which I work. Our college art department is an advanced center for digital expression, and my colleague Bob Evans, an artist and professor of visual communications, has mentored me through the different phases of exploration. My first exposure to Photoshop involved a brief demonstration in the art department of what the medium can do. I was thrilled to discover that I could use all the painting techniques of traditional media in making digital art. I also found that the use of the mouse

as an expressive vehicle furthers my attempts to achieve free and sponta-
neous expression.

## "JUST ANOTHER MEDIUM"

Sliding the mouse, a movement that had become ingrained after years
of computer use, gave me an alternative to my usual ways of drawing and
applying paint in the studio. As Matisse discovered in his painting, the
use of different instruments and gestures can enhance spontaneity and
create new visual effects. He would attach brushes to long wooden han-
dles in order to vary his more habitual movements. We move among me-
dia to experience changing physical qualities and challenges that elicit
new expressions from us.

Evans insists that Photoshop is "just another medium" to be used to-
gether with the many other options for artmaking. I would not be creat-
ing the kind of images I do on the computer without having developed
painting techniques in other media. Conversely, a person can also begin
painting on the computer and then apply what they have learned to
more traditional media. What strikes me most about Photoshop is its ex-
pressive transferability and similarity to conventional painting processes.

With the best digital art, it is not possible to tell whether an image was
made on the computer or was scanned from a painting on paper or can-
vas. Evans advises people to avoid programs in which "the computer," not
the person, "makes the art." "The worst stuff looks like computer art," he
says. If people can already paint, Evans feels it is possible for them to learn
how to express themselves on Photoshop after ten minutes of initial ex-
ploration.

Photoshop authentically conveys "the expression of the person making
the art," rather than the tricks of the machine. According to Evans, some
painting programs offer "automatic effects" in contrast with the "resist-
ance from the medium" that occurs in Photoshop. "If you make it too
easy," he says, "people express the program and not themselves." In intro-
ducing hundreds of students and artists to digital artmaking, Evans has
observed that "some people can't make the leap to take over from the ma-
chine. They let the machine dominate. They can't trust the process and let
the computer operate as a paint brush, as a fancy tool."

My experience in making digital pictures has been that the process en-
courages me to complement what I do on the computer with work in my
studio using physical materials. This reciprocal relationship, wherein the

different media inform and stimulate one another, makes it clear that the computer will not "eliminate painting as it eliminated traditional hand-done graphic design" (Evans 1999).

## ART THERAPY APPLICATIONS

The least intimidating way to introduce art therapy clients to digital artmaking is in one-on-one sessions where client and therapist sit comfortably before a monitor and experiment with possibilities. The interactive powers of the computer energize and deepen the triadic relationship among client, therapist, and image. The spatial separation between the mouse and the image being shaped makes the picture on the screen equally accessible and visible to therapist and client, and there is a unique perceptual fluidity among the three participants.

When an art therapy client works on a horizontal surface or an easel, the process of creation often is obscured from the therapist's view. Though connected to its maker through the movements of the mouse, a digital image remains an autonomous presence, visible to both parties. I have spent many hundreds of hours making and viewing digital images, and their perceptual qualities continue to stimulate me.

The quality of colors and the opportunity to move freely and spontaneously with a mouse contribute to the energetic powers of the digital image. A mouse lacks the kinesthetic nuance of a pencil or paintbrush; painting on a computer, one loses the subtle dynamics of soft versus firm pressure. However, these are replaced by a remarkable ability to utilize a wide array of expressions, ranging from bold to delicate, by simply modifying the characteristics of the on-screen painting tool. With Photoshop anyone can make broad gestures like those of the abstract expressionists or darting flicks and atmospheric fields of colored strokes such as the impressionists applied.

Drawing pads are available as alternatives and additions to making lines with a mouse. To use a drawing pad, one moves a stylus over a touch-sensitive tablet, creating a corresponding image on the monitor. Some people are more comfortable with the drawing pad because it corresponds to the conventional act of sketching. However, I have been more satisfied with the expressive quality of pictures that I make with the mouse, which prevents me from getting too tight and fussy with my movements. The slight handicapping with regard to precision that I experience with the mouse helps me to be more spontaneous. It offers a very supple kind of

control and dexterity, but it also discourages attempts at excessive delineation, which hamper the expressive movement of a picture.

Photoshop offers a vast array of tools that enable artists to make quick and dramatic changes to every aspect of an image—color, surface quality, composition, and so forth—without danger of losing the original. Copies can be made instantly of the different phases of the image, and the ability to document changes and the development of an image offer new and strong materials to the therapeutic process. Photoshop has a "history" feature that automatically stores the sequence of expressions, allowing one to review each stage in the creation of an image. Like other powerful tools and technological advances, these features have shadows or dark sides. Perfectionistic types may become even more obsessed with trying to get it "right" by undoing and redoing every brushstroke, thus curbing spontaneity.

However, I feel that new digital devices significantly augment the physical resources of art therapy. If I am exploring abrupt changes and shifts from dark to light in a person's life, digital media enable us to quickly depict corresponding alternations on the monitor. Practitioners of active imagination can isolate and magnify details of pictures as separate images on the screen, which allows them to concentrate on particular elements while being able to easily return to the whole.

A person's entire portfolio of paintings made within therapy can be reviewed on the screen as a "gallery" of thumbnails (miniature versions of images); and with a click of the mouse, a full-scale image appears. People enjoy viewing digital paintings on computer monitors, which display images with excellent light and color. Inexpensive color inkjet printers enable clients to have copies of the art if this is desired. High-quality prints can also be made on special types of paper and canvas via printing technologies that, although more costly, are becoming increasingly affordable.

Digital artmaking holds enormous promise for physically challenged clients. A single finger on a touch pad can create bold and expansive gestures. Less is distinctly more when it comes to the maneuverability of touch pads. The tactile features of drawing and painting with fingers become available in a more precise and visually diverse way than what we can achieve through traditional media. The simple process of painting with fingertips on a touch pad can open up a whole new world of art therapy exploration for all people.

Those interested in more detailed information about using computers

with people with special needs should visit the Center for Applied Special Technology (CAST) Web site (http://www.cast.org). By offering alternatives for expression and different ways of engaging materials, CAST has pioneered the use of technology as a way to "expand opportunities for all people, including those with disabilities."

In sum, the image-making properties of digital art can enhance many of the things we currently do within art therapy, while introducing new elements into practice. However, digital media do have their shortcomings. Lacking smell and weight and texture, computer art cannot reproduce the visceral relationship people have with traditional media. Also, the process of computer artmaking does not yield a three-dimensional "thing" as its outcome.

The absence of the art object has a potentially salutary effect in that we "imagine" the digital artwork as physically present with us. Thus its very lack of materiality may promote a deeper emotional relationship with the image through imagination. And, of course, one can always make a print. Ultimately, I am not making a case for or against digital art in relation to traditional media. Each brings its distinct attributes to the art therapy process.

There are no negatives when it comes to the resources digital technology brings to art therapy research, training, and supervision, as well as to communication with those outside the field. Accessibility and storage of images for both clinical practice and research will be revolutionized by computer technologies and the dramatic expansion of memory offered by each successive generation of machines. Large amounts of visual information can be easily sent to colleagues in different parts of the world. Excellent color copies of images are finally accessible via the Internet, and this feature alone will transform art therapy. Professional journals might consider developing Web pages that include color illustrations of articles and exhibitions of art therapists' work at low cost. It is now technologically feasible to provide online training and supervision, accompanied by simultaneous image-making experiences. "Distance art therapy" may become an option when it is not possible to meet in person. However, I predict that art therapy, like psychotherapy in general, will always be primarily based in the energies and sense of relationship that occur when people meet together in person.

Rhoda Kellogg, the pioneering researcher of children's art, described in a lecture that I attended years ago how she maintained file cabinets filled

with thousands of children's pictures, all drawn on the same small paper surface to ensure that they fit into the filing system. I was struck by the extent to which her research interests limited the range of expression possible for the children. And I silently wondered how this tightly controlled process affected the outcome of the child's expression. With no easels and no opportunities to paint with bold colors and large brushes, wouldn't a child's natural—or at least potential—expansiveness and spontaneity be suppressed?

Yet I admired Kellogg's archive of information and her systematic process of inquiry, which generated voluminous data for analysis and comparison. At the time, the storage area in my art therapy studio was brimming with different sizes of paintings and drawings that would not surrender to an orderly scheme of storage and retrieval. There was also the issue of who owned the art. For these and other reasons I eventually stopped collecting my clients' artworks, and my research interests moved in new directions. Digital media offer exciting options for archiving and research since an image can now be present in many places at the same time. Digital cameras make it possible to store artworks in computer files, which can be made available to others via the Internet or low-cost compact discs.

Civilization does advance through new technologies, and art therapy needs to move with it. In addition to the digital painting software that I have described, advances in computer multimedia applications are perfectly suited for integrating artistic creation and perception with other forms of communication such as voice, text, touch, and movement. Art therapy, perhaps more than any other therapeutic modality, stands to benefit from these new technologies. We simply need the imagination and creative resources to seize the opportunity.

**REFERENCE**

Evans, R. 1999. Private conversation.

# Art Healing Is for Everyone

The many ways in which art heals have never ceased to evoke my curiosity and wonder. I have always worked in a community of creative arts therapists, artists, people from different health professions, and others committed to art and healing. We have participated as equals, and our diverse backgrounds contribute to the overall creative mix. I have been proud to serve art therapy and other creative arts therapy professions, but I strongly believe that the healing powers of art are not the exclusive domain of these disciplines.

In this part I present essays that reflect upon my discipline of art therapy and how it relates to the larger healing process of art, which is universally accessible to all people. Art is an idea and a process that will never be encapsulated by a profession. Equally boundless are the healing powers connected to creative expression, and this great potential sustains my desire to learn more about how art heals.

"Art Therapy Is a Big Idea" (2000) was published in *Art Therapy: The Journal of the American Art Therapy Association* in response to an invitation from the editor, Cathy Malchiodi, to contribute to a special issue exploring art therapy's future and whether it is an idea

open to all or a closed profession. This essay integrates many of the themes presented in earlier sections of this book into a summary portrait of what art therapy can be. Art therapy must cultivate a larger vision of itself, one integrated with all aspects of health care, if it is not to be relegated to the status of an adjunctive mental health subdiscipline. The segment of the art therapy community that is determined to establish stringent regulations of practice will ultimately limit the expansion of the healing function of art.

Rarely does anyone fall to the left of me in relation to political and philosophical issues about art therapy, but in questioning whether art therapy should even exist as a profession, Cathy has done so. In my response I take a moderate view, both supporting the widest possible application and expansion of the art therapy idea and affirming the unique professional identity and training of the art therapist. I'm not sure Cathy disagrees with me. We both share a deep commitment to our art therapy colleagues in spite of the efforts of certain segments within our community to restrict application of the idea. If we can just cultivate the idea and methods of art therapy in the most liberal way and then allow the process to find its way through the world, we will be in a far better position than that resulting from a tightly controlled professional guild trying to enforce who can and cannot engage the creative process. As the idea spreads, there will be an even greater need for skilled art therapists.

The future expansion of art and healing will be based upon art's ability to connect with the many different ways of practicing therapy. In "An Inclusive Vision of Art Therapy: A Spectrum of Partnerships" (1997) I reflect upon how art therapy came into existence through synergistic relationships with other disciplines and how future growth requires the continuation of this spirit of collaboration. It would be a serious mistake to respond to the gains of art therapy by focusing exclusively on the development of a specialized and self-contained profession that severs itself from the creative relationships that brought it into existence. The creative arts therapies are profoundly interdisciplinary, and they will continue to forge innovative alliances with new partners. This essay on the spectrum of relationships returns to the theme I raised at the beginning of the book: art therapy is part of a larger commitment to the healing power of art.

We need to do more to explore Hans Prinzhorn's (1922) belief that creativity is a basic human need and promote universal access to the healing powers of artistic expression. It is ironic that therapists in a discipline as

progressive as ours are advocating policies that, if adopted, would restrict the healing qualities of art from reaching the widest possible application. I am confident that the issues of professional development and public protection will find their way to the most effective resolution if our over-arching philosophical framework is one of universal access. That said, we must of course be conscientious in differentiating the situations where professionally trained and licensed professionals are required from those where they are not.

No profession can confine the archetypal way that art heals to its own bailiwick. One might just as well try to patent a human instinct. Our work is too powerful and too important to be available only to a small segment of society. We must strive to bring these vital resources to all people. But even if our institutions fail to achieve universal access, I am confident that art will keep finding its way to people in need. "Can't fence anything with wings," as a Connemara farmer once told me.

My desire has always been to strengthen the wings of art's healing power, to let it fly more freely and widely. Professions build and maintain fences in order to promote the interests of their members. The art therapy profession, composed of many artists who share an open-ended commitment to art and healing, has from its inception struck a balance between creative discovery, service to the widest possible audience, and the maintenance of a profession. I urge my colleagues to continue this tradition with an increased effort to collaborate closely with people from other disciplines who want to become seriously engaged in the process of art and healing.

"The Way of Empathy" (1999) identifies what I consider to be the great frontier for the future of art and healing. The creative imagination and art renew themselves in places where the soul is in conflict. Communities of people within the workplace are the future of the creative process, and they are in need of the healing powers of art. This essay anticipated my book *Creating with Others: The Practice of Imagination in Life, Art, and the Workplace* (2003), and to my delight, art therapy audiences across the United States have responded with enthusiasm to this expansion of their vision and practice.

I conclude this book with "The Test of Time," a revised version of an essay originally published in 1983 as "Angels Dancing on the Head of a Pin" in a book on therapeutic efficacy. This brief statement has retained its relevance and expresses well my current position with regard to art and public health. The healing function of art has been with us through-

out history and its powers persist undiminished. So much depends upon simply being more aware of what we have and what it can do for us. We can become so busy justifying ourselves through analyzing and presenting data that we lose the larger and readily available view of how the eternal healing qualities of the arts are available to everyone. The chapter also reflects on whether or not limits can be placed on who makes use of art for the purpose of healing, a practical issue that has emerged as a defining theme of this book.

Rereading this chapter, I was struck by its revolutionary tone and by the recognition that I might not have written something as forceful today. This observation affirmed the value of going back to these papers, recharging myself, and offering to a new generation of art therapists, and an ever-increasing community of people committed to art and healing, a collection of writings to help them carry on the work in endlessly creative and personal ways.

**27**

## Art Therapy Is a Big Idea

*This essay was written in response to a question posed by
Cathy Malchiodi, editor of* Art Therapy: The Journal of
the American Art Therapy Association. *I and others
were asked: "Is art therapy a profession or an idea?"*

I define art therapy as a *process* that corresponds to the universal forces
of creation. Some fifteen years ago I wrote, "The transformative energy
of art corresponds to, and possibly is, the energy of healing" (1989, 42),
and I continue to hold this belief. Art, like healing, "makes whole"; both
have an ability to transmute physical and psychological disturbances
into affirmations of life.

Creative energy is activated through the art therapy experience; and
when supported and guided, this energy finds its way to areas of need.
Given its energetic basis, and the intimate relationship between energy
flow and physical health, art therapy may be as helpful in the treatment
of physical disorders as it is in psychotherapy.

My hope is that professionals who are committed to the field's artistic
basis will undertake research promoting a rapprochement between, and
eventually a deep integration with, medicine and other disciplines. But
before art therapy seeks to form such alliances, we must endeavor to
more completely understand the unique dynamics of our art-based dis-
cipline (Allen 1992, 1995) and the ways "colors, shapes, lines, and images"

influence us (Malchiodi 1998). The best collaborations are formed between fully individuated and insightful partners.

When we connect the healing power of art to the release and circulation of blocked energy within persons, relationships, and environments, some important questions about practice are raised: Given this new understanding of art therapy, what is the role of the therapist? Does the therapist "keep the space" (McNiff 1995) and allow the energy to naturally find its way to blocked or afflicted areas in need of transformation? How, if at all, does this milieu of therapeutic art energy differ from the "holding environment" described by D. W. Winnicott, who perceived the analyst as a creator of spaces that act upon people and who felt that transformation was often inhibited by clever therapeutic interventions (1981)? What unique energies and properties does the art experience contribute to the holding environment or transformative space? Is it the art experience, the relationship with the therapist, the overall space of creation, or a combination of these factors that generates art's medicines? Without the involvement of therapists, can a person or a group activate the therapeutic energies of art? If so, are there particular situations that would make this solitary or unsupervised work inadvisable?

The ways of transformation and therapeutic change are not always easy or pleasant. A college professor who has followed the development of my work in art therapy once said to me, "I am fascinated by the idea of art therapy because my creative work has always torn me apart." The professor was clearly referring to the idea of art being therapeutic, which seemed to contradict, and perhaps helped to articulate, his particular experience of art. I replied that psychological and physical transformations, like the creative process, often involve the destruction of existing attitudes and behaviors. Such changes, especially when they bear upon the core themes of a person's life, are often attended by considerable tension and discomfort.

Trained art therapists can guide people through these challenging and often frightening aspects of creative transformation, and therein lies the strongest argument for the existence of a formal art therapy profession. In creating therapeutic spaces that offer safety, support, and guidance, we provide what Winnicott viewed as the most potent contributions of the therapist. When art therapy services are offered through healthcare systems, clinical agencies, schools, and other institutions, and when people present themselves to the general public as qualified to act as art ther-

apists, then the role of a profession as a keeper of standards and quality service is essential.

In response to the question "Is art therapy a profession or an idea?" I must answer, "It is both and more." Art therapy is an energy and a process that flows under, through, and beyond all of our concepts and modes of professional organization. Its vast power of creative transformation never loses its ability to inspire my commitment and fascination. I feel a sense of reverence for, even submission to, this work. When I began to view the art therapy experience as a contemporary manifestation of ancient shamanic continuities (McNiff 1979), I realized that my work was connected to a "big" idea. Identification with this world tradition affirmed the eternal relevance of healing through art and strengthened my vocation.

The use of art as a healing activity across cultures and historical epochs has led me to regard art therapy as an "idea" in the Platonic sense, a transcendent "pattern" that holds "all the objects of our physical perception" (Hamilton and Cairns 1961, 76). According to Socrates, the principles and truths embedded in these patterns are given to us naturally, are our birthright. I have always felt that we are born knowing the healing properties of art, but that we simply don't use them very much and thus appear to "forget" them.

Though we may lose sight of it, the idea of art therapy is always available, offering its varied resources of thought and creation. Art therapy is eternal and capable of holding all points of view. For example, at the beginning of these reflections I used the words *process* and *belief* to describe art therapy. My art therapy colleague Bruce Moon has proposed a "faith in the product" within art therapy, reminding us of the gifts of physical things and their vital place within the overall process of what we do (1994). Every position has a complementary aspect that grows from it. Process and product depend upon each other completely. Art therapy is an idea and a profession that holds varieties as well as contradictions. It welcomes and assimilates the polarities of science and art, studio and clinic, artist and therapist.

Art therapy can do more to enlarge its vision, practical applications, and public image. We have to continuously think in new ways about what we do. Ralph Waldo Emerson wrote, "Not he is great who can alter matter, but he who can alter my state of mind." History has shown that major and lasting transformations are based on imaginative interpretations of the nature of reality, often initiated by those who may not

wield considerable influence within institutional centers of authority. We cannot always change the physical conditions of our lives, but we can transform our perception of the opportunities they offer and the obstacles they set before us. Such is the case in art therapy, which may not have the leverage wielded by medicine and psychology, but holds limitless imaginative potential.

Art therapy is a big idea that is often controlled and guarded by narrow professional thinking. In our attempts to fit art therapy to the Procrustean bed of mainstream science and psychology, we have sometimes overlooked the larger sense of what we are and what we can be. I suggest moving into the future by gathering a diverse community of art therapists, artists, and people from varied professions who wish to advance common goals of healing through art. As a discipline of the creative imagination, art therapy can do for itself what it does for others. Rather than attempting to exclude people from its ranks by establishing rigid standards of practice, art therapy can recast itself as a visionary collaboration to which every person is invited to enrich and carry forward the many ways that art heals.

**REFERENCES**

Allen, P. 1992. Artist-in-residence: An alternative to "clinification" for art therapists. *Art Therapy: Journal of the American Art Therapy Association* 9 (1): 22–29.

———. 1995. *Art is a way of knowing: A guide to self-knowledge and spiritual fulfillment through creativity*. Boston: Shambhala Publications.

Hamilton, E., and H. Cairns, eds. 1961. *The collected dialogues of Plato*. Bollingen Series 71. Princeton, NJ: Princeton University Press.

Malchiodi, C. 1998. *The art therapy sourcebook*. Los Angeles: Lowell House.

McNiff, S. 1979. From Shamanism to art therapy. *Art Psychotherapy* 6 (3).

———. 1989. *Depth psychology of art*. Springfield, IL: Charles C. Thomas.

———. 1995. Keeping the studio. *Art Therapy: Journal of the American Art Therapy Association* 12 (3): 179–183.

Moon, B. 1994. *Introduction to art therapy: Faith in the product*. Springfield, IL: Charles C. Thomas.

Winnicott, D. W. The use of an object and relating through identifications. In M. Davis and D. Wallbridge. 1981. *Boundary and space: An introduction to the work of D. W. Winnicott*. New York: Brunner/Mazel, p. 81.

# 28

*An Inclusive Vision of Art Therapy*

## A SPECTRUM OF PARTNERSHIPS

### CREATIVE SYNERGY

Helen Landgarten and Darcy Lubbers, in their introduction to *Adult Art Psychotherapy* (1991), present one of the most useful ideas in art therapy literature. They challenge readers to find "creative ways" to incorporate art into their particular ways of practicing psychotherapy, since art therapy "is synergistic with practically any goal or approach." This wide spectrum of synergies is the key to the current success of art therapy practice, and it is critically important to future growth and creative vitality.

A synergy involves a multiplicity of interactions between the participants, resulting in a whole that is greater than the sum of its parts. When art therapy works collaboratively with another discipline, there are going to be effects that cannot be planned in advance. This type of relationship is the basis of the creative process.

There has been an ongoing tension in art therapy between those who favor expansionist visions of what the work can be and those committed to a more closely regulated profession. The former emphasize how art therapy can be adapted to any situation where art is used with people, while the latter focus more exclusively on clinical practice. Such conflict is inevitable in every profession. Rather than allow the strife to evolve into hardened opposition, I prefer to look at polarization as a necessary

psychological condition. When we approach opposition from the perspective of creative tension, we see different positions as helping to express the totality of a situation. Complementary perspectives imply each other's existence; and when we relinquish our devotion to one side, the opposites can begin to function creatively as a synergistic pair.

Underlying the appeal and creative vitality of art therapy is the pragmatic and very concrete process of connecting. The term *art therapy* itself suggests a joining of interests and disciplines. Once we accept that the simple act of creating new relationships is the core of our professional enterprise, the fallacy of attempting to hypostatize the field into a single entity will become apparent. Rather than seeking to eliminate contrary perspectives, we might begin to appreciate how the different positions energize and shape one another.

Healing is a process that transforms conflicting forces into a new and more productive relationship. Art does the same thing. It may be useful to apply the healing function of the creative process to a re-visioning of art therapy. We can use all of art therapy's resources and conflicts to create our profession anew. If we act in a way that corresponds to the creative process, we will stay open and continuously introduce new combinations of art and therapy.

## UNIVERSAL ERUPTIONS

In order for art therapy to sustain its synergistic potential, there must be a vital source from which new connections emerge. Every way of practicing art therapy will benefit if there is a strong art basis at the core of the profession's identity. Goals, applications, theories, and styles of practice endlessly flow from a mainstream of creation that can never be solidified into a fixed idea. When we focus too much on one particular way of being in partnership, we lose the basis for future synergies. Highly specialized practices do not offer a fertile and expansive basis for future creativity. As Edith Cobb wrote in *The Ecology of Imagination in Childhood,* "Overspecialization, which creates rigidity of response, is a formidable threat to any species, occasionally resulting in extinction through sheer inability to change and adapt" (1993, 110).

The source of art therapy's influence and attraction to other disciplines is the making of art and the presence of images. If we move too far afield from committed practice in the studio, we lose the primary

process of creation. Over the past three decades my techniques, theories, and experiments with art therapy have constantly changed, but the process of making art and its therapeutic benefits have remained relatively constant. All the ways of practicing art therapy flow from the studio and return there for renewal.

I have encountered thousands of people who were exploring art therapy as a career path. Almost universally they seemed to be most attracted to the field by its atmosphere of exploration and inexhaustible possibilities. Most of these people expressed an interest in combining art with something else—psychology, social service, special education, religion, health care, cancer treatment, childhood development, aging, community, and so forth. People drawn to art therapy are not satisfied with the exclusively commercial approach to art that permeates much of the society, nor do they relish the idea of working in isolation. They choose art therapy because they want to work with art as a way of relating to the depths of the individual psyche—their patients' and their own.

Art therapy is an extension of an innate human impulse to create a meaningful relationship between the maker of art and the images produced. It is also an expression of a yearning for creative community.

Even today, after three decades of existence as a professional field, art therapy is constantly being "discovered" firsthand by people through their personal experiences and yearnings. Throughout the world, people involved in both therapy and creative expression discover art's healing power; and as they begin to research this phenomenon, they find the field of art therapy.

Art therapy is a contemporary manifestation of the eternal healing function of art. The therapeutic use of art has no single point of origin; it has appeared all over the world and throughout history in diverse incarnations. This indigenous presence is the most important indicator of art therapy's potential. If it has persisted through time as a way of remedying the ills of the human spirit, then it is likely to continue into the future as a vital therapeutic process.

When I first studied art therapy, the work of Hans Prinzhorn was my most consistent source of inspiration and guidance. Prinzhorn wrote about the essential elements of the artmaking process. His work does not currently receive much attention, probably because he did not write about using art with specific therapeutic objectives in mind, which is the dominant

model in our field today. However, I see him as art therapy's most useful bridge to the world of art and public health. Prinzhorn does not tell *us* what to do in therapy or healing, although he has written one of the most lasting and useful accounts of what *art* does for the people who make it.

In the first years of my career I was focused on helping patients to make art with an intuitive belief that the process would be beneficial to them. I sensed that expression was the most important thing in the therapeutic studio. When previously withdrawn people expressed themselves authentically, they came to life and interacted with their environments; and when we exhibited their art, this contributed yet another cycle of therapeutic affirmation. Prinzhorn furthered my appreciation for the artworks that my adult patients made. He helped me see the significance in the spontaneous expressions of ordinary people.

Hans Prinzhorn was a European medical doctor and art historian who combined his interests to write the influential book *Bildnerei der Geisteskranken* (Artistry of the Mentally Ill) in 1922. His work stimulated international interest in the psychopathology of expression. However, most people seem to have missed the essential message of Prinzhorn, who felt that wondrous and sometimes bizarre visual communications dwell within everyone's psyche, not just those of the mentally ill. Fascinated with the uncensored aboriginal images of creative expression, he saw the paintings and drawings of people living in asylums as "the eruptions of a universal human creative urge."

The art therapy profession has been surprisingly inattentive to Prinzhorn's suggestion that expression is a basic psychic need for all people. His work by example gives us a potent admonition to integrate all approaches to art as healing. Prinzhorn proposed the existence of "psychic forms of expression" that are inborn, but subject to inhibition, in all people. He became interested in the artwork of psychiatric patients because they painted in environments that "favor the primeval developmental processes" by suspending "the common everyday strictures" on expression (1972, 242). Prinzhorn was unique in positing universal human needs for expression and suggesting that our lives will be less complete if these needs are not met. He recognized that expression is a need of the human spirit, not simply an instrument for revealing pathology. In the Prinzhorn tradition, the art therapist becomes a cultural worker, an archeologist of sorts, who helps to unearth the potential imagery that we all carry and do not express.

In the United States, art therapy's primary partnerships over the past thirty years have been with medicine and psychiatry. The first art therapy books, written by Margaret Naumburg, were closely aligned with psychoanalytic theory and psychiatry. Although the professional practice of art therapy flourished in the United States, the early inspirations for the psychotherapeutic application of creative expression originated in the European schools of psychoanalysis. Early in the twentieth century, both Freud and Jung made effective clinical use of visual imagery and creative expression.

Therapeutic programs for children in medical facilities have used art both for the rehabilitation of expressive faculties and as a primary mode of communication within the psychotherapeutic relationship. Child psychotherapy has become synonymous with play therapy, in which pictures are made, environments are built, and figures are shaped with clay, sand, and other materials. The making of art engages the senses, offers communication through images, and provides stimuli for stories and dramatic enactment. The construction and use of puppets, masks, and costumes generate spontaneous dramatic enactments; this free movement from one art form to another affirms the cooperation of all of the arts in child psychotherapy.

Many art therapists support tight regulation of who is authorized to practice art therapy; they believe that this approach would yield many benefits, including a simplified professional image, regular and predictable outcomes, and clearer expectations from the public. Opposing this movement toward consolidation of the field, there exists a drive toward innovation and expansion of art therapy through relationships with diverse therapeutic practices and collaboration with professionals from other health disciplines and artists.

"May God us keep from single vision," pleaded William Blake, reflecting his concern about the increasing dominance of the materialistic worldview that evolved into what we currently call "scientism." Slavish devotion to one side of a conflict has fatal consequences during periods demanding new partnerships. This truth applies as much to the evolution of a profession like art therapy as it does to international relations, problem-solving efforts in any area, or relationships with others. The art therapy profession has been almost exclusively tied to the medical model. During the profession's development in the 1970s and early 1980s, these connections to

psychiatry resulted in many new jobs in hospitals, day treatment centers, and clinics for children. More recent losses of art therapy positions within the mental health area will no doubt bring a new sense of relevance to initiatives outside the psychiatric sphere.

In recent years many new synergies have emerged between art therapy and other fields, including AIDS treatment, trauma relief, coping skills, hospice and pastoral care, public health, bereavement, forensic psychology, prisons, holistic medicine, cancer treatment, general health care, work with families in homeless shelters, chemical dependency, psychospirituality, ecopsychology, social activism, physical disabilities, and learning disabilities. The attrition of mental health positions has resulted in an influx of art therapists into private practice, with others establishing open studios in urban centers and exploring entrepreneurial ways to make the art and healing experience available to people. Wherever there is affliction, suffering, and human need, art will always emerge as a remedy.

## ART THERAPY IN SCHOOLS

I believe that the use of art as a way of healing must continue to grow in schools. What remains unclear is whether this practice should be restricted to licensed art therapists. During the 1970s there were many of us who focused on a partnership between art therapy and education. "That's where the children are," I would say. "We have to take the service to them, rather than expect them to come to us." I envisioned classroom teachers and special education teachers using art therapy as a way of interacting with their students and furthering learning. However, integrating art therapy and art education seemed a dimmer prospect. The typical art teacher sees hundreds of children each week, leaving little time for building relationships with students.

Although there are many examples of art therapists providing services within school systems, there has not been a thorough integration of art therapy with special education. While there are many important contributions that art therapy can make as a self-contained profession, I am also interested in how it can blend with other professions.

I do not support there being fixed boundaries between education and therapy. Throughout the 1970s I worked to bring art therapy into regular and special classroom environments, allowing children to creatively express feelings and enhance perceptual skills (1974, 1976, 1979, McNiff and Knill 1976, 1978, McNiff and McNiff 1976). Teachers have responded

enthusiastically to these suggestions, while many art therapists, determined to establish their field as a distinct profession requiring licensure, have taken an ambivalent stance.

Art therapists trying to advance themselves as psychotherapists and clinicians have not wanted to be viewed as educators. Yet teachers and therapists deal with the same fundamental issues related to the well-being of children. Early contributors to art education theory such as Viktor Lowenfeld (1939, 1947) and Florence Cane (1951) were committed to an integration of therapeutic sensibilities with art skills, but the art education field has become relegated to the status of "special subject."

I have always wanted to initiate a creative arts therapy concentration within a special education masters program but found it difficult because neither of the potential partners was willing to experience what they thought would be a watering-down of their own discipline. Integrations are apt to threaten professions that instinctively react to change by fortifying boundaries. I know that there are many special education professionals and classroom teachers who would like to work in a more creative and therapeutic manner. There is no question that a more psychologically sophisticated use of artistic expression within the daily classroom experience will benefit children. Many of the art therapy graduate students that I trained went on to work as art teachers in schools, but they are generally perceived as "teachers" who happen to have training in art therapy.

The partnership between education and therapy has been restricted by concerns that schools have about becoming involved with things other than academics and the belief that "serious therapy" takes place outside school. We have also limited the art therapy experience to services delivered by the "professional art therapist," a staff position most schools cannot afford. In today's era of human service consolidation, there are many advantages to integrating art therapy practices into related disciplines. Ideally, someone who is qualified both as an art therapist and an educator would give art therapy services in the schools. If art therapists want to work in schools and take advantage of the many opportunities to serve children in these settings, it is not too much to ask that they acquire teaching certification.

## ART THERAPY AND ARTISTS

There has been a glaring absence of dialogue between art therapy and what we call the "art world." My early professional development took place

during the late 1960s and early 1970s, when we envisioned an artistic culture that served the community. The idea of art therapy filled my imagination with possibilities. Leaders of the conceptual art movement were attracted to what I was doing because it complemented their works, which posed provocative questions about the nature of art and its function in our lives. We felt that art could do so much more than what was being presented in the conventional gallery system.

Many artists reject the idea of art therapy because they feel that the pure process of making art is complete unto itself and has no need for professional adaptations that will weaken the aesthetic experience. As an art therapist I share this commitment to artmaking. Yet I also see the art therapist as a person who is dedicated to practicing art in a way that serves others. Art has many functions, and the art therapist revives its healing capacity. I have never been comfortable with the idea that art's sole purpose is to serve itself.

Art schools and the art world have not appreciably demonstrated a desire to use art as a means of serving others. I constantly hear artists disparaging art therapy because they feel it takes attention away from the contemplation of objects. Yet there are many art therapists who have committed their careers to interacting with objects in order to access their medicines. In addition to art therapy's focus on the beneficial effects of making art, we are always exploring how to deepen our relationship to our creations. Perhaps these investigations can be of use to artists. Perhaps art therapy offers healing possibilities to art itself.

Today, increasing numbers of art therapists are offering their services through community-based studios. Pat Allen's landmark 1992 paper, "Artist-in-Residence: An Alternative to 'Clinification' for Art Therapists," and her 1995 book, *Art Is a Way of Knowing*, have made important contributions to bridging art and art therapy. But notwithstanding the efforts of Allen and a handful of others, art therapy has not done enough to welcome artists into its community. Art therapy's emphasis on professional criteria for practice has given artists a very clear message that they are not qualified to practice art therapy unless they undergo serious training. But what about artists whose work is focused on personal and social healing? Do we want this work more closely connected to art therapy? I certainly do, and I feel that close partnership with innovative artists will offer the creative stimulus that art therapy needs. We need to distinguish among the different ways that art heals, maintaining high standards for clinical

practice while encouraging other applications that may not require the same level of training and credentialing.

## RESEARCH

Research is emerging as one of the most promising frontiers for the art therapy profession. Rather than analyzing artistic data with conventional behavioral science research methods, I have advocated using the artistic process as a primary mode of inquiry (1986, 1987, 1993, 1998a, 1998b, 2001). We are not just providers of data. We offer new ways of discerning experience. But there is reluctance within many sectors of the art therapy profession to harness the potential power of the artistic process as a basis of research. We have meekly acceded to the prevailing standards of behavioral science research for too long. Now we must begin to explore the gifts that the artistic process offers to psychological inquiry.

I am pleased by the recent response of the art therapy community to my call for art-based research. There is also a growing realization that the field needs to focus on practical outcome studies that show the benefits of the art and healing experience. Thankfully, the research focus has begun to shift to describing the healing effects of the artmaking process as well as the way in which relationships with therapists and supportive groups influence these experiences. This movement toward healing outcomes is quietly bringing the various sectors of the art therapy community to common ground, a fact reflected in the American Art Therapy Association's mission statement, which focuses on how the process of making art is "healing and life enhancing."

Idiosyncratic diagnostic theories and procedures are giving way to reproducible outcome research, thus focusing art therapists on the pragmatic and universally accepted basis of the work. We know from experience that art heals, and researchers are now exploring how best to describe and assess what people experience.

## THE INTEGRATING IMAGE

Everything significant about art therapy emanates from making connections among previously separate disciplines, yet within the profession we often have trouble managing our own diversity. It is time for the profession to look upon itself with a psychological eye.

Not long ago I spoke to a journalist who was researching a book on new therapeutic trends. He had interviewed art therapists who gave him

the impression that ours is a highly polarized profession. He found the oppositional attitude between clinical/scientific and studio/artistic positions unusual for a relatively small and new field.

I personally look at the different positions within the art therapy field as individual voices within the overall chorus of our profession. Each of these contributes to a free and improvisatory interplay that can produce an infinitude of sonorities—some harmonious, some dissonant, but all worth taking into account. Where or when the next major innovation in art therapy will emerge can never be planned, but it is much more likely to come from someone who appreciates the synergistic complexities of the field than someone fixated upon a single view.

Art therapy is an integration that has revitalized both art and therapy. Yet it is remarkable that an innovative combination of elements can quickly become an established entity that some attempt to preserve in a relatively rigid way. New integrations upset the status quo. Will art therapy commit itself to a future of new partnerships? Can the profession enlarge its collective imagination to hold the complexity of different modes of practice?

I believe that the idea of art therapy is resilient and deeply rooted in human experience. I welcome new ways of operating, and I feel that the profession will be strengthened if we can look upon our differences as signs of vitality and creative growth.

Prinzhorn's conviction that artistic expression is a basic psychic need for all people provides the foundation for a reimagining of what art therapy can be. I offer the following four principles as keys to furthering art therapy's ability to integrate its many different aspects:

1. Avoid identification with a single model.
2. Keep all options open for new and creative partnerships.
3. Retain artmaking and depth psychology as the bases of the work.
4. Stay closely attuned to the images that we create in art therapy and the process of making them.

Of these, the fourth principle—to return again and again to the physical images and process of artistic expression—is most crucial to art therapy's vitality. We can trust that the artistic process will always take us where we need to go and show us what we need to see.

The images of art will hold all interpretations, and they symbolize what our profession can become. New ways of practicing therapy emerge from

images and return to them for the next cycle of creation. We imitate them as life imitates art. They are the reason for art therapy's existence, and we will find our way into the future by staying closely attuned to them. No matter where we stand within the field of art therapy, images offer sources of integration. All of our different methods are attempts to access their gifts. While our therapeutic systems and values change and often conflict with one another, the images of creative expression maintain their place at the core of human communication. The future of art therapy will depend upon how resourceful we are in finding new ways for art to serve others.

**REFERENCES**

Allen, P. 1992. Artist-in-residence: An alternative to "clinification" for art therapists. *Art Therapy* 9 (1): 22–29.

———. 1995. *Art is a way of knowing*. Boston: Shambhala Publications.

Cane, F. 1951. *The artist in each of us*. New York: Pantheon.

Cobb, E. 1993. *The ecology of imagination in childhood* (1977). Dallas: Spring Publications.

Landgarten, H., and D. Lubbers. 1991. *Adult art psychotherapy*. New York: Brunner/Mazel.

Lowenfeld, V. 1939. *The nature of creative activity*. New York: Harcourt, Brace.

———. 1947. *Creative and mental growth*. New York: Macmillan.

McNiff, S. 1974. Organizing visual perception through art. *Academic Therapy Quarterly* 9 (6).

———. 1976. Art activities for evaluating visual memory. *Academic Therapy Quarterly* 11 (3).

———. 1979. Robert Coles, children of crisis and art education. *Art Teacher* 9 (2).

———. 1986. Freedom of research and artistic inquiry. *The Arts in Psychotherapy* 13 (4): 279–284.

———. 1987. Research and scholarship in the creative arts therapies. *The Arts in Psychotherapy* 14 (2): 285–292.

———. 1993. The authority of experience. *The Arts in Psychotherapy* 20 (1): 3–9.

———. 1998a. *Art-based research*. London: Jessica Kingsley Publisher.

———. 1998b. Artistic inquiry: Research in creative arts therapy. In *Foundations of expressive arts therapy*, ed. S. Levine and E. Levine. London: Jessica Kingsley Publisher.

———. 2001. Creating outside the lines: Enlarging psychological research through the arts. *Bulletin of Psychology and the Arts* 2 (2). Also published in *The Healing Art: The Journal of the Russian Art Therapy Association*, 2002.

McNiff, S., and P. Knill. 1976. Musik in der Ausdruckstherapie für Lernbehinderte. *Schweizerische Musikzeitung* [Swiss Journal of Music] 1.

———. 1978. Musik und Gruppenimprovisation in der Ausdruckstherapie für Lernbehinderte. *Musik und Kommunikation*. November 1, 1978.

McNiff, S., and K. McNiff. 1976. Art therapy in the classroom. *Art Teacher*, Spring 1976.

Prinzhorn, H. 1972. *Artistry of the mentally ill*. New York: Springer-Verlag. Originally published as *Bildnerei der Geisteskranken*. Berlin: Verlag Julius Springer, 1922.

# 29

*The Way of Empathy*

**THE PRACTICE OF CREATIVITY IN THE WORKPLACE**

### AN INTEGRATION OF ART AND LIFE

When creative expression is viewed exclusively as something done by artists working alone and separate from the world, life and art often suffer. Many artists, faced with the demands of earning a living, feel that they must establish clear divisions between their creative expression and their employment. However, as an artist who has spent his life in various jobs, I have always focused on the integration of work and creative activity. My art and my livelihood are inseparable; and in my experience, their integration yields benefits for both.

In my work with the creative process, I have sought to open every area of daily life—from the personal to the public—to the medicines of art. Healing often occurs through the process of integrating diverse spheres and finding a common purpose and deeper meaning to everything we do.

Artistic creations emerge from the details of our lives and from how we perceive those details. Given that our jobs are where we spend the most time and expend the most effort each day, it seems natural to engage the workplace as a source of creative subject matter and energy. The workplace is the world that we inhabit, the environment where we experience many of our discontents, and I believe that we can make it a more satisfying and productive place through the conscious use of the creative process.

Many people are initially incredulous about this possibility. "How can I do this?" they ask. "My job demands all of my time and energy. I am not an artist."

I reply, "Your art does not have to be separate from your work. You can be an artist of life, and you can use all of the time and energy you put into work as a basis for your creative process."

This chapter addresses the practicalities of how to achieve an integration of art and work. When someone says that they are not creative or talented, I respond by asking them to examine where and when that point of view originated. The creative process is based on how a person perceives the world, so the best place to begin is with attitudes and beliefs. I believe that any person with a creative vision can take advantage of life situations and make them into art.

### GIVING VALUE

My way of teaching creative perception begins with identifying something that a person finds worthless—a spot on the floor, a scrap of paper, a quick scribble with a pencil.

When the person says to me, "That's nothing," I say, "Listen to the voice that is judging and dismissing this thing in front of us. Who is speaking? What is the origin of this voice?"

It is important to become aware of our automatic tendencies to dismiss things, which block opportunities for creative perception. Details ordinarily considered peripheral and of no account can be sources of innovation and insight when approached with a creative eye. I might ask the person, "What does the scrap of paper have to say about being called 'nothing'?" Communicating with the "worthless" scrap of paper as if it is a living thing moves us beyond our habitual ways of viewing life and extends our range of creative perception.

The most important step in reframing one's perceptions of things involves giving value to what is initially seen as worthless: "Can you make the scrap of paper the most important thing in your world for a moment and look at it with attentiveness and wonder? Examine its torn edges and folds. Become aware of the way it reflects light and creates shadows within itself."

And finally, wonder becomes the gateway to creativity: "As you look carefully at the scrap of paper, is it possible to become fascinated with its qualities?"

Wonder is something we bring to the perception of the world, or perhaps the world gives this gift to us. It is a way of looking that can be applied to anything. If we find wonder in scraps of paper, spots on the floor, and pencil scribbles, we are ready to become fascinated with what we already attend to in our daily lives.

Ralph Waldo Emerson observed that people tend to act things out in life before apprehending their significance. Most of us fail to recognize the creative value of our workplace's small and routine details. Subject matter for creative reflection is plentiful, but we don't take the time—and don't feel that we have the time—to engage it in more significant ways.

Emerson was correct in his description of creative action as being a step or two ahead of the reflecting mind. We use the term *awareness* to denote how we become conscious of the value of what is already present. Like no other realm in contemporary life, the workplace offers us a wealth of actions to be reconsidered from the vantage point of creative perception. The creative transformation of the workplace begins with the simple process of perception. The actions, as Emerson suggests, are already there. We simply have to start looking at them in more creative ways; and from this process of artistic perception, further creative acts will emerge and multiply.

### CREATIVE EMPATHY WITH OTHERS

Feeling misunderstood and unappreciated by one's co-workers is perhaps the greatest source of suffering in the workplace. On the other hand, understanding the perspectives of others can be one of the most difficult skills to cultivate within an organizational setting. Sometimes it is easier to establish empathy and compassion for a scrap of paper than to seriously entertain a point of view contrary to our own. To help close such rifts of understanding, one can initiate a process of creative compassion through storytelling and role-playing exercises. Everyone has a story to tell, and most people feel safe working in the relatively familiar format of narrative.

When we tell stories about a particular aspect of the workplace, the personal imagination is invited to contribute in a way that is not possible in formal organizational communication. Perceptions, feelings, and values previously unable to enter the discourse are introduced, enriching everyone's view of the shared enterprise. Informal storytelling flourishes in every workplace, but it is rarely cultivated in a serious way, with the exception of ritual acknowledgments of group and individual achievements,

anniversaries, and so forth. Unfortunately, the stories told in these formats tend to be stock accounts of the community's life and offer little new information; they simply maintain the status quo. In contrast, creative stories generate new perceptions of, and therefore possibilities for, daily operations in the workplace.

I believe that it can be of great value for a group of employees to tell more idiosyncratic and personal stories about the organizations in which they work—a day in the life of the water cooler in the hallway, the coffee maker, or the copy machine. How do these artifacts view the surrounding community? What do they see and hear? Do they have access to information that others do not know?

Imagination is amplified when we look at the world from the perspective of something other than ourselves. However, the average person tends to have difficulty personifying inanimate objects. As people become more relaxed and confident in storytelling, they begin to think more poetically. In poetic expression it is "natural" to give a voice to objects and situations that are typically ignored.

Most of us will need to begin our storytelling from our accustomed personal perspective. But as soon as we begin to openly explore the storytelling process, we realize that there are untold stories behind the ones we normally tell, stories unknown even to ourselves.

Histories offer a comfortable opening to storytelling. How did you get to this particular place and position? What was the environment like when you arrived? How has it changed? Has something been lost? Improved?

When recreating your history, include your sense of the perceptions of other people. What was comfortable for you and for other people? What was difficult?

Others define us more than we realize. What we value or dislike in other people often says more about who we are than does a direct attempt to describe ourselves. Explore your history in the organization by telling stories about other people. Tell the stories of moments at work that were especially enjoyable or difficult: your most humorous experience, your most embarrassing moment, your greatest achievement, and so forth.

Expand the perspective of your history by telling it from the point of view of another person in the organization. This shift enables you to draw from the familiar basis of your own experience, but the perspective of the other person significantly expands the scope of what is perceived and conveyed. As we begin to appreciate the very different ways that people can

perceive the same thing, we begin to develop the empathy that is needed both in order to lead and to heal.

As a leader of groups, I try to make sure that I demonstrate different ways of expression and various possibilities for exploring a theme. I emphasize the importance of authentic communication and assure participants that there is no right or wrong way to tell a story.

I subtly introduce dramatic elements into the storytelling process. The story naturally extends itself into body movements, role-playing, vocal expressions, visual-art works, and poems that further its expression.

When people are telling their stories, I encourage them to be aware of the surrounding space and to make use of it. I might start by sitting in a chair and then get up onto my feet to emphasize a particular point with my whole body and then return to the chair. Dramatic amplifications are most effective when they emerge from a person's natural expressive style, when they keep us grounded in who and where we are at that particular moment.

When describing a situation involving another person or what another person might feel, I encourage the storyteller to adopt the subject's voice rather than try to "explain." This shift into dramatic role-playing seems to be effortless and natural when it is used to more directly express something that needs to be said. A more empathetic and imaginative understanding of the event is furthered by the evoked presence of the person being portrayed. There is generally a sense of satisfaction and relief that accompanies an accurate expression of the feeling.

Exaggeration can be useful in furthering the drama and emotion of a story. Modulating one's tone of voice and speed of speech, as well as using expressive sounds, brings the vocal element of artistic expression into the simple telling of a story. The same is true of body movement, which conveys different meanings when we slow down or speed up the tempo, vary the degree of sensitivity or forcefulness of gesture, and so forth. Exaggeration also introduces humor and its life-affirming medicines into the workplace.

Fiction is another powerful way to explore and understand interpersonal situations. Sometimes creative fiction helps us get much closer to the truth than literal description. During an active conflict, literal accounts often degenerate into judgmental axe grinding, because we feel compelled to defend our personal territory. Fiction gives a safe anonymity that cannot be realized when we speak as ourselves. Paradoxically, imaginary figures often

bring us closer to the facts and the atmosphere of a situation than do our personal "explanations," which tend to repeat stereotypic positions. It is easier to identify with a fictional character, a figure that aggregates qualities shared by many different people.

I encourage people to define their workplaces by speaking from the perspectives of the many people within them. The strongest and most creative groups are the ones that most thoroughly acknowledge and articulate their differences. Many practical benefits accrue from establishing empathy with positions contrary to our own. Not only does creative empathy give us the opportunity to step out of fixed roles and expectations, it also helps us to envision what other people need. Changing perceptions can serve as a most reliable mode of healing.

When we watch films or read a novel, we generally find it easy to empathize with the characters presented. But in our daily lives at work or even in our families, empathy can be much harder to evoke. This reluctance to let go of a point of view can be traced to the fear of losing ourselves, of becoming nothing. We are terrified of the disorientation we imagine will result from not having a point of view. Who am I if I do not have a point of view? And the more insecure we are about this, the more tenaciously we cling to a fixed perspective and find it impossible to entertain the views of others.

A colleague of mine describes herself as too empathetic: "I am always looking at everything from everyone else's point of view, and I find it difficult to establish my own positions."

I am not advocating a state of total relativism. The creative imagination requires a firm point of self-reference and the ability to perceive, interpret, and decisively integrate varied possibilities.

Creativity requires flexibility and a willingness to accept new ideas from outside our existing frames of reference. Another colleague once described how he tries to keep "a soft hand on the tiller" when he is involved in creative activities because the process will always lead him in unexpected directions. If a focus is too rigidly established, it becomes difficult to dislodge and change.

Ideally the practice of creativity brings an expansion and sharpening of perception that improves the quality of a person's interactions with others and the surrounding environment. The creative practitioner strives to understand the perspectives of others, always wary of the limitations of a narrow personal vision, and constantly open to the refinements of perspective

that take shape through exchanges with others. The practice of creativity teaches us that we do not act alone. Our creations and our lives are enhanced when we realize that every person and every thing is a potential source of imagination.

As an artist who spends the majority of his time at work, I must find ways to use what is at hand in my environment. Working alone in my studio is not enough to satisfy my personal aesthetic vision. I have to do something in the world and with it, always realizing that this exchange shapes my creative vision. There is a mainstream of creativity moving through every day and every place. It awaits discovery and offers itself for transformation.

Repeatedly I discover how the ecology of relationships, communications, and challenges within the workplace and my community of students and colleagues is my most reliable source for new and creative insights. Like most other people, I've also experienced some of my greatest pain and distress at work when being negatively perceived, criticized, or misunderstood by others. At times I have done things to contribute to these uncomfortable experiences. The creative opportunities of community life will always be paired with setbacks. Healing in the workplace requires an acceptance of its imperfections and difficulties. Like the artistic process, the workplace will never be subject to our complete control. And like the artistic process, the workplace offers us some of life's greatest opportunities to heal, affirm, and create with others.

## 30

*The Test of Time*

I am often asked whether I can produce statistical evidence for the "efficacy" of the arts as healing. In my book *Art-Based Research* (1998) and elsewhere, I encourage and support outcome studies and satisfaction surveys that will confirm the effectiveness of art as a healing process. But ultimately I regard this quest for statistical proof of efficacy as redundant: I already know that art heals and everyone else does too. There is also the practical problem that quantitative assessments are contrary to the ways of art. Certainly we can engineer outcome studies to generate numbers, but this is not how the creative process operates. The numbers exist in another world, separate from the organic activity of art.

Most people tacitly understand how dancing, making music, writing poetry, and other forms of creative expression relieve tension and provide feelings of fulfillment. Perhaps no other form of healing has been so widely experienced in people's everyday lives. Vast historical and cultural evidence also confirms the healing powers of the arts. Art heals by reaching into the deepest and most intimate parts of the soul, and therein lies its eternal appeal to the human spirit.

The healing powers of the arts transcend the fleeting trends of contemporary culture, having survived for thousands of years what the philosopher David Hume described as the "test of time." Their ability to accept,

engage, and transform the most intense experiences and emotions gives the arts their staying power and efficacy.

Emotional difficulties are problems of the soul. It thus seems logical to relate to these problems through the language of the soul—the arts, which express the many nuances of emotional life through symbols, movements, and sounds corresponding to a person's inner feelings. The arts place a value on deepening the mysteries of life and opening ourselves to them with a conviction that the process of creatively engaging problems and tensions is healing.

Almost as universal as the healing power of art is the human desire to claim ownership. And as awareness of art's therapeutic potential grows, so does the desire of people and groups to call it their own. Because of this, important questions have arisen regarding who is qualified to practice art and healing: Can a profession "trademark" the use of art as a healing modality, thus setting itself up as the gatekeeper to the creative process? Or is the healing process of art ubiquitous and as accessible to people as their sensory experience?

Within the creative arts therapy community there is an ongoing debate between those who, like myself, support a more inclusive and expansive idea of art therapy and those who wish to restrict the practice of the arts in therapy to individuals with specialized credentials. Narrow focus on educating and licensing professionals to work with specific media has been the primary deterrent to an integrated use of all of the arts in healing. When I train art therapists, I maintain an overarching goal of preparing leaders who will bring the healing powers of the arts to every sector of the healthcare field and encourage other professionals to participate. As I have emphasized throughout this book, it is possible to advance and strengthen the professional community of people who commit their life's work to the healing function of art—and to a particular art form—while also including other health professionals and artists who share this vision.

Imagine the absurdity of discouraging a pediatric nurse or social worker from engaging a withdrawn and traumatized child in creative activities that facilitate self-expression, the transformation of pain and stress, catharsis, and communication with other people. Drawing, painting, creative movement, dramatic enactment, play, rhythmic expression, and other artistic media offer these clinicians ways of interacting with children that often feel safer and more natural than direct verbal discussion.

When dealing with devastating losses, traumas, and crises—many of which cannot be fully expressed in words—people need to have access to the full range of human communications and creative outlets. Like doctors who study nutrition and use their knowledge to promote the widest possible social well-being, creative arts therapists serve the healing power of art by encouraging the broadest possible participation and helping people gain a deeper understanding of art's healing powers. Art is as much a public health phenomenon as it is a way of communicating within professional therapeutic relationships.

Most people who use the arts for healing do so at their own initiative—millions and millions of people in every historical epoch. And while the creative process currently enjoys a fruitful partnership with various healthcare disciplines, it is also accessible to a person in need of help who is creating alone or with a group in a studio. Artists everywhere, whether advocates of professional regulation like it or not, are increasingly focusing their work on healing their own wounds and those of the world. To my delight these artists are taking the lead in expanding our notions of how art heals both in personal and social realms. Such artists have been particularly useful in keeping us focused on the public domain, whereas therapists have a tendency to draw more circumscribed boundaries around their practice. Art is the healer, and it is available to all—its powers transcend enclosures. For creativity, like other forces of nature, is not completely subject to human control.

The spontaneous use of art as a mode of healing by people everywhere has to become the basis of all discussions of professional practice. When we accept that art healing is and should be available to everyone, then we can begin to discuss how professionals can contribute to this process. When we start with professionals and their qualifications, we radically circumscribe the domain of practice, furthering professional agendas at the expense of people who can benefit from the process of art and healing.

There will be times when people need others to inspire and guide them in healing through art. In contemporary society, the creative arts therapist is available to provide this service. In previous epochs, shamans and healers carried on this work, relating the forces of creativity to the beliefs of their time and place.

Over the years I have observed a deep craving for creative expression and healing among health professionals from many disciplines. Burnout is a serious problem in human service and health organizations throughout

the world. The work exacts a heavy toll from professionals who themselves need sources of renewal. Their initiatives bridled by stultifying bureaucracies, healthcare workers long for more creative ways to practice and continue learning.

We cannot impart the spirit of creativity to others unless we experience it within ourselves. This feeling of creativity is the life force itself. Regeneration, transformation, and healing cannot take place without it. In order to heal, one must transform apathy, distraction, and discontent into the creative force of healing. Creation and healing are the same energy; they transform pain rather than being destroyed by it.

I believe that the more our work focuses on the primary process of art and the more inclusive it is, the better prepared it will be to flourish in relation to the test of time. I am sorry to say (or, perhaps more honestly, pleased to say) that this power is beyond the measurements of a statistical formula. It is the eternal realm of art, creativity, and healing transformations.

**REFERENCE**

McNiff, S. 1998. *Art-based research*. London: Jessica Kingsley Publisher.

## SOURCES AND CREDITS

Chapter 2, "The Creative Space": Previously published in a different form as "Keeping the Studio" in *Art Therapy: Journal of the American Art Therapy Association* 12, no. 3 (1995). Reprinted with permission from the American Art Therapy Association, Inc. (AATA).

Chapter 3, "Letting Go in a Safe Place": A rewritten excerpt from "The Studio: Space of Transformation," a conversation between Shaun McNiff and Arunima Orr, in *Create* 6 (1997).

Chapter 4, "Embracing Upheaval": Originally published as "Art Is Soul's Medicine" in the exhibition catalog for *Healing and Art*, Gustavus Adolphus College, St. Peter, MN, 1992. The exhibition was held in conjunction with the Nobel Conference XXVIII.

Chapter 5, "The Early Work, 1970–1974: Anthony, Bernice, and Christopher": The descriptions of the work of Anthony and Bernice were originally published in *Art Therapy at Danvers*, Addison Gallery of American Art, Phillips Academy, Andover, MA, 1974. Their art, together with Christopher's, was presented in a 1972 exhibit by the same title that originated at the Addison Gallery and traveled to museums and university galleries throughout the Northeast.

A description of my work with Christopher was published in "The Effects of Artistic Development on Personality," *Art Psychotherapy* 3, no. 2 (1976), and an expanded description of my work with Anthony was published in

"Anthony: A Study in Parallel Artistic and Personal Development," *American Journal of Art Therapy* 14, no. 4 (1975). I also briefly discussed my work with Anthony and Christopher in *Art as Medicine* (Boston & London: Shambhala Publications, 1992).

Chapter 6, "The Art Therapist as Artist": Published in *Proceedings of the Thirteenth Annual Conference of the American Art Therapy Association*, Philadelphia, October 20–24, 1982.

Chapter 7, "Aesthetic Meditation" (2003). New essay written for this book.

Chapter 8, "The Interpretation of Imagery": An abridged version of an essay published with the same title in *The Canadian Art Therapy Association Journal* 3, no. 1 (1987).

Chapter 9, "Treating Images as Persons and Dialoguing with Them" (1991): Originally published as "Ethics and the Autonomy of Images" in *The Arts in Psychotherapy* 18, no. 4 (1991).

Chapter 10, "The Challenge of Disturbing Images" (1993): Excerpted from "The Authority of Experience," in *The Arts in Psychotherapy* 20, no. 1 (1993).

Chapter 11, "Images as Angels" (1994): Presented (in a different form) at the General Session, 24th Annual Conference of the American Art Therapy Association, Atlanta, Ga., November 1993, and published in *Art Therapy: Journal of the American Art Therapy Association* 11, no. 1 (1994). Reprinted with permission from the American Art Therapy Association, Inc. (AATA).

Chapter 12, "Angels of the Wound" (1995): Published in *Earth Angels: Engaging the Sacred in Everyday Things* by Shaun McNiff (Boston: Shambhala Publications, 1995). Reprinted by arrangement with Shambhala Publications, Inc., Boston, www.shambhala.com. Also reprinted as "Angels of the Wound: The Crucifix Re-Visioned" in *Nourishing the Soul*, ed. Charles Simpkinson and Anne Simpkinson (San Francisco: Harper Collins, 1995).

Chapter 13, "Artistic Auras and Their Medicines" (1995): Originally published as "Auras and Their Medicines" in *The Arts in Psychotherapy* 22, no. 4 (1995).

Chapter 14, "The Effects of Different Kinds of Art Experiences" (2003). New essay written for this book.

Chapter 15, "Pandora's Gifts: Using All of the Arts in Healing" (2001): A revised and expanded version of "Pandora's Gifts: The Use of Imagination and All of the Arts in Therapy," published in *Approaches to Art Therapy: Theory and Technique*, 2nd ed., ed. Judith Rubin (Philadelphia: Brunner-Routledge, 2001).

Chapter 16, "A Pantheon of Creative Arts Therapies" (1987): An expanded version was published in the *Journal of Integrative and Eclectic Psychotherapy* 6, no. 3 (1987), with commentaries by Thomas Moore and Irene Corbit.

Chapter 17, "Working with Everything We Have" (1982): Originally published in the *American Journal of Art Therapy* 21, no. 4 (1982) and presented in "The Great Debates: The Place of Art in Art Therapy," a plenary session at the 13th Annual Conference of the American Art Therapy Association, Philadelphia, 1982.

Chapter 18, "A Review of *Jung on Active Imagination* by Joan Chodorow" (1998): Previously published, in a different form, as "Jung on Active Imagination: A Review" in *Art Therapy: Journal of the American Art Therapy Association* 15, no. 4 (1998). Reprinted with permission from the American Art Therapy Association, Inc. (AATA).

Chapter 19, "From Shamanism to Art Therapy" (1979): Originally published in *Art Psychotherapy* 6, no. 3 (1979).

Chapter 20, "The Shaman as Archetypal Figure" (1989): Originally published in *Common Boundary* 7, 5 (1989).

Chapter 21, "The Shaman Within" (1988): Originally published in *The Arts in Psychotherapy* 15, no. 4 (1988).

Chapter 22, "The Basis of Energy" (2001): A revised version of "Creativity and Healing: A Rain of Energy," published in *Poiesis: A Journal of the Arts and Communication*, no. 3 (2001).

Chapter 23, "The Healing Powers of Imagination" (1999): A revised version of "Cultivating Imagination," published in *Poiesis: A Journal of the Arts and Communication*, no. 1 (1999).

Chapter 24, "Surrender to the Rhythm" (2003/1980): Originally published as "The Metaphysics of Rhythm: Surrender and the Art of Life" in *Poiesis: A Journal of the Arts and Communication*, no. 5 (2003). The chapter is a modified version of "Metaphysics of Rhythm," originally presented in the "Symposium on Metaphor, Myth, and Mode in Artistic Expression," American Psychological Association Annual Convention, Montreal, 1980.

Chapter 25, "Video Enactment in the Expressive Therapies" (1980): A revised version of an essay originally published in *Videotherapy in Mental Health*, ed. J. Fryrear and B. Fleshman (Springfield, IL: Charles C. Thomas, 1980).

Chapter 26, "A Virtual Studio" (1999): Previously published in a different form as "The Virtual Art Therapy Studio" in *Art Therapy: Journal of the Amer-*

*ican Art Therapy Association* 16, no. 4 (1999). Reprinted with permission from the American Art Therapy Association, Inc. (AATA).

Chapter 27, "Art Therapy Is a Big Idea" (2000): Previously published in a different form in *Art Therapy: Journal of the American Art Therapy Association* 17, no. 4 (2000). Reprinted with permission from the American Art Therapy Association, Inc. (AATA).

Chapter 28, "An Inclusive Vision of Art Therapy: A Spectrum of Partnerships" (1997): Originally published as "Art Therapy: A Spectrum of Partnerships," in *The Arts in Psychotherapy* 24, no. 1 (1997).

Chapter 29, "The Way of Empathy: The Practice of Creativity in the Workplace" (1999): An extensively revised version of an essay originally published in *The Soul of Creativity*, ed. Tona Pearce-Myers (Novato, CA: New World Library, 1999).

Chapter 30, "The Test of Time" (1983): A revised and abridged version of an essay originally published as "Angels Dancing on the Head of a Pin: The Illusions of Psychotherapeutic Efficacy," in *The Therapeutic Efficacy of the Major Psychotherapeutic Techniques*, ed. J. Hariman (Springfield, IL: Charles C. Thomas, 1983).

# SELECTED PUBLICATIONS BY SHAUN MCNIFF

## BOOKS

*Art as Medicine: Creating a Therapy of the Imagination.* Boston: Shambhala Publications, 1992.

*Art Therapy at Danvers.* Andover, MA: Addison Gallery of American Art, Phillips Academy, 1974.

*Art-Based Research.* London: Jessica Kingsley Publisher, 1998.

*The Arts and Psychotherapy.* Springfield, IL: Charles C. Thomas, 1981.

*Creating with Others: The Practice of Imagination in Art, Life, and the Workplace.* Boston: Shambhala Publications, 2003.

*Depth Psychology of Art.* Springfield, IL: Charles C. Thomas, 1989.

*Earth Angels: Engaging the Sacred in Everyday Things.* Boston: Shambhala Publications, 1995.

*Educating the Creative Arts Therapist: A Profile of the Profession.* Springfield, IL: Charles C. Thomas, 1986.

*Fundamentals of Art Therapy.* Springfield, IL: Charles C. Thomas, 1988.

*Trust the Process: An Artist's Guide to Letting Go.* Boston: Shambhala Publications, 1998.

## CONTRIBUTIONS TO BOOKS AND CATALOGS

"Angels Dancing on the Head of a Pin." In *The Therapeutic Efficacy of the Major Psychotherapeutic Techniques,* edited by Jusuf Hariman. Springfield, IL: Charles C. Thomas, 1983.

"Angels of the Wound: The Crucifix Re-visioned." In *Nourishing the Soul*, edited by Charles Simpkinson and Anne Simpkinson. San Francisco: Harper Collins, 1995.

"Art Is Soul's Medicine." Introduction to *Healing and Art,* exhibition catalog, edited by Laura Stone and Don Palmgren. St. Peter, MN: Gustavus Adolphus College, 1992.

"Artistic Inquiry: Research in Creative Arts Therapy." In *Foundations of Expressive Arts Therapy*, edited by Stephen Levine and Ellen Levine. London: Jessica Kingsley Publisher, 1998.

"Celebrations of Memory." Catalog essay for *Mother of Grace: An Exhibition of Gloucester Photographs by Dana Salvo*, Cape Ann Historical Museum, Gloucester, MA, 1999.

"Clinical Breadth and the Arts: Interdisciplinary Training in the Creative Arts Therapies." In *Perspectives on Music Therapy Education and Training*, edited by Cheryl Dileo Maranto and Kenneth Bruscia, et al. Philadelphia: Temple University Esther Boyer College of Music, 1987.

"Computers as Virtual Studios." In *Art Therapy and Computer Technology: A Virtual Studio of Possibilities*, edited by Cathy Malchiodi. London: Jessica Kingsley Publisher, 2001.

"Creating with the Workplace." Foreword to *Follow Your Bliss: A Practical, Soul-Centered Guide to Job-Hunting and Career-Life Planning*, by Helen Barba. Universal Publishers, http://upublish.com, 2000.

"Creative Practice." In *Soul Work: A Field Guide for Spiritual Seekers*. San Francisco: Harper Collins, 1998.

"The Discipline of Total Expression: An Abiding Conversation." In *Crossing Boundaries: Explorations in Therapy and the Arts*, edited by Stephen Levine. Toronto: EGS Press, 2002.

Foreword to *Adult Art Therapy*, edited by Helen Landgarten and Darcy Lubbers. New York: Brunner/Mazel, 1991.

Foreword to *Artistic Inquiry in Dance/Movement Therapy*, by Lenore Wadsworth Hervey. Springfield, IL: Charles C. Thomas, 2000.

Foreword to *Art Therapy and Political Violence*, edited by Debra Kalmanowitz and Bobby Lloyd. London and New York: Brunner/Routledge, 2004.

Foreword to *Expressive Therapies*, edited by Cathy Malchiodi. New York: Guilford, 2004.

Foreword to *Group Process Made Visible: Group Art Therapy*, by Shirley Riley. Philadelphia: Brunner/Routledge, 2001.

Foreword to *Introduction to Art Therapy*, by Bruce Moon. Springfield, IL: Charles C. Thomas, 1993.

Foreword to *Minstrels of the Soul*, by P. Knill, H. Barba, and M. Fuchs. Toronto: Palmerston Press, 1995.

Foreword to *Photo Art Therapy: A Jungian Perspective*, by Jerry Fryrear and
Irene Corbit. Springfield, IL: Charles C. Thomas, 1992.

Foreword to *Teaching for Aesthetic Experience: The Art of Learning*, edited by
Gene Diaz and Martha B. McKenna. New York: Peter Lang, 2004.

Foreword to *The Ecology of Imagination in Childhood*, by Edith Cobb. Dallas:
Spring Publications, 1993.

"Group Art Therapy." In *The Psychotherapy Handbook*, edited by Richie
Herink. New York: New American Library, 1980.

Introduction to *Art That Heals* exhibition catalog, edited by Christopher
Greenman. Louisville: Kentucky Art and Craft Foundation, 1992.

"Letting Pictures Tell Their Stories." In *Sacred Stories: Healing in the Imagina-
tive Realm*, edited by Charles Simpkinson and Anne Simpkinson. San Fran-
cisco: Harper Collins, 1993.

"Pandora's Gifts: The Use of Imagination and All of the Arts in Therapy." In
*Approaches to Art Therapy: Theory and Technique*, 2nd ed., edited by Judith
Rubin. Philadelphia: Brunner-Routledge, 2001.

"The Practice of Creativity in the Workplace." In *The Soul of Creativity*, edited
by Tona Pearce-Myers. Novato, CA: New World Library, 1999.

"Through the Children's Eyes." Foreword to *How We See God and Why It
Matters: A Multicultural View through Children's Drawings and Stories*, by
Robert Landy. Springfield, IL: Charles C. Thomas, 2001.

"Truman Nelson: An Interview with Shaun McNiff." In *The Truman Nelson
Reader*, edited by William Schafer. Amherst: University of Massachusetts
Press, 1989.

"Video Enactment in the Expressive Therapies." In *Videotherapy in Mental
Health*, edited by Jerry Fryrear and Bob Fleshman. Springfield, IL: Charles C.
Thomas, 1980.

### JOURNAL ARTICLES, ESSAYS, AND INTERVIEWS

"Anthony: A Study in Parallel Artistic and Personal Development." *American
Journal of Art Therapy* 14, no. 4 (1975).

"Art Activities for Evaluating Visual Memory." *Academic Therapy Quarterly* 11,
no. 3 (1976).

"Art and Music Therapy for the Learning Disabled," with Paolo Knill. *New
Ways* 1, no. 2 (1975).

"Art and Religion in Psychotherapy." *Bulletin of the National Guild of Catholic
Psychiatrists* 30 (1984).

"The Art Therapist as Artist." In *Proceedings of the 9th Annual Conference of
the American Art Therapy Association*, edited by Linda Gantt, Grace Forrest,
Diane Silverman, and Roberta Shoemaker. Philadelphia: American Art
Therapy Association, 1978.

"Art Therapy in the Classroom." with Karen McNiff. *Art Teacher*, Spring 1976.

"The Art Therapy Intensive." *Art Therapy: Journal of the American Art Therapy Association* 1, no. 1 (1983).

"Art Therapy Is a Big Idea." *Art Therapy: Journal of the American Art Therapy Association* 17, no. 4 (2000).

"Art Therapy Registration and Standards of Practice." *Art Education* 33, no. 4 (1980).

"Art Therapy: A Spectrum of Partnerships." *The Arts in Psychotherapy* 24, no. 1 (1997).

"Art, Artists and Psychotherapy: An Interview with Robert Coles." *Art Psychotherapy* 3, nos. 3–4 (1976).

"The Artistic Soul of Psychiatry." *The Canadian Art Therapy Association Journal* 2, no. 2 (1986).

"Auras and Their Medicines." *The Arts in Psychotherapy* 22, no. 4 (1995).

"The Authority of Experience." *The Arts in Psychotherapy* 20, no. 1 (1993).

"Competency Evaluation." *American Art Therapy Association Newsletter* 11, no. 4 (1981).

"Conversations with Images: An Application of James Hillman's Method of Personifying to Art Therapy." *C.R.E.A.T.E.: Journal of the Creative and Expressive Arts Therapies Exchange*, no. 2 (1992).

"Creating Outside the Lines: Enlarging Psychological Research through the Arts." *Bulletin of Psychology and the Arts* 2, no. 2 (2001). Also published in *The Healing Art: The Journal of the Russian Art Therapy Association*, no. 2 (2002).

"Creative Transformation and Artistic Healing: In Service of a Big Idea: An Interview with Shaun McNiff," by Revital Totem Silver. *Poiesis: A Journal of the Arts and Communication* 2 (2000).

"Creativity and Healing: A Rain of Energy." *Poiesis: A Journal of the Arts and Communication* 3 (2001).

"Cross-Cultural Psychotherapy and Art." *Art Therapy: Journal of the American Art Therapy Association* 1, no. 3 (1984).

"Cultivating Imagination." *Poiesis: A Journal of the Arts and Communication* 1 (1999).

"A Dialogue with James Hillman." *Art Therapy: Journal of the American Art Therapy Association* 3, no. 3 (1986).

"Enlarging the Vision of Art Therapy Research." *Art Therapy: Journal of the American Art Therapy Association* 15, no. 2 (1998).

"Ethics and the Autonomy of Images." *The Arts in Psychotherapy* 18, no. 4 (1991).

"Everyday Sacraments." *Shambhala Sun* 4, no. 4 (1996).

"Expanding the Spectrum." *The Arts in Psychotherapy* 15, no. 4 (1988).

"Freedom of Research and Artistic Inquiry." *The Arts in Psychotherapy* 13, no. 4 (1986).

"From Shamanism to Art Therapy." *Art Psychotherapy* 6, no. 3 (1979).

"Hillman's Aesthetic Psychology." *The Canadian Art Therapy Association Journal* 5, no. 1 (1990).

"How It All Began." *The Current* (Lesley College magazine) 8, no. 2 (1979).

"Images as Angels." *Art Therapy: Journal of the American Art Therapy Association* 11, no. 1 (1994).

"Images of Fear," with Robert Oelman. *Art Psychotherapy* 2, no. 2 (1976).

"Imaginal Realism." *C.R.E.A.T.E.: Journal of the Creative and Expressive Arts Exchange* 3, no. 1 (1993).

"Inside the Cut." *Split Shift*, no. 1 (1996). An essay examining the relationship between the poets Vincent Ferrini and Charles Olson.

"Integrating Life and Art Therapy." *American Journal of Art Therapy* 39, no. 2 (2000).

"Interview with Shaun McNiff," by Stephen Levine. *C.R.E.A.T.E.: Journal of the Creative and Expressive Arts Therapies Exchange*, no. 5 (1995).

"Interview with Shaun McNiff." In *A Leap of Faith: The Call to Art*, by Ellen Horowitz. Springfield, IL: Charles C. Thomas, 1999.

"Keeping the Studio." *Art Therapy: Journal of the American Art Therapy Association* 12, no. 3 (1995).

"Motivation in Art." *Art Psychotherapy* 4, nos. 3–4 (1977).

"A New Perspective in Group Art Therapy." *Art Psychotherapy* 1, nos. 3–4 (1973).

"On Art Therapy: A Conversation with Rudolf Arnheim." *Art Psychotherapy* 2, nos. 3–4 (1975).

"On Being a Male Art Therapist." In *Creativity and the Art Therapist's Identity*, edited by Roberta Shoemaker. *Proceedings of the Seventh Annual Conference of the American Art Therapy Association*, Baltimore. Pittsburgh: American Art Therapy Association, 1976.

"Organizing Visual Perception through Art." *Academic Therapy Quarterly* 9, no. 6 (1974).

"Pantheon of Creative Arts Therapies: An Integrative Perspective." with commentaries by Thomas Moore and Irene Corbit. *Journal of Integrative and Eclectic Psychotherapy* 6 no. 3 (1987).

"Research and Scholarship in the Creative Arts Therapies." *The Arts in Psychotherapy* 14, no. 2 (1987). Also published in *Studies in Clinical Application of Drawings*, edited by Japanese Association for Family Drawings. Tokyo: Kongo Shuppan, 1992.

"Robert Coles, Children of Crisis and Art Education." *Art Teacher* 9, no. 2 (1979).

"Rock and Roll, Ecstatic Transformation and Shamanism." *Transforming ART* (Australia) 2, no. 1 (1987).

"Rudolf Arnheim: A Clinician of Images." *The Arts in Psychotherapy* 21, no. 4 (1994).

"Setting Standards for Art Therapists." In *The Use of the Creative Arts in Therapy*. Washington, DC: American Psychiatric Association, 1980.

"The Education of Imagination: Stepping into the Unknown." *The Center Post: An Occasional Journal of the Rowe Camp and Conference Center* 10, no. 2 (1998).

"The Effects of Artistic Development on Personality." *Art Psychotherapy* 3, no. 2 (1976).

"The Emergence of an Arts Institute." *The Lesley College Graduate School Newspaper* 1, no. 1 (1976).

"The Interpretation of Imagery." *The Canadian Art Therapy Association Journal* 3, no. 1 (1987).

"The Metaphysics of Rhythm: Surrender and the Art of Life." *Poiesis: A Journal of the Arts and Communication* 5 (2003).

"The Myth of Schizophrenic Art." *Schizophrenia Bulletin* 9 (1974).

"The Revolutionary Morality of Truman Nelson." *Left Curve*, no. 15 (1991).

"The Shaman as Archetypal Figure." *Common Boundary* 7, no. 5 (1989).

"The Shaman Within." *The Arts in Psychotherapy* 15, no. 4 (1988).

"The Studio: Space of Transformation. A Conversation between Shaun McNiff and Arunima Orr." *C.R.E.A.T.E.: Journal of the Creative and Expressive Arts Therapies Exchange*, no. 6 (1997).

"Truman Nelson, an Interview." *Minnesota Review*, Spring 1978.

"Video Art Therapy," with Christopher Cook. *Art Psychotherapy* 2, no. 1 (1975).

"The Virtual Art Therapy Studio." *Art Therapy: Journal of the American Art Therapy Association* 16, no. 4 (1999).

"Working with Everything We Have." *American Journal of Art Therapy* 21, no. 4 (1982).

## BOOK REVIEWS

Review of *An Encyclopedia of Archetypal Symbolism*, edited by Beverly Moon. *The Arts in Psychotherapy* 19 (1992).

Review of *Art in Education: An International Perspective*, edited by Robert Ott and Al Hurwitz. *American Journal of Art Therapy* 24 (August 1985).

Review of *The Arts in Therapy*, by Bob Fleshman and Jerry Fryrear. *The Arts in Psychotherapy* 9, no. 1 (1982).

Review of *Clinical Art Therapy: A Comprehensive Guide*, by Helen Landgarten. *American Journal of Orthopsychiatry* 53, no. 2 (1983).

Review of *Every Person's Life Is Worth a Novel*, by Erving Polster. *Voices: Journal of the American Academy of Psychotherapists* 23, no. 1 (1987).

Review of *Existential Art Therapy: The Canvas Mirror*, by Bruce Moon. *The Canadian Art Therapy Association Journal* 6, no. 1 (1991).

Review of *Family Art Psychotherapy*, by Helen Landgarten. *Art Therapy: Journal of the American Art Therapy Association* 5, no. 1 (1988).

Review of *Fundamentals of Artistic Therapy: The Nature and Task of Painting Therapy*, by Margarethe Hauschka. *American Journal of Art Therapy* 28, no. 1 (1989).

Review of *Jackson Pollock: An American Saga*, by Steven Naifeh and Gregory White Smith. *American Journal of Art Therapy* 29, no. 2 (1990).

Review of *Jung on Active Imagination*, edited and with an introduction by Joan Chodorow. *Art Therapy: Journal of the American Art Therapy Association* 15, no. 4 (1998).

Review of *Maximus to Gloucester: The Letters of Charles Olson to the Editor of the* Gloucester Daily Times, edited by Peter Anastas. Published as letter to the editor, *Gloucester Daily Times*, June 22, 1992.

Review of *No Easy Answers: Teaching the Learning Disabled Child*, by Sally Smith with Karen McNiff. *The Arts in Psychotherapy* 7, no. 1 (1980).

Review of *Parables of Sun and Light: Observations on Psychology, the Arts, and the Rest*, by Rudolf Arnheim. *The Arts in Psychotherapy* 17, no. 2 (1990).

Review of *Phototherapy in Mental Health*, edited by David Krauss and Jerry Fryrear. *Art Therapy* 2, no. 1 (1985).

Review of *Ten Paintings*, by D. H. Lawrence. *Art Therapy: Journal of the American Art Therapy Association* 4, no. 3 (1987).

**AUDIO PROGRAM**

*Art Will Heal Your Life.* Boulder, CO: Sounds True, 2001.

# INDEX

Active imagination, 73, 79, 103–104, 149, 154, 171–179, 191, 260, 297, 305
Addison Gallery of American Art, x–xi, 11, 41, 51, 239–240, 243–244, 249, 254, 295, 299
Adobe Photoshop, 256–260
*Adult Art Psychotherapy* (Landgarten), 271, 281, 300
Akenside, Mark, 223, 228
Albers, Josef, 129–130, 135
   *Interaction of Color*, 129, 135
Alchemy, 11, 16, 53, 172, 174, 231–232
Alcoholics Anonymous, 124
Allen, Pat, 12, 18, 27, 267, 270, 278, 281
   *Art Is a Way of Knowing*, 27, 267, 278, 281
Allport, Gordon, 76
American Art Therapy Association
   educational guidelines, 25
   journal, xv, 9, 263, 267
   mission, 3, 169, 279
   presentations, 11, 71

Amplification, 174, 287
Analogizing, 71, 93, 143–144, 175, 204
Anderson, Walt, 163, 167
Andrews, Lynn, 202, 208
Angels, 54, 71–72, 100–111, 127, 265, 296, 298–299, 303
   earth angels, 102
   of the wound, 72, 103, 112–120, 296, 300
*Anima mundi* (soul of the world), 124, 126
Animism, 89, 92
Anthony, 10, 34–41, 43, 51, 295–296, 301
Anthroposophical practice, 60, 126
"Antidevelopmental," xii
Archetypal psychology, 71, 102, 178
Archetypal qualities, 90–91, 102, 142, 265, 304
   art expression, 46–47
   James Hillman's psychology of, 71, 84, 102, 178, 195

Archetypal qualities *(continued)*
  Jungian, 91, 172, 142, 172, 174, 178, 218, 222
  labeling, 174
  mandalas, 74
  Marsilio Ficino's view on, 102
  shamanic, xii, 182, 194–200, 205
  wounds, 115, 118
Aristotle, 103
Arnheim, Rudolf, x, 81, 94, 110, 135, 162, 192, 254, 303–305
  balance and tension, 97, 187
  expressiveness of images and objects, 71, 84, 93, 103, 122, 248
  gestalt psychology, 84, 155, 248
  visual thinking, 78
*Art as Medicine: Creating a Therapy of the Imagination* (McNiff), ix, 12, 71, 102, 105, 109, 111, 136, 220, 296, 299
Art-based research, 279
*Art-Based Research* (McNiff), 12, 281, 290, 293, 299
*Art Is a Way of Knowing* (Allen), 27, 267, 278, 281
*Artistry of the Mentally Ill (Bildnerei der Geisteskranken,* Prinzhorn), 274, 282
*Art Museum as Educator, The* (video), 240, 244, 254
  *Arts and Psychotherapy, The* (McNiff), 148, 152, 162, 167, 181, 299
Art therapy in schools, 276–277
Asclepius, 227
Auras, 16–17, 24, 72–73, 121–136, 220, 252, 296, 302
Authentic expression, 23, 30, 59, 110, 132–133, 143, 178, 235, 248, 274, 287
Autonomy of images, 32, 71, 84–85, 87–90, 93, 111, 122, 259, 296, 302

Bachelard, Gaston, 23, 27, 65–67, 100, 110
Barfield, Owen, 101, 110
Beauty, 13, 54, 57–60, 117, 225
Beginner's mind, 17
Benedict, Ruth, 186, 192
Bentley, Eric, 190, 192
Bernard of Clairvaux, 59, 67
Bernice, 10, 34, 41–47, 51, 295
Bias, 83, 110, 129, 233
*Birth of Tragedy, The* (Nietzsche), 4, 220
Blake, William, 215, 226, 275
  *Marriage of Heaven and Hell, The,* 215
Blocks, 32, 70, 79, 144, 154, 157, 206, 218, 231–232, 234, 268, 284
Bohr, Niels, 175
*Book of Life, The* (Ficino), 102, 111, 136
Botticelli, Sandro, 102
Breath, 233–237
Buddhist principles, 71, 207
Burgy, Don, 11, 31

Cage, John, 165
Cairns, Huntington, 84, 94, 269–270
Cane, Florence, 277, 281
Carnap, Rudolf, 211
Cassirer, Ernst, 188
  *Philosophy of Symbolic Forms, The,* 188, 192
Castaneda, Carlos, 202, 208
Center for Applied Special Technology (CAST), 261
Chagall, Mark, 90–91
Charmides, 3
Circulation of creativity, 60, 217
  energy, 148, 157, 212–215, 217–219, 231, 255, 257, 268
  expressions and images, 156, 255, 257
  groups, 5, 12, 58
Circumambulation, xii, 149, 176–177
Chodorow, Joan, 149, 171–180, 297, 305

Christopher, 10–11, 34, 47–51, 295–296
Clinification, 27, 270, 278, 281
Cobb, Edith, 155, 162, 224–225, 229, 272, 281, 301
*Ecology of Imagination in Childhood*, 162, 224, 229, 272, 281, 301
Co-creation, 12, 217
Coleridge, Samuel Taylor, 223, 228
Collage, 140, 142, 256
Color, 133, 155
  analogies, 144
  anthroposophy, 126–127
  art diagnosis, 69, 75, 79, 93, 101
  case of Anthony, 36–38
  case of Bernice, 44, 46
  case of Christopher, 50
  dialogue, 88, 105, 109, 124
  digital, 240–241, 256–257, 259–262
  healing effects, 59–62, 64, 104, 126–131, 134, 219, 267–268
  overlooked, 57
  responsive movement, 106, 159
  watercolor, 20, 150
Compassion, 103, 114, 118, 215, 218, 285
Complementary aspects, 174–175, 269, 272
Conceptual art, 11, 31, 165, 278
*Concerning the Spiritual in Art* (Kandinsky), 127, 136
Condon, William, 246, 254
Confucius, 210
Consensual validation, 138
Contagion of creation, 213, 219, 227, 237
Cook, Christopher, x, 11, 165, 240, 243, 304
Corbin, Henry, 103–104, 110
Corbit, Irene, 142, 145, 240, 297, 301, 303
Correspondence principle, 56, 73, 88, 130, 137–138, 144, 184

Craft, 131–134
*Creating with Others* (McNiff), 5, 265, 299
Crucifix, 72, 114–120, 300
Csikszentmihalyi, Mihaly, 213, 220
Czaplicka, Maria Antoinette, 185, 192

Dana-Farber Cancer Institute, 4
Danvers State Hospital, ix, xi–xii, 9–11, 47, 51, 71, 243, 295, 299
  Dark places, 29, 60, 91, 102, 114, 126, 207–208, 218–219, 260
  dark angels, 102, 116
  dark gods, 117
darkness, 102, 197, 219
Da Vinci, 77, 171, 275
Delacroix, Eugène, 130, 136
Depth psychology, 22, 25, 126, 172, 178, 189, 201–202, 280
*Depth Psychology of Art* (McNiff), 12, 95, 270, 299
Diagnostic art interpretation, 32, 69, 76–77, 82–83, 130–131, 134, 174, 212, 279
  Dialogue, 19, 56, 183, 198, 200
  imaginal, 71–72, 86–94, 101, 106–110, 124, 154, 176
  interpretation, 76, 78, 81, 83
Digital art, 240–242, 255–262
Dionysian rites, 231
Disintegration, 31, 185–186, 214
Disturbing experiences and images
  embracing, 6–7, 102–103, 127, 207, 222, 233, 236
  sources of expression, 10, 24, 31–32, 43, 52, 71, 96–99, 110, 115
Dobyns, York, 213, 220
Double, 251
Drumming, 73, 104, 110, 138, 153–154, 157, 187, 191, 197, 202–203, 206–207, 230, 236–237
Durkheim, Émile, 184

*Earth Angels: Engaging the Sacred in Everyday Things* (McNiff), 10, 72, 136, 296, 299
Ecology, 83, 102, 129, 148, 153, 155, 177, 217, 225, 289
 creative ecology, 19, 148, 170, 225
 of imagination, 155, 162, 224, 229, 272, 281, 301
 social ecology, 18
*Ecology of Imagination in Childhood* (Cobb), 162, 224, 229, 272, 281, 301
Einstein, Albert, 224
Eliade, Mircea, 30, 183–187, 192, 202, 208
 *Shamanism: Archaic Techniques of Ecstasy*, 192, 202, 208
Emerson, Ralph Waldo, 269, 285
Empathy, 17, 33, 70, 78, 98, 143, 184, 186, 265, 283–289, 298
Entropy, 192
Ethical treatment of images, 71, 82, 85, 111, 296, 302
Evans, Bob, 255, 257–259, 262
Exaggeration, 287
Exhibition, 56
Explanationism, 154

Familiars, 84, 102, 192
Fasanella, Ralph, 118
Feder, Bernard, 163, 167
Feder, Elaine, 163, 167
Ficino, Marsilio, 102, 111, 124, 136
 *Book of Life, The*, 102, 111, 136
Fiction, 88, 287–288
Fleshman, Bob, 163, 167, 297, 301, 304
Flying sparks, 21, 224
*Foundations of Expressive Arts Therapy* (Levine), 152, 162, 281, 300
Fragmentation, 31, 152, 164, 188, 213, 233
 rhythmic, 235

Freud, Sigmund, 77, 91, 127, 171–172, 175, 186, 189, 275
Fryrear, Jerry, 142, 145, 163, 167, 240, 297, 301, 304, 305
 *Photo Art Therapy*, 142, 145, 301

Gadamer, Hans-Georg, 83, 94, 158, 162
 *Philosophical Hermeneutics*, 83, 94
*Gates of the Dream* (Róheim), 251, 254
Gauguin, Paul, 139, 142
Gestalt psychology, 84, 155, 248
gestalt therapy, 83–85, 95, 190
Goethe, Johann Wolfgang von, 126, 130
Good-enough mother, 29
Greening, 130

Hallucinogens, 187
Hamilton, Edith, 84, 94, 269–270
Harner, Michael, 202, 208
Harrison, Jane, 198–199
Hauschka, Margarethe, 126, 136, 305
*Healing Fiction* (Hillman), 88, 94
Healing the healers, 22
Heidegger, Martin, 65, 71, 123, 136
Heraclitus, 190, 195, 231
Heuristic examination, 12
Hildegard of Bingen, 129–130
Hillman, James, 71, 84, 87–88, 94, 101, 119–120, 136, 174, 195, 302–303
 *Healing Fiction*, 88, 94
Hobbes, Thomas, 223
Holland, 21, 164
Homeopathic medicine, 105, 127, 138
Homer, 89, 124
 *Iliad*, 89
Huang-po, 121
Hufgard, Sister M. Kilian, 59, 67
Hume, David, 290
Hunt, William Morris, 133, 136

*Iliad* (Homer), 89
Image abuse, 70, 76–78

Imaginal perspectives, 83, 85–94, 175, 178, 195, 222–223
Imagining the image further, 154
Improvisation, 24, 56, 158–161, 192, 205, 216, 236, 246–247
Indigenous healing practices, 20, 138–139, 231
*Interaction of Color* (Albers), 129, 135
Interior designers, 24
Intermediate realm of imagination, 224–225
Internet, 257, 261–262
Intersubjectivity, 76
In the zone, 225
Ishmael, 65

James, E. O., 185, 192
Jones, Maxwell, 17, 22, 155
Joyce, James, 54
Judging, 59, 76, 88, 143
Jung, Carl Gustav, 84–86, 91, 94, 100–101, 136, 142, 145, 189, 275, 301
    active imagination, 73, 79, 149, 154, 171–179, 191, 297, 305
    archetypal pain, 218
    circumambulation, xii, 149, 176–177
    *Memories, Dreams, Reflections*, 176
    *Mysterium Coniunctionis*, 176
    post-Jungian archetypal psychology, 71
    purposeful psyche, 97, 222
    sand-tray, 73, 142, 172
    savior as insignificant thing, 196
    scientific materialism, 123

Kagan, Jerome, 76
Kandinsky, Wassily, 127, 130, 132, 136
    *Concerning the Spiritual in Art*, 127, 136
Kapitan, Lynn, 12, 18, 27
Katz, Richard, 202, 208
Kaulity, Mamfred, 196

Keeper of the studio, 20, 24, 28
Kellogg, Rhoda, 261–262
King Lear, 32
Kline, Franz, 104
Knill, Paolo, 91, 167, 196, 276, 282, 300–301
    intermodal expressive therapy, 151–152, 155, 162–163
    shamanic exploration, 202
*Kreatieve therapie*, 164

La Barre, Weston, 184, 192
Labeling images, 32, 70, 77, 79, 82, 90, 128, 174
Landgarten, Helen, 271, 281, 300, 304–305
    *Adult Art Psychotherapy*, 271, 281, 300
Landy, Robert, 12, 301
Langer, Susanne, 78–79, 81
    *Philosophy in a New Key*, 78, 81
Larsen, Stephen, 187, 192, 202, 208
    *Shaman's Doorway, The*, 187, 192, 208
Lawrence, D. H., 102, 116–118, 120, 197–199, 207–208, 305
    *Mr. Noon*, 116–117, 120
    *Plumed Serpent, The*, 197, 199, 207–208
Lesley University, x, xii, 240, 244, 303–304
Letting go, 9–10, 28–30, 92–93, 158–159, 207, 218, 226, 295, 299
Levine, Ellen, 152, 155, 178, 281, 300
Levine, Stephen, 12, 152, 155, 162, 214, 220, 281, 300, 303
    *Foundations of Expressive Arts Therapy*, 152, 162, 281, 300
Lévi-Strauss, Claude, 183–184, 192
Linear thought, xii, 13, 27, 151, 155, 175, 177, 210, 223, 228, 233
Linge, David, 83, 94

Listening, 18, 28, 83, 138, 184, 203, 235, 237
Literalism, 86, 145
  psychological interpretation, 32, 69–71, 75, 79
Lommel, Andreas, 185, 192
Looking deeply, 57,
Looking psychologically, 173
Lowen, Alexander, 190
Lowenfeld, Viktor, 277, 281
Lubbers, Darcy, 271, 281, 300
Lucretius, 124

Malchiodi, Cathy, 9, 12, 263–264, 267–268, 270, 300
Mandala, 48–49, 74, 176–177
*Marriage of Heaven and Hell, The* (Blake), 215
Masks, 92, 98, 102, 275
*Massa confusa*, 233
Matisse, Henri, 258
McKenna, Dennis, 187, 193
McKenna, Terence, 187, 193
McNiff, Shaun: works by
  *Art as Medicine: Creating a Therapy of the Imagination*, ix, 12, 71, 102, 105, 109, 111, 136, 220, 296, 299
  *Art-Based Research*, 12, 281, 290, 293, 299
  *Arts and Psychotherapy, The*, 148, 152, 162, 167, 181, 299
  *Depth Psychology of Art*, 12, 95, 270, 299
  *Earth Angels: Engaging the Sacred in Everyday Things*, 10, 72, 136, 296, 299
  *Trust the Process: An Artist's Guide to Letting Go*, 10, 131, 299
Melville, Herman, 65
  *Memories, Dreams, Reflections* (Jung), 176
Metaphysics, 230, 297, 304

Metaphysics (Aristotle), 103
Metarhythm, 235
Milieu, 17, 26, 268
Miller, Henry, 230
Mindfulness, 57
Mirroring, 107, 158
Mishima, Yukio, 165, 167
Miss X, 174
*Moby Dick* (Melville), 65
Monet, Claude, 127, 133
Moon, Beverly, 304
Moon, Bruce, 12, 18, 27, 269–270, 300, 304–305
Moon, Catherine, 12, 18, 27
Moore, Henry, 138–139
Moore, Thomas, 94, 297, 303
Moreno, J. L., 189–191, 193
*Mr. Noon* (Lawrence), 116–117, 120
Mr. O, 85, 176
*Mysterium Coniunctionis* (Jung), 176
Mysticism, 73, 117, 209

Nadel, S. F., 185, 193
Naming, 191
Narcissus, 244
Narrative, 13, 70, 72, 105, 107, 128, 155, 202, 209, 211, 214, 285
Naumburg, Margaret, 275
New Age, 4–5, 60, 73
Nietzsche, Friedrich, 4, 78, 97, 99, 165, 189–190, 193, 214, 219–220, 232
  *Birth of Tragedy, The*, 4, 220

O'Connor, Mary Louise, 4
Offspring of expression, 66, 84, 90
O'Keeffe, Georgia, 76
Overspecialization, 272

Pandemonium, 151, 158
Pandora, 149, 151–162, 296, 301
Participation mystique, 17

*Patterns of Culture* (Benedict), 186, 192

Pathology, 12, 32, 44, 75, 77, 82, 87, 185, 274

Perfectionism, 25, 117, 234, 260, 289

Performance art, 11, 82, 104, 215–216, 236
  John Cage and, 165
  objects, 139
  responding to images, 24, 56, 93, 97–98, 124, 155, 158–159
  responding to others, 161
  shamanic, 203
  space, 159
  total expression, 125, 147

Perls, Frederick, 83–84, 87, 95

Persona, 172

Personal objects, 139–140

Person-centered therapies, 85

Personifying, 85, 88–89, 91, 171, 175, 192, 286, 302

Phenomenology, 71, 83, 204

*Philosophical Hermeneutics* (Gadamer), 83, 94

*Philosophy in a New Key* (Langer), 78, 81

*Philosophy of Symbolic Forms, The,* (Cassirer) 188, 192

*Photo Art Therapy* (Fryrear), 142, 145, 301

Photography, 57, 73, 140, 142, 165, 239, 249, 255–256

Physics, 155, 211–213, 217
  chaos theory, 213–214
  quantum, 130, 175
  work, 212, 216, 219

Picture therapy, 169

Plato, 84, 94, 269–270

*Plumed Serpent, The* (Lawrence), 197, 199, 207–208

Pollock, Jackson, 143, 305

Princeton University Engineering Anomalies Research Laboratory, 213

Prinzhorn, Hans, 44, 264, 273–274, 280, 282
  *Artistry of the Mentally Ill* (*Bildnerei der Geisteskranken*), 274, 282

Projections, 76–77, 81–82

Psychoanalysis, 126, 171, 275
  psychoanalytic methods, 132, 184–185, 189–191, 275

Psychodrama, 185, 190–191

Psychosis, 185, 226, 232–235

Public health, 18, 265, 274, 276, 292

Purposeful psyche, 173, 222

Rank, Otto, 76, 81, 165, 189, 193

Reciprocal relations, 73, 138, 213, 215, 224, 258
  Reducing images, 93, 221
  Georgia O'Keefe's paintings, 76
  Gestalt therapy, 83
  narratives, 13
  personal characteristic and pathologies, 21, 32, 75, 79, 87, 204
  psychological concepts, 69–70, 125, 130, 174, 189, 223

Reframe, 27, 98, 103, 109, 116, 284

Reich, Wilhelm, 190

Renoir, Auguste, 96

Richter, Jean Paul, 223, 229

Rights of images, 82, 85, 94

Robbins, Arthur, 163, 167

Rochberg-Halton, Eugene, 213, 220

Roffman, Eleanor, xii

Rogers, Carl, 97

Róheim, Géza, 251, 254

Rolling Thunder, 195

Romantics, 21, 223–224

Sacred place, 30

Safety, 5, 9, 28–30, 33, 49, 81, 105, 109, 113, 133–134, 140, 153, 155, 159, 161, 203, 207, 225, 227–228, 236, 251, 268, 285, 287, 291, 295

Saint Augustine, 195
Sanctuary, 17–18, 23, 30, 110
Sand-tray, 73, 142, 172
Schizophrenic art, 44, 304
Self-confrontation, 244–246, 252
Self-regulating systems, 148, 174, 186,
    214
  psyche, 177
Shamanism, 6, 102, 148, 162, 181–208,
    231, 269–270, 292, 297,
    303–304
  dismemberment, 214
  eating pain, 202
  familiars, 84
  illumination crisis, 89, 172
  objects from nature, 140
  picture's speaker, 92
  soul loss, 194, 200, 210, 204–205,
    231
  soul retrieval, 231, 252
  sucking out illness, 202
  technological, 251–253
  travel between worlds, 194–195, 206,
    231
  vision quest, xii
*Shamanism: Archaic Techniques of
    Ecstasy* (Eliade), 192, 202, 208
*Shaman's Doorway, The* (Larsen), 187,
    192, 208
Shadow, 97, 172, 260
  dreams, 222
Shelley, Percy Bysshe, 76
Shrines, 142
Silverman, Julian, 186, 193
Slipstream, 5, 148
Socrates, 3, 84, 90, 195, 269
Speaker for the image, 92
Speaker's meaning, 101, 110
Stamos, Theodoros, 129
Standardized assessments, 77
Steiner, Rudolf, 60, 125–126
Stereotypic imagery, 46, 49, 288

Stevens, Wallace, 86, 125, 136
Stories, 94, 112, 118, 166, 203, 275
  alleviating depression, 134
  improving, 88
  Jung's practice, 177
  new versions, 104–105
  responding to art, 71–72, 79–81, 154,
    301
  workplace, 285–287
Stuck condition, 32, 88, 92, 101, 107,
    153, 203, 236
Sullivan, Harry Stack, 138
Surrender, 207–208, 210, 230–237, 297,
    304
Symptoms, 26, 112, 119, 219
Synergy, 264, 271–272, 280

Talking cure, 123, 191
Taoism, 175
*Temenos* (sacred place), 30
Texture, 79, 93, 105, 116, 124, 128, 245,
    261
Theory indigenous to art, 86, 210
Therapeutic community, 17–18, 27, 40,
    155, 162
  of images and creative expression,
    22–24, 155
Thich Nhat Hanh, 235
Thin places, 225
Thoreau, Henry David, 54
*To the Lighthouse* (Woolf), 211
Total expression (*Gesamtkunstwerk*),
    105, 125, 147–149, 161, 240, 300
Totemism, 192
Transcendent function, 173, 175, 178
Transference, 186
Trust the process, 22–23, 31, 135, 148,
    173, 235, 258
*Trust the Process: An Artist's Guide to
    Letting Go* (McNiff), 10, 131,
    299
Tutelary spirits, 192

Unconscious, 172–174, 176, 186, 189, 201

Universal design, 24, 241

Video therapy, 165, 239–240, 243–255, 297, 301, 304
   playback, 247–252
   video portraits, 250

Virtual studio, 241, 255–262, 297, 300, 304

Wagner, Richard, 147, 220

Waldorf Schools, 60

Watkins, Mary, 86–87, 95

Weiser, Judy, 140, 145

Wilson, Bill, 124

Winnicott, Donald W., 29, 228–229, 268, 270

Witch's cauldron, 30

Withholding judgment, 79–80

Witnessing, 23, 51, 110, 159, 173, 248

Woolf, Virginia, 211

Workplace, 5, 265, 283–289, 298–301

Zen, 30, 121

# BOOKS BY SHAUN MCNIFF
## PUBLISHED BY SHAMBHALA PUBLICATIONS

*Art As Medicine: Creating a Therapy of the Imagination*

The medicine of the artist, like that of the shaman, arises from his or her relationship to "familiars"—the themes, methods, and materials that interact with the artist through the creative process. *Art As Medicine* demonstrates how the imagination heals and renews itself through this natural process. The author describes his pioneering methods of art therapy—including interpretation through performance and storytelling, creative collaboration, and dialoguing with images—and the ways in which they can revitalize both psychotherapy and art itself.

*Art Heals: How Creativity Cures the Soul*

The field of art therapy is discovering that artistic expression can be a powerful means of personal transformation and emotional and spiritual healing. In this book, Shaun McNiff reflects on a wide spectrum of activities aimed at reviving art's traditional healing function.

*Creating with Others: The Practice of Imagination in Life, Art, and the Workplace*

*Creating with Others* is designed to address group creativity in both theory and practice. Shaun McNiff draws examples from the creative arts as well as from organizational life and everyday work situations. He shows how leaders can be facilitators of creative teamwork, and how artists and other creative people can collaborate fruitfully with others.

*Earth Angels: Engaging the Sacred in Everyday Things*

By the time you finish this book, the term "inanimate object" will no longer have a place in your vocabulary, for Shaun McNiff will awaken you to the wondrous energies streaming out of familiar things and bringing a sense of magic into everyday life. Does a Styrofoam cup have soul? McNiff says yes, for the most debased things show us that the presence

of the divine depends upon the quality of attention that we bring to our experiences.

## Trust the Process: An Artist's Guide to Letting Go

Whether in painting, poetry, performance, music, dance, or life, there is an intelligence working in every situation. This force is the primary carrier of creation. If we trust it and follow its natural movement, it will astound us with its ability to find a way through problems—and even make creative use of our mistakes and failures.